THE SEPARATE PLATES OF *William Blake*

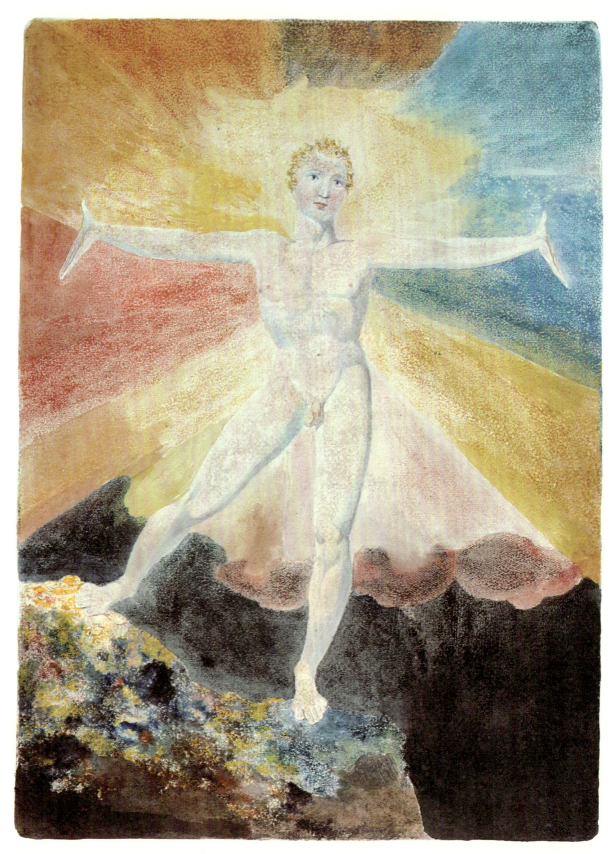

"Albion rose." First state, color-printed impression 1B. 27.2 × 19.9 cm

THE SEPARATE PLATES OF

William Blake

A Catalogue · Robert N. Essick

PRINCETON UNIVERSITY PRESS

Copyright © 1983 by Princeton University Press
Published by Princeton University Press, 41 William Street,
Princeton, New Jersey
In the United Kingdom: Princeton University Press,
Guildford, Surrey

Publication of this book has been aided by a grant from the
Guggenheim Foundation

This book has been composed in Linotron Sabon

Clothbound editions of Princeton University Press books are
printed on acid-free paper, and binding materials are chosen for
strength and durability

Printed in the United States of America by Princeton University
Press, Princeton, New Jersey

Color plates and black and white illustrations by Meriden Gravure
Company, Meriden, Connecticut

Designed by Laury A. Egan

Library of Congress Cataloging in Publication Data

Essick, Robert N.
The separate plates of William Blake.
Bibliography: p. Includes index.
1. Blake, William, 1757-1827—Catalogs. I. Title.
NE642.B5A4 1982 769.92'4 82-7588
ISBN 0-691-04011-7 AACR2

For My Father and Brother

Contents

Part One.
Plates Designed and
Executed by Blake

Contents

Contents

ix

Contents

List of Illustrations

Preface

Among William Blake's graphic works are plates executed and originally published as individual works of art or as companion prints. These have customarily been classified as "separate plates," a category that excludes illustrations published in books and prints issued as a series of more than two. Blake was not, however, an artist who rigidly observed the generic boundaries of his own time, much less those of modern cataloguers. He began preliminary work on at least one separate plate that he never completed. Several plates were no doubt intended for publication as book illustrations but are known today only through separate impressions. Still others were originally sold both as book illustrations and as separate prints. All these types of "separate plates," broadly defined, are the subject of this catalogue.

William Michael Rossetti was the first to attempt to list, however incompletely, all of Blake's engravings. His work was published as an appendix to Alexander Gilchrist's *Life of Blake* (1863 and 1880). Rossetti's list is important today only for its historical primacy. The next catalogue, Archibald G. B. Russell's *The Engravings of William Blake* (1912), is a vast improvement. Russell attempted to describe all of Blake's plates except for the illuminated books. His catalogue is generally accurate, fairly detailed, and still useful. The only major limitations, given Russell's intentions, are the paucity of illustrations, failure to distinguish some states of the plates, and the inclusion of several works engraved by a different Blake.[1] Because of Russell's volume, it is fair to say that a good deal more was known about Blake's prints than his writings until Keynes' great *Bibliography of William Blake* appeared in 1921.

Russell's catalogue remained the standard source of information on the separate plates for many years. Laurence Binyon's *Engraved Designs of William Blake* (1926) is a handsome volume with fine illustrations, but it covers only plates designed and engraved by Blake and adds little information not found in Russell. Thomas Wright's alphabetical list of "Blake's Paintings, Colour Prints, Sketches and Engravings" appended to his *Life of William Blake*[2] is no more than a synopsis of earlier catalogues. David Erdman's brief article on "The Dating of William Blake's Engravings," first published in 1952,[3] is exceptionally important but treats only three plates.

In 1956, the firm of Emery Walker in Dublin published Geoffrey Keynes' *Engravings by William Blake: The Separate Plates*. Since then it has been the standard catalogue of its subject and is the most important predecessor to this volume. Keynes was the first to give information on paper, provenances, and other matters relating to individual impressions. Unfortunately, there is no consistency in the type and amount of information given for each impression and the coverage of prints in American collections is highly selective. The very fine collotype reproductions include all the original graphics and a selection of the copy plates. Handsomely printed and limited to five hundred copies, the book is now both scarce and dear.

In recent years, Keynes' work has been supplemented, but not replaced, by numerous articles, books, and exhibition catalogues with new information on states and individual impressions. The most significant of these publications include Keynes' own *Bibliotheca Biblio-*

[1] See Part Seven, LXIX, in this catalogue.
[2] Two volumes, Olney: Thomas Wright, 1929.
[3] *Philological Quarterly*, 31 (1952), 337-343; reprinted with a new postscript by Erdman in Essick, ed., *The Visionary Hand*, pp. 161-171.

graphici, a complete catalogue of his great book and print collection; David Bindman's *Complete Graphic Works of William Blake*; and Martin Butlin's catalogue of the Tate Gallery exhibition held in 1978. Bindman reproduces all of Blake's original graphics; and although the accompanying notes are most informative, the book does not purport to be a complete catalogue. Beginning in 1972, the *Blake Newsletter*, which changed its name to *Blake: An Illustrated Quarterly* in the summer of 1977, has published very useful handlists of important Blake collections, most of which include some separate plates.[4] *Blake Books*, by G. E. Bentley, Jr., includes those separate plates (such as "Albion rose" and "Laocoön") that bear inscriptions of sufficient length and originality to be considered part of Blake's work as a writer.[5] In *William Blake, Printmaker*, I presented new information on Blake's techniques and stylistic development, including some radical revisions in dating the states of his plates.

This new catalogue of Blake's separate plates has been necessitated by the great amount of information that has come to light since Keynes' 1956 catalogue. Several scholars have diligently been discovering new separate plates at least provisionally attributable to Blake, a great many previously unrecorded impressions, and documents of all sorts that help us understand these materials. Thanks to their efforts, I have been able to include much factual information not available in earlier catalogues. I have also given more attention than my predecessors to tracing provenances (although this has often resulted in frustrating inconclusiveness), listing sales records of untraced impressions, describing paper sizes and types, and indicating the condition of individual impressions. Parts Three through Six include types of prints that have not previously been catalogued or described in any detail. This is not a revision of any previous work; it is based on an examination of original impressions and all relevant primary documents. The illustrations include all extant states of all plates described in Parts One through Five that show any changes in the image (with but one exception),[6] almost all the known preliminary drawings,[7] and color reproductions of all impressions color printed by Blake himself.

I have taken as my first responsibility the recording of all determinable facts about each plate and each impression I have been able to locate. No doubt there are other extant impressions, particularly of the more frequently printed plates such as "Chaucers Canterbury Pilgrims," which have escaped my net. The lists of untraced impressions should prove helpful in tracing the histories of new impressions as they come to light. The determination of states and the dates of their execution are frequently complex matters with Blake's works, and thus I have focused particular attention on these issues. In the "discussion" section of each entry I have considered problems in dating, medium and technique, printing history, and the relation of preliminary drawings to the development of the plate. Interpretations of the symbolism of the original graphics have not been developed at length, but I hope that my brief iconographic discussions will offer a guide to further work in the field of Blake scholarship that continues to attract the most laborers.

I have tried to avoid arcane abbreviations or systems of symbols so

[4] See 5 (Spring 1972), devoted to the British Museum collection; 9 (Winter 1975-1976), on the Rosenwald Collection of the National Gallery of Art and the Library of Congress; and 11 (Spring 1978), covering the Essick, Huntington, Metropolitan Museum of Art, Boston Museum of Fine Arts, and Fogg Art Museum collections.

[5] Because *Blake Books* is the most important single bibliography of Blake's writings and works about him and will no doubt be the most consulted reference work on him for years to come, I have taken particular care to point out any errors in it that affect the separate plates. I have not indicated corrections and additions to Keynes, *Engravings by Blake: The Separate Plates*; these would be so extensive as to become excessively interruptive and tedious.

[6] I have been unable to acquire a photograph of the second state of "Chaucers Canterbury Pilgrims," both impressions of which are in private collections.

[7] Related and preliminary sketches in Blake's *Notebook* are not reproduced here. These drawings are all readily accessible in two facsimile editions: *The Note-Book of William Blake*, ed. Geoffrey Keynes, London: Nonesuch Press, 1935; reprinted New York: Cooper Square Publishers, 1970; and *The Notebook of William Blake*, ed. David V. Erdman with the assistance of Donald K. Moore, Oxford: Clarendon Press, 1973; revised edition, New York: Readex Books, 1977.

that the format of this catalogue will be self-explanatory in the main and accessible to anyone interested in Blake's separate plates. A few points, however, need attention here:

The plates in each Part of the catalogue are arranged chronologically by first state, as well as that can be determined. Impressions of each state are listed alphabetically by owner's name, with examples in anonymous private collections gathered at the end of each series. Individual traced impressions are designated by a letter, or letters, preceded by a number indicating the state, when that can be determined (e.g., impression 1A, 2B, 2C, etc.). Impressions of indeterminable state are designated by a letter or letters without number. Untraced impressions are referred to by a number.

All plates are intaglio copperplate etchings and/or engravings, designed and executed by Blake, unless noted otherwise.

If I have not been able to confirm the presence of an impression in a particular collection, I have recorded it as untraced even if located in that collection by previous authorities. When I have been able to confirm, either personally or through reliable and recent documents, the presence of an impression in a collection, I have listed it as traced even if I have not been able to examine the print or have not been permitted to publish the owner's name. Impressions located in the British Museum are housed in the Department of Prints and Drawings of that institution.

Dimensions are in centimeters, height followed by width. Because of paper shrinkage or stretching over the years, the sizes of the image and plate mark can vary from one impression to another by a measurable amount, even for fairly small plates. With a print as large as "Chaucers Canterbury Pilgrims," the differences can be considerable, as I have recorded. When the original copperplate is not extant, the sizes indicated are the average of all recorded impressions, with some adjustments made for examples with extreme variance from the mean. For impressions on laid India paper, sheet dimensions are those of the mounting sheet, not the India paper.

Unless otherwise indicated, all impressions are printed in black ink on untinted paper without visible watermark. All hand tinting, pen and ink work, or color printing have been noted.

Information on exhibitions is generally limited to those for which a catalogue or handlist was published.

All Sotheby, Hodgson, and Christie's auctions were held in London, unless otherwise noted. All Anderson Galleries and Parke-Bernet auctions were held in New York.

In references to Blake's illuminated books, plate numbers and copy designations follow those given in Bentley, *Blake Books*.

For all impressions not reproduced in this volume, I have listed at least one reproduction if the impression has ever been reproduced.

Information on frequently cited published works may be found in the Bibliography.

This catalogue was substantially completed in June 1981. With but few exceptions, discoveries, sales, and acquisitions after that date have not been recorded here.

Acknowledgments

The research and writing of this catalogue have been generously assisted by a fellowship from the John Simon Guggenheim Memorial Foundation. I am also indebted to the Foundation and its executive officers, Gordon N. Ray and G. Thomas Tanselle, for a supplementary grant supporting the color reproductions in this volume. I am grateful to Dean David H. Warren, College of Humanities and Social Sciences, University of California, Riverside, for a grant-in-aid for photography and research assistantships.

A book of this kind is in many ways a cooperative effort, requiring help from curators, private collectors, and print dealers. Their institutions and collections are listed in this catalogue, and my appreciation for the special information they have provided is acknowledged in the footnotes. But I must record here my thanks to those whose assistance extended well beyond their normal responsibilities to inquisitive visitors: R. John Blackley, Michael Clarke of the Whitworth Art Gallery, Douglas Cleverdon, Edward Croft-Murray, Merlin Cunliffe, Stephanie Dickey and Nancy Bialler of Sotheby Parke Bernet, Ellen Dunlap of the University of Texas, Andrew Edmunds, Henry Gerstley, George Goyder, Mrs. Ramsey Harvey, Donald Heald, Joseph Holland, Mrs. Gerard Lambert, Ian Lowe of the Ashmolean Museum, Christopher Mendez, P. S. Morrish of the Brotherton Library, William Plomer of Agnew's, Mary Priester of the Yale University Art Gallery, Mrs. Lucile Rosenbloom, Elizabeth Roth of the New York Public Library, Leo Steinberg, Peter VanWingen of the Library of Congress, Richard Vogler, and Irena Zdanowicz of the National Gallery of Victoria. The staff of the Huntington Library have offered expert and ever-cheerful assistance on many occasions and have made their beautiful research institution the ideal place for writing this book.

Many friends and fellow-devotees of Blake's art have given freely of their time, knowledge, and encouragement. It is a pleasure to record my debts to Nicolas Barker, Shelley Bennett, Elizabeth Bentley, David Bindman, Martin Butlin, Frances Carey, Detlef Doerrbecker, David Erdman, Ruth Fine, Everett Frost, Christopher Heppner, Jenijoy La Belle, Thomas Lange, Raymond Lister, James McCord, W.J.T. Mitchell, Morton Paley, Michael Phillips, and Dennis Read. I have also been fortunate to have research assistants whose efforts have added so much to this catalogue: Stephanie Babin (San Marino), Diana Dethloff (London), Janice Lyle (London and Santa Barbara), Julie McKemy (Florence), and Michael Young (Philadelphia). Christine Ivusic of Princeton University Press has offered both initial enthusiasm for this project and a sure hand in guiding it to completion.

I thank the following institutions and individuals for permission to reproduce works in their collections: Her Majesty Queen Elizabeth II; Auckland City Art Gallery, New Zealand; Bodleian Library, Oxford; Museum of Fine Arts, Boston; Trustees of the British Museum; Martin Butlin; Research Library, University of California, Los Angeles; Museum of Art, Carnegie Institute, Pittsburgh; Art Institute of Chicago; Cincinnati Art Museum, gifts of Mr. and Mrs. John W. Warrington and Mr. and Mrs. John J. Emery; Merlin Cunliffe and the National Gallery of Victoria, Australia; Glasgow Museums and Art Galleries, Stirling Maxwell Collection, Pollock House; Mrs. Ramsey Harvey;

Acknowledgments

Henry E. Huntington Library and Art Gallery; G. Ingli James; Herbert F. Johnson Museum of Art, Cornell University; Sir Geoffrey Keynes; Library of Congress, Rosenwald Collection; McGill University Libraries, Department of Rare Books and Special Collections, Lawrence Lande William Blake Collection; The Trustees of the Pierpont Morgan Library; National Gallery of Art, Washington, D.C., Rosenwald Collection; Philadelphia Museum of Art, gift of Mrs. William T. Tonner; Princeton University Library; Rosenbach Museum and Library, Philadelphia; Lucile Johnson Rosenbloom; Royal Academy of Art, London; Leo Steinberg; Tate Gallery; Gabinetto Disegni E Stampe degli Uffizi, Florence; F. B. Vanderhoef, Jr.; Victoria and Albert Museum; National Museum of Wales; Whitworth Art Gallery, University of Manchester; Yale University Art Gallery; M. H. de Young Memorial Museum, The Fine Arts Museum of San Francisco, Dr. T. Edward and Tullah Hanley Memorial Collection. Ownership of each work is indicated in the List of Illustrations.

Finally, I wish to emphasize my special indebtedness to two eminent scholars whose assistance has been crucial to my work. G. E. Bentley, Jr., has made available to me his vast store of knowledge of things Blakean, from the location of separate plates to the minutiae of sales records. His scholarly writings, his generosity, and his friendship continue to be of inestimable value.

Sir Geoffrey Keynes was the first to suggest that I undertake the writing of a new catalogue of Blake's separate plates. I have been blessed with his help and with the gift of a glorious week in August spent in his company, surrounded by the treasures he has allowed me to describe in this volume. His character as a scholar, collector, and lover of Blake has been the guiding spirit of all my endeavors.

Robert N. Essick
Altadena, California
June 1981

Introduction

William Blake's work as an engraver and etcher of separate plates can only be understood fully within the context of his complete career as a printmaker.[1] But a brief overview of his separate plates and the broad outline of their chronology may be helpful to users of this catalogue.

When Blake began his career as an independent printmaker late in 1779, the large, separate etching/engraving assumed much the same position in the hierarchy of the graphic arts as that traditionally given to the epic in the hierarchy of literary genres. The reputations of the most successful line and stipple engravers then active in England, such as William Woollett, Sir Robert Strange, and Francesco Bartolozzi, were acquired for the most part through their execution of large, highly wrought separate prints reproducing "history" paintings or portraits of the noble and famous. While Blake's master, James Basire, produced several fine separate plates, most of Blake's training directed his talents toward the somewhat less exalted area of book illustration. Thus, Blake must have considered himself fortunate to have been hired, within less than four years after his release from apprenticeship in August 1779, by the important print publisher Thomas Macklin to execute two stipple plates after Watteau, "Morning Amusement" and "Evening Amusement" (Figs. 58, 59), and another pair after Meheux and Thomas Stothard, "Robin Hood & Clorinda" and "The Fall of Rosamond" (Figs. 60, 61). These are typical "fancy" prints of their day, demonstrating Blake's technical facility and ability to submit his individual talent to contemporary tastes in reproductive engravings. His fee of £80 for "The Fall of Rosamond" hardly placed Blake in the top rank of his craft—Macklin paid William Sharp the enormous sum of £700 for engraving Sir Joshua Reynolds's "Holy Family"— but it was a decent amount for one just beginning in the trade.[2]

After this promising start, Blake's fortunes as an engraver of large, commercial plates declined through the decade of the 1780s. The last commissions from important publishers came in 1788. But the companion prints executed for John Raphael Smith (Figs. 68-72) hardly have the grandeur in size or subject Blake must have desired, and the large and fine plate of the "Beggar's Opera" for John and Josiah Boydell's Hogarth volume was followed by only one further commission from the largest publisher of prints in England.[3] Blake was occasionally hired to execute stipple portraits and fancy plates throughout his life (Figs. 77, 79, 82, 83), but only by lesser artists and publishers. His one commission from an important artist, Thomas Phillips (Fig. 78), was for a private plate apparently not intended for publication or general distribution. In 1803, Blake confessed to William Hayley, "Every Engraver turns away work that he cannot execute from his superabundant Employment. Yet no one brings work to me." Two years later, for the same correspondent, Blake reviewed his career in reproductive engraving and looked to its future with an eye schooled by past disappointments: "But my Fate has been so uncommon that I expect Nothing. I was alive & in health & with the same Talents I now have all the time of Boydell's, Macklin's, Bowyer's, and other Great Works. I was known by them & was look'd upon by them as Incapable of Employment in those Works; it may turn out so again."[4]

[1] For this type of study, see my *William Blake, Printmaker*, published by Princeton University Press in 1980.

[2] These fees are recorded in the "Monthly Retrospect of the Fine Arts," *Monthly Magazine*, 11 (April 1801), 246. Sharp's plate, with an image 30.3 × 25.1 cm, bears an imprint dated 1793. For a brief survey of the ways engravers were hired and prints published in eighteenth-century England, see David Alexander and Richard T. Godfrey, *Painters and Engraving: The Reproductive Print from Hogarth to Wilkie*, New Haven, Connecticut: Yale Center for British Art, 1980, pp. 11-13.

[3] See Part Six, LXI, *The Original Works of William Hogarth*, and LXIII, *Boydell's Graphic Illustrations of the Dramatic Works, of Shakspeare*, in this catalogue.

[4] Letters of 7 October 1803 and 11 December 1805; see Keynes, ed., *Letters of Blake*, pp. 68-69, 120. Among the "Great Works" to which Blake refers are Boydell's Shakespeare Gallery, Macklin's Bible and Poet's Gallery, and Robert Bowyer's illustrated edition of David Hume's *History of Great Britain*.

Many of Blake's efforts at engraving separate plates show his desire to circumvent the commercial publishers who were so willing to ignore him. In 1784, Blake joined with James Parker, another former apprentice of Basire's, to form a print selling and publishing business. Their only surviving publications engraved by Blake, "Zephyrus and Flora" and "Calisto" after Stothard (Figs. 62, 63), show that the partners were willing to feed the public's taste for delicate stipple prints. But this attempt to become their own publishers and sell directly to the public soon ended for unknown—but probably economic as well as personal—reasons.

The reproductive print, painstakingly copied by an engraver after a painting or drawing by another artist, was the dominant state of the art in Blake's day. There was, however, an alternative tradition of original graphics in which the artist designed, executed, and published his own "inventions." William Hogarth was the most famous English practitioner in this mode, although he hired French journeymen to execute some of his later plates. James Barry, closer to Blake in time and taste, was a more important if less outwardly successful precursor. Barry's prints were highly individual in style and expression, often varied from one impression to another in printing and tinting, and had historical, literary, and allegorical subjects.[5] In similar fashion, Blake began, perhaps while still an apprentice, to prepare a number of designs based on subjects taken from British history and intended for eventual engraving. The gestation period seems to have been long and arduous, for the only plate that has survived from this project, "Edward & Elenor" (Fig. 6), was not published until 1793. Blake also worked for many years on at least two plates of biblical subjects, "Job" of 1793 and "Ezekiel" of the next year (Figs. 7, 12). These three large plates were executed in formal linear patterns that clearly distinguish them from Blake's copy work in stipple and place them stylistically within the norms for "historical"[6] engraving established by Woollett. They constitute Blake's first major attempt to restore original printmaking to what he believed to have been its traditional and rightful supremacy over mere copy work. There is not the slightest shred of evidence that his contemporaries paid the least attention to his efforts.

A stylistically more adventuresome approach to intaglio graphics is exemplified by three smaller plates of the early 1790s, "Albion rose," "The Accusers of Theft Adultery Murder," and "Lucifer and the Pope in Hell" (Figs. 15, 17, 20). These express some of Blake's political ideas also found in his writings of that decade. In 1790, Blake published, and probably engraved, a plate of Henry Fuseli's "Timon and Alcibiades" executed in a style of etching that harks back to the prints of Jusepe de Ribera, Salvator Rosa, and John Hamilton Mortimer. Rather than covering the entire plate with formal patterns of hatching and crosshatching, Blake used a free and energetic approach that leaves much of the copper untouched and permits individual lines to assume greater expressive presence. In his three political prints, as well as his book illustrations for Edward Young's *Night Thoughts* of 1796-1797, Blake appears to have been attempting an integration of this dramatic style with the more conventional patterns of copy engraving. This

[5] See *A Series of Etchings by James Barry, Esq., from His Original and Justly Celebrated Paintings, in the Great Room of the Society of Arts Manufacturers and Commerce, Adelphi,* London: W. Bulmer for Colnaghi, 1808; Alexander and Godfrey, *Painters and Engraving,* pp. 46-51; and William L. Pressly, *The Life and Art of James Barry,* New Haven and London: Yale University Press, 1981. Blake greatly admired Barry and apparently planned at one time to write a poem about him; see Erdman, ed., *Poetry and Prose of Blake,* p. 790, and Erdman, *Prophet Against Empire,* pp. 38-42.

[6] Blake described "Edward & Elenor" and "Job" as "Historical" engravings in his important prospectus *To the Public* of 10 October 1793; see Erdman, ed., *Poetry and Prose of Blake,* p. 670.

frequently took the form of simply increasing the size and decreasing the regularity of patterns, as in the background and foreground of "Albion rose"; or employing enlarged versions of techniques, such as the worm lines in the foreground of "Lucifer and the Pope in Hell," generally reserved for small, picturesque book illustrations. Stylistically, these prints range between the sublime and the exaggerations of caricature. The results are rarely as successful as the intention is admirable or the symbolism of the designs intriguing.

In the late 1780s, Blake began an even more radical departure from the aesthetics and economics of commercial engraving. His invention of relief etching permitted the execution of words and pictures together on the same copperplate, and thus he used it primarily to create the so-called illuminated books. These, and the few separate plates produced with the new technique, are remarkable for their bold, almost primitive, directness. While the late eighteenth century produced many simple wood and metal cuts, these were thought appropriate only for illustrations in children's books and catchpenny prints hawked in the streets. Grand and serious subjects demanded more sophisticated graphic renderings and a much higher finish. Blake's use of relief techniques to create images that clearly proclaim themselves as inheritors of the great tradition of Western figurative art violated this basic principle of graphic decorum. One can hardly imagine prints more completely antithetical in mode of production and taste than Blake's rugged relief etchings and his own early, fashionably smooth, stipple plates.

Even for a printmaker as inventive as Blake, it is surprising to find that every one of his separate relief plates is the product of a different experimental process. The poor inking and printing of the only extant impression of "The Approach of Doom" (Fig. 4) cannot completely disguise the fact that it is a complex integration of black- and white-line techniques, the former painted on the plate in acid-resist and the latter scraped out of the resist. For "Deaths Door" of 1805 (Fig. 25), originally intended as an illustration for a new edition of Robert Blair's *The Grave*, Blake abandoned his original form of relief etching and executed the entire image in white line. In contrast, the mysterious relief plate (Figs. 28, 29) showing the torso and legs of a figure very similar to the rising youth in "Deaths Door" is dominated by black lines, including surprisingly fine crosshatching patterns and pebble-like surfaces that are almost a relief equivalent of intaglio stipple. This reunion of bold relief work and the delicate patterns native to reproductive engraving continues in "The Chaining of Orc" (Fig. 45) with its technically inexplicable combinations of relief surfaces and grainy textures reminiscent of aquatint. The "Enoch" of 1806-1807 (Fig. 30) would seem to be a marriage between Blake's relief etching and the new art of stone lithography. Finally, "The Man Sweeping the Interpreter's Parlour" (Figs. 54-56) in white line may very well be etched or engraved in pewter rather than copper. Until the present century, the whole history of printmaking offers no artist who matches Blake's range of technical virtuosity.

While Blake was rapidly developing his talents as a relief etcher in the early 1790s, he was also experimenting with new color-printing techniques. Several of his early stipple and line plates, including those

after Cosway and Morland (Figs. 64, 68, 71), had been commercially printed in colored inks *à la poupée*—that is, with each color (usually three or four and rarely more than five) applied to the appropriate parts of the plate with small inking balls and printed in one pull of the press.[7] Blake's method was necessarily different, because he was working with relief plates, and required the skills of a painter as much as a printer. He occasionally printed pages of the illuminated books in two colors of ink, but the process he used extensively from about 1794 to 1796 made use of opaque pigments, suspended in a glue or low-solubility gum medium, painted directly on the plate. Because his relief etchings were bitten to an extremely shallow depth, the color could be applied to the recessed areas as well as relief plateaus. When printed, this viscous medium would create fascinatingly reticulated surfaces that generally required extensive hand work with pen, ink, and brush to define the outlines and details of the image.

As with relief etching, Blake used his special method of color printing primarily for the illuminated books and illustrations from them printed without the texts. Two separate plates, "A Dream of Thiralatha" (Pls. 4, 5), originally intended as a book illustration, and "Joseph of Arimathea Preaching to the Inhabitants of Britain" (Pls. 7, 8), are known only in the form of richly color-printed impressions. Because the etched image served only as a guide for the "painting" of the plate, Blake was able to use his technique for color printing from the surfaces of intaglio plates. The successful results can be seen in the impressions of "Albion rose," "The Accusers of Theft Adultery Murder," and "Lucifer and the Pope in Hell," reproduced in color in this volume (Frontispiece and Pls. 1-3, 6). The impressions of "Albion rose" in the Huntington Library and "The Accusers" in the National Gallery of Art, Washington, appear to be second pulls with little, if any, addition of new pigments to the plate. Probably only two, or at most three, impressions could be taken without cleaning the plate and beginning the entire process over again. This technical limitation may explain why, for the five color-printed plates, there are at most only two extant impressions of each.

Blake rapidly developed his color printing in a way that led him ever further from the traditional metal working of his craft. The color impressions taken from intaglio plates are in fact planographic prints not dependent upon any etching or engraving. In *The Song of Los* of 1795, Blake printed the full-page designs and the title page from plates that were either completely unengraved or bore no incisions greater than a scratched outline. Although their attribution to Blake is certainly open to question, two somewhat earlier and evidently experimental works (Pl. 9 and Fig. 3) may be precursors to this type of planographic printing. The final stage in this evolution is represented by the magnificent color-printed drawings of 1795 in which the images were stamped from blank copperplates or millboard.[8] These are printed works existing in up to three impressions, but they are not etchings or engravings of any sort. They are much closer, in both means of production and final effect, to drawings or paintings than to conventional eighteenth-century graphics. The taste and technology of the day emphasized the uniform repeatability of the identical image through

[7] For the history of this and other processes, see Joan M. Friedman, *Color Printing in England, 1486-1870*, New Haven, Connecticut: Yale Center for British Art, 1978.

[8] The color-printed drawings are outside the scope of this catalogue since they are primarily watercolor drawings rather than "prints" as generally defined. They are described fully in Martin Butlin, *The Paintings and Drawings of William Blake*, 2 vols., New Haven and London: Yale University Press, 1981. This invaluable catalogue was published after the completion of the present work. Its author, however, very generously permitted me to consult an early set of proofs in the summer of 1979.

many printings. Blake could not have produced prints more completely contrary to these values.

In 1800, Blake and his wife left London to work under the patronage of William Hayley in Felpham near the Channel coast. The relationship with Hayley became ever more disturbed and, Blake believed, a threat to his artistic consciousness. Blake returned to London in 1803, but continued to labor through deep anxieties alternating with brief periods of intense enlightenment. These experiences brought many changes to all of Blake's activities as a poet and artist. He returned to some of his early separate plates to rework the images and add inscriptions commensurate with his altered ideas on religion, history, and art. One of the first plates he revised was probably "Albion rose" which, in its final state, shows extensive burnishing to create the radiance about the figure's head and shoulders (Fig. 15). All engravers of Blake's time were of course familiar with the scraper and burnisher for making corrections in the copper, but the use of burnishing as an element of composition is most unusual. It is a characteristic and centrally important feature of Blake's nineteenth-century revisions.

Blake even returned to an apprentice plate (Fig. 1) to convert it into "Joseph of Arimathea Among the Rocks of Albion" (Fig. 2). Through the dramatic juxtaposition of burnished highlights and heavily engraved dark areas, Blake has transformed a competent but dull production of his youth into a powerful image. He applied a similar repertoire of graphic techniques to his large "Job" and "Ezekiel" plates (Figs. 8, 12). There is no recorded impression of the first state of the latter, but a comparison between the "Job" first and second states gives one a good sense of the extent of Blake's development as a master printmaker. The final state of "Job" is his finest separate intaglio plate.

From 1804 to 1820, Blake produced only a few new separate plates. By far the most significant is "Chaucers Canterbury Pilgrims" of 1810 (Figs. 35-39). It is Blake's last attempt to design, execute, and publish a large separate print with the hope of achieving some popular and critical success. He etched and engraved the design in hard, simple, linear outlines and patterns reminiscent of Basire's prints of antiquarian subjects, particularly medieval sculpture. Blake wrote that this style was in the great tradition "of Albert Durer, Lucas [van Leyden], Hisben [i.e., Hans Sebald Beham], Aldegrave [i.e., Heinrich Aldegrever], and the old original Engravers,"[9]—and thus the appropriate way to visualize the words of England's greatest medieval poet. But once again Blake was unable to turn connoisseurs from their love of reproductive prints and disabuse them of "the artfully propagated pretence that a Translation or a Copy of any kind can be as honourable to a Nation as An Original."[10]

Blake's friendship with the young artist John Linnell marks the next turning point in his career as a printmaker. Shortly after their first meeting in 1818, Linnell commissioned Blake to "lay in" the portrait plate of James Upton (Figs. 80, 81). Linnell was an expert engraver and etcher, but unlike Blake he had never been trained in the conventional linear patterns of eighteenth-century copy work. His portrait plates are typically filled with dense patterns of fine-line hatching, crosshatching, stipple, and flick work remarkable for their variety and

[9] Erdman, ed., *Poetry and Prose of Blake*, p. 556.
[10] "Public Address," *c.* 1809-1810, ibid., p. 565.

responsiveness to different textures, shadows, and highlights. Linnell's influence on Blake's own practice can be demonstrated by comparing his 1813 portrait of Earl Spencer (Fig. 78) with the 1820 portrait of Robert Hawker (Fig. 82). The former is an exceptionally heavy and dark version of the dot and lozenge technique Blake had used years before in the portrait of John Caspar Lavater (Fig. 66) and "Head of a Damned Soul" (Fig. 73). If it were not for Blake's signature on the Hawker portrait, it would be tempting to attribute the plate to Linnell.

Linnell's influence and patronage extended to every area of Blake's graphic activities in the last nine years of his life. He commissioned the *Job* and Dante print series and may even have been involved, at least indirectly, in the final revisions made in some of Blake's most important plates. Linnell used burnishing to highlight faces in his portrait plates and, as we have seen, this technique is a key element of the final states of "Job" and "Ezekiel." These cannot be dated with any specificity and they may have been executed as late as the early 1820s when Blake was finding renewed powers as an engraver, at least in part because of Linnell's presence. Even the "Laocoön" of *c.* 1820 (Fig. 51)—as much a manifesto as a picture—contains burnished highlights on the densely hatched and crosshatched figures. The fourth state of "Chaucers Canterbury Pilgrims" (Figs. 37-39) can be dated with some assurance to *c.* 1820-1823, and this reworked state is also characterized by darkly engraved passages modulated with burnished areas of illumination.

Blake's final, eminently flexible, graphic styles are definitively displayed in the *Job* and Dante series. Only one small separate plate, left unfinished at his death, hints at the mastery he achieved in his craft after such a long struggle. Like the *Job* plates, "George Cumberland's Card" (Fig. 57) was cut with the graver alone and is devoid of the preliminary etching and mechanical hatchings of reproductive graphics. Its style as well as motifs, suggesting both death and liberation, make it a modest yet appropriate finale to Blake's career as an artist of the separate plate.

Blake's reputation as a printmaker grew slowly, if unspectacularly, through the nineteenth century. By its last years, several enthusiasts, notably W. E. Moss and W. A. White, began to build significant collections of Blake's prints. They were followed in the 1920s by Lessing J. Rosenwald, whose great collection of illuminated books and separate plates is now divided between the Library of Congress and the National Gallery of Art, Washington; and by Sir Geoffrey Keynes, whose remarkable efforts as a collector and scholar have contributed so much to Blake's modern reputation as poet, painter, and printmaker.

Blake has always appealed more to book collectors than fine-print connoisseurs, and interest in him as an artist has not extended outside the English-speaking world until very recent years. It is instructive to compare the early auction prices fetched by "Mʳˢ Q" (Fig. 83), a conventional fancy print of very little importance to Blake's graphic oeuvre, with the prices brought by some of his greatest original prints. Because of the popularity of delicate portraits of Regency ladies printed in colors, "Mʳˢ Q" continued well into this century to be Blake's most

expensive single print. Several impressions were offered by Maggs Bros. of London for £80 each from 1918 to 1925. In 1910, Moss acquired his fine impressions of "Job" and "Ezekiel" (Figs. 8, 12) for £33 the pair; twenty-seven years later they were sold from his collection for £13 and £19, respectively. These prices would of course be multiplied many times over if such rare prints should come on the market today. Yet the prices realized by Blake's great but more available works, such as the *Job* series, indicate that print collectors and curators have not elevated him to the "Great Masters" category inhabited by Dürer, Rembrandt, Goya, and Picasso.

The last dozen years have seen a great increase of interest in Blake's art. Literary scholars and a few art historians have written extensively about his pictorial works and one of Blake's images, "The Ancient of Days," has become one of the best-known icons of our century.[11] The appreciation of Blake as an innovative artist of the print has lagged behind this burgeoning enthusiasm for his "visionary" designs and their symbolism. I hope that this volume will provide basic information about the role printmaking played in Blake's life and contribute to a revaluation of his position in the history of the graphic arts.

[11] The basic motif of an ancient man leaning down and holding compasses has appeared in newspaper cartoons, restaurant menus, advertisements, and bookplates.

Part One. *Plates Designed and Executed by Blake*

I.
Joseph of Arimathea Among the Rocks of Albion

FIGURES 1, 2

First state: 1773

Inscriptions: none in the plate

Image, including framing lines: 22.9 × 11.9 cm

Plate mark: 25.6 × 14 cm

IMPRESSIONS

1A.

Sir Geoffrey Keynes, Suffolk. Printed in brown ink on laid paper, 26.6 × 15.6 cm, slightly foxed. A repaired tear, about 7 cm long, runs from the right edge of the sheet just below the design. Inscribed by Blake in black ink along the bottom right edge of the sheet: "Engraved when I was a beginner at Basires | from a drawing by Salviati after Michael Angelo." From the collection of Frederick Izant, sold by order of his executor at Sotheby's, 14 December 1939, lot 5, described as a "proof, with an inscription by Blake," with twenty other prints, including "Rev. John Caspar Lavater," impression 3J, by and after Blake (£2 10s. to Keynes, as he notes on the mat). Lent by Keynes to the British Museum in 1957, no. 56(2a) in the exhibition catalogue. Described in Keynes, *Bibliotheca Bibliographici*, no. 551i; Bentley, *Blake Books*, pp. 266-267, copy A. First reproduced in Keynes, *Blake Studies* (1949), pl. 14; reproduced in brown in Keynes, *Engravings by Blake: The Separate Plates*, pl. 1. Reproduced here, Fig. 1.

Second state: c. 1810-1820

The entire design has been reworked dramatically. The fine crosshatchings of the first state have been darkened and varied through the addition of bolder patterns. Extensive burnishing has been added to the sky, upper left, to create rays of sunlight, to the crests of the completely reworked waves, to the figure's clothing and body, and to facets of the rocks. The positions of the fingers of the man's right hand have been altered slightly.

Inscription upper right: JOSEPH | of Arimathea | among The Rocks of Albion

Inscription below image: Engraved by W Blake 1773 from an old Italian Drawing | This is One of the Gothic Artists who Built the Cathedrals in what we call the Dark Ages | Wandering about in sheep skins & goat skins of whom the World was not worthy | such were the Christians | in all Ages | Michael Angelo Pinxit

Image and plate mark dimensions: same as in first state

IMPRESSIONS

2B.

British Museum, accession no. 1864.6.11.2. Printed on the same type
of wove paper as impressions 2C, 2D, 2E, and 2I, 28.7 × 16.6 cm,
pasted to the mat. Rather crudely touched with gray wash on the
figure's hat and shoulders and on the rocks above his head. Very likely
acquired directly from Blake or Mrs. Blake by Frederick Tatham, who
sold this and impression 2C to the British Museum in June 1864,
according to the Museum's accession records. This or impression 2C
exhibited at the British Museum in 1957, no. 2(2c) in the catalogue;
and at the Hamburg Kunsthalle and Frankfurt am Main Kunstinstitut
in 1975, no. 1 in the exhibition catalogue. Listed in Bentley, *Blake
Books*, pp. 266-267, copy B or C (where the former is mistakenly
described as "colour-printed" and its history confused with that of
"Joseph of Arimathea Preaching to the Inhabitants of Britain," impres-
sion 1A). Reproduced in Bindman, *Complete Graphic Works of Blake*,
fig. 401.

2C.

British Museum, accession no. 1864.6.11.3. Printed on the same type
of wove paper as impressions 2B, 2D, 2E, and 2I, 29 × 16.4 cm,
pasted to the mat. Touched with considerable amounts of gray wash
on the figure's legs and shoulders and on the rocks above his head,
between his legs, and to the right. The ridge of rocks to the right of
the figure's left leg is poorly printed. For provenance and exhibitions,
see impression 2B.

2D.

Robert N. Essick, Altadena, California. Printed on the same type of
wove paper as impressions 2B, 2C, 2E, and 2I, 27.8 × 19.5 cm. Sold
anonymously at Sotheby's, Hodgson's rooms, 12 November 1976, lot
384 with a copy of the [1870] small paper folio edition of Blair's
Grave with plates after Blake (£1,000 to Donald Heald for Essick).
Now framed. Reproduced in Essick, *William Blake, Printmaker*, fig.
184. Perhaps the same as untraced impression 1, 2, or 3.

2E.

Sir Geoffrey Keynes, Suffolk. Printed on the same type of wove paper
as impressions 2B-2D and 2I, 25.3 × 16.1 cm (trimmed just within
the plate mark at top and bottom). A 2.3 cm length of the double-
rule border to the right of the figure's knee is poorly printed. In his
Engravings by Blake: The Separate Plates, p. 4, Keynes states that this
is "probably" the impression offered for sale in Quaritch's *General
Catalogue of Books* of 1887, no. 13844 (£4), where it is described as
a "fine impression" measuring "10 in. by 5½ in." (25.4 × 14 cm,
which corresponds to the height of the sheet of impression 2E and to
the width of the plate mark). This impression was previously offered
for £4 in Quaritch's four-page advertising flyer, "William Blake's Orig-
inal Drawings," dated May 1885, and later offered in his February
1891 catalogue, no. 102 (£3). Keynes further states in his separate

plates catalogue, and on the mat, that this is the impression purchased by W. E. Moss from Robson & Co., c. 1916, and sold with the Moss collection at Sotheby's, 2 March 1937, lot 138 (£9 10s. to the dealer Francis Edwards for Keynes). Lent by Keynes to the British Museum in 1957, no. 56(2b) in the exhibition catalogue. Listed in Keynes, *Bibliotheca Bibliographici*, no. 551ii; Bindman, *Blake: Catalogue of the Collection in the Fitzwilliam Museum*, no. 551ii, as part of Keynes' bequest to the Museum; Bentley, *Blake Books*, pp. 266-267, copy D. Reproduced in Keynes, *Engravings by Blake: The Separate Plates*, pl. 2.

2F.
Sir Geoffrey Keynes, Suffolk. A posthumous impression on wove paper, 29.8 × 24 cm, watermarked J WHATMAN | 1828. Heavily inked and printed, with slight and crudely applied touches of gray wash on the figure's hat, upper right arm, and the rocks above his head and to the right. Very probably acquired by George Richmond (from Mrs. Blake or Frederick Tatham?); sold by his daughter-in-law, Mrs. John Richmond, to Keynes in 1927 (as noted by him on the mat). Listed in Keynes, *Bibliotheca Bibliographici*, no. 551iii; Bindman, *Blake: Catalogue of the Collection in the Fitzwilliam Museum*, no. 551iii, as part of Keynes' bequest to the Museum; Bentley, *Blake Books*, pp. 266-267, copy E (where the watermark date is incorrectly given as "1825" and the impression wrongly described as "colour-printed").

2G.
Pierpont Morgan Library, New York. Printed on wove paper, 27.6 × 15.9 cm. The print has been touched with pale gray wash in a number of places: the figure's robe just above his left thigh, the water close to the shore lower left, just below "Albion" (upper right inscription), to the right of the figure's left sleeve, left of his cap, below his left foot, and very faintly elsewhere on the rocks to the right. The upper right corner of the double-rule border, which prints poorly in several impressions, has been strengthened with gray wash. Included as the ninth leaf in an extra-illustrated copy of Allan Cunningham's "William Blake," 1830, in the collection of W. H. Herriman, who died in July 1918 and bequeathed it to the American Academy in Rome (received in 1920). The Academy sold the entire collection to the Pierpont Morgan Library in 1976. First described by Charles Ryskamp (actually Thomas V. Lange) in the [London] *Times Literary Supplement*, 14 January 1977, p. 40. Now disbound; reproduced here, Fig. 2. Perhaps the same as untraced impression 1, 2, or 3.

2H.
National Gallery of Art, Rosenwald Collection, Washington, D.C. Printed on wove paper, 25.3 × 16.1 cm, cut close within the plate mark at the top and now somewhat browned. This impression bears odd white lines and flicks on the figure's right forearm and in the area below his crossed arms. They appear to have been scratched into this impression, not into the copperplate, and yet they seem to be raised a bit above the surrounding printed lines. Rosenwald and National

Gallery of Art collection stamps on verso. Acquired, probably *c.* 1890-1904, by W. A. White, who lent it (anonymously) to the Grolier Club, New York, in 1905 and 1919, nos. 57 and 23 in the exhibition catalogues; and to the Fogg Art Museum in 1924. Acquired by Rosenbach, *c.* 1929, and listed by him on an undated typescript (now in the Rosenbach Library) of the White collection, with an evaluation or price of $25. Sold by Rosenbach to Lessing J. Rosenwald on 7 December 1938 for $135 (according to a payment voucher now in the Rosenbach Library). Lent by Rosenwald to the Philadelphia Museum of Art in 1939, no. 217 in the exhibition catalogue; to the National Gallery of Art in 1957, no. 66 in the exhibition catalogue; to the University of Iowa in 1961, no. 16 in the exhibition catalogue; and to Cornell University in 1965, no. 16 in the exhibition catalogue (in which the impression reproduced, p. 13, is not this one). Given by Rosenwald to the National Gallery in 1945 and moved from the Alverthorpe Gallery, Jenkintown, Pennsylvania, to Washington in 1980. Listed in Bentley, *Blake Books*, pp. 266-267, copy F (where the print is incorrectly located in the Library of Congress and its history confused in part with that of "Joseph of Arimathea Preaching to the Inhabitants of Britain," impression 1B). Reproduced in Klonsky, *Blake*, p. 19; Bentley, ed., *Blake's Writings*, I, 643. Perhaps the same as untraced impression 1 or 2.

2I.

Trinity College, Watkinson Library, Hartford, Connecticut. Richly printed on wove paper, 30.4 × 24.3 cm, bearing on the verso the collection stamp of the Watkinson Library and a strip of paper along the left edge from a previous mounting. The paper appears to be of the same type as in impressions 2B-2E. Much of the image has been delicately tinted with very pale gray washes; darker patches of the wash appear on the figure's hat, right hand, and left wrist, and on the rocks left of his right shoulder, above his head, and to the right. To the left of the last line of the inscriptions are a few faint lines that may be fragments of an earlier inscription or the present inscriptions in a different position. Minor spotting just within and outside the plate mark. Perhaps the impression once owned by Horace E. Scudder and lent by him to the Boston Museum of Fine Arts, 1880 and 1891, nos. 13 and 119 in the exhibition catalogues; and lent by Mrs. Scudder to the Fogg Art Museum in 1924. Acquired at an unknown date by Allan R. Brown, who gave it to the Watkinson Library in 1939. Listed in Bentley, *Blake Books*, pp. 266, 268, copy H. Perhaps the same as untraced impression 1.

2J.

Private collection, Great Britain. Printed on wove paper trimmed within the plate mark to 25 × 12.7 cm, framed. Touched with pale gray wash in small patches on the rocks above and on both sides of the figure and on his right hand and right shoulder. Acquired by W. Graham Robertson by 1907, when he reproduced it in his edition of Gilchrist's *Life of Blake*, facing p. 20 (image only). Exhibited at the Bournemouth Arts Club, Southampton Art Gallery, and Brighton Art Gallery in

1949, no. 51 in the catalogue. Listed in Preston, ed., *Blake Collection of Robertson*, no. 129; Bentley, *Blake Books*, pp. 266-267, copy G. Sold at the Robertson auction, Christie's, 22 July 1949, lot 83 (£18 18s. to Agnew's). Acquired shortly thereafter by the present owner. Perhaps the same as untraced impression 1 or 2.

2K.

Private collection, San Francisco, California. Acquired at an unknown time by Lord Nathan of Churt as part of an extra-illustrated copy of Michael Bryan, *A Biographical Dictionary of Painters and Engravers*, 1889. Removed from the volume and sold at Sotheby's, 20 May 1963, lot 17 (£25 to Colnaghi). Sold by Colnaghi to the San Francisco print dealer R. E. Lewis, whose inquiries on my behalf have not been answered by the present owner. Perhaps the same as untraced impression 1, 2, or 3. Not seen.

UNTRACED IMPRESSIONS, very probably all of the second state

1.

Offered for £1 4s. by Francis Harvey in his sale catalogue of *c.* 1864, who probably acquired it, along with the "Pickering Manuscript" of Blake's poems, from Frederick Tatham. Probably acquired by the Rev. Samuel Prince, from whose collection an impression of the print was sold at Sotheby's, 11 December 1865, lot 280, described as a "brilliant impression" (£1 2s. to Timmins). Perhaps the same as impression 2D, 2G, 2H, 2I, or 2J, or untraced impression 3 or 4.

2.

From the collection of Alexander Gilchrist, whose wife lent it to the Burlington Fine Arts Club in 1876, no. 281 in the exhibition catalogue. This impression passed by inheritance to Gilchrist's son, Herbert H. Gilchrist, who lent it to the Pennsylvania Academy of the Fine Arts in 1892, no. 154 in the exhibition catalogue. H. H. Gilchrist is probably the descendant of Alexander Gilchrist who sold the print at Sotheby's, 24 June 1903, lot 34, with an impression of "Democritus" engraved by Blake for Lavater's *Essays on Physiognomy* (£5 to Maggs). Perhaps the same as impression 2D, 2G, 2H, or 2J, or untraced impression 3 or 4. Both impressions 2H and 2J are good candidates to be this impression.

3.

According to a clipping from the sale catalogue in the collection of Sir Geoffrey Keynes, an impression was offered by Lowe Brothers of Manchester in their February 1915 catalogue, item 110 (with unspecified plates from *Songs of Experience*). Perhaps the same as impression 2D, 2G, or 2K, or untraced impression 1, 2, or 4.

4.

Craddock & Barnard, October 1959, catalogue no. 93, item 49, described as "cut just on the plate-mark" and "sold." According to Osbert Barnard of Craddock & Barnard, the print was sold, prior to

the publication of the catalogue, for £25 to Robert Gathorne-Hardy, who died in 1973. Perhaps the same as one of the other untraced impressions.

As the inscription on the second state indicates, Blake engraved his first separate plate at the age of fifteen or sixteen in only his second year of apprenticeship to James Basire. The print may have been a type of shop exercise intended as a demonstration of the young man's skills. The figure is based closely on the unidentified man wearing a Phrygian cap and standing on the far right of "The Crucifixion of Saint Peter" painted by Michelangelo in the Pauline Chapel of the Vatican. The fresco was completed in 1549. Blake could have known the entire painting through the engravings by Giovanni Battista Cavalieri (1525-1597) and Michele Lucchese (active *c*. 1550), and the figure alone without background in the (unfinished?) engraving attributed to Nicolas Beatrizet (also known as Niccolo Beatrici, *c*. 1515-1560).[1] Both the original painting and the engravings show the figure with eyes closed, whereas they are clearly open in both states of Blake's print. In comparison to these earlier versions, Blake has also altered slightly the beard and the positions of the fingers of the right hand. As he notes in the pen and ink inscription on impression 1A, Blake's immediate source was a "drawing" (perhaps an engraving after a drawing) by "Salviati"—i.e., either Francesco Rossi Salviati (1510-1563) or his less famous student Gioseffo Porta (1535-1585), who used the same name. No such drawing or print is known. The background is apparently Blake's own invention, although it may have been influenced by the very similar seascape and rocky cliff in Sir Joshua Reynolds' portrait of Commodore Keppel, painted in 1754.

With his extensive revisions for the second state, Blake transformed a technically competent but dull and flat apprentice plate into an energetic work of art and a statement of some of his more important religious and aesthetic beliefs. For this reason the print is included here with Blake's original graphics rather than grouped with his reproductive work. The inscriptions identify the figure as Joseph of Arimathea, Christ's disciple who, according to an old Somersetshire legend, brought Christianity to England.[2] Blake further identifies Joseph as an apostle of Christian art: as he states on his "Laocoön" plate of *c*. 1820, "Jesus & his Apostles & Disciples were all Artists."[3] For Blake, the universal genius of Christian art was most fully embodied in the Gothic style; thus Joseph, who according to the legend built a church at Glastonbury, can be further identified with the builders of Gothic cathedrals. That the figure is taken from Michelangelo, a fact underscored by the final line of the engraved inscriptions, adds a further creative hero to the religious and artistic heritage linking Blake, the builders of medieval churches, Joseph of Arimathea, and Christ.

In 1926, Binyon argued that Blake engraved the inscriptions in 1773,[4] but Keynes' discovery of the unique impression of the first state made a much later date probable.[5] Erdman, in his essay "The Dating of William Blake's Engravings," first published in 1952,[6] argued for

[1] All three engravings are reproduced in Leo Steinberg, *Michelangelo's Last Paintings*, New York: Oxford University Press, 1975, figs. 93-95. The Beatrizet print is reproduced in Keynes, *Engravings by Blake: The Separate Plates*, pl. 3.

[2] Blake could have learned of this story from oral recountings or printed sources such as William of Malmesbury's *De Antiquitate Glastoniensis Ecclesiae*, first published in 1727, or the anonymous *Lyfe of Joseph of Armathea*, published by Pynson in 1520. There were also several issues, between about 1770 and 1810, of a popular tract entitled *The History of that Holy Disciple Joseph of Arimathea*. See also "Joseph of Arimathea Preaching to the Inhabitants of Britain."

[3] Erdman, ed., *Poetry and Prose of Blake*, p. 271.

[4] *Engraved Designs of Blake*, p. 35.

[5] Keynes, *Blake Studies* (1949), pp. 45-46, states that he discovered the first state "a few years ago" (i.e., 1942) and that "it was twenty years later [i.e., 1793], or more, that Blake again took up his juvenile plate, rubbed the surface down and almost completely re-engraved it."

[6] *Philological Quarterly*, 31 (1952), 337-343; reprinted, with a new postscript by Erdman, in Essick, ed., *The Visionary Hand*, pp. 161-171.

a second state date of 1809-1820 on the basis of the inscriptions containing attitudes toward Christianity and the arts not found elsewhere in Blake's writings until his *Descriptive Catalogue* (1809), *Jerusalem* (*c.* 1804-1820), and "Laocoön" (*c.* 1820). Although Blake writes of "the rocks/Of Albion" in "King Edward the Third," published in his *Poetical Sketches* in 1783, he did not refer directly to Joseph of Arimathea until he wrote verses on p. 52 of his *Notebook* in about 1818.[7] Further, the song beginning "and did those feet in ancient time" on the second plate of *Milton* (*c.* 1804-1808) shows the same interest in ancient legends about the arrival of Christianity in England expressed by this plate in its second state. The semi-gothic lettering and the considerable use of burnishing as an element of composition further indicate a post-1803 date.[8] These associations suggest a date of *c.* 1810-1820.

The 1828 watermark of impression 2F strongly suggests that the copperplate was in Blake's possession until his death in 1827. It probably passed to Mrs. Blake, and she or Frederick Tatham took at least this one posthumous impression from it. Since impression 2F contains spots of gray wash generally similar to those on impressions 2B and 2C (both from Tatham's collection), 2G, 2I, and 2J, it is difficult to attribute any of the tinting to Blake himself. All of the tinting on the extant impressions was probably executed in diluted India ink applied with a brush.

[7] Erdman, ed., *Poetry and Prose of Blake*, pp. 428, 470. The position of these lines, vertically along the inner margin of the *Notebook* page, indicates that they were written after the *Public Address* (*c.* 1810) and probably at the same time as, or even as a preface to, *The Everlasting Gospel* (*c.* 1818), passages of which are written on the same page.

[8] As I argue in *William Blake, Printmaker*, pp. 178-186, for this and other revised plates with similar features. See also the Introduction to this catalogue.

II.
Charity

FIGURE 3

Planographic transfer print

One state: c. 1789

No inscriptions

Plate mark: none visible

Image: 18.7 × 13.3 cm

The only known impression was acquired by the *British Museum* from T. Rowe in 1958. Its earlier history is not known. The dirty sheet of laid paper, 19 × 14.9 cm, is pasted to the mat. An India ink wash, slightly grayer than the black printing ink, has been added around the figures and used to delineate a few surfaces and lineaments of their bodies, notably on the central figure's legs and right side of her torso. There is no evidence of a plate mark, and the splotchy, crude printing also suggests that the image was transferred from another piece of paper or from a millboard. The print may be one of Blake's earliest attempts at planographic printing and a technical link between his monochrome printing of relief plates and color-printing experiments of the sort represented by the river scene after Stothard (Pl. 9) and the small and unfinished version of the color-printed drawing of "Pity" in the British Museum.

The tentative attribution of the print to Blake is based on the unusual printing technique, the anatomical and gestural similarity between the figures and those appearing in Blake's work from the late 1780s through most of his career, and the similarities between this print and the pencil drawing (about 8 × 6.5 cm) on p. 35 of Blake's *Notebook*, reversed. In this slight sketch, one of the numbered emblems Blake drew in his *Notebook, c.* 1787-1793, the central figure's head leans to the left (right in the print) toward two children, one of whom holds the adult's hand. The pair of children on the right embrace, as do the pair on the left in the print. The only motifs in the drawing not repeated in the print are the slight suggestions of a gown on the adult and the cloud beneath the five figures.

Blake's interest in gently supportive relationships between adults and children is also evinced by the *Songs of Innocence* (1789). The grouping of figures and the emotional expression in this print are similar to rejected pl. a of *Songs of Innocence and of Experience* (1794), a tailpiece found in only three early copies (B, C, and D) of that volume.

The title given to the print, first suggested in 1972,[1] is based on the general resemblance between the composition and traditional emblems of charity. The dating is even more conjectural.[2] The planographic technique associates the print with Blake's color printing of 1794 to 1796; but the subject and format, their feminine sweetness and baroque qualities reminiscent of Stothard's work, suggest an earlier period contemporary with the *Notebook* emblem series and the *Songs of Innocence*.

The use of a heavy ink wash surrounding figures is also found in a drawing of three adults and two children (British Museum, 15 × 14.5 cm) and in a pen and ink sketch of a statue of a male nude standing

[1] In "A Handlist of Works by William Blake in the Department of Prints & Drawings of the British Museum," *Blake Newsletter*, 5 (1972), 236.

[2] Bindman, *Complete Graphic Works of Blake*, p. 467, suggests a date of 1788-1789.

beside a pitcher (estate of Theodore Besterman, 13.9 × 7.5 cm). The delineation of the figure and hatching strokes in the latter drawing are somewhat similar to the rendering of the woman in "Charity." Neither drawing is typical of Blake's work, but both may be attributed tentatively to him and dated *c.* 1785 and *c.* 1778-1780, respectively.

III.
The Approach of Doom

FIGURES 4, 5

Relief and white-line etching

One state: c. 1792

No inscriptions

Image and plate mark: 29.7 × 20.9 cm

The only known impression of "The Approach of Doom,"[1] now in the *British Museum*, is printed on a sheet of thin wove paper, 33.8 × 24.6 cm, pasted to the mat (Fig. 4). The plate appears to have been heavily inked in some areas (note the solid splotches of ink, particularly upper left) and lightly inked in those places where a grainy, reticulated texture appears. The white streak upper right appears to be the result of poor inking, or intentional wiping, rather than a bitten area in the copper. The print was probably once in the collection of Mrs. Alexander Gilchrist (died 1885), from whom it passed to her son, Herbert H. Gilchrist. He lent it to the Pennsylvania Academy of the Fine Arts in 1892, no. 190 in the exhibition catalogue. In June 1894, Gilchrist sold the print, along with thirteen other works by Blake, for £150 to the British Museum, where it was exhibited in 1957, no. 22(7) in the catalogue. Lent to the Tate Gallery in 1978, no. 35 in the exhibition catalogue.

The design is based loosely on Robert Blake's pen and sepia wash drawing (Fig. 5), also acquired by the British Museum from Gilchrist in June 1894. It measures 33.5 × 47.5 cm and was probably executed *c.* 1785, only two years before Robert's death at the age of about twenty. A pencil sketch of two groups of huddled figures (sheet 31.3 × 21.2 cm; Tate Gallery, London) has been attributed to Robert Blake by Martin Butlin.[2] It may represent an early stage in the development of the composition. The attribution of the original design to Blake's brother makes the work, in the strictest sense, a reproductive plate. It has, however, generally been grouped with Blake's original graphics because of his changes in the design and the artistic and personal intimacy between the designer and the etcher.

Gilchrist described the print as "one of [Blake's] earliest attempts, if not his very earliest, in that peculiar stereotype process he . . . invented."[3] Subsequent authorities have followed this view and generally dated the plate *c.* 1788. But the poor quality of the only impression should not blind us to the advanced graphic technique. Like the frontispiece to *America* (1793), "The Approach of Doom" is a sophisticated combination of fine black-line relief and white-line etching, including white-line crosshatching on the upper thigh of the aged, bearded figure closest to the viewer. The odd swirled lines delineating clouds may have been scratched through the acid-resist with a comblike instrument. Bindman has suggested that some of the lines may have been part of a print originally intended for intaglio inking and printing.[4] The large variety of fine white-line techniques suggests that this was an experimental plate, but not one contemporary with Blake's simple relief etchings of *c.* 1788 for *All Religions are One* and *There is No Natural Religion*. It would not have been unusual for Blake to return to one of his younger brother's designs as the basis for a later

[1] This title was first used in Binyon, *Engraved Designs of Blake* (1926).

[2] *William Blake: A Complete Catalogue of the Works in the Tate Gallery*, London: Tate Gallery, 1971, p. 80, the sketch reproduced fig. 85.

[3] *Life of Blake* (1863), I, 58.

[4] *Complete Graphic Works of Blake*, p. 467.

etching: this is also the case with pl. 5 of *The Song of Los* (1795). The subject of "The Approach of Doom"—a group of people huddled on the margin of the sea and fearful of some unseen presence to the left—is generally similar in setting and emotional suggestion to the frontispiece to *Visions of the Daughters of Albion* (1793) and in accord with Blake's sense of impending catastrophe for the old order in "Our End is come" (Fig. 17, the first state of "The Accusers," 1793). Finally, Blake's development of his relief and white-line techniques shows a steady progression from small plates, averaging 5.5×4 cm, of *c.* 1788 to the largest plates, averaging 23.5×16.9 cm, in the illuminated books *America* (1793) and *Europe* (1794). "The Approach of Doom," at 29.7×20.9 cm, is larger than any other relief or white-line etching. For these reasons, a date of *c.* 1792 seems the most likely.

As traces of the earlier design indicate, pl. 14 of *The Book of Urizen* (1794) was made from the lower left quarter of "The Approach of Doom" and pl. 27 from the upper left quarter. Bentley, on the basis of approximate measurement parallels, suggests that pls. 5 and 16 of *Urizen* could have been made from the remaining right half of "The Approach of Doom"; but as he notes, "the remaining lines of the original engraving are too faint to allow for confident identification."[5] Pl. 16 of *Urizen*, copy B, shows white-line scratches, upper left, of what would seem to be a sun with lines of radiance, and this would probably rule out the use of "The Approach of Doom" for that plate. The large bitten whites delineating the three most prominent figures may have prevented reuse of that portion of the copper without scraping and burnishing away all relief areas.

Based on identical plate measurements and the strong probability that Blake etched both sides of most of the copperplates of the illuminated books, Bentley also suggests that "The Approach of Doom" copperplate pieces used for *Urizen* previously had pls. 20 and 12 of *The Marriage of Heaven and Hell* etched on their versos. Martin Butlin and David Bindman have argued that *The Marriage* was completed in 1790.[6] If this dating and the conjectures based on plate dimensions are correct, then "The Approach of Doom" must have been etched no later than 1790. Yet most authorities still accept a date of 1790-1793 for *The Marriage* and even identical plate sizes do not offer absolute proof that two different designs were etched on the front and back of a single piece of copper. Thus the weight of evidence still favors the slightly later date of *c.* 1792 for "The Approach of Doom," and its possible reuse for *The Marriage* lends some support for a *c.* 1793 completion date for that work.

[5] *Blake Books*, p. 167.
[6] *Burlington Magazine*, 103 (1961), 368; *Blake as an Artist*, p. 71. See also Butlin, *Blake*, Tate exhibition catalogue, pp. 40-41, where the print is dated *c.* 1787-1790.

IV.
Edward & Elenor

FIGURE 6

One state: 1793

Signature below image, center: Painted and Engraved by William Blake

Title inscription: Edward & Elenor

Imprint: Published 18th August 1793 by W Blake No 13 Hercules Buildings Lambeth

Image: 30.7 × 45.7 cm

Plate mark: 37.5 × 48.7 cm

IMPRESSIONS

1A.

British Library, Department of Western Manuscripts. Blake cut an impression printed on cream wove paper into two pieces, leaving out a strip from the middle about 4.6 cm wide, and used the verso of the right part for leaf 44 recto and the verso of the left part for leaf 45 verso of his manuscript of *Vala*, or *The Four Zoas*, that he began to compose in 1796 or 1797. On each piece the middle area of the image where the cut was made is along the fore-edge of the manuscript leaf. The right section is on a sheet 39.3 × 30.7 cm (measured along the bottom edge) and 29.9 cm (measured along the top edge). Blake has written three lines in the top margin and a British Museum collection stamp in red ink appears in the lower part of the large right margin. There are small tears along the ragged left side of the print. The left section is on a sheet 41.5 × 32 cm and has the numbers 45 and 44 (lined through) written in pencil in the upper right corner. In the lower part of the large left margin is a pencil sketch of a standing figure with right arm raised and left arm reaching down to a kneeling figure. These were executed as part of Blake's work on the *Vala* designs and are not related to the print. Blake gave the *Vala* manuscript to John Linnell, whose heirs sold it at Christie's, 15 March 1918, lot 206 (£420 to Parsons). Acquired in May 1918 by the British Museum (now British Library) from an anonymous donor. This impression is reproduced in Binyon, *Engraved Designs of Blake*, pl. 3 (image only); Bentley, ed., *Vala or The Four Zoas*, facsimile pp. 88-89.

1B.

British Museum. Richly inked and printed on cream wove paper, 41.2 × 53.5 cm, pasted to the mat. Acquired by the British Museum from Cecil H. Drummond in April 1938. Exhibited at the British Museum in 1957, no. 22(3) in the catalogue; at the Royal Academy in 1972, no. 508 in *The Age of Neo-Classicism* catalogue; and at the Tate Gallery in 1978, no. 18 in the catalogue. Reproduced here, Fig. 6.

[1] See David Bindman, "Blake's 'Gothicised Imagination' and the History of England," in Paley and Phillips, eds., *Blake: Essays in Honour of Keynes*, pp. 29-49.

In 1779 Blake began to execute a number of small watercolors picturing important events in British history. Some nine or ten of these drawings are extant or have been recorded in this century.[1] Later,

14

Part One.
Plates Designed and Executed by Blake

[2] The first, 32 × 48.5 cm, is reproduced in Keynes, *Drawings of Blake*, pl. 3; the second, 30.2 × 47 cm, is reproduced in Paley and Phillips, eds., *Blake: Essays in Honour of Keynes*, p. 32; the third, 28 × 40.5 cm, is reproduced in Keynes, *Drawings of Blake*, pl. 7; the fourth, 36.2 × 57.5 cm, is reproduced in Keynes, *William Blake's Illustrations to the Bible*, Jura, France: Trianon Press for the William Blake Trust, 1957, fig. 56 (where the composition is incorrectly titled "Saul and David"). The last, 32 × 47 cm, was sold at Sotheby's, 30 November 1978, lot 72, reproduced in the catalogue.

[3] Gilchrist, *Life of Blake* (1863), II, 201; (1880), II, 207.

[4] *A Father's Memoirs of His Child*, p. xxi, reprinted in Bentley, *Blake Records*, p. 423. Malkin's source for information about Blake's early career was very likely the artist himself. Gilchrist, *Life of Blake* (1863), I, 30, also refers to Blake's "engraving two designs from English history," one of which is "*King Edward and Queen Eleanor*, 'published' by him at a later date (from Lambeth)."

[5] Erdman, ed., *Poetry and Prose of Blake*, p. 671. There is no extant copy or even other record of this book of historical engravings.

[6] *William Blake, Painter and Poet*, p. 9. See also LXIV, "The Penance of Jane Shore," in Part Seven of this catalogue.

[7] *Engraved Designs of Blake*, p. 37. Keynes, *Engravings by Blake: The Separate Plates*, pp. 17-18, states that "the conventional manner of the engraving suggests also that the engraving may have been made soon after his apprenticeship. . . . Blake may, on the other hand, have deliberately used this style at a later date." Bindman, *Complete Graphic Works of Blake*, p. 467, claims that the "conception and execution appear to belong to the late 1770s or early 1780s."

[8] Erdman, ed., *Poetry and Prose of Blake*, p. 670. The other "highly finished" engraving is "Job."

[9] London, 1723-1731, IV, 273.

Blake apparently began to prepare some larger designs of the same or similar historical subjects. Five extant drawings, all about the same size as "Edward & Elenor," bear witness to this second project: the pencil sketch of "The Penance of Jane Shore" in Keynes' collection, the watercolor "Ordeal of Queen Emma" in a private British collection, "St. Augustine Converting King Ethelbert of Kent" (sometimes called "Joseph of Arimathea Preaching") in the National Gallery of Art, Washington, "Edward III Presenting the Black Prince to the Barons" in a private British collection, and the pencil drawing "Non Angli Sed Angeli—St. Gregory and the British Captives" in the collection of Robert H. Taylor, Princeton, New Jersey.[2] These five, plus two somewhat smaller watercolors ("The Penance of Jane Shore" in the Tate Gallery and "Non Angli Sed Angeli" in the Victoria and Albert Museum), may not have been completed until *c.* 1793 or even later. In 1863, Rossetti listed a drawing or painting in colors of "King Edward and Queen Eleanor," which he dates *c.* 1779, but nothing further is known of this work.[3] According to Benjamin Heath Malkin, shortly after the end of Blake's apprenticeship "he began to engrave two designs from the History of England."[4] These may have been either plates for "The History of England, a small book of Engravings," which Blake advertised in 1793,[5] or "Edward & Elenor" and another large plate. In 1895, Richard Garnett unequivocally stated that the latter was the case and indicated that the second plate was entitled "The Penance of Jane Shore," but he does not give his evidence for this and it may be only speculation.[6] "Edward & Elenor" remains the only extant graphic production to have resulted from Blake's activities, extending from 1779 to at least 1793, as an illustrator of British history.

Binyon, who knew the print only through impression 1A, dates it "many years earlier" than 1793 because of what he took to be the mechanical style of its execution.[7] He was probably led to this conclusion by comparing "Edward & Elenor" to the second states of the large "Job" and "Ezekiel" prints (Figs. 8, 12) and mistakenly assuming that these beautifully executed plates represent Blake's graphic style in 1793 and 1794. There is no convincing reason to believe that "Edward & Elenor" was finished before Blake's inscribed date of 1793, although he may have begun to design the image and work on the plate years before. The lettering style of the title is similar to the first state of "Job" (1793, Fig. 7). Blake listed the print as "Edward and Elinor, a Historical Engraving. Size 1 ft. 6½ in. by 1 ft.: price 10s. 6d." and referred to it as one of "two large highly finished engravings" in his prospectus *To the Public* of 10 October 1793.[8]

The engraving pictures a famous incident in the life of King Edward I as told in Rapin de Thoyras, *History of England*.[9] During the siege of Acre, Edward was wounded by a would-be assassin's poison-tipped arrow. Queen Eleanor is shown sucking the poison from the wound, thereby saving the King's life. Blake's interest in this event may have been stimulated by his apprenticeship drawings of the tombs of Edward and Eleanor in Westminster Abbey. His engraving of the head of Eleanor's tomb effigy was later published in Richard Gough, *Sepulchral Monuments in Great Britain*, pt. I, vol. I (1786).

[10] Compare Mortimer's "Vortigern and Rowena" (exhibited 1779), reproduced in the 1978 Tate exhibition catalogue, p. 35.

The flattened space of the design, the frieze-like arrangement of figures and their costumes, all bespeak Blake's response to the neo-classical styles of the 1780s. More specifically, the composition shows the strong influence of John Hamilton Mortimer, whose work Blake admired.[10]

V.
Job

FIGURES 7-11

First state: 1793

Signature below image, center: Painted and Engraved by William Blake

Title inscription: JOB

Imprint: The area where the quotation from the Book of Job and imprint appear in the second state has been trimmed off the only known impression. Keynes, *Engravings by Blake: The Separate Plates*, p. 10, reports that there are "the tops of a few letters of the third line [i.e., the quotation] which appears to have been different from the third line in the second state." This area is now covered by the mat in the only known impression.

Image: 34.4 × 48.2 cm (with loss of image at the top and sides)

Plate mark: trimmed off in the only known impression

IMPRESSIONS

1 A.

Sir Geoffrey Keynes, Suffolk. Printed on wove paper, now framed and matted to, or slightly within, the image except at the bottom where a .5 cm margin contains the signature. According to Keynes, *Engravings by Blake: The Separate Plates*, p. 11, the print was dirty and damaged, with the loss of part of the image at the top and sides, when he first acquired it, and he had it cleaned and remargined. Before it was trimmed, the image and plate mark were probably the same size as in the second state. Sold anonymously at Sotheby's, 21 May 1935, lot 297, where it is stated that "the text is cut from the bottom, and the other edges are cut or defective" (£10 to Quaritch for Keynes). Lent by Keynes in 1937 to the Bibliothèque Nationale, Paris, no. 49 in the exhibition catalogue, and to the Albertina, Vienna, no. 39 in the exhibition catalogue; to the British Museum in 1957, no. 67(3) in the exhibition catalogue; and to the Tate Gallery in 1978, no. 31 in the exhibition catalogue. This or impression 2B may be the work lent by Sir Charles Dilke to the Burlington Fine Arts Club in 1876, no. 290 in the exhibition catalogue, where it is listed simply as "Engraving: Job." Described in Keynes, *Bibliotheca Bibliographici*, no. 554(i), where the sheet size is given as 41 × 54.5 cm including the remargining. Reproduced here, Fig. 7.

Second state: 1804 or later

The entire design has been reworked dramatically. The fine lines of the first state have been darkened and varied through the addition of bolder patterns. Extensive burnishing has added highlights to many surfaces, particularly the faces, and was used to create the jagged bolt of lightning in the background. Job's forehead has been extended about .2

cm toward the top of the image, his robe extended in a continuous fold across both feet rather than in two folds, and tears now stream down his cheeks and beard. The positions of the fingers of the left hand of the figure on the far left have been altered. All impressions show fragments of chapter and verse inscriptions, almost completely removed from the plate by burnishing, below and slightly to the right of their present position at the end of the quotation from the Book of Job.

Signature and title: same as in the first state, but the lines have been recut so that they print more darkly

Quotation below title: What is Man That thou shouldest Try him Every Moment? Job VII C 17 & 18 V

Imprint: Published 18 August 1793 by W Blake Nº 13 Hercules Buildings Lambeth

Image: 34.8 × 49.1 cm

Plate mark: 46 × 54 cm

IMPRESSIONS

2B.
British Museum. Printed on India paper laid onto wove, 54.8 × 64.8 cm, pasted to the mat. The original plate mark area was damaged, but has been expertly restored. Sold from the collection of R. A. Potts, Sotheby's, 18 June 1912, lot 236 (£21 to Colnaghi). Acquired by the British Museum from Colnaghi in June 1913 (with "Ezekiel," impression 2A). Exhibited at the British Museum in 1957, no. 23(2) in the catalogue; and at the Hamburg Kunsthalle and Frankfurt am Main Kunstinstitut in 1975, no. 7 in the catalogue. This or impression 1A may be the work lent by Sir Charles Dilke to the Burlington Fine Arts Club in 1876, no. 290 in the exhibition catalogue, where it is listed simply as "Engraving: Job." Reproduced in Bindman, *Complete Graphic Works of Blake*, fig. 144; Essick, *William Blake, Printmaker*, fig. 62.

2C.
Fitzwilliam Museum, Cambridge. Printed on wove paper, 49 × 67.2 cm, with considerable foxing. Linnell records in his journal for 2 March 1830 that he took Mr. Haviland Burke to visit Mrs. Blake, from whom Burke purchased "two Prints of Job & Ezekiel, 2 gs." on behalf of John Jebb, Bishop of Limerick.[1] The Bishop (died 1833) bequeathed this impression of "Job" and impression 2B of "Ezekiel" to his chaplain, the Rev. Charles Forster (died 1871), from whom the prints passed by inheritance to his son, E.M.L. Forster (died 1880), then to his sister, Miss Laura M. Forster (died 1924), and finally to her nephew, the novelist E. M. Forster. Given by him to King's College, Cambridge, in 1953, from which the prints passed to the Fitzwilliam Museum in 1954. Described in Bindman, *Blake: Catalogue of the Collection in the Fitzwilliam Museum*, no. 18.

[1] Bentley, *Blake Records*, p. 379.

Part One.

Plates Designed and Executed by Blake

[2] See Bentley, *Blake Records*, p. 288 n. 3.

[3] *Dictionary of National Biography*, XIX, 382.

[4] *Engravings of Blake*, pp. 68-69; *Engraved Designs of Blake*, p. 49; *Engravings by Blake: The Separate Plates*, pp. 10-12; *Blake*, Tate 1978 exhibition catalogue, pp. 39-40; *Complete Graphic Works of Blake*, pp. 467, 471-472. Neither Russell nor Binyon knew of the existence of the first state.

[5] For a more detailed discussion of this observation and its consequences, see Essick, *William Blake, Printmaker*, pp. 64-73.

[6] Erdman, ed., *Poetry and Prose of Blake*, p. 670. The other "highly finished" engraving is "Edward & Elenor." A 1793 date for the first state was first suggested in Lindberg, *Blake's Illustrations to Job*, pp. 13-14, 249-250.

[7] As I argue in *William Blake, Printmaker*, pp. 178-186, for this and other revised plates with similar features. Lindberg's dates for the second state of *c.* 1797 or *c.* 1798 (*Blake's Illustrations to Job*, pp. 14, 250) are based on the dubious proposition that "the reading of Young [while illustrating his *Night Thoughts*] aroused Blake's old interest in Job" (p. 14).

[8] "Thoughts on the 1978 Tate Gallery Exhibition," *Blake: An Illustrated Quarterly*, 13 (1979), 19.

2D.

Sir Geoffrey Keynes, Suffolk. Printed on India paper laid onto wove, framed and matted within the plate mark. Sold from the collection of Mrs. William Dobinson, *née* Ellen M. Chevalier, at Sotheby's, 1 December 1910, lot 127, with "Ezekiel," impression 2C (£33 to W. E. Moss). Lent by Moss to the Whitworth Art Gallery in 1914, no. 103 in the exhibition catalogue. Sold with the Moss collection at Sotheby's, 2 March 1937, lot 174, where it is stated that "this may be an impression from the plate as re-worked, *circa* 1810-14" (£13 to Keynes). Lent by Keynes to the Tate Gallery in 1978, no. 32 in the exhibition catalogue. Mrs. Dobinson, who acquired this impression through inheritance, was the great-granddaughter of both Thomas Chevalier (1767-1824), the eminent surgeon who was a friend of John Linnell's and may have known Blake, and of Charles Heathcote Tatham (1772-1842), father of Blake's friend and early biographer Frederick Tatham.[2] Further, C. H. Tatham's second daughter, Julia, married George Richmond in 1831.[3] Thus there are at least three family connections through which Mrs. Dobinson could have inherited this impression from someone who acquired it directly from Blake or Mrs. Blake. Described in Keynes, *Bibliotheca Bibliographici*, no. 554(ii). Reproduced here, Fig. 8.

Russell, Binyon, Keynes, Butlin, and Bindman all accept the inscribed date of 1793 on the second state as the year of its execution.[4] Because the first state is considerably more conventional and less dramatic in execution than the second, the last three authorities date the first state in the mid-1780s. However, Blake's imprint dates of engraving (*sculpsit* as distinct from *invenit*) incised in his copperplates always record the publication of the first state.[5] He seems not to have added new dates even when he thoroughly reworked the image and other inscriptions. Thus it is likely that the first state of the print was not completed until 1793 and that this is the state Blake listed as "Job, a Historical Engraving. Size 1 ft. 7½ in. by 1 ft. 2 in.: price 12*s*." and referred to as one of "two large highly finished engravings" in his prospectus *To the Public* of 10 October 1793.[6]

The extensive burnishing used as an element of design in the second state indicates a post-1803 date for its execution.[7] It is extremely difficult to determine the date more specifically. The statement in Sotheby's catalogue of 1937 that impression 2D "may be an impression from the plate as re-worked, *circa* 1810-14" is an intriguing foreshadowing of the late dating proposed here, but the basis for the Sotheby claim is not known. Butlin has very tentatively suggested a date of *c.* 1808-1809 on the basis of similarities between the lighting effects in the second state and those displayed in Blake's paintings and watercolors of that period.[8] It is even possible that Blake did not revise the plate until after he met John Linnell in 1818. His young patron was adept in the use of burnishing and often printed even unfinished proofs of his own plates on laid India, as are two of the three known impressions of the "Job," second state, but none of Blake's intaglio graphics unquestionably printed before 1825. No impression has a

Part One.
Plates Designed and Executed
by Blake

[9] For further discussion of Linnell's influences on Blake, see Essick, *William Blake, Printmaker*, pp. 219-223.

[10] For a listing of states and reproductions, see William L. Pressly, *The Life and Art of James Barry*, New Haven and London: Yale University Press, 1981, p. 269, figs. 58, 102. When Barry thoroughly reworked his plate, *c.* 1790, he enlarged considerably the bolt of lightning above the figures. This revision may have suggested to Blake the addition of lightning to the second state of his own "Job" plate.

[11] *Blake's Illustrations to Job*, p. 246.

[12] Butlin questions Lindberg's statement for similar reasons in his review of Lindberg's book, *Art Bulletin*, 57 (1975), 296.

history that can be traced back earlier than 1830, and impressions 2C and 2D have provenances that associate them with Linnell and his friends. Revising "Job" may have been a preliminary to the *Job* series of engravings, a way for Blake to display his mature graphic style before Linnell commissioned the twenty-one smaller plates.[9]

Blake's development of the "Job" design began at least as early as the mid-1780s. The pen and wash drawing of "Job, His Wife and His Friends" (Fig. 9) in the Tate Gallery probably dates from *c.* 1785. It measures 31.1 × 45.1 cm and shows Job in the center with his wife on the left and friends on the right. This composition, or at least its subject, may have been influenced by James Barry's "Job Reproved by His Friends," engraved in 1777.[10] On the verso (Fig. 10) of Blake's drawing are a number of pencil sketches, including in the center an alternate version of Job's wife showing her in the position used in all subsequent versions. The next stage of composition would seem to be the pen and wash drawing, 32.5 × 46 cm, untraced since it was sold from the collection of Miss Brenda G. Warr, Sotheby's, 17 December 1928, lot 138 (£115 to Maggs). It is described as follows in the auction catalogue: "Job is seated on the left, depicting grief in face and gesture; his wife, in the centre, is seated beside him, hands clasped on knees, her head turned towards him; the three friends kneel in a group to the right; trees are faintly outlined on the dark background: on the reverse is a pencil sketch of a standing figure, fully draped, with wild look and flying hair and beard." This arrangement of the figures is repeated in the highly finished gray wash drawing, 32.2 × 48.2 cm, now in the M. H. de Young Memorial Museum, San Francisco (Fig. 11). It is probably the immediate preliminary for the engraving, reversed. As in the second state of the plate, Job has tears streaming down his cheeks and beard; but the background, general tone, and characterization of the figures are closer to the first state.

Even if all three drawings of "Job" were executed in the 1780s, the completion of the first state of the plate is not necessarily contemporaneous with them. Blake frequently continued to modify and reuse a favorite composition over many years and in several media, as is demonstrably the case with this subject. He sketched a somewhat different version of the scene in his *Notebook*, p. 20, probably by 1793. Lindberg has described this as "apparently the first sketch for Blake's Job engraving of 1793,"[11] but it is later than at least the Tate drawing (Fig. 9), shows the figures with different positions and gestures than either the other drawings or the print, and would seem to be part of the series of small *Notebook* emblems.[12] Blake modified the composition again in his Job watercolor series executed for Thomas Butts (*c.* 1805) and Linnell (*c.* 1822-1827), and produced a final graphic version as pl. 10 of his *Job* engravings (*c.* 1825).

For the companion print to "Job" and a discussion of their relationship, see "Ezekiel."

VI.
Ezekiel

FIGURES 12-14

First state: 1794

There are no recorded impressions of the hypothetical first published state. For the reasons for believing that the only extant state is a second state, see discussion following the census of impressions.

Second state: the only recorded state, 1804 or later

Signature below image, center: Painted & Engraved by W Blake

Title inscription: EZEKIEL

Quotation below title: I take away from thee the Desire of thine Eyes, Ezekiel xxiv [followed closely by two faint vertical lines, the first taller than the second, leaning to the right at the same angle as the preceding roman numeral. Russell, *Engravings of Blake*, p. 69 and pl. 7, and Binyon, *Engraved Designs of Blake*, p. 49, record "16" following *xxiv*; Keynes, *Engravings by Blake: The Separate Plates*, p. 23, records C 16, perhaps by way of analogy with the inscription on "Job." I am not able to resolve the two lines into either a C or 16. A number of fine lines between and below *Eyes, Ezekiel xxiv* are probably fragments of a partially erased inscription. Faint lines to the left of the letters in *Eyes* indicate that the word had at one time been scratched into the plate in a slightly different location.]

Imprint: Publishd October 27 1794 by W Blake N° 13 Hercules Buildings Lambeth

Image: 35.5 × 48 cm

Plate mark: 46.4 × 54 cm

IMPRESSIONS

2A.
British Museum. Printed on India paper laid onto wove, 55.6 × 67.8 cm, pasted to the mat. Sold from the collection of R. A. Potts, Sotheby's, 18 June 1912, lot 237 (£21 to Colnaghi). Acquired by the British Museum from Colnaghi in June 1913 (with "Job," impression 2B). Exhibited at the British Museum in 1957, no. 23(3) in the catalogue; and at the Hamburg Kunsthalle and Frankfurt am Main Kunstinstitut in 1975, no. 8 in the catalogue. Reproduced here, Fig. 12.

2B.
Fitzwilliam Museum, Cambridge. Printed on wove paper, 48.9 × 67 cm, somewhat foxed. For provenance, see "Job," impression 2C. Described in Bindman, *Blake: Catalogue of the Collection in the Fitzwilliam Museum*, no. 19.

2 C.

Sir Geoffrey Keynes, Suffolk. Printed on India paper laid onto wove, framed and matted within the plate mark. The mat covers the imprint. Sold from the collection of Mrs. William Dobinson, *née* Ellen M. Chevalier, at Sotheby's, 1 December 1910, lot 127, with "Job," impression 2D (£33 to W. E. Moss). For information on Mrs. Dobinson's family connections leading back to Blake or Mrs. Blake, see "Job," impression 2D. Lent by Moss to the Whitworth Art Gallery in 1914, no. 102 in the exhibition catalogue. Sold with the Moss collection at Sotheby's, 2 March 1937, lot 175 (£19 to Keynes). Lent by Keynes to the Tate Gallery in 1978, no. 33 in the exhibition catalogue. Described in Keynes, *Bibliotheca Bibliographici*, no. 556. Reproduced in Keynes, *Engravings by Blake: The Separate Plates*, pl. 15 (including the imprint, which appears to be printed very lightly).

Blake executed "Ezekiel" as a companion to the "Job" plate and as part of a projected series of prints based on "subjects from the Bible" announced in Blake's prospectus *To the Public* of 10 October 1793.[1] The images of these two prints are about the same size and have similar compositional density, with the huddled figures filling almost all the pictorial space and with minimal sense of recessional distance. All three extant impressions of "Ezekiel" have provenances that associate them with impressions of "Job," and Blake's development of the two designs would seem to be parallel. The pencil, pen, and India ink wash drawing of "Ezekiel" (33 × 47 cm, Fig. 13) in a private Massachusetts collection is about the same size, and was probably executed in the same mid-1780 period, as the "Job" drawing in the Tate Gallery (Fig. 9). Similarly, the highly finished gray wash drawing of "Ezekiel" (34.5 × 48 cm, Fig. 14) in the Philadelphia Museum of Art parallels the "Job" drawing in the de Young Museum (Fig. 11) in size, style, and probable date of execution. It contains the background wall, its decorations including hovering angels, and details of face and costume not in the earlier sketch and is probably the immediate preliminary for the print.

If the evident parallels between "Ezekiel" and "Job" extend beyond the extant evidence and into the execution of the plates, then it is probable that the only known state of the former is a second state and that "Ezekiel" once existed in a first state similar to the "Job" first state. This argument by analogy is supported by the skillful use of burnishing to add highlights to clothing and Ezekiel's face, and to create the halos of Ezekiel and of his dead wife who is resting on a bier. Like the burnishing used as an element of composition in the second state of "Job" (Fig. 8), this technique indicates a post-1803 date for its execution.[2] Further, there are fragments of previously etched or engraved lines partially erased by the burnishing, most evident in the halo above Ezekiel's wife. This is very good evidence for a state prior to that represented by the extant impressions, and it was probably this lost first state that Blake executed in 1793-1794 and dated 27 October 1794 in the imprint. The second state may not have

[1] Erdman, ed., *Poetry and Prose of Blake*, p. 670. Blake is probably referring to "Ezekiel" and some unknown print when he notes in this prospectus that he has "two more" highly finished engravings (in addition to "Job" and "Edward & Elenor") "nearly ready."

[2] As I argue in *William Blake, Printmaker*, pp. 178-186, for this and other revised plates with similar features.

been executed until as late as 1818 when Blake met John Linnell—see "Job" for a brief discussion of this possibility.

It is impossible to know in detail what the first state of "Ezekiel" looked like, but by extrapolating backward from the second state, and by using the differences between the two states of "Job" (Figs. 7-8) and the finished drawing of "Ezekiel" (Fig. 14) as guides, we can reconstruct the general appearance of the first state. The highlights of burnishing and halos, absent from both drawings, would not have been present. As in the "Job" first state, the costumes of the foreground figures would have been delineated through more uniform hatching patterns and would have lacked the strong lines defining deep folds in the second state. There is nothing to indicate, however, that the "Ezekiel" first state would have been as dark as the "Job" first state or would have contained its dense crosshatching and dot and lozenge techniques. The upper corners of "Ezekiel" are very likely the least reworked areas of the plate, and show that at least the background in the first state was composed of carefully executed fine-line hatchings and delicate right-angle crosshatching. The figures were probably also executed in similar types of patterns that are far closer to conventional reproductive techniques than the masterful variety of tones and textures given to the second state.

Both "Job" and "Ezekiel" present reactions to physical and spiritual vicissitude. Each centers on a patriarchal figure, eyes raised heavenward, accompanied by wife and friends. Contrasts, emphasized in the second states of the prints, evolve immediately out of these similarities: the questions of Job, exemplified by the inscribed quotation, and the accusations of his friends set within a dark wilderness; the faith and acceptance of Ezekiel portrayed before a wall adorned with art. Job squats in dejection, palms facing outward as if to show his innocence and with tears streaming from his eyes; Ezekiel kneels in prayer with arms humbly folded and, as God has commanded (Ezekiel 24:16), he refuses to weep over his wife's death. Job's heavy burden is underscored by the thick crosshatching defining his covering. The more delicate lines of "Ezekiel" follow the flowing contours of garments and the burnished areas suggest enlightenment rather than oppression. Ezekiel is a true prophet who has heard the voice of God and found his purpose as an embodiment of Israel's destiny within the very moment of his trial (Ezekiel 24: 19-24). Job waits for God to answer his anguished plea: "What is Man That thou shouldest Try him Every Moment?" Ezekiel has already passed through Job's dark night of the soul and, like his wife, has risen to that higher plane of being symbolized by their halos.

VII.
Albion rose ("Glad Day" or "The Dance of Albion")

FRONTISPIECE,
PLATE 1, AND
FIGURES 15-16

First state: c. 1793

Signature: perhaps *WB inv 1780* on the hillock, lower left, but obscured in color printed impressions 1A and 1B

Image: See image size for the second state. In the first state, the image must have had about the same width as the second state, but it may have extended into the area at the bottom of the plate devoted to the inscription in the second state.

Plate mark: 27.2 × 19.9 cm (as indicated by impression 1B)

IMPRESSIONS printed in intaglio

There are no extant intaglio impressions of the first state. The only evidence for its existence, at least as incised lines in the copperplate, is provided by impression 1B. The color printing in this impression is thin enough to reveal the intaglio lines as slight white lines, most clearly visible in the reproduction here (see Frontispiece) in the clouds to the right of the figure's left knee and below and to the right of his left foot. With a strong backing light showing through the paper of this impression, one can see that the first state lacked the bat-winged moth, worm, and shafts of light radiating from the figure in the second state. The horizontal hatching lines of the background seem to have extended much closer to the head and shoulders of the figure and there may have been more hatching and crosshatching on his body. The presence of the signature, inscriptions below the image, and execution of details cannot be determined.

IMPRESSIONS color printed with glue- or gum-based pigments applied to the surface of the copperplate, *c. 1794-1796*

1A.

British Museum. Color printed to the edge of the plate, 27.2 × 20 cm, on wove paper, 34.6 × 24.7 cm, pasted to the mat. Hand finished with ink and watercolors. White vertical lines, probably intended to represent rain, have been scratched into the pigment, lower right. This impression was once part of the *Large Book of Designs*, copy A, which Blake printed *c.* 1794-1796 for the miniature painter Ozias Humphry.[1] Bequeathed by Humphry (died 1810) to his natural son William Upcott. By 1828 this and other prints from the *Large Book of Designs* were bound or inserted at the end of *Europe*, copy D, also in Upcott's collection.[2] After his death in 1845, the volume was sold in the New Bond Street auction rooms of R. H., T., and C. Evans on 15 June 1846, lot 277, with *America*, copy H, and the Large and perhaps the Small Books of Design, both copies A, "inserted" (£7 2s. 6d. to Evans). Sold by Evans, unbound, with the other prints in the *Large Book of Designs*, copy A, and four illuminated books (not including *Europe*, copy D), to the British Museum in February 1856. Restored by S. W. Littlejohn sometime between 1904, when he joined the British Museum staff, and his death in 1917.[3] Exhibited at the British Museum in 1934,

[1] Blake refers to this sale, but does not say when it occurred, in a letter to Dawson Turner of 9 June 1818 (Keynes, ed., *Letters of Blake*, p. 142). A date of *c.* 1794-1796 for the completion of all the Books of Design is likely because the impression of the title page of *The Book of Urizen* included in copy B of *The Small Book of Designs* has the etched date of 1794 changed to 1796 (on the impression, not on the copperplate). It is most unlikely that Humphry would have purchased these designs after 1797 because he went blind in that year.

[2] "Albion rose," impression 1A, is probably the print described by Richard Thomson as "a figure of an angel standing in the sun" at the end of *Europe*, copy D. Thomson was quoted in 1828 by J. T. Smith in *Nollekens and His Times*, II, 479 (Bentley, *Blake Records*, p. 472).

[3] The restoration is mentioned in passing in Laurence Binyon and Sir Sidney Colvin, "The Late Stanley William Littlejohn," *Burlington Magazine*, 32 (1918), 16. I have not been able to determine the extent of the restoration.

no. 199 in the catalogue; and in 1957, no. 7(2) in the catalogue. Lent to the National Library of Scotland, Edinburgh, in 1969, no. 55 in the exhibition catalogue; to the Royal Academy in 1972, no. 509 in *The Age of Neo-Classicism* catalogue; to the Hamburg Kunsthalle and Frankfurt am Main Kunstinstitut in 1975, no. 60 in the exhibition catalogue; and to the Tate Gallery in 1978, no. 10 in the exhibition catalogue. Listed in Bentley, *Blake Books*, pp. 78-79, copy C. Reproduced here, Pl. 1.

1B.

Huntington Library, San Marino, California. Color printed to the edge of the plate, 27.2 × 19.9 cm, on wove paper, 36.8 × 26.3 cm, watermarked, upper left, "1794 | J WHATMAN." Hand finished with ink and watercolors. The thinness of the color printing indicates that this is probably a second pull printed immediately after impression 1A with slight, if any, addition of more pigments to the copperplate. This impression may have once been gathered together with other color-printed designs into a second copy (B) of the *Large Book of Designs*, although the existence of such a volume or collection is based only on analogy with copy A acquired by Humphry *c.* 1795-1796 (see the provenance of impression 1A). Perhaps one of the prints by Blake acquired in August 1797 by Dr. James Curry, a friend of Humphry's.[4] Acquired by Frederic Robert Halsey between 1903 and 1915, who bound the print at the end of *The Song of Los*, copy E. The position of the print in this volume is indicated by offsetting on a loose fly-leaf at the end, by a small penciled "9" on the print (lower left, indicating that it followed the eighth and last plate in *The Song of Los*), and by the partially erased pencil inscription "an additional plate" (lower right). An inscription on the verso, "end" (in pencil, lower right), may also be related to the position of the print in *The Song of Los*; but the other verso inscription, "14" (in pencil, lower right), is not relevant to any known binding arrangement. It must have been while bound in the illuminated book that the print was gilt along its top edge, as are the other leaves in *The Song of Los*, copy E. Halsey acquired this illuminated book, unbound, from the collection of the Earl of Crewe, at Sotheby's, 30 March 1903, lot 9 (£174 to Sabin). The auction catalogue describes the volume as "consisting of 8 leaves in colours . . . 4 of which are full-page figures without text." Since there are only three leaves without text in *The Song of Los*, the cataloguer either miscounted these or miscounted the total number of leaves. If the latter, "Albion rose" may have already been part of the illuminated book when Halsey acquired it. Sold by him with his library to the Huntington Library in 1915, where in 1953 the print was removed from the binding. Listed in Bentley, *Blake Books*, pp. 78-79, copy D. Reproduced here as the Frontispiece.

Second state: c. 1804 or later

Blake burnished out the horizontal lines surrounding the head and shoulders and added the bold engraved lines radiating from the figure, the worm near his left foot, and the

[4] See G. E. Bentley, Jr., "Dr. James Curry as a Patron of Blake," *Notes and Queries*, 27 (1980), 71-73.

bat-winged moth. That Blake burnished away the horizontal lines from the area now containing the moth is indicated by fragments of these lines on the moth's right wing and left side of the abdomen. Oddly, the horizontal background lines also continue right through the hilltop below the right foot. Perhaps the figure was balanced only on his left foot in the first state, and when Blake added the hill beneath his left foot in the second state (as he had previously done with color printing in impressions 1A and 1B), he did not bother to remove the horizontal lines. Many details may also have been altered; see the note on intaglio impressions of the first state.

Signature on the hillock, lower left: WB inv 1780

Inscription below the image: Albion rose from where he labourd at the Mill with Slaves | Giving himself for the Nations he danc'd the dance of Eternal Death.

Image: 25.1 × 18.8 cm

Plate mark: 27.2 × 19.9 cm (as indicated by impression 1B)

IMPRESSIONS

2C.

British Museum. Printed on wove paper trimmed just outside the image to 25.4 × 19 cm, thereby cutting off the lower inscription except for small fragments of the tops of the first two letters. Now pasted to the mat. This is very probably the impression described by Alexander Gilchrist in his *Life of Blake* (1863), I, 32. By 1880 in the collection of Mrs. Alexander Gilchrist, who in that year lent it to the Boston Museum of Fine Arts, no. 114 in the exhibition catalogue. Inherited by her son, Herbert H. Gilchrist, who lent it to the Pennsylvania Academy of the Fine Arts in 1892, no. 178 in the exhibition catalogue. Sold by Gilchrist to the British Museum in June 1894, with thirteen other works by Blake, for £150. Exhibited at the British Museum in 1934, no. 198 in the catalogue, and in 1957, no. 56(1). Lent to the Hamburg Kunsthalle and Frankfurt am Main Kunstinstitut in 1975, no. 3 in the exhibition catalogue; and to the Tate Gallery in 1978, no. 11 in the exhibition catalogue. Listed in Bentley, *Blake Books*, p. 78, copy A. Reproduced in Binyon, *Engraved Designs of Blake*, pl. 4.

2D.

National Gallery of Art, Rosenwald Collection, Washington, D.C. Printed on wove paper trimmed within the plate mark to 26.8 × 19.3 cm. Rosenwald and National Gallery of Art collection marks on verso. Mounted in a window cut in a sheet of paper with a brown ink framing line and bearing stab holes along the left edge. Collected in "about 1853"[5] by George A. Smith, who bound it into a half morocco volume with other prints by Blake, Blake's manuscript "Order" of the *Songs of Innocence and of Experience*, and the manuscript of Cunningham's life of Blake.[6] The print was probably pasted to the mounting sheet

[5] According to Keynes, *Engravings by Blake: The Separate Plates*, p. 6. Keynes, *Bibliography of Blake*, p. 319, notes that, when the volume was in the collection of MacGeorge, it contained a "prefatory note signed 'G.A.S. 1855.' "

[6] For a list of most of the materials known to have been in this volume, see Bentley, *Blake Books*, pp. 337-341.

when bound into this volume and inscribed "91" in ink (upper right on the mount) to indicate its position in the volume. Sold by Smith at Christie's, 1 April 1880, lot 168 (£66 to Quaritch). Sold or lent by Quaritch to William Muir, who based several of his facsimiles on works in the volume. After some prints were extracted, probably by Muir, the collection was offered for £80 by Quaritch in his *General Catalogue of Books* of November 1882; in his four-page advertising flyer, "William Blake's Original Drawings," dated May 1885; and in his *General Catalogue of Books* of 1887, item 10,252 (£80 in each case). Acquired by Bernard Buchanan MacGeorge, who in 1906 listed it in his privately printed *Catalogue of the Library of Bernard B. MacGeorge*, Glasgow: James Maclehose and Sons, 1906, p. 17. After MacGeorge's death, sold at Sotheby's, 1 July 1924, lot 133 (£345 to Parsons). Parsons was apparently in partnership with Maggs Bros. or sold the volume to them, for it was offered in Maggs' catalogue 456 of 1924, item 53, for £630. Acquired by George C. Smith, Jr., who disbound the volume and rebound this print in a full blue morocco volume with three other works also from the original group: "The Chaining of Orc," "The Man Sweeping the Interpreter's Parlour" (impression 2K), and "The Accusers of Theft Adultery Murder" (impression 3G). It is probably at this time that the mounting sheet was inscribed in pencil "Unique," lower left, and "1" in a circle, upper right, to indicate its position in the new volume. Listed by Smith in the anonymous catalogue of his collection in 1927, no. 36, and lent by him to the Fogg Art Museum in 1930 (only "Albion rose" shown). Sold posthumously with Smith's collection, Parke-Bernet, 2 November 1938, lot 42, with the three other prints listed above ($450 to Rosenbach for Lessing J. Rosenwald). When acquired by Rosenwald the print was stained and foxed.[7] He had it disbound and cleaned in 1939 and lent it in that year to the Philadelphia Museum of Art, no. 218 in the exhibition catalogue; in 1957 to the National Gallery of Art, no. 67 in the exhibition catalogue; in 1961 to the University of Iowa, no. 1 in the exhibition catalogue; and in 1965 to Cornell University, no. 18 in the exhibition catalogue. Given by Rosenwald to the National Gallery of Art in 1945 and moved from the Alverthorpe Gallery, Jenkintown, Pennsylvania, to Washington in 1980. Listed in Bentley, *Blake Books*, pp. 78-79, copy B, where it is incorrectly described as belonging to the Library of Congress. Reproduced here, Fig. 15.

[7] As shown in a photograph, now in my possession, made for Mr. Rosenwald and labeled "before treatment May 1939."

[8] The traditional title of "Glad Day" was given to the print by Gilchrist in his *Life of Blake* (1863), I, 32. Russell, *Engravings of Blake*, p. 54, accepts this title, but notes that "the design is likely to have been inspired" by the image of "jocund day" in Shakespeare's *Romeo and Juliet*, III, v, 9-10. Keynes, *Engravings by Blake: The Separate Plates*, pp. 6-9, uses the title "The Dance of Albion."

[9] "Blake's 'Glad Day,'" *Journal of the Warburg and Courtauld Institutes*, 2 (1938), 65, pl. 12a.

[10] *Art of Blake*, p. 34, pls. 6a,b.

The dated signature visible in the final state of "Albion rose"[8] clearly indicates that Blake "invented" the composition in 1780. This is probably when he executed the pencil drawing (Fig. 16) of the figure only (with his face seen straight-on and lifted slightly rather than turned a little down and to the viewer's right) on a sheet 20.6 × 28.8 cm, now in the Victoria and Albert Museum. In 1938, Anthony Blunt suggested that the figure was based on a proportional body illustrated in Vincenzo Scamozzi's *Idea dell' Architettura Universale* (Venice, 1615),[9] but he later proposed as an alternative source two engravings in *De' Bronzi di Ercolano* (1767-1771) showing the front and back of a bronze faun.[10] The significance of this sculptural source is increased

Part One.
Plates Designed and Executed
by Blake

[11] This pencil sketch on the verso is reproduced in Keynes, *Drawings by Blake*, pl. 2. Blake later etched this back view in white line as a representation of "Albion" (so inscribed on the plate) on pl. 76 of *Jerusalem* (c. 1804-1820).

[12] *Engravings of Blake*, p. 54. There is also a curious resemblance between the visage in the print and that in a black chalk studio study by Blake of a naked youth who may be his beloved brother Robert (47.9 × 37 cm, British Museum, reproduced in Butlin, Tate Gallery exhibition catalogue, 1978, p. 30).

[13] Erdman, ed., *Poetry and Prose of Blake*, p. 418.

[14] David V. Erdman has associated "Albion rose" with the description of "The millions" who threw off their vestments of war "& stood a naked multitude" on pl. 15 of *America* (*Prophet Against Empire*, pp. 7, 10).

[15] Keynes, ed., *Letters of Blake*, p. 101.

[16] For further discussion of Blake's use of burnishing in his nineteenth-century revisions and its relationship to the 1804 letter to Hayley, see Essick, *William Blake, Printmaker*, pp. 178-186, especially pp. 182-183, for an interpretation of the final state of "Albion rose." Russell, *Engravings of Blake*, p. 54 n.5, was the first to associate the inscription with the letter to Hayley.

by the fact that Blake drew a back view of the figure, balanced on his right rather than left foot, on the verso of the "Albion rose" drawing.[11] Russell was the first to suggest that the visage, at least in the print, is similar to Blake's own.[12] If indeed the figure is an idealized self-portrait, the inscribed date on the print may have personal significance as Blake's first full year of liberation from his apprenticeship to Basire. There is also a similarity between the design and the following image from Blake's "King Edward the Third," published in the *Poetical Sketches* of 1783:

> . . . the gallant sun
> Springs from the hills like a young hero
> Into the battle, shaking his golden locks
> Exultingly; this is a promising day.[13]

It is most unlikely that the first state of the plate visible beneath the color printing of impressions 1A and 1B was executed (*sculpsit* as distinct from *invenit*) as early as 1780. The uncluttered and energetic etching-engraving of the figure and the simplicity of the linear patterns delineating the setting are similar to the graphic style of two etched plates after Fuseli, "Timon and Alcibiades" and "Falsa ad Coelum" (the former dated 1790); to most of the plates in *For Children: The Gates of Paradise* (1793); and to "Our End is come" (first state of "The Accusers," 1793) and "Lucifer and the Pope in Hell" (c. 1794). Thus a date of *c.* 1793 is probable. At this stage in Blake's development of the plate, he may have associated the figure with the forces of political and social revolution personified by Orc in the illuminated books of 1793-1794. A similarly energetic Orc-figure, but with more snake-like hair and a more troubled expression, appears on pl. 12 of *America* (1793);[14] another version of the same type of youthful male nude represents "Fire" on pl. 5 of *For Children: The Gates of Paradise*. The color-printed impressions of this first state of "Albion rose" were very probably produced in 1795-1796 when Blake seems to have done most of his work in that medium (see the history of impression 1A and note 1).

The inscription added to the final state of the plate offers several keys to its date. The idea of Albion as a person does not appear in Blake's poetry until some of the later revisions of *The Four Zoas* manuscript, probably made after 1800, and in *Milton*, begun about 1803. The concept of triumphant self-sacrifice is also a theme of the later epics *Milton* and *Jerusalem*. The image of laboring at the mill has its ultimate source in a line from the opening speech of Milton's *Samson Agonistes*, "Eyeless in *Gaza* at the Mill with slaves." Blake first used these Miltonic images in *America*, pl. 6 ("Let the slave grinding at the mill, run out into the field"), but a more significant parallel to the "Albion rose" inscription, and one that stresses the personal associations Blake may have had with the print, is found in his letter to William Hayley of 23 October 1804. There he writes that he had been "a slave bound in a mill among beasts and devils," but now he is "again enlightened with the light [he] enjoyed in [his] youth."[15] The burnishing and rays of light added to the final state present visually the light imagery in this letter.[16] Finally, Erdman's hypothesis—that

Blake consistently engraved a left-pointing serif on the letter "g" in his copperplate hand from *c.* 1791 to 1803—indicates a post-1803 date for the "Albion rose" inscription because of the serif pointing to the right on the "g" of "Giving." Thus, both textual and graphic evidence point to a date of *c.* 1804 or later for the execution of this final state.

The worm and bat-winged moth added to the final state have been variously interpreted, but always with the erroneous supposition that they are part of the first state of the print.[17] The significance of the reticulated earthworm may be explained by a passage in *Jerusalem*: "Let the Human Organs be kept in their perfect Integrity/At will Contracting into Worms, or Expanding into Gods."[18] Albion and the worm beneath his feet picture respectively the unlimited expansion and the limit of material contraction delineating the contrary destinies of which man is capable. The bat-like wings of the moth, a creature of the night and thus associated with the "twenty dark" years Blake says he is leaving behind in the 1804 letter to Hayley, identify it with the repressive spectres of Blake's nineteenth-century writings, including "that spectrous Fiend" whose reduction to his proper station is announced in the same letter. Albion, as the incarnation of human aspirations, rises like the resurrected Christ, a source of spiritual illumination dispelling the creatures of darkness.

[17] See Blunt, "Blake's 'Glad Day,' " p. 66; Joseph Anthony Wittreich, Jr., *Angel of Apocalypse: Blake's Idea of Milton*, Madison: University of Wisconsin Press, 1975, pp. 55, 56, 64.

[18] Erdman, ed., *Poetry and Prose of Blake*, p. 203.

VIII.
The Accusers of Theft Adultery Murder

PLATES 2, 3
FIGURES 17-19

First state: 1793

Title inscription: *Our End is come*

Imprint: *Publishd June 5: 1793 by W Blake Lambeth*

Image: 18.3 × 9.5 cm

Plate mark: 21.8 × 12.1 cm

IMPRESSIONS

1A.

Bodleian Library, Oxford. Printed in olive green on wove paper, 23.5 × 14.4 cm. The ink was poorly wiped along the lower margin, resulting in a streak beyond the lower right corner of the image. Inscribed on the verso in black ink "Douce/MM. 834" and in pencil, upper right, "3." Bentley, *Blake Books*, p. 298, reports that "there may be indecipherable pencil notes" on the verso, but these are not now visible. Bound by 1834 as a frontispiece to *The Marriage of Heaven and Hell*, copy B.[1] Bentley, *Blake Books*, p. 287 n.3, notes that the print "appears to be conjugate with the succeeding leaf," the title page to *The Marriage* on which the print is offset, and that the print "is stabbed in the same pattern as the other leaves." This information can no longer be confirmed because the print was removed from the volume in the winter of 1977-1978 and rebound by gluing it to a stub of modern white paper bound into the spine. There is a fragmentary stub of the frontispiece paper, still present in the spine between the rebound frontispiece and title page, left in place after the print was cut out for rebinding, but I am unable to determine any conjugacy from it. The first gathering of *The Marriage*, at least as presently sewn, is quarto, and this would seem to exclude conjugacy between "Our End is come" and the gathering where one would expect to find it. No stab holes are now visible on the frontispiece; they were probably trimmed off during rebinding. This impression is on the same type of paper as other leaves in *The Marriage*, copy B, of which pls. 13, 16, 21, and 24 are printed in similar (although to my eye not identical) shades of olive-green ink. According to Francis Douce's acquisition list (Bodley, MS Douce e.67, f.40ᵛ), copy B of *The Marriage* was acquired by him in April 1821 from "Dyer"—probably either the London printseller Charles George Dyer or, somewhat less likely, the Exeter bookseller Gilbert Dyer.[2] Bound by 1834 in half-red morocco over marbled boards, and bequeathed by Douce in that year to the Bodleian Library. Keynes and Bentley incorrectly describe this impression as the second state, and Keynes remarks that it "shows evidence at the bottom of the print of erasure of a previous inscription."[3] Ink printed from the surface of the plate in the inscription area shows a pattern of horizontal streaks that may indicate that this part of the copperplate was scraped and burnished, perhaps to erase previous inscriptions; but there are no fragments of any such inscriptions and a prior state of the plate cannot be assumed on the basis of such minimal evidence. Described in Bentley, *Blake Books*, pp. 76-77, copy B. Reproduced here, Fig. 17.

[1] Erdman notes that copy B "seems a miscellaneous collection of proof pages" and "was not necessarily assembled by Blake himself" in Paley and Phillips, eds., *Blake: Essays in Honour of Keynes*, p. 164 n.6. But in *The Illuminated Blake*, p. 390, Erdman speculates on some ways "Our End is come" may illustrate "A Song of Liberty" appended to all complete copies of *The Marriage*.

[2] These names were kindly suggested to me by Professor G. E. Bentley, Jr. In *Blake Books*, p. 298, Bentley tentatively suggests that the seller may have been the author George Dyer, but he no longer thinks this is the case.

[3] *Engravings by Blake: The Separate Plates*, pp. 19, 21; *Blake Books*, p. 76.

Second state: 1793-1796

*Title inscription: When the senses are shaken | And the soul
is driven to madness* [to the right] Page 56

Imprint and plate mark: same as in first state

Image: probably the same as in first state, but perhaps in-
creased slightly as in the third state

IMPRESSIONS printed in intaglio

There are no extant intaglio impressions of the second state, but its
existence is confirmed by three independent pieces of evidence. An
impression, now untraced, with the title inscription recorded above
and an image size of 18.3 × 9.7 cm, was lent by Edward W. Hooper
to the Boston Museum of Fine Arts in 1891. The exhibition catalogue,
pp. 32-33, no. 111, notes that the figure on the right does not wear
a laurel wreath (given to him in the third state) and that the heads
"differ in execution and in minor details" from the reproduction of
the heads only (from the third state) in Gilchrist, *Life of Blake* (1880),
I, 304.[4] Fragments of the title inscription and page reference given in
the Boston catalogue can be seen in several impressions of the third
state (see descriptions of impressions 3D, 3F-3I, below).[5] The color
printing in impression 2C (Pl. 3) is thin enough to reveal a good many
of the underlying intaglio lines, particularly in the floor and along the
right side of the plate. These indicate that the horizontal hatching lines
on the wooden post on the right, visible in the third state, have been
incised into the copper; but that other third-state alterations—includ-
ing the laurel wreath and shirt given to the figure on the right, the
spiky hair given to the figure on the left, the addition of flames left
and right, and the burnishing on the floor and along the right side—
have not yet been executed. The absence of the flames and burnishing
on the left is confirmed by the presence of lines defining wood grain
(as in the first state) visible in color-printed impression 2B (Pl. 2).
Thus, the copperplate used for the color-printed impressions must
have been in the second state, as described in the 1891 Boston cata-
logue, or some other intermediate state. Lacking any corroborating
evidence for a further state, I have assumed the first alternative for
the purposes of this catalogue.

IMPRESSIONS color printed with glue- or gum-based pigments applied
to the surface and some intaglio lines of the copperplate, *c.* 1794-1796

2B.

British Museum. Color printed to the edge of the plate, 21.5 × 11.8
cm, on wove paper, 34.5 × 24.7 cm. Hand finished with ink and
watercolors. Binyon states that this impression "is on Whatman paper,
with the watermark 1794,"[6] but this cannot be confirmed because the
print is pasted to the mat. This impression was once part of the *Large
Book of Designs*, copy A, and is probably the print described by
Richard Thomson as "a group of three furies surrounded by clouds

[4] This reproduction, engraved by W. J.
Linton, is a reasonably accurate rendering
of the general character of the heads; but
it does not replicate Blake's third state line
for line and thus it is not a good basis for
judging the state of the Hooper impres-
sion. W. M. Rossetti includes only the
third state in his list of Blake's engravings
in Gilchrist, *Life of Blake* (1863), II, 257;
(1880), II, 279.

[5] The presence of these fragments in the
final state, but not in the single extant
impression of the first state, strongly sug-
gests the sequence of states given here.

[6] *Engraved Designs of Blake*, p. 49.
Russell, *Engravings of Blake*, p. 67, was
the first to give the date of the watermark,
but he does not record that the paper is
Whatman.

and fire" bound at the end of *Europe*, copy D.[7] For the subsequent history of that part of the *Large Book of Designs* containing this impression of "The Accusers," see "Albion rose," impression 1A. Exhibited at the British Museum in 1957, no. 7(4) in the catalogue; lent to the Hamburg Kunsthalle and Frankfurt am Main Kunstinstitut in 1975, no. 55 in the exhibition catalogue. Listed in Bentley, *Blake Books*, pp. 76-77, copy G. Reproduced here, Pl. 2.

2C.

National Gallery of Art, Rosenwald Collection, Washington, D.C. Color printed to the edge of the plate, 21.4 × 11.9 cm, on wove paper, 32 × 24 cm, bearing stab holes along the left edge and the National Gallery of Art collection mark on the verso. Hand finished with ink and watercolors. The thinness of the color printing in some areas indicates that this is probably a second pull printed immediately after impression 2B with perhaps some addition of more pigments to other areas of the copperplate. This impression may have once been gathered together with other color-printed designs into a second copy (B) of the *Large Book of Designs*. For early provenance, see "Albion rose," impression 1B. Probably acquired by Isaac D'Israeli (died 1848) or his son Benjamin, later Earl of Beaconsfield. The print may have been among the "one hundred and sixty designs" by Blake that Isaac D'Israeli said he owned in a letter to Thomas Frognall Dibdin of 24 July 1835[8] and among the "170 Drawings &c by W. Blake" that the Earl of Beaconsfield told W. M. Rossetti he owned in 1862.[9] For some time the print was "bound up somewhat irregularly in a cloth case"[10] with a number of relief etchings, including *America*, copy A; *The Song of Los*, copy B; "A Dream of Thiralatha," impression 1B; and "Joseph of Arimathea Preaching to the Inhabitants of Britain," impression 1B. It may have been during this period that the print was inscribed with the number "3," upper right, just above the image, in gray ink.[11] The Earl of Beaconsfield died in 1881, and the print was sold separately at an anonymous Hodgson auction, 14 January 1904, lot 227 (£15 15s. to Quaritch). Acquired soon after by William A. White, who lent it (anonymously) to the Grolier Club in 1905 and 1919, nos. 39 and 21 in the exhibition catalogues, and to the Fogg Art Museum in 1924. Sold after White's death through Rosenbach to Rosenwald in May 1929 with "Joseph of Arimathea Preaching," impression 1B, for $3,000 (according to an invoice dated 1 May 1929, now in the Rosenbach Museum and Library, Philadelphia). Lent by Rosenwald to the Fogg Art Museum in 1930; to the Print Club of Philadelphia in 1930, no. 27 in the exhibition catalogue; to the Philadelphia Museum of Art in 1939, no. 83 in the exhibition catalogue; to the National Gallery of Art in 1957, no. 68 in the exhibition catalogue; and to the University of Iowa in 1961, no. 19 in the exhibition catalogue. Given by Rosenwald to the National Gallery of Art in 1945 and moved from the Alverthorpe Gallery, Jenkintown, Pennsylvania, to Washington in 1980. Listed in Bentley, *Blake Books*, pp. 76-77, copy H, where it is incorrectly described as belonging to the Library of Congress. Reproduced here, Pl. 3.

[7] Thomson was quoted in 1828 by J. T. Smith in *Nollekens and His Times*, II, 479-480 (Bentley, *Blake Records*, p. 472). This impression is also listed by W. M. Rossetti in Gilchrist, *Life of Blake* (1863), II, 239, no. 231; (1880), II, 253, no. 260.

[8] See Dibdin, *Reminiscences of a Literary Life*, London: John Major, 1836, p. 788 (Bentley, *Blake Records*, p. 243).

[9] See Rossetti's letter to Mrs. Gilchrist of 8 December 1862; printed in *Letters of William Michael Rossetti*, ed. Clarence Gohdes and Paul Baum, Durham, North Carolina: Duke University Press, 1934, p. 5.

[10] According to Hodgson's auction catalogue, 14 January 1904, lot 222. The volume was "now broken up" at the time of this sale.

[11] Keynes and Wolf, *Blake's Illuminated Books: A Census*, p. 89, states that the plate was "numbered 3 by Blake," but they do not cite the evidence for this attribution.

Third state: c. 1805-1810 or later
Blake has thoroughly reworked the image, adding many new linear patterns to motifs already part of the design and adding some new elements of design. The hair of the figure on the left has been made spiky and flame-like, and his skirt extended another fold to the left. The figure on the right has been given a laurel wreath and the margin of clothing has been defined just below his neck and at both calves. Many lines have been added to his face, giving him a more terrified expression. Flames, defined by both lines and burnishing, have been added beneath the feet and up both sides of the image. The tip of the spear behind the middle figure has been lengthened slightly. A strong boundary line, most visible at the top and bottom, now circumscribes the image.

Inscription above the figures within the image: The Accusers of Theft Adultery Murder

Signature below the image: WBlake inv & sculp

Inscription below the signature: A Scene in the Last Judgment | Satans' holy Trinity The Accuser The Judge & The Executioner

Image: 18.4 × 10 cm (slightly larger than the first state, particularly in width)

Plate mark: same as in first state

IMPRESSIONS

3D.

Boston Museum of Fine Arts. Printed on wove paper, 25.4 × 16 cm, slightly browned with age. The initials "F. K." (Frederick Keppel) are written in ink and circled lower left, and "Designed and Engraved by William Blake" is written in pencil in an early hand, perhaps John Linnell's, just above the bottom edge of the sheet. The first word of the second-state title inscription (*When*) is still visible just below the image to the left of the signature, and the loop of the "P" of "Page 56" can be seen .8 cm to the right of the penultimate line of the third-state inscriptions. Boston Museum of Fine Arts collection stamp on verso. Acquired by the Museum through the Frederick Keppel Bequest in October 1913. Listed in Bentley, *Blake Books*, pp. 76-77, copy D, where the history of this impression prior to 1913 is confused with that of "Joseph of Arimathea Among the Rocks of Albion," impression 2I.

3E.

British Museum. Printed on wove paper, 38.1 × 27.6 cm, pasted to the mat. Poorly printed in the lower inscription area ("& The Executioner" indistinct), at the upper right corner, and at several spots in the flames and wooden post on the right. Four parallel scratches

extend in a diagonal course, left to right, from the middle of the lower edge of the image to the last line of inscription. The absence of these lines in all other impressions of the third state indicates that they were pulled prior to the scratching of the plate and that this impression was pulled after all others extant. Rubbed along the right side, and with a repaired tear running up from the bottom of the sheet to the plate mark. Acquired, probably from Blake or Mrs. Blake, by John Linnell, and sold by the Linnell Trustees at Christie's, 15 March 1918, lot 190, with "Mirth," impression 1A, and "a parcel" of other plates by Blake (£54 12s. to A. Martin for the British Museum, which accessioned the print in April 1918). Exhibited at the British Museum in 1957, no. 58(3b) in the catalogue. Listed in Bentley, *Blake Books*, pp. 76-77, copy C. Reproduced in Binyon, *Engraved Designs of Blake*, pl. 10.

3F.

Sir Geoffrey Keynes, Suffolk. Printed on wove paper, 22.9 × 14.8 cm, slightly foxed. A slight remnant of the "P" of "Page" from the second-state inscriptions can be seen .9 cm to the right of the penultimate line of the third-state inscriptions. Acquired at an unknown time by W. E. Moss, who stamped the verso with his collection mark. Perhaps the copy reproduced (heads only) in Gilchrist, *Life of Blake* (1863), I, 256, and lent by Herbert H. Gilchrist to the Academy of the Fine Arts, Philadelphia, in 1892, no. 153 in the exhibition catalogue. Lent by Moss to the Manchester Whitworth Institute in 1914, no. 87 in the exhibition catalogue, and sold with his collection, Sotheby's, 2 March 1937, lot 185 (£6 10s. to Morgan for Keynes, as he notes on the mat). Described in Keynes, *Bibliotheca Bibliographici*, no. 555; Bindman, *Blake: Catalogue of the Collection in the Fitzwilliam Museum*, no. 555, as part of Keynes' bequest to that Museum; Bentley, *Blake Books*, pp. 76-77, copy E. Reproduced in Keynes, *Engravings by Blake: The Separate Plates*, pl. 13.

3G.

National Gallery of Art, Rosenwald Collection, Washington, D.C. Printed on wove paper trimmed along or just within the plate mark to 21.8 × 11.9 cm. The first word of the second-state title inscription (*When*) is still visible just below the image and to the left of the signature, and fragments of "Page 56" can be seen to the right of the penultimate line of the third-state inscriptions. A few other scratches in the signature and inscription areas are probably also remainders of the second-state inscription. Rosenwald and National Gallery of Art collection stamps on verso. Mounted in a window cut in a sheet of paper bearing stab holes along the left edge and the number "94" in ink, upper right. Collected in about 1853 by George A. Smith, who bound it into a half-morocco volume with other prints by Blake. For the subsequent history of this collection, see "Albion rose," impression 2D. Listed by George C. Smith, Jr., in the 1927 anonymous catalogue of his collection, no. 37. Lent by Rosenwald to the Philadelphia Museum of Art in 1939, no. 223 in the exhibition catalogue; and to Cornell University in 1965, no. 19 in the exhibition catalogue. Given

Part One.
Plates Designed and Executed
by Blake

by Rosenwald to the National Gallery of Art in 1945 and moved from Alverthorpe Gallery, Jenkintown, Pennsylvania, to Washington in 1980. Listed in Bentley, *Blake Books*, pp. 76-77, copy F, where it is incorrectly described as belonging to the Library of Congress. Reproduced here, Fig. 18.

3H.

Pennsylvania Academy of the Fine Arts, Philadelphia. Printed on wove paper, 26.2 × 16 cm, with a few small smudges of ink printed from the surface of the plate near the upper left corner and lower right. Slight fragments of the second-state inscriptions are visible to the left of the signature, right of the penultimate line of the third-state inscriptions (the "P" of "Page," very faint), and below "The Accuser" in the last line. Acquired at an unknown date by John S. Phillips, and given with his collection to the Pennsylvania Academy in 1876. Placed on deposit in 1955 at the Philadelphia Museum of Art and lent by that institution to Adelphi University, Garden City, New York, in 1977, no. 15 in the exhibition catalogue. Returned to the Pennsylvania Academy in 1979. Reproduced in *Blake: An Illustrated Quarterly*, 11 (Winter 1977-1978), 136.

3I.

Whitworth Art Gallery, Manchester. Printed on wove paper, 22.6 × 13.3 cm, with a few spots of weak printing in the image. The inscriptions below the design are faintly printed, but the "P" of "Page" from the second-state inscriptions is still visible right of the penultimate line of the third-state inscriptions. Acquired at an unknown date by Thomas Murgatroyd of the John Rylands Library and presented by him to the Whitworth Art Gallery in 1927. Listed in Bentley, *Blake Books*, pp. 76-77, copy I.

There are two early prototypes for the three figures in "The Accusers of Theft Adultery Murder." In "Tiriel Denouncing his Four Sons and Five Daughters,"[12] one of the finished wash drawings of *c.* 1789 illustrating Blake's poem *Tiriel*, Blake pictures three of the sons (the face of the fourth appears behind them) clustered together in fear like the trio in "The Accusers." The son on the right wears a spiked crown like the one worn by the central figure in "The Accusers," but the costuming and visages are otherwise dissimilar. A pencil sketch (Fig. 19) of this *Tiriel* design,[13] although perhaps a preliminary for the wash drawing, is more directly related to "The Accusers." The standing figure on the left and one of the women clutching his knees were used for the design on pl. 11 of *Europe* (1974); the three figures on the right were borrowed directly for "The Accusers" with only slight modification.

The first state of the plate, "Our End is come," was executed by means of the linear patterns common to the copy engravings of Blake's era, but with more white space than is usual in commercial plates, including Blake's own. Some of the patterns, notably the wood grain on the floor and the posts right and left, have something of the bold

[12] 18.2 × 27.1 cm, collection of Sir Geoffrey Keynes. Reproduced in William Blake, *Tiriel*, ed. G. E. Bentley, Jr., Oxford: Clarendon Press, 1967, p. 40.

[13] Sometimes entitled "War and the Fear of Invasion," 17.9 × 23.9 cm, Whitworth Art Gallery, Manchester. On the verso (reproduced in Keynes, *Drawings by Blake*, pl. 27) are sketches of Hebrew letters in human form, apparently unrelated to the recto drawing.

scale and energy also found in Blake's two etched plates after Fuseli, "Timon and Alcibiades" and "Falsa ad Coelum" (the former dated 1790); in "Albion rose" (*c.* 1793); in most of the plates in *For Children: The Gates of Paradise* (1793); in "Lucifer and the Pope in Hell" (*c.* 1794); and finally in many of the *Night Thoughts* illustrations (1796-1797). The imprint of the first state places the print in the same period as Blake's political interests expressed in *America* (1793) and *Europe* (1794). He also portrayed figures frightened by some unseen presence in "The Approach of Doom" of *c.* 1792 (Fig. 4) and the frontispiece to *Visions of the Daughters of Albion* (1793). Further, the title inscription associates the print with Blake's description in *America* of rulers shuddering with fear when confronted by revolution that concludes with the phrase "their end should come."[14] In this context, the plate can be interpreted as a contrary to "Albion rose," a portrait of a monarch and his guardian soldiers huddled in terror as the spirit of liberation arises.

The second-state inscriptions recorded in the 1891 Boston exhibition catalogue refer us to the opening lines of the "Prologue" to "King Edward the Fourth" on page 56 of *Poetical Sketches* (1783):

> O For a voice like thunder, and a tongue
> To drown the throat of war!—When the senses
> Are shaken, and the soul is driven to madness,
> Who can stand?[15]

The page reference inscribed on the plate would certainly be cryptic to anyone not thoroughly familiar with Blake's first book of poems. He may have planned to use the plate as an illustration accompanying a copy of *Poetical Sketches* or a new edition of "King Edward the Fourth."

The hypothesis that Blake consistently engraved a left-pointing serif on the letter "g" in his copperplate hand from *c.* 1791 to *c.* 1803 indicates a pre-1803 date for the third-state inscriptions on "The Accusers" because of the serif pointing slightly leftward on the "g" of "Judge" (not visible in the reproduction of impression 3G, Fig. 18).[16] All other evidence, however, points to a later date of execution for the third state and suggests that the left-pointing serif is merely a relapse into an earlier practice. The extensive use of burnishing as an element of composition indicates that the plate was revised in the same post-1803 period when Blake executed the final states of "Albion rose," "Job," and "Ezekiel."[17] The new inscriptions on "The Accusers" are in unical, semi-gothic letters. This upright hand is somewhat similar to the Roman uncial style of the early illuminated books, *For Children: The Gates of Paradise* (1793), and the white-line etching of "Deaths Door" (1805), but its first appearance on a separate intaglio plate dated in the imprint is "Chaucers Canterbury Pilgrims" of 1810. There it is in the form of large, open, title letters; the lower-case form on "The Accusers" does not appear again until the "Laocoön" of about 1820.

Like the lettering (except for the troublesome serif), the meaning of the new inscriptions places the third state of "The Accusers" later than 1803. Blake's first "Last Judgment" design was executed for

[14] Erdman, ed., *Poetry and Prose of Blake*, p. 56.

[15] Ibid., p. 430.

[16] David Erdman, "Dating Blake's Script: the 'g' hypothesis," *Blake Newsletter*, 3 (1969), p. 10, notes "a slight left serif in Judgment" in some (unidentified) impressions, but I have been able to detect only the directionless nub of a serif.

[17] As I argue for these plates, all with similar uses of burnishing, in *William Blake, Printmaker*, pp. 178-186.

Robert Cromek's edition of Robert Blair's *The Grave* in October 1805; but it was not until 1808 that he completed the watercolor now at Petworth House and described it in a letter to Ozias Humphry, and Blake wrote "A Vision of the Last Judgment" in his *Notebook* two years after that. It seems likely that he would not reinterpret one of his earlier plates as "A Scene in the Last Judgment" until this 1805-1810 period when he was thoroughly involved with that subject as an artist and writer. His concern with false accusation culminates at about the same time. In 1803, Blake was accused of seditious remarks against the King by the soldier John Scolfield. Blake was acquitted the next year. On 28 May 1804, the quarrels among competing publishers and engravers led Blake to tell William Hayley that "in London every calumny and falsehood utter'd against another of the same trade is thought fair play. . . . we are not in a field of battle, but in a City of Assassinations."[18] In May 1807, Cromek wrote a self-serving letter to Blake accusing him of ingratitude. The stream of incrimination became public in September 1809 with Robert Hunt's merciless review of Blake's exhibition of paintings. It must have been no earlier than that year that Blake introduced the character of Hand (Hunt and his brother editors) into *Milton* and *Jerusalem* to form a trinity of accusers and perverters of art with Hyle (Hayley) and Coban (possibly Cromek or someone connected with the sedition trial). On pl. 93 of *Jerusalem*, Blake etched the three accusers of Socrates and compared them to Caiaphas, and wrote in "A Vision of the Last Judgment" that Christ came to deliver man from "Satans Accusation."[19] The laurel wreath added to the swordsman brings into the design a Greek and Roman motif in accord with Blake's attacks, in the last two decades of his life, on classical civilization as the enemy of Christian vision and true art. Thus, the final state of the print is probably a production of *c.* 1805-1810 at the earliest. In their final, nineteenth-century states, "Albion rose" portrays self-sacrifice and forgiveness of sin; "The Accusers" shows the final judgment of those who accuse and wish to sacrifice others.

[18] Keynes, ed., *Letters of Blake*, p. 93.

[19] Erdman, ed., *Poetry and Prose of Blake*, p. 553. On the last plate of *For the Sexes: The Gates of Paradise* (c. 1818), Blake refers to Satan as "The Accuser who is the God of This World."

IX.
A Dream of Thiralatha

PLATES 4, 5

Relief etching

One state: *c.* 1793

Inscriptions: see discussion below

Image and plate mark: 11.7 × 17 cm

IMPRESSIONS

1A.

British Museum. Color printed in gum- or glue-based pigments applied to both relief and etched surfaces to the edge of the plate, hand finished with pen and ink and watercolors. Printed on wove paper, 34.6 × 24.9 cm, pasted to the mat. A bold watermark, 1794 | J WHATMAN, is visible along the right edge of the sheet when viewed in a raking light. This impression was once part of the *Large Book of Designs*, copy A, which Blake printed about 1796 for the miniature painter Ozias Humphry. For the provenance, see "Albion rose," impression 1A.[1] Acquired by the British Museum in February 1856 and exhibited there in 1957, no. 7(6) in the catalogue. Listed as "Misfortune and Happiness(?)" by W. M. Rossetti in Gilchrist, *Life of Blake* (1863), II, 239, no. 233; (1880), II, 254, no. 262; and in Bentley, *Blake Books*, pp. 89, 106, as *America*, pl. d. Reproduced here, Pl. 4.

1B.

National Gallery of Art, Rosenwald Collection, Washington, D.C. Color printed, like impression 1A, on wove paper, 21.3 × 24 cm, with a small number "9" in gray ink above the image upper right, stab holes along the left edge, old paste marks on the top corners of the verso, and the Rosenwald and National Gallery of Art collection stamps on the verso. Hand finished with pen and ink and perhaps watercolors. This impression may have once been gathered together with other color-printed designs into a second copy (B) of the *Large Book of Designs*, although the existence of such a volume or collection is based only on analogy with copy A of a *Large Book of Designs* (see "Albion rose," impression 1A). For the history of this group of prints up to 1904, see "The Accusers of Theft Adultery Murder," impression 2C. Sold separately at an anonymous Hodgson auction, 14 January 1904, lot 223 (£42 to Quaritch for F. P. Osmaston). Sold by Mrs. L. M. Osmaston at Sotheby's, 14 November 1928, lot 692 (£170 to Gabriel Wells). Acquired by Mr. and Mrs. Anton G. Hardy and sold from their collection at Parke-Bernet, 14 January 1942, lot 20 ($575 to Rosenbach for Rosenwald). Lent by Rosenwald to the National Gallery of Art in 1957, no. 75 in the exhibition catalogue; to the University of Iowa in 1961, no. 17 in the exhibition catalogue; and to Cornell University in 1965, no. 7 in the exhibition catalogue. Given by Rosenwald to the National Gallery of Art in 1945 and moved from the Alverthorpe Gallery, Jenkintown, Pennsylvania, to Washington in 1980. Listed in Bentley, *Blake Books*, pp. 89, 106-107, where it is incorrectly located in the Library of Congress. Reproduced here, Pl. 5.

[1] "A Dream of Thiralatha," impression 1A, is probably the print described by Richard Thomson as "a figure of a man sitting beneath a tree in the deepest dejection" added as an extra design, with "Albion rose," impression 1A, and others, at the end of *Europe*, copy D. Thomson was quoted in 1828 by J. T. Smith in *Nollekens and His Times*, II, 480 (see Bentley, *Blake Records*, p. 472).

The color printing on both impressions of this relief etching extends over and obscures a text, apparently also etched in relief, extending down from the top edge of the plate. Impression 1B was printed with considerable pressure and the text can be read (with the aid of a mirror) as a blind embossment on the verso. It reads as follows:

> As when a dream of Thiralatha flies the midnight hour:
> In vain the dreamer grasps the joyful images, they fly
> Seen in obscured traces in the Vale of Leutha, So
> The British Colonies beneath the woful Princes fade
>
> And so the Princes fade from earth. scarce seen by souls
> of men
> But tho' obscurd, this is the form of the Angelic land.

Russell, in *Engravings of Blake*, pp. 69-70, was the first to transcribe this complete text, entitle the design according to the first line, and suggest that the color print was "a cancel leaf from one of the Prophetical Books, probably the 'America.'" This last conjecture seems probable for several reasons: the width of the plate is the same as pls. 17 and c of *America* (and within .3 cm of pls. 1, 2, 5, 8-14, 16, and 18 as measured on impressions);[2] the lettering style and size are the same as in *America*; and the reference to the "British Colonies" is consistent with the subject of *America*. If the plate was indeed originally intended for *America* it must have been produced *c.* 1793. Both extant impressions, however, were probably pulled *c.* 1794-1796 when Blake printed his Books of Design. The *America* cancelled plate must have been cut, or (less probably) simply masked with a piece of paper, just above the first line of text in order to print the design as a separate plate. Bentley, *Blake Books*, p. 99, suggests that "there must have been text or design cut off at the bottom." This would have been necessary if one assumes that the image originally appeared between lines of text, as does the design on *America*, pl. 16; but the image may have appeared below all text (as in *America*, pls. 6, 7, 9, 11-15, 17, and b) and thus cutting or masking the copperplate would have been required only at the top edge.

Most of the image is clearly etched in relief, as revealed by the blind embossments from it on the verso of impression 1B. These verso embossments show that the upper outline of the arched tree extends to the last line of text, stops, and then starts again to continue the tree toward the left. No other design in *America* is broken by a line of text in this way—a situation that might suggest that the design was executed on the cancelled *America* plate at a later time than the text. However, it would have been extremely difficult, if not impossible, to etch the design in relief *after* the text had been etched in relief on the plate without first removing the letters from the copper in order to have a flat surface on which to execute a new image. Further, the design can reasonably be interpreted as an illustration to the text still on the plate: the bent figure on the right is the dreaming Thiralatha and the standing figure on the left is a dream projection of her self trying to grasp one of the personified "joyful images." Since the print is only known in the form of two color-printed impressions, it is

[2] See Bentley, *Blake Books*, p. 70.

39

[3] The original plate, if intended for *America*, must have been between 22.8 and 24.5 cm high, the range of sizes in the other full-size *America* plates.

[4] Erdman, ed., *Poetry and Prose of Blake*, p. 64.

included here as one of Blake's separate plates even though it was probably executed, in its original full-plate form,[3] as an illustration to *America* (1793).

Thiralatha is also named in *Europe* (1794), pl. 14, where she is grouped with Sotha as one of the "secret dwellers of dreamful caves."[4] "Diralada," named on pl. 3 of *The Song of Los* (1795), may be the same character in Blake's evolving myth. The airborne child on the left is similar to the figure on pl. 20 of *The Book of Urizen* (1794).

X.
Lucifer and the Pope in Hell

PLATE 6
FIGURES 20, 21

One state: *c.* 1794

Inscriptions: none visible in the extant impressions

Image: 18.3 × 24.6 cm

Plate mark: Impression 1B, on a sheet 19.9 × 27.4 cm, may have been trimmed along the plate mark or just within it

IMPRESSIONS printed in intaglio

1A.
British Museum. Printed on wove paper trimmed within the plate mark to 18.8 × 25.2 cm, pasted to the mat. Acquired by the British Museum from Colnaghi in July 1966, who acquired it shortly before from a private owner. I have not been able to trace the earlier history of this unique intaglio impression. Lent to the Tate Gallery in 1978, no. 84 in the exhibition catalogue. Reproduced here, Fig. 20.

IMPRESSIONS color printed in glue- or gum-based pigments applied to the surface and some intaglio lines of the copperplate, *c.* 1794-1796

1B.
Huntington Library, San Marino, California. Color printed in dark blue, dark brown, and golden brown on wove paper, 19.9 × 27.4 cm. The color printing extends beyond the etched image on all four sides to the edge of the sheet. The printed sheet has been pasted to a piece of backing paper of the same size, which in turn has been backed with black tape along its edges and pasted to the mat. Hand finished with ink and watercolors. The intaglio lines visible as white lines beneath the color printing on the Pope's robe, on the serpent or worm and figures on the left, in the flames, and in the area beneath the figures extending the full length of the etched image show no differences from impression 1A. The forms to the right of the Pope, including the face in outline, are completely obscured by the color printing. The cloth swirling above and to the right of Lucifer's left leg has been extended by the coloring further toward the top of the print. Perhaps acquired by Frederick Tatham from Blake or Mrs. Blake and sold by him at Sotheby's, 29 April 1862, lot 185, two unidentified works "in colours" (15s. to Harvey). Acquired by George A. Smith and lent by him to the Burlington Fine Arts Club in 1876, no. 167 in the exhibition catalogue. Sold from Smith's collection at Christie's, 16 July 1880, lot 101 (£2 10s. to Pearson). Acquired by Thomas Glen Arthur, and listed by him in his *Catalogue, for Private Use, of Autographs, Pictures, Drawings, Etchings and Engravings Collected by Thomas Glen Arthur* (n.p.: privately printed, 1890), p. 1. Sold by Arthur at Christie's, 20 March 1914, lot 52 (£14 14s. to Sabin). According to Sessler's records, they acquired the print from Robson in July 1923 for $407 and sold it in the next month to Henry E. Huntington.[1] Described by W. M. Rossetti in Gilchrist, *Life of Blake* (1880), II, 254, no. 267, "Satan showing the Pope his Destiny in Hell. *Colour-printed.*" Listed in C. H. Collins Baker, *Catalogue of William Blake's Drawings and*

[1] According to Ruthven Todd's unpublished typescript (now in the Library of Congress) of a catalogue of Blake's drawings and paintings, p. 77, this impression was among the "collection of Miscellaneous Water-colors" exhibited at the Grolier Club, New York, in 1919, no. 46 in the catalogue. In Todd's annotated copy of the 1919 exhibition catalogue, now in my collection, he notes that no. 46 was "various, mostly Huntington," but does not identify the individual works. Records at the Grolier Club, however, indicate that the works in no. 46 were lent by A. E. Newton and W. A. White. I have not been able to find any evidence to support Todd's statements.

Part One.
Plates Designed and Executed
by Blake

Paintings in the Huntington Library, revised by R. R. Wark, San Marino: Huntington Library, 1957, p. 44. Reproduced here, Pl. 6.

The earliest extant version of this composition is the pen and gray wash drawing, "The King of Babylon in Hell," in the Royal Library, Windsor (36 × 43.2 cm, Fig. 21). This drawing of *c.* 1783, inscribed lower right "Hell beneath is moved for thee to meet thee at thy coming.— Isaiah," takes its subject from the following passage in the Book of Isaiah:

> That thou shalt take up this proverb against the king of Babylon, and say, How hath the oppressor ceased! the golden city ceased! The Lord hath broken the staff of the wicked, and the sceptre of the rulers. He who smote the people in wrath with a continual stroke, he that ruled the nations in anger, is persecuted, and none hindereth. . . . Hell from beneath is moved for thee to meet thee at thy coming: it stirreth up the dead for thee, even all the chief ones of the earth; it hath raised up from their thrones all the kings of the nations. All they shall speak and say unto thee, Art thou also become weak as we? art thou become like unto us? Thy pomp is brought down to the grave, and the noise of thy viols: the worm is spread under thee, and the worms cover thee. How art thou fallen from heaven, O Lucifer, son of the morning! how art thou cut down to the ground, which didst weaken the nations! (14: 4-6, 9-12)

The most significant changes in the print (Fig. 20) are the substitution of the Pope, crowned with his triple tiara, for the King, the addition of the serpent or "worm" (Isaiah 14: 11) around the figures on the left, and the considerable alterations in the position and character of Lucifer. Further modifications were introduced into the watercolor of *c.* 1805 (36.2 × 31.7 cm, Boston Museum of Fine Arts), including the addition of an upside-down figure to the right of the Pope.[2] The face of this (falling?) figure, and to a lesser extent the head immediately to the left of the Pope's right foot in the intaglio print, are somewhat similar in expression to the "Head of a Damned Soul" engraved by Blake after Fuseli (Fig. 73). This final extant version of "The King of Babylon in Hell" is probably the work Blake sold to Thomas Butts in May 1805.[3] W. M. Rossetti lists a smaller colored drawing similar to this Boston Museum work,[4] but nothing further is known of it and Rossetti may only be listing color-printed impression 1B.

The transformation of the monarch of the early drawing into the Pope follows the tradition in Protestant polemics wherein the King of Babylon is taken for a typological prefiguration of the leader of the Catholic Church.[5] Both the character of the Pope and the figure of Lucifer in the print suggest a further meaning of the design. The scales on the latter also cover Rintrah, or "War,"[6] on pl. 8 of *Europe.* The triple-crowned Pope is also pictured (full-face rather than in profile) on pl. 14 of *Europe.* David Erdman has identified this Pope in the illuminated book as a caricature of George III,[7] and his resemblance to contemporary caricatures of the King is even stronger in the separate

[2] Reproduced in Darrell Figgis, *The Paintings of William Blake,* London: Ernest Benn, 1925, pl. 85.

[3] See Blake's accounts of 3 March 1806, where the work is entitled "Hell beneath is moved for thee &c from Isaiah" (Bentley, *Blake Records,* p. 572).

[4] Gilchrist, *Life of Blake* (1863), II, 238, no. 222 (collection of "Mr. Harvey"); (1880), II, 253, no. 253.

[5] First noted in conjunction with this print by Butlin in the 1978 Tate exhibition catalogue, p. 58.

[6] So identified by George Cumberland in copy D of *Europe.*

[7] *Prophet Against Empire,* p. 213; *The Illuminated Blake,* p. 169.

42

[8] Keynes, *Engravings by Blake: The Separate Plates*, p. 36, proposes a date of *c.* 1805 for the color-printed impression, presumably because of its similarity to the watercolor version of that year. Such a dating contradicts most of the evidence concerning Blake's activities as a color printer. At the time Keynes wrote his catalogue the intaglio impression had not yet come to light.

plate. James Gillray also emphasized the King's heavy brow, bald head without wig, large nose, thick lips, and jowls in "The Hopes of the Party" of 19 July 1791, in which George is being led to execution by Horne Tooke, Sheridan, and Fox. In Blake's print, King George, head of the Church of England and thus adorned as a mock-Pope, is led in chains by Lucifer-Revolution-War to join his cousin monarchs of Europe and their helmeted minions in the fiery pit. Blake has converted his biblical illustration of the 1780s (Fig. 21) into a powerfully iconoclastic comment on the politics of his age.

Like the two other political prints of the early 1790s, "Albion rose" (first state) and "The Accusers" (first state, Fig. 17), "Lucifer and the Pope in Hell" is executed in an energetic etched style, but with more use of enlarged versions of such conventional patterns as worm lines and crosshatching, much as in the *Night Thoughts* plates of 1796-1797. These stylistic features, as well as the similarities in themes and motifs between the separate plate and *Europe* (1794), suggest a date of *c.* 1794 for the execution of the intaglio image. The color-printed impression was probably pulled *c.* 1794-1796 when Blake appears to have done most of his complex color printing.[8]

XI.
Joseph of Arimathea Preaching to the Inhabitants of Britain

PLATES 7, 8
FIGURE 22

Relief etching

One state: c. 1793-1796

No inscriptions

Image and plate mark: 7.8 × 10.7 cm

IMPRESSIONS

1A.

British Museum. Color printed in gum- or glue-based pigments applied to both relief and etched surfaces to the edge of the plate, hand finished with ink and watercolors. Printed on wove paper, 34.9 × 24.6 cm. According to Russell, *Engravings of Blake,* p. 56, Binyon, *Engraved Designs of Blake,* p. 97, and Keynes, *Engravings by Blake: The Separate Plates,* p. 28, the paper is watermarked 1794, but this cannot be confirmed because the sheet is pasted to the mat. This impression was once part of the *Large Book of Designs,* copy A. For the history of this collection of color prints, see "Albion rose," impression 1A. Exhibited at the British Museum in 1957, no. 6(2) in the catalogue. Listed as "An Aged Man addressing a Multitude" by W. M. Rossetti in Gilchrist, *Life of Blake* (1863), II, 239, no. 232; (1880), II, 254, no. 261. Reproduced here, Pl. 7.

1B.

National Gallery of Art, Rosenwald Collection, Washington, D.C. Color printed in gum- or glue-based pigments applied to both relief and etched surfaces to the edge of the plate, hand finished with ink and watercolors. Printed on wove paper, 32 × 24 cm, bearing stab holes along the left edge, a small number "5" in gray ink just above the image, upper right, and the National Gallery of Art collection mark on the verso. The thinness of the color printing indicates that this is probably a second pull printed immediately after impression 1A with slight, if any, addition of more pigments to the metal plate. This impression may have once been gathered together with other color-printed designs into a second copy (B) of the *Large Book of Designs,* although the existence of such a volume or collection is based only on analogy with copy A of the *Large Book of Designs.* For the history of this group of prints up to 1904, see "The Accusers of Theft Adultery Murder," impression 2C. Sold separately at an anonymous Hodgson auction, 14 January 1904, lot 228, "A Coloured Print, presumably John the Baptist Preaching Repentance" (£26 10s. to Quaritch). Acquired soon after by William A. White, who lent it (anonymously) to the Grolier Club in 1905 and 1919, nos. 40 and 22 in the exhibition catalogues, and to the Fogg Art Museum in 1924. Sold after White's death through Rosenbach to Rosenwald in May 1929 with "The Accusers of Theft Adultery Murder," impression 2C, for $3,000. Lent by Rosenwald to the Fogg Art Museum in 1930; to the Print Club of Philadelphia in 1930, no. 27 in the exhibition catalogue; to the Philadelphia Museum of Art in 1939, no. 83 in the exhibition catalogue; to the National Gallery of Art in 1957, no. 70 in the

exhibition catalogue; to the University of Iowa in 1961, no. 20 in the exhibition catalogue; and to Cornell University in 1965, no. 17 in the exhibition catalogue. Given by Rosenwald to the National Gallery of Art in 1945, and moved from the Alverthorpe Gallery, Jenkintown, Pennsylvania, to Washington in 1980. Reproduced here, Pl. 8.

The print is based on Blake's pencil drawing of *c.* 1780, now in the Rosenbach Museum and Library, Philadelphia (Fig. 22). This drawing, 28.5 × 42.1 cm, bears on its verso the upper half of a pencil sketch of a seated girl playing a harp; the lower half of the sheet is in the Tate Gallery.[1] Another pencil drawing of "Joseph Preaching," also in the Rosenbach Museum, is in Blake's free and energetic style of *c.* 1820-1825.[2] In this later version, right and left are as in the print, and the woman with hands clasped and raised over her head (not in the early drawing) is retained, but further modifications to all the figures are introduced. It may be a working sketch for a watercolor never executed. A pencil drawing[3] in the National Gallery of Art, Washington, has sometimes been identified as Joseph of Arimathea visiting Britain, but it probably represents St. Augustine converting King Ethelbert of Kent. This work, perhaps of *c.* 1793, is completely different from the print and its two related sketches of Joseph of Arimathea preaching. Keynes has pointed out that the group of small figures to the right of the penultimate line on pl. 4 of *The Marriage of Heaven and Hell* (*c.* 1790-1793) is reminiscent of "Joseph of Arimathea preaching to the inhabitants of Britain, with his thorn staff planted before him in the ground."[4]

In the drawing of *c.* 1780 (Fig. 22), vertical lines, perhaps representing staves like the one held by Joseph or the frame of the church he built of wattles, can be seen rising above the heads of his audience. These were apparently etched into the plate, for although the pigments delineating the background landscape and sky have been printed and painted right over the vertical lines, they still appear in the prints as indentations in the colors. These faint lines, as well as the plate mark visible on the verso of impression 1B, confirm that the image was indeed etched and/or engraved in relief on a metal plate.

The small size of the plate suggests that it may have been one of Blake's early relief etchings,[5] but both extant impressions were probably printed *c.* 1794-1796 when Blake pulled the color prints for his Books of Design (see "Albion rose," impression 1A). The subject of the plate is taken from the Somersetshire legend that Joseph of Arimathea visited England. The event pictured is described in an anonymous pamphlet perhaps known to Blake, *The History of that Holy Disciple Joseph of Arimathea*: "he at length landed at Barrow-bay in Somersetshire, and then proceeding onwards of his journey eleven miles that day; came to Glastenbury [*sic*] in the same county; where, fixing his pilgrim's staff in the ground, it was no sooner set in the earth, but just like Aaron's rod (which blossomed flowers when there was a contest betwixt him and other learned Jews for the priesthood) it was presently turned into a blossoming thorn, which supernatural miracle made the numerous spectators, who came to see this wonder,

[1] Described and reproduced, recto and verso, in Martin Butlin, *William Blake: A Complete Catalogue of the Works in the Tate Gallery*, London: Tate Gallery, 1971, p. 75. The Tate sketches are not related to the print.

[2] 34.5 × 49 cm; reproduced in Keynes, *Drawings of Blake*, pl. 17.

[3] 28 × 39 cm; ibid., pl. 7.

[4] *The Marriage of Heaven and Hell*, Introduction and Commentary by Sir Geoffrey Keynes, London: Oxford University Press, 1975, unpaginated commentary on pl. 4.

[5] Russell, *Engravings of Blake*, p. 56, compares the plate to *Songs of Innocence* (1789) and *Songs of Experience* (1794) and states that it is "probably of about the same date." Binyon, *Engraved Designs of Blake*, p. 97, suggests a date of "about 1789-90." Keynes, *Engravings by Blake: The Separate Plates*, p. 28, dates the plate 1794, apparently on the assumption that it was executed shortly before the color-printed impressions were made. Russell was the first to identify the subject of the print.

[6] London, n.d. (*c.* 1780), p. 7. There are several other issues of this work, *c.* 1770-1810. See also "Joseph of Arimathea Among the Rocks of Albion."

be very attentive to hear his preaching the Gospel, which was concerning Christ crucified for the redemption of mankind."[6] The tree behind and above Joseph in Blake's plate may be the thorn, although it looks more like an oak, and Joseph is still holding a staff. Perhaps the miracle has just begun. The wide base of the disciple's staff, at which two spectators appear to stare, suggests that it is beginning to take root.

XII.
Moore & Co's Advertisement

One state: c. 1797-1798

Inscription between the columns: AT | Moore & C°'s | MANU-FACTORY & WAREHOUSE, | *of* | **Carpeting** AND **Hosiery** | Chiswell Street, | MOOR-FIELDS. | *The greatest variety of* CARPETS, *from the lowest Scotch,* | *& Kidderminster, Wilton &* *Brussels, to the finest* | Axminster, Turkey & Persia. | *Private Families may be supplied with Silk, Cotton,* | *Worsted, and Thread* STOCKINGS *of all kinds & qualities,* | *on the most reasonable terms.* | *Colours & patterns of Carpeting may be changed to suit the taste of* | *the Purchaser, & patterns of Hosiery made to any size.* | **N.B.** | *Merchants, Shopkeepers, and Upholsterers,* | *supplied at Wholesale Prices.*

Inscription below the image, left: Common Carpet Loom

Inscription below the image, center: Persia & Turkey Carpet Loom

Inscription below the image, right: Stocking Frame

Signature below the image, right: Blake. d. &.sc:

Quotation below the image, center:
Hoec tibi Londini tellus dat munera: victa est
Pectine Britannico jam Babylonis acus
Vid. Mart. Lib. 14. Ep. 150.

Image: 26.7 × 22 cm

Plate mark: 35.2 cm × [cut off in the only known impression—but see discussion below]

The only known impression of the "Moore & Co's Advertisement," now in the *British Museum*, is printed on wove paper, 36.5 × 27.7 cm, pasted to the mat.[1] Acquired by the British Museum in July 1868 from "Mr. Ellis" (according to the Museum's accession records)—probably the New Bond Street bookdealer of that name. Exhibited at the British Museum in 1957, no. 56(3) in the catalogue, and at the Tate Gallery in 1978, no. 143 in the catalogue. Reproduced here, Fig. 23.

Russell and Keynes date the plate *c.* 1790,[2] but London directories list "Moore & Co. Carpet-warehouse, 45 Chiswell St." only in the years 1797 and 1798.[3] The charming figures in the print show the continued influence of Thomas Stothard on Blake's representations of people, particularly when placed in more or less contemporary dress and settings, as do some of the plates in *Songs of Innocence* (1789) and the illustrations to Mary Wollstonecraft's *Original Stories from Real Life* (1791). In several of the plates Blake engraved after Daniel Chodowiecki for C. G. Salzmann's *Elements of Morality* (1791) he added rugs with patterns similar to those in the carpets wrapped about the columns in the Moore advertisement.[4] The adaptation from Martial may be translated as "the district of London offers you these

[1] Russell, *Engravings of Blake*, p. 57, states that this impression is "printed on Whatman paper," but this cannot now be confirmed.

[2] *Engravings of Blake*, p. 56; *Engravings by Blake: The Separate Plates*, pp. 15-16.

[3] According to David V. Erdman, "The Suppressed and Altered Passages in Blake's *Jerusalem*," *Studies in Bibliography*, 17 (1964), 36 n.34.

[4] See Robert N. Essick, "The Figure in the Carpet: Blake's Engravings in Salzmann's *Elements of Morality*," *Blake: An Illustrated Quarterly*, 12 (1978), 10-14.

Part One.
Plates Designed and Executed by Blake

[5] The tell-tale fragments of intaglio lines, appearing as white lines in the relief etching, were first noted and identified in Erdman, "The Suppressed and Altered Passages in Blake's *Jerusalem*," pp. 36-37.

[6] Reproduced in *Blake Newsletter*, 6 (1972), p. 20. In the essay, "William Blake in the Herbert P. Horne Collection," accompanying this reproduction, Martin Butlin suggests (p. 19) that the recto drawing might be by Robert Blake.

[7] See Bentley, *Blake Records*, pp. 2-3.

[8] *Dictionary of National Biography*, IV, 287. Chiswell Street, the address given in Blake's plate, runs past the south side of Finsbury Square. See also Gerald P. Tyson, *Joseph Johnson: A Liberal Publisher*, Iowa City: University of Iowa Press, 1979, pp. 96-102, 149, 253 n.31. Tyson records, p. 149, that Christie married the daughter, not the grand-daughter, of "Mr. Moore, owner of an extensive carpet manufactory."

[9] For a thorough discussion of this imagery, see Morton D. Paley, "The Figure of the Garment in *The Four Zoas, Milton, and Jerusalem*," in *Blake's Sublime Allegory*, ed. Stuart Curran and Joseph Anthony Wittreich, Jr., Madison: University of Wisconsin Press, 1973, pp. 119-139. For the parallels between Blake's designs of women spinning thread and the girl left of the base of the column on the right in the Moore plate, see Jenijoy La Belle, "Blake's Visions and Re-visions of Michelangelo," in *Blake in His Time*, ed. Essick and Pearce, pp. 13-22.

services: the needle of Babylon is already surpassed by the loom of Britain." At the top of the design are the Royal Arms (center) flanked by the crest (right) and feathers (left) of the Prince of Wales.

Blake apparently kept the copperplate in his possession, for he later cut it into pieces and etched on the lower left quarter, 20.3 × 14.4 cm, pl. 96 of *Jerusalem* (c. 1804-1820).[5] Nearly identical plate dimensions and fragments of a platemaker's mark suggest that Blake had first used the verso of this piece of copper for pl. 64 of *Jerusalem*. From these relief etchings we can determine that the Moore copperplate must have been about 31.4 cm wide (assuming that the left edge of *Jerusalem*, pl. 96, is the same as the left edge of the Moore plate, as seems likely) since the right edge of the *Jerusalem* plate was cut about 1.3 cm short of the middle of the advertisement, as fragments of its intaglio inscriptions show.

A pencil sketch (Fig. 24) of a preliminary version of the design, 21 × 23 cm on paper 30.4 × 24.5 cm, is in the collection of the Fondazione Horne, housed in the Gabinetto Disegni e Stampe of the Uffizi Gallery, Florence. This sketch is no doubt of about the same date as the plate, although it is on the verso of an unrelated drawing, 18.5 × 24 cm, perhaps of a subject taken from English history, of c. 1779-1780.[6]

Blake may have been known to Moore & Co. through his family's hosiery business, continued by Blake's brother James until about 1812.[7] An alternative connection may have been through Joseph Johnson, Blake's friend and publisher of several books with illustrations engraved by him. Another member of Johnson's circle and editor of the *Analytical Review*, Thomas Christie, married the grand-daughter of "Mr. Moore, an extensive carpet manufacturer in Finsbury Square."[8] These contacts with weaving and cloth making and selling may have influenced Blake's use in his poetry of images drawn from these activities.[9]

XIII.
Deaths Door

FIGURES 25-27

White-line etching

One state: 1805

Title inscription on the right post: DEATHS | DOOR

Image and plate mark: 18.6 × 11.7 cm

The only known impression of "Deaths Door" (Fig. 25), now in the collection of *Lucile Johnson Rosenbloom*, Pittsburgh, is printed on wove paper, evenly browned with age, pasted to the mat. The cover mat, with a window 19.3 × 12.3 cm, is also pasted down and covers the edges of the sheet on which the plate is printed. The print has been delicately hand tinted with India ink washes in the lines of radiance around the upper figure, on his neck and chest, on the earth under his right hand and right of his left hand, on the border, upper right, down to the area of the title inscription, and in the lower left corner.[1] This impression was probably acquired from Blake by Samuel Palmer, who gave it in 1875 to his son, Alfred Herbert Palmer.[2] Lent by him to the Victoria and Albert Museum in 1926, no. 27 in the exhibition catalogue, where it is described as a "soft metal engraving in the woodcut manner." Sold from Palmer's collection at Christie's, 20 February 1928, lot 33, "soft metal engraving" (£546 to Sabin). Acquired by Gabriel Wells no later than 1939 and lent by him in that year to the Philadelphia Museum of Art, no. 228 in the exhibition catalogue, where the print is described as a "relief-etching on pewter." Sold by Wells to Sessler's in March 1939, with an "autograph letter concerning Blake's death,"[3] for $500. Sold by Sessler's to Charles J. Rosenbloom in September 1939 for $750. After Mr. Rosenbloom's death in 1973, the print passed by inheritance to his widow, the present owner, who lent it to the Tate Gallery in 1978, no. 152 in the exhibition catalogue. Mentioned in Gilchrist, *Life of Blake* (1863), I, 201; (1880), I, 248.

In September or early October 1805, Robert Cromek commissioned Blake to prepare a series of illustrations for a new edition of Robert Blair's *The Grave*.[4] Cromek issued a prospectus for this publication in November 1805 in which it is stated that the designs were "invented and to be engraved by William Blake" and that "the original Drawings, and a Specimen of the Stile of Engraving, may be seen at the Proprietor's, Mr. Cromek."[5] This "Specimen" was very probably the white-line etching of "Deaths Door." Its rugged and primitive boldness, coupled with public reaction to such a "Stile of Engraving," no doubt contributed to Cromek's decision to take away from Blake the commission to execute his designs and to give it to the conventional copy engraver Louis Schiavonetti, whose plates appear in Cromek's 1808 edition of *The Grave*. This supposition is supported by Allan Cunningham: "Blake's mode of engraving was as peculiar as his style of designing; it had little of that grace of execution about it, which attracts customers, and the Inventions, after an experiment or two, were placed under the fashionable graver of Louis Schiavonetti."[6] Many years after the events, Thomas Stothard's son told much the same story: "I have heard it stated by my father that Cromek got Blake to make for him

[1] These washes do not register in most reproductions, but there is some slight evidence of their presence upper right and lower left in the collotype reproduction in Keynes, *Engravings by Blake: The Separate Plates*, pl. 25.

[2] According to A. H. Palmer in the 1926 Victoria and Albert Museum exhibition catalogue, p. 27. The date of the gift is also recorded in a note, signed "V. Philip Sabin," kept with the print. Mrs. Rosenbloom also has a note by A. H. Palmer, dated 1908 with a postscript by him dated 1923, quoting Gilchrist's reference to the plate. In a letter of 5 February 1881, Samuel Palmer refers to his son's ownership of the print (Lister, ed., *Letters of Palmer*, II, 1060).

[3] According to Sessler's purchase records. This letter is by George Richmond to Samuel Palmer, 15 August 1827, and was sold by Sessler's to Joseph Holland, Los Angeles, in November 1955 for $75. For the text of this letter, see Keynes, ed., *Letters of Blake*, p. 171.

[4] The relevant facts about this project and the subsequent quarrel between Blake and Cromek are set forth in Bentley, *Blake Records*. For further discussion, a catalogue of the designs, and a facsimile of Cromek's 1808 *Grave*, see Essick and Paley, *Blair's Grave*.

[5] Reproduced and discussed in G. E. Bentley, Jr., "Blake and Cromek: The Wheat and the Tares," *Modern Philology*, 71 (1974), 366-379.

[6] *Lives of British Painters*, II, 160; Bentley, *Blake Records*, pp. 490-491. Cunningham's suggestion that there may have been more than one "experiment" cannot be confirmed by any evidence known to me and is contradicted by Robert Stothard's version of the incident.

[7] Robert T. Stothard, letter in *Athenaeum*, no. 1886 (19 December 1863), 838; Bentley, *Blake Records*, p. 172.

[8] Robert Blair, *The Grave*, London: R. H. Cromek, 1808, p. 32. The image of the rising bird in the last line of the poem may have suggested to Blake the youth rising above the tomb, a motif that by 1808 was already part of his pictorial repertoire.

[9] Blair, *The Grave* (1808), p. 34. The author of "Of the Designs" is not recorded in the volume, but he may have been either Cromek or Blake's friend Benjamin Heath Malkin. According to Cromek's first and second prospectuses, Malkin was to contribute "a Preface containing an explanation of the Artist's views on the designs."

[10] Suggested in W. H. Stevenson, "Death's Door," *Blake Newsletter*, 4 (1970), 49.

[11] Reproduced in Essick and Paley, *Blair's Grave*, figs. 15, 27.

50

a series of drawings from Blair's 'Grave.' Cromek found, and explained to my father, that he had etched one of the subjects, but so indifferently and so carelessly . . . that he employed Schrovenetti [*sic*] to engrave them."[7] Clearly, Blake intended "Deaths Door" to be a book illustration; but it was not published as such, and thus may be considered as a separate plate.

"Deaths Door" illustrates the following lines from Blair's *Grave*, inscribed on an early proof state of Schiavonetti's rendition of the design (dated 1 February 1806; collection of Robert N. Essick) and again on the second published state:

'Tis but a night, a long and moonless night;
We make the grave our bed, and then are gone![8]

In "Of the Designs" appended to Cromek's edition, the illustration is described as showing "the Door opening, that seems to make utter darkness visible; age, on crutches, hurried by a tempest into it. Above is the renovated man seated in light and glory."[9] This description fits the white-line etching as well as the published intaglio plate; for in spite of Schiavonetti's reversal of right and left in the design and the great differences in style, the two plates are basically similar in their essential motifs. Schiavonetti or his journeymen eliminated only the spiky vegetation along the lower right side of the tomb and substituted a clump of delicate vegetation for the thorny vine climbing up the left side of the tomb in Blake's plate. It is of course possible that the unrecorded drawing on which Schiavonetti presumably based his plate also contained these variations.

The rising youth and the old man entering the tomb had been part of Blake's stock of motifs long before he came to illustrate *The Grave*. The first rendition of the old man at the entrance to a tomb is probably the pencil sketch, 6 × 4.5 cm, on p. 71 of Blake's *Notebook*, inscribed "Deaths Door" and executed *c.* 1787-1793 as part of a series of emblems. This design was published as pl. 15, "Death's Door," in *For Children: The Gates of Paradise* (1793). In the same year, Blake used another version of the design, with a horizontal rather than vertical major axis, on pl. 14 of *America*. The rugged tomb entrance in this version, as in the *Grave* illustration, seems to lead into the side of a hill. Blake may have modeled its structure on eighteenth-century mine entrances.[10] A pencil drawing of the old man (22.5 × 14.7 cm; Hornby Library, Liverpool) is on the verso of an early wash drawing of a young girl welcomed by two others at a doorway (to heaven?).[11] An inscription by Francis Palgrave on the verso drawing links it to *The Grave*, but like the recto design it was probably executed prior to Cromek's commission. The rising youth, generally similar to the one in the separate plate but with different leg and arm positions, also appears in *America*, pl. 8, and on pl. 21 of *The Marriage of Heaven and Hell* (1790-1793). The headless body in an experimental relief and white-line etching (Figs. 28, 29) is almost identical in arm, leg, and torso positions to "Deaths Door," but it was probably executed later than the *Grave* illustration, *c.* 1805-1822. The first composition to join the two figures is probably the pencil sketch, 44.4 × 31.8 cm, formerly in the collection of Frederick Shields but untraced since 1912

[12] The present reproduction was made from the illustration in Irene Langridge, *William Blake*, London: George Bell and Sons, 1904, facing p. 184.

[13] An India ink drawing of "Death's Door . . . for the Frontispiece [*sic*] to Blair's *Grave*" was sold from the William Bell Scott collection at Sotheby's, 21 April 1885, lot 172 (£11 15s. to B. F. Stevens), but has been untraced since the auction. The watercolors of "Death's Door" exhibited at the Boston Museum of Fine Arts in 1880, no. 73 in the catalogue, and in 1891, nos. 63 (old man only, similar to *America*, pl. 14) and 95 in the catalogue, are copies not by Blake. The first and/or third of these may be the pen and ink and watercolor drawing, on laid paper 29.2 × 21.6 cm, now in the Widener Collection, Harvard University (noted in Bentley, *Blake Books*, p. 531). This drawing, definitely not by Blake, is probably one of the so-called Camden Hotten forgeries—see Morton D. Paley, "John Camden Hotten, A. C. Swinburne, and the Blake Facsimiles of 1868," *Bulletin of the New York Public Library*, 79 (1976), 259-296.

[14] A pyramid behind the rising youth also appears in copy D of *The Marriage of Heaven and Hell*, pl. 21.

[15] Erdman, ed., *Poetry and Prose of Blake*, p. 672. See "The Man Sweeping the Interpreter's Parlour" for further information on this technique.

[16] Ibid. The date of this "Memorandum" is uncertain.

(Fig. 26).[12] Blake may have referred back, at least in his mind's eye, to this drawing (with an alternate version of the rising youth lower right) when working on the *Grave* illustrations, but the figure with outstretched arms at the top links this work to pl. 10 of *America* and suggests that all the sketches on the sheet were executed in the mid-1790s. The only extant drawing of the design with a strong possibility of being contemporaneous with the *Grave* commission is the ink over pencil drawing, 47 × 32.1 cm, in the Carnegie Institute Museum of Art, Pittsburgh (Fig. 27).[13] The pyramid and inscriptions were probably suggested by the images of "the tap'ring pyramid, th' Egyptian's pride,/And wonder of the world!" and "the mystic cone, with hieroglyphics crusted" in Blair's *Grave*, p. 9. The awkward pen and ink tracing of the pencil lines is probably by another hand, and the suggestions of inscriptions on the lintel and at the bottom of the design do not follow the original pencil work. The pyramid tends to dominate the entire composition,[14] and it may have been for this reason that it was not included in the etching. A slight pencil sketch of the design appears on the verso.

The immediate preliminary drawing for the plate was no doubt turned over to Cromek, who exhibited "the original Drawings" for *The Grave* (according to his first prospectus) and who in turn must have passed them along to Schiavonetti for engraving. None of the finished preliminary drawings for the published designs have been preserved. It is unlikely that Schiavonetti worked from the white-line etching rejected by Cromek and probably returned to Blake (assuming that the impression later acquired by Palmer was one Cromek had) or destroyed.

The description of "Deaths Door" in the 1926 Victoria and Albert Museum exhibition catalogue as a "soft metal engraving in the woodcut manner" suggests that the plate may have been produced by the engraving (as distinct from etching) technique Blake called "Woodcut on Pewter" and described on p. 4 of his *Notebook*.[15] The only extant impression, however, has a quality of line more typical of etching than engraving. Further, the crosshatching patterns on the youth's body show very little of the breakdown and fragmentation of relief "islands" between the crossing intaglio lines that usually occur far more extensively when such fine work is attempted on a soft metal like pewter. Thus it is more likely that "Deaths Door" is an example of white-line etching on copper, also described on p. 4 of Blake's *Notebook*: "To Woodcut on Copper Lay a Ground as for Etching. trace &ᶜ. & instead of Etching the blacks Etch the whites & bite it in."[16]

XIV.
Experimental
Relief Plate

FIGURES 28, 29

Relief and white-line etching, perhaps with engraving

One state: c. 1805-1822

No inscriptions

Image and plate mark: 16.5 × 9.5 cm

IMPRESSIONS

1A.

National Gallery of Art, Rosenwald Collection, Washington, D.C. Printed in relief on wove paper, 17 × 10.3 cm, with the National Gallery of Art collection mark on the verso. Mounted in a window cut in a sheet of paper with a brown framing line. The history of this impression up to 1924 is the same as "Albion rose," impression 2D. This impression was probably pasted in its present mounting sheet early in its history when it was acquired by George A. Smith in the 1850s[1] and bound into a volume with other works by Blake.[2] Disbound by George C. Smith and listed by him in the anonymous catalogue of his collection in 1927, no. 38. Lent by Smith to the Fogg Art Museum in 1930. Sold posthumously with Smith's collection, Parke-Bernet, 2 November 1938, lot 24 ($800 to Rosenbach for Lessing J. Rosenwald). Lent by Rosenwald to the Philadelphia Museum of Art in 1939, no. 224 in the exhibition catalogue; to the National Gallery of Art in 1957, no. 72 in the exhibition catalogue; to the University of Iowa in 1961, no. 23 in the exhibition catalogue; and to Cornell University in 1965, no. 21 in the exhibition catalogue. Given by Rosenwald to the National Gallery of Art in 1945 and moved from the Alverthorpe Gallery, Jenkintown, Pennsylvania, to Washington in 1980. Reproduced here, Fig. 28.

1B.

National Gallery of Art, Rosenwald Collection, Washington, D.C. Printed in intaglio from the etched recesses on wove paper, 17.4 × 10.3 cm, inscribed in pencil, lower left, "W. Blake fecit" in an unidentified hand. The darker patches in the upper and lower panels were probably caused by incisions in the copper, somewhat deeper than contiguous etched areas, in which more ink was deposited. Some of these dark patterns correspond to areas where Blake did white-line etching or engraving; the remaining dark spots may have been caused by step-etching or tool work used to deepen the larger white areas in order to avoid foul inking in relief impressions. National Gallery of Art collection stamp on verso. This is probably the untitled "Blake print" acquired by Sessler's in February 1951 from "Nicholson" for $48 and sold to Carl Zigrosser for $60 in November 1951.[3] Given by Zigrosser to Lessing J. Rosenwald in June 1961. Lent by Rosenwald to the University of Iowa in November 1961, no. 23 in the exhibition catalogue; and to Cornell University in 1965, no. 21 in the exhibition catalogue. Given by Rosenwald to the National Gallery of Art and moved from the Alverthorpe Gallery, Jenkintown, Pennsylvania, to Washington in 1980. Reproduced here, Fig. 29.

[1] The date is uncertain; but Keynes, in his description of "Albion rose," impression 2D (*Engravings by Blake: The Separate Plates*, p. 6), states that all the prints in Smith's bound collection were acquired in "about 1853."

[2] The list of works in this volume given in Bentley, *Blake Books*, pp. 337-339, does not include this print. It was described by Russell (*Engravings of Blake*, p. 90) as part of this volume in 1912, then in the collection of B. B. MacGeorge.

[3] According to Sessler's acquisition and sales records.

52

Part One.
Plates Designed and Executed by Blake

[4] Erdman, ed., *Poetry and Prose of Blake*, p. 52. It seems a little odd to describe a headless figure as looking and laughing.

[5] *Engravings of Blake*, p. 90.

[6] *Engravings by Blake: The Separate Plates*, p. 39.

[7] "Blake Original and New," *Modern Language Quarterly*, 25 (1964), 357. Grant's comment about Schiavonetti cannot be taken literally (i.e., Schiavonetti could certainly do more than "make headless torsos") and probably means that his engraving style was mindless and tended to fragment and destroy Blake's designs published in Cromek's 1808 edition of Blair's *Grave*.

[8] *Complete Graphic Works of Blake*, p. 480. I can find nothing in the two extant impressions to substantiate Bindman's claim that the plate is a "line-engraving" or his tentative suggestion that the intaglio impression shows "some aquatint."

[9] See Bentley, *Blake Records*, pp. 187-188, 211 and n.3, 212; Keynes, ed., *Letters of Blake*, p. 137.

[10] The fact that the two impressions are on the same type of paper suggests that they were pulled by the same printer at about the same time. Impression 1A is typical of Blake's work as a relief inker and printer.

[11] For a brief discussion of these earlier versions, see "Deaths Door." Keynes, *Engravings by Blake: The Separate Plates*, p. 39, suggests that this separate plate "may have been a trial or practice etching made during the composition of 'Death's Door.'" However, there is nothing in Blair's *Grave* that the more mysterious motifs in this design could illustrate, and Keynes acknowledges the fact that "in 1805 Blake can scarcely have needed to make any such trial."

[12] See, for example, the description of the lark mounting "with a loud trill from Felphams Vale" on the penultimate plate of *Milton* (Erdman, ed., *Poetry and Prose of Blake*, p. 142) and compare the bird in the separate plate to the one pictured, lower right, on pl. 27 of *Milton*.

Blake's dike method of relief etching required him to build a border of wax around his plate before pouring acid on it. The area beneath the wax remained in relief and, when inked as it is in impression 1A, printed as a border around the entire plate. The presence of such a border at the top of impression 1A indicates that the upper figure was, like his twin image below, originally etched headless.

This curious image has never been adequately explained or even convincingly titled. Russell, who was the first to describe the print in 1912, associated the image with the figure of the rising youth on pl. 8 of *America* (1793), and therefore borrowed a line of text from this plate in the illuminated book to entitle the separate plate "Let Him Look Up into the Heavens & Laugh in the Bright Air."[4] Russell interpreted the image as presenting "the release of man from the tyranny of material existence," and thus "his head, the symbol of his intellectual part, passes out of the design into the infinite and immaterial."[5] Russell associated the cat's head in the upper panel and the band of geometrical shapes between the two panels with "an Egyptian inspiration," but did not speculate on their significance. Joseph Wicksteed, quoted by Keynes in 1956, saw the two heads beneath the upper figure's left hand as "the cruelties of repression and predatory desire, the cat being a beast of prey eager to pounce on the bird liberated on the right," while the "masks," lower right, show "what Man is reduced to when he is confused with States—call them the masks of Tragedy and Comedy, or Experience and Innocence travestied."[6] Wicksteed also suggested possible meanings of some of the symbols on the central band, but did not relate them to any traditional system of symbols or interpret the group as a whole. John E. Grant has described the print as "an indignant graphic comment on the Cromek villainy" and an indication that "all Schiavonetti can do is make headless torsos, with miscellaneous heads strewn around."[7] Although he makes no attempt to interpret the meaning of the design, David Bindman has offered an interesting suggestion about the reason for its execution as a relief plate with his question, "Could this print have been made in connection with Blake's account of his 'new method of engraving?'"[8] No such account is known to have been published, but several letters between Blake and George Cumberland in 1807 and 1808, and entries in the latter's journal, indicate that Blake had begun to write on his "new Mode of Engraving" and that the two friends had discussed its publication.[9] A connection between this project and the separate plate might also explain the impression inked and printed in intaglio (assuming it was pulled by Blake)[10] as an attempt to show the relationship between relief and conventional techniques.

The dating of the plate depends on its possible associations with other works by Blake. The leg, torso, and arm positions of the headless figures are nearly identical to those of the rising youth in "Deaths Door" (Fig. 25) of 1805 but differ from earlier versions of this figure type in Blake's art.[11] The possible connection with Blake's plan to publish on his relief processes places the plate's execution two or three years after "Deaths Door." The bird, upper left, may be a lark, one of the central symbols of inspiration and liberation in the later plates of *Milton* (c. 1804-1808).[12] The advanced relief and white-line tech-

Part One.
Plates Designed and Executed
by Blake

niques,[13] including black-line crosshatching, exhibited by the plate are generally similar in their level of technical development to *Jerusalem* (*c.* 1804-1820), but the stipple-like texturing on the legs of the repeated figure does not appear again until pl. 2 of *The Ghost of Abel* (1822). Thus this evidently experimental and still mysterious separate plate would seem to be one of Blake's nineteenth-century productions, *c.* 1805-1822.

[13] The white-line work is confined to a small area to the right of the cat's head and to the left of the man's right hand in the upper panel, and in the lower margin of the bottom panel.

XV.
Enoch

Modified lithograph, printed in relief from a stone

One state: 1806-1807

Inscription on the open book held by the central figure:
"Enoch" in Hebrew

Inscription on the tablet or manuscript held by a floating figure on the right: "And Enoch walked with God" (from Genesis 5:24) in Hebrew

Signature on the step lower right: WBlake. inv

Image: 21.7 × 31 cm

IMPRESSIONS

1A.

British Museum. Printed on a sheet of buff wove paper, 22.6 × 31.9 cm, pasted to a sheet of wove paper bound as the ninety-third leaf in a volume of miscellaneous lithographs and one engraving. The first forty-three leaves of this volume, bound in full calf rebacked, consist mainly of *Specimens of Polyautography*, London: G. J. Vollweiler, 1806. This volume was acquired by the British Museum in July 1874 from "Mr. Rimell" (according to the Museum's accession records). Exhibited at the British Museum in 1957, no. 60(2), titled "Job in his Prosperity," in the catalogue. Reproduced here, Fig. 30.

1B.

Mrs. Edward Croft-Murray, Richmond, Surrey. Printed on wove paper, matted and framed. According to the owner, the paper, the margins of which are now covered by the mat, is slightly larger than 22.5 × 32.2 cm. There is a slight discoloration of the paper above the central figure's head. The backing mat has a window cut into it, revealing all but a few letters on the right of an ink inscription in an early hand, probably George Cumberland's, on the verso of this impression:

> White Lyas—is the Block | draw with Ink composed of asphaltum dissolved in dry[?] | Linseed oil—add fine venetian Tripoli &[?] Rotten Stone Powder. | Let it dry. when dry saturate the stone with water and | Dab it with the broad Dabber, and [*deleted*] coverd very thinly with | best Printers Ink- and Print as a block—. | of Blake.

This inscription shows through on the recto above the central figure. This impression probably once belonged to Cumberland, who may have acquired it directly from Blake. Purchased by Edward Croft-Murray in 1957 for £3 from Colnaghi's, who acquired it in a large lot of drawings and Italian prints (the latter perhaps also from Cumberland's extensive collection of such works) at a Sotheby's auction of the same year. Perhaps this sale was Sotheby's, 27 November 1957, lot 1, "a parcel of drawings in various mediums mainly of the Italian School" (£22 to "Schidhof"). Lent by Croft-Murray to the National

Part One.

Plates Designed and Executed
by Blake

Library of Scotland, Edinburgh, in 1969, no. 81 in the exhibition catalogue; and to the Fitzwilliam Museum in 1971, no. 75 on the single leaf of "Additional items on exhibition." Inherited by Mrs. Croft-Murray upon her husband's death in 1980. Reproduced in Bindman, *Complete Graphic Works of Blake*, fig. 413; and in Essick, *William Blake, Printmaker*, fig. 166. The verso inscription is reproduced in *Blake: An Illustrated Quarterly*, 14 (1981), 182.

1C.
Sir Geoffrey Keynes, Suffolk. Printed on dark chocolate brown wove paper, 25.1 × 34.5 cm, slightly spotted. Inscribed "3 guineas" in pencil on the verso. Sold from the collection of Edward J. Shaw, Sotheby's, 29 July 1925, lot 157, with five other prints by Blake, including "The Fall of Rosamond," impression 2C, and "Rev. John Caspar Lavater," impression 2B (£11 to Keynes). Lent in 1937 by Keynes to the Bibliothèque Nationale, Paris, no. 54 in the exhibition catalogue; and to the Albertina, Vienna, no. 44 in the exhibition catalogue. Listed in Keynes, *Bibliotheca Bibliographici*, no. 559; and in Bindman, *Blake: Catalogue of the Collection in the Fitzwilliam Museum*, no. 559, as part of Keynes' bequest to the Museum. Reproduced, on a brown background somewhat lighter than the color of the original, in Keynes, *Engravings by Blake: The Separate Plates*, p. 26.

1D.
Raymond Lister, Cambridgeshire. Printed on brown wove paper, 22.3 × 31.9 cm, with a repaired tear across the top left corner. Matted and framed. The paper color is not quite as dark a chocolate as in impression 1C. Acquired by Lister in late 1972 or early 1973 from Colnaghi's, who offered it for sale in their November 1972 catalogue, *Original Printmaking in Britain 1600-1800*, item 112 and pl. xxvii (£5,000).[1] Lent anonymously by Lister to the Hamburg Kunsthalle and Frankfurt am Main Kunstinstitut, no. 112 and fig. 112 in the exhibition catalogue. Reproduced in Lister, *Infernal Methods*, fig. 23.

The inscription on the verso of impression 1B, very probably by Cumberland, would seem to be a brief description of the technique used to produce the image. The "Block" or stone was white lias, a limestone from an area near Bath in southwestern England, rather than the Kellheim stone used by Alois Senefelder in the lithographic process he invented in the mid-1790s.[2] Instead of lithographic chalk or ink, Blake drew his design with a mixture of asphaltum and linseed oil which, if not the acid resist he actually used in his copperplate relief etchings, must have been a liquid with very similar physical properties. Cumberland does not indicate as much, but such a mixture would probably have to be heated so as to flow evenly from the brush, or other instrument of application, and harden quickly upon contact with the cool stone. Blake added "Tripoli" and/or rotten stone, both fine polishing compounds, to his resist, perhaps simply as a thickener or to increase the receptivity of the resist to printing ink. At this point,

[1] Bindman, *Complete Graphic Works of Blake*, p. 480, incorrectly states that there are "five impressions" of "Enoch." The author did not realize that the impression (1D) sold by Colnaghi's is the same as the one owned by Lister.

[2] For the invention of lithography and its early history in England, see John Thomas Smith, *Antiquities of Westminster*, London: J. T. Smith, 1807, pp. 48-50; Thomas Fisher, "The Process of Polyautographic Printing," *Gentleman's Magazine*, 78 (March 1808), 193-196; [Henry Bankes], *Lithography; or the Art of Making Drawings on Stone*, Bath, 1813; Alois Senefelder, *Complete Course of Lithography*, London: R. Ackermann, 1819; Charles Hullmandel, *The Art of Drawing on Stone*, London: Hullmandel and R. Ackermann, [1824]; Felix H. Man, "Lithography in England (1801-1810)," in *Prints*, ed. Carl Zigrosser, New York: Holt, Rinehart and Winston, 1962, pp. 97-130; Michael Twyman, "Lithography in England 1801-1818," in *Lithography 1800-1850*, London: Oxford University Press, 1970, pp. 26-40. In this last book, p. 30, Twyman notes that Blake subscribed to Smith's *Antiquities*; but the "William Blake, Esq. Sunbury House, Middlesex" in the List of Subscribers, p. 274, is not our poet and artist who, from 1803 to 1821, resided at 17 South Molton Street, London.

Part One.
Plates Designed and Executed by Blake

3 See Fisher, p. 194, and Bankes, p. 15. The lithographic etch was used both to clean the stone of any grease and lower its surface slightly except where covered by the lithographic ink or chalk. In his *Complete Course of Lithography*, p. 10, Senefelder notes that, when he first developed his new technique, he etched the stone "about a 10th part of a line, (or 1-120th part of an inch)." Such etching away of the uncovered surface of the stone apparently persisted into the early period of English lithography, for both Fisher, p. 194, and Bankes, p. 15, include it as an integral part of the process. Fisher remarks that "that part of the face of the stone not actually covered with the ink is lowered about the thickness of half a line." Modern planographic lithography does not have this relief feature of its forebear.

4 My analysis of the accuracy of Cumberland's inscription is dependent, in part, on my own experiments in printing from varnish delineations on unetched surfaces; see Essick, *William Blake, Printmaker*, pp. 110-111 and fig. 109.

5 Smith, *Antiquities of Westminster*, p. 50.

6 A somewhat similar use of acid resist on a lithographic stone, but one that required etching, is briefly noted by William Home Lizars in his "Accounts of a New Style of Engraving on Copper in Alto Relievo," *The Edinburgh Philosophical Journal*, 2 (January-April 1820), 23. In a letter dated 22 January 1819, Cumberland wrote his son to "tell *Blake* a Mr Sivewright [thanked by Lizars for assistance] of Edinburg has just claimed in Home Philosophical Journal of Last Month As his own invention Blakes Method—& calls it Copper Blocks I think" (see Essick, *William Blake, Printmaker*, p. 117). There is no "Home Philosophical Journal," and the relationship between Cumberland's letter and Lizar's article (the former dated a year before the publication of the latter) remains a mystery. Perhaps Cumberland failed to change to the new year when he dated his letter, and thus it was actually written in January 1820 and does indeed refer to Lizars' article. In any case, it is quite possible that Blake knew of Lizars' work, but the information could not have

the usual procedure in early nineteenth-century lithography, at least as practiced in England, would have required a lithographic etch, water wash, and gum-water treatment to increase the stone's ability to hold water and repel ink.3 If we can assume that Cumberland did not leave these steps out of his description accidentally, Blake's method did not require etching or "gumming up," and he added only water to repel the printing ink from the uncovered surface of the stone. The shortening of the conventional procedure may have been possible because Blake's resist would itself raise the image above the level of the stone, for thick varnish or asphaltum will solidify at a slightly higher level than any smooth surface to which it is applied.4 Finally, Blake inked the stone with a "broad Dabber," which must have been a large type-printer's inking ball of the sort generally used in early lithography,5 and printed the stone "as a block"—that is, in relief like a woodcut.

If we can trust the impression 1B inscription, "Enoch" was produced by a hybrid technique combining the stone and water elements of early lithography with the acid resist of Blake's own relief etching.6 The awkward execution of some passages in the design (note, for example, the two faces, upper left) may be the result of the experimental nature of the medium and Blake's unfamiliarity with lithography. It is even possible that Cumberland played a role in the preparation of the stone; similar types of gracelessness of line and stiffness in the figures appear in the outline engravings he made for his *Thoughts on Outline* (1796). George Cumberland, Jr., published lithographs of his father's designs in his *Scenes Chiefly Italian* of *c.* 1821.7 There is no evidence linking these prints, which appear to be conventional lithographs, with "Enoch" or the inscription on impression 1B.

Russell, Binyon, and Keynes have all associated the production of "Enoch" with the lithographic publishing endeavors of Georg Jacob Vollweiler.8 Late in 1800, Senefelder came to England and patented his new process of "polyautography," as lithography was then called. He taught the new technique to Philipp André, to whom Senefelder sold the patent when he returned, after about seven months, to Germany. In 1803, André issued *Specimens of Polyautography* containing twelve lithographs by various English artists, including Barry, Stothard, and Fuseli. When André left London in 1805, Vollweiler took over as patentee. He reissued *Specimens*, adding to it twenty-four new prints, in 1806 and 1807.9 Like the first issue, Vollweiler's publication attracted little notice, and he returned to Germany in August 1807. The lithography equipment passed into the hands of D. Redman, who removed the business to Bath in 1813.

"Enoch" was not published as part of either issue of the *Specimens*,10 and the description of Blake's experimental procedures on impression 1B would seem on the face of it to dissociate his work from the Senefelder-André-Vollweiler enterprise. It seems improbable that the inventor of lithography or his official successors would sponsor a project that did not follow normal lithographic procedures on which they held the patent. Yet, several crucial pieces of evidence do link "Enoch" with Vollweiler's activities.11 Thomas Fisher, writing in the *Gentleman's Magazine* in 1808, remarked that "M. Andre imported them [the lithographic stones] from Germany, although his successor

57

Part One.

Plates Designed and Executed
by Blake

reached him until long after he had produced "Enoch."

[7] See G. E. Bentley, Jr., *A Bibliography of George Cumberland*, New York: Garland Publishing, 1975, pp. 31-34.

[8] *Engravings of Blake*, p. 91; *Engraved Designs of Blake*, pp. 21-22; *Engravings by Blake: The Separate Plates*, pp. 43-44.

[9] The title page is dated 1806, but some of the prints are inscribed 1807.

[10] Fisher, *Gentlemen's Magazine*, p. 195, lists the artists who contributed to the Vollweiler issue, and Blake is not named therein. Impression 1A, bound up with prints from the *Specimens*, is not mounted on paper with a brown aquatint border, as are all the works actually issued with the *Specimens*, 1803 and 1806.

[11] When writing *William Blake, Printmaker*, I was unaware of most of this evidence, and thus my discussion of the dating of "Enoch" in that book, pp. 161-163, is misleading. I first presented this new evidence and conclusions based on it in "Blake's 'Enoch' Lithograph," *Blake: An Illustrated Quarterly*, 14 (1981), 180-184.

[12] "Lithography in England," p. 108.

[13] Five of the Stroehling lithographs on brown paper are in the British Museum. In 1803, Ackermann could have learned of lithography only from André, who very probably also provided Ackermann with the stones and pulled the impressions.

[14] According to Twyman, *Lithography*, p. 34.

[15] Man, "Lithography in England," p. 112, states that "Enoch" is "clearly recognizable as a Vollweiler print."

[16] *Engravings of Blake*, p. 91. Binyon, *Engraved Designs of Blake*, p. 79, titles the print "Job Restored to Prosperity."

[Vollweiler] assured me that stone [i.e., white lias] of a nearly similar quality might be procured in the neighbourhood of Bath, but not, he believed, in very large blocks" (pp. 193-194). This statement does not prove that Vollweiler actually used white lias, but it does indicate that he was amenable to its use and suggests that one of the reasons his successor, Redman, moved to Bath was the availability of proper stones in that area. According to Man, "Vollweiler issued circulars asking amateurs to try their hand in the new art, offering instructions and materials, with the stones on loan at a moderate price."[12] Thus, Vollweiler may have provided white lias stones to artists who, like Blake, had little contemporary fame and thus would not have been asked to contribute to *Specimens*. The paper on which three impressions of "Enoch" are printed offers a further connection with Vollweiler. Impression 1A is on the same type of buff colored paper, and both image and sheet are of about the same size, as several of the *Specimens* prints, second issue, bound with it. The chocolate brown paper of impressions 1C and 1D is similar in color and texture to the stock used for the crayon manner lithographs in P. E. Stroehling's *Original Sketches Drawn Upon Stone*, published by Vollweiler shortly before he left London, and for the prints in *Twelve Views in Scotland, Delineated by a Lady* [F. Waring] *in the Polyautographic Art of Drawing Upon Stone*, published by Rudolph Ackermann in 1803.[13] I know of no other prints by Blake, executed in any medium, printed on these unusual types of paper. Finally, a standard plate printing press of the early nineteenth century could not have been adapted easily for lithographic printing because of the thickness of the stone. Blake must have turned to someone with the requisite equipment to pull good quality impressions of his work. The only people in England so equipped until 1812 were André, Vollweiler, and Redman.[14] Thus, the preponderance of the evidence indicates that Blake learned of lithography from Vollweiler, rented or borrowed the stone from him, delineated "Enoch" in an acid resist similar (if not identical) to the liquid he had used for years in his relief etchings, and returned the stone to Vollweiler for printing.[15] The first three of these steps must have occurred in 1806 or early 1807, after Vollweiler had taken over the London lithographic business from André and before he too departed for Germany. The printing could have been done by Redman at a later time, but it would have been to the economic advantage of all concerned to proof "Enoch" shortly after its execution and remove Blake's work from the stone so that it could be used again for another work.

Russell believed that this print represented "Job in Prosperity," with the patriarch seated with his children about him.[16] The error is understandable because the design is closely connected with Blake's development of a composition he also used in his Job illustrations. The two earliest extant works in this group are a pen and wash drawing of *c*. 1780-1785 in the Princeton University Library (45.7 × 59.7 cm; Fig. 31) and a pen, pencil, and watercolor drawing of *c*. 1780-1785 in the Cincinnati Art Museum (45.4 × 61 cm; Fig. 32). The subjects of these two works are uncertain: the former may picture Job and his family restored to prosperity or Moses and Aaron flanked by angels; the latter probably represents Job and his family (compare pl. 2 in the

Part One.

Plates Designed and Executed by Blake

Job engravings of 1825 and in the two earlier watercolor series), but has recently been titled and exhibited as "Enoch Walked with God."[17] Fig. 31 may have served as a major source for the basic compositional format of "Enoch." Fig. 32 may have also been before Blake's notice when developing "Enoch" because he had transformed the early drawing into the second design in his series of watercolor Job illustrations, executed for Thomas Butts, only a year or two before the lithograph. There is no extant, direct, finished preliminary drawing for "Enoch," but a pencil sketch of a generally similar composition, reversed, at the University of California, Los Angeles (sheet 21.2 × 27 cm; Fig. 33), may be of about the same date as the print. A slight alternative sketch of the hovering woman on the right and one of her companions appears on the verso (Fig. 34).[18] The foremost figure on the verso, holding a partially unrolled scroll rather than a book or tablet, does not appear in any of the earlier designs in this group and may have been a step in the development of the figure holding a similar scroll on the left in the lithograph. Blake also portrayed Enoch in his watercolor "Epitome of James Hervey's *Meditations Among the Tombs*" (Tate Gallery) of *c.* 1820. Sometime after 1821 he drew a series of at least six illustrations to the Ethiopic *Book of Enoch*,[19] but none is compositionally related to the lithograph.

The true subject of "Enoch," indicated by the Hebrew inscriptions, was first presented by Binyon and Keynes in their 1936 portfolio, *Illustrations of the Book of Job by William Blake*.[20] Enoch, is, of course, the patriarchal figure in the center of the composition, with youthful personifications of music, painting, and poetry near him. In Blake's large "Last Judgment" painting, now lost, these arts are represented by Enoch's descendant, Noah, and his two sons Shem and Japhet. As Blake describes them in "A Vision of the Last Judgment" (1810), "these three Persons represent Poetry Painting & Music the three Powers in Man of conversing with Paradise which the flood did not Sweep away."[21] "Enoch" would seem to participate in a similar type of Old Testament interpretation and allegorization. Eusebius and other early theologians, both Christian and Jewish, credited Enoch with the invention of writing and considered him to have been a divinely inspired instructor in many fields of learning.[22] These traditional associations may have prompted Blake's placement of Enoch in the center of the arts, the father to all three. The hovering figures in the print suggest the spiritual inspiration of prophecy and the arts. The grape vines offer a natural analogue to artistic fruitfulness, and the pointed arches inscribed on the steps bring into the design the "Living Form" of Gothic art.[23]

[17] See Nancy L. Pressly, *The Fuseli Circle in Rome: Early Romantic Art of the 1770s*, New Haven: Yale Center for British Art, 1979, p. 137.

[18] The inscription at the bottom on the verso is simply a reference to Gilchrist, *Life of Blake* (1863), II, 253, where the drawing is called "In maiden meditation, fancy-free."

[19] For reproductions and discussion, see G. E. Bentley, Jr., "A Jewel in an Ethiop's Ear," in *Blake in His Time*, ed. Essick and Pearce, pp. 229-235 and pls. 139-144.

[20] New York: Pierpont Morgan Library, p. 8 of the first fascicle, where Joseph Wicksteed is credited with the discovery. I cannot explain why some authorities persist in believing that the print represents Job in prosperity—see, for example, the 1957 British Museum exhibition catalogue, p. 18; S. Foster Damon, *A Blake Dictionary*, Providence: Brown University Press, 1965, pp. 126, 217 (where it is suggested that Job is holding a book labeled "Enoch"); Klonsky, *Blake*, p. 28.

[21] Erdman, ed., *Poetry and Prose of Blake*, p. 548. For the portrayal of these three figures in the pencil drawing of "The Last Judgment" in the National Gallery of Art (Rosenwald Collection), see Damon, *Blake Dictionary*, pl. I, and its "Key," item 68.

[22] See *The New Schaff-Herzog Encyclopedia of Religious Knowledge*, ed. Samuel Macaulay Jackson, Grand Rapids, Michigan: Baker Book House, 1950, IV, 148-149.

[23] *On Homers Poetry* [and] *On Virgil* (*c.* 1820); Erdman, ed., *Poetry and Prose of Blake*, p. 267.

59

XVI.
Chaucers
Canterbury
Pilgrims

FIGURES 35-44

First state: 1810

Inscribed names of the pilgrims below the image:
 Reeve Chaucer Clerk of Oxenford Cook Miller
Wife of Bath Merchant Parson Man of Law Plowman
Physician. Franklin 2 Citizens Shipman The Host
Sompnour Manciple Pardoner Monk Friar a Citizen
Lady Abbess Nun 3 Priests Squires Yoman
Knight Squire

Title inscription, open letters: CHAUCERS CANTERBURY
PILGRIMS

*Signature and imprint: Painted in Fresco by William Blake &
by him Engraved & Published October 8. 1810, at Nº 28.
Corner of Broad Street | Golden Square*

Image, measured on the copperplate:[1] 30.55 (left side) to
 30.65 (middle) to 30.5 (right side) × 94.9 cm

Size of copperplate: 35.6 (left side) to 35.8 (right side) ×
 97.05 cm

IMPRESSIONS

1A.
National Gallery of Art, Rosenwald Collection, Washington, D.C.
Printed on wove paper with the Rosenwald and National Gallery of
Art collection stamps on the verso. Image, 29.9 × 93 cm; plate mark,
35.1 cm. × trimmed off on the left; sheet, 39.5 × 95.1 cm. A shadow
of the original drypoint inscription and ruled lines of the title prints
slightly above and to the left of the engraved letters. Repaired tears
in lower margins and on right margin extending into the image. Recent
tears with some loss of surface on the Knight's chest, knee, and just
above his foot. Light brown stains in the sky above the Lady Abbess.
Perhaps the impression sold at Sotheby's, 19 November 1929, lot 288,
"first state" (£50 to Maggs), and listed in Colnaghi's records as having
been purchased for £50 at Sotheby's on 18 [*sic*?] November 1929.
According to their records, Sessler's acquired this impression from
Colnaghi's in April 1930 for £75 and in turn sold it to Lessing J.
Rosenwald in March 1933 for $720. Lent by Rosenwald to the Little
Museum of La Miniatura, Pasadena, California, in 1936, no. 11 in
the exhibition catalogue; and to the Philadelphia Museum of Art in
1939, no. 123 in the exhibition catalogue. Given by Rosenwald to the
National Gallery of Art in 1945 and moved from the Alverthorpe
Gallery, Jenkintown, Pennsylvania, to Washington in 1980. Repro-
duced in Keynes, *Engravings by Blake: The Separate Plates,* pls. 27
(full print), 28 (left one quarter), and 31 (right one quarter). Repro-
duced here, Fig. 35.

Second state:[2] *c.* 1810-1820
 Crosshatching has been added to the (right?) rear leg of the
horse ridden by the Wife of Bath, visible just to the right of

[1] See the following discussion for more
information on the copperplate (Fig. 44).
Because of the large size of the plate, and
the variety of papers on which it was
printed and the conditions under which
impressions have been preserved, there are
considerable differences in the sizes of the
image and plate mark from one impres-
sion to another. These sizes have been re-
corded for many of the impressions de-
scribed here to give some sense of the
range of these variations.

[2] This state has not been previously re-
corded. The third state recorded here cor-
responds to the second state as described
in Keynes, *Engravings by Blake: The Sep-
arate Plates,* pp. 46-47. The fourth state
corresponds to Keynes' third, and the fifth
state corresponds to Keynes' fourth and
fifth (the last not a true state but a re-
printing of the previous state). Prior to the
publication of Keynes' catalogue in 1956,
the standard descriptions of the plate were
Russell's in *The Engravings of Blake*
(1912), pp. 91-92, and Binyon's in *The
Engraved Designs of Blake* (1926), pp.
60-62. Both these authorities distinguish
only two states, the first with the Broad
Street address (first through third states
described here), and the second with the
quotation from Chaucer replacing the ad-
dress (fourth and fifth states described
here). Most of the pre-1960 sales and ex-
hibition catalogues cited here seem to fol-
low this two-state enumeration.

60

Chaucer's right foot, and the crosshatching on this same horse's rump has been extended further to the right toward the young girl's neck. Crosshatching has been added to the neck of the Knight's horse, just above the reins, and shading lines have been added to this horse's right front leg, belly, and flank just beneath his tail. A considerable number of fine lines have been added to the sunrise on the far right to extend and add to the flashes of radiance (running diagonally right to left), and two diffused horizontal bands of darkness have been added above the horizon. Through contrast with these dark bands, the radiance just above the horizon now seems much more intense (see the reproduction of the third state, Fig. 36).

Inscribed names of the pilgrims below the image: a period has been added after each name except for *Squire* at the far right

Other inscriptions and dimensions: same as in first state

IMPRESSIONS

2B.

Sir Geoffrey Keynes, Suffolk. Printed on wove paper, framed. Image 29.8 × 92.9 cm; plate mark 35.1 × 94.9 cm; sheet approximately 49 × 99 cm (according to the owner). Delicately hand tinted with watercolors in rich hues similar to those in Blake's tempera painting of this design, but with a few minor variations. The faces of the pilgrims and attendant figures have been carefully tinted in flesh tones. The woman and old man, lower left, are dressed in shades of brown; the girl holding a flask has a yellow dress and the boy with a cask is also dressed in yellow. The Reeve's clothes are brown, as is the Clerk's horse. Chaucer's gown is rose-red with a yellow hem; his horse is black. The Miller's hair is red and his face ruddy; his collar is blue. The Wife of Bath has a rose-red rug over her lap and her jewelry and stockings are orange-red. The Parson's gown is black. The Man of Law wears a blue shirt. The Franklin's coat is orange-red. The Shipman's clothes are blue. The Host's clothes are golden yellow, his hat, belt, and boots blue, his saddle blanket and bridle orange-red, and his horse red-brown. The Pardoner's gown and shoes are blue and his horse dark brown; the crosses on his back and purse are rose-red. The Lady Abbess rides a light brown horse and the Nun wears a black habit. The Knight's armor is touched with black; his saddle is golden yellow; his scarf, bridle, and saddle blanket are orange-red. The roof tiles on the inn are red and the sky above them is tinted black and blue. The ground below the horses is colored in shades of brown and rose-red; the background landscape is tinted in shades of green, blue, and black. The sunrise on the right is orange-red. The clothes of the Clerk, Miller, Plowman, Sompnour, three Priests, and the Wife of Bath's gown are uncolored. The coloring is in all probability by Blake himself. Probably the impression acquired at an unknown date by Hubert Stuart-Moore and his wife, Evelyn Underhill. Purchased in a

London sale room by E. Kersley, *c.* 1959, who sold it to Keynes in April 1969. According to Keynes, *Engravings by Blake: The Separate Plates*, p. 48 n.2, "This impression was found many years ago rolled up in association with documents relating to property in Broad Street, Golden Square."[3] Lent anonymously by Keynes to the National Library of Scotland, Edinburgh, in 1969, no. 110 in the exhibition catalogue; and to the Tate Gallery in 1978, no. 210 in the exhibition catalogue, where it is reproduced much reduced. Listed in Bindman, *Blake: Catalogue of the Collection in the Fitzwilliam Museum*, no. 560i, as part of Keynes' bequest to the Museum.

2C.

Private collection, Central California. Printed on wove paper, framed and matted within the plate mark. Image 30.2 × 94.1 cm. Inscribed (by Frederick Tatham?) in pencil in the lower left margin, 3.4 cm below the image, in a clear hand: "This print was colored by the Artist W Blake, and given by Mrs Blake to F. Tatham Esqr." Partially hand tinted with pale watercolors in hues similar to those in Blake's tempera painting of the design, as in impression 2B. The faces of the pilgrims from the Shipman (center) through the Knight on the right have been delicately tinted with flesh tones. The girl holding a flask (just below the Cook) wears a yellow dress. The Wife of Bath's hat is blue. The Host is mounted on a chestnut horse bearing a red saddle blanket and his boots, belt, and hat are blue. The Pardoner wears a blue gown, and the crosses on his back and on the bag hanging from his left shoulder are red. The Lady Abbess wears a black habit, the beads draped over her right wrist are red, and her horse's saddle is blue and red. Most of the foreground is tinted in several shades of earth browns, the background foliage is light green, and a few areas of the sunset have been touched with pale rose. There is no coloring on the Tabard Inn or any of the characters left of the girl holding a flask. The incomplete coloring is in all probability by Blake himself. According to Keynes, *Engravings by Blake: The Separate Plates*, p. 48 n.1, "this impression was in 1912 in the possession of Messrs Robson, London." Acquired at an unknown time by Frank J. Hogan of Washington, D.C., and sold with his collection at Parke-Bernet, 24 April 1945, lot 39 ($525). Acquired in the same year by David McKell, Chillicothe, Ohio, from whom it passed by inheritance to his son, Dr. David McKell, Saratoga, California. Now in the collection of a descendant of Dr. McKell's.

Third state: c. 1810-1820

A great deal of hatching and crosshatching has been added to the image, generally darkening its tone. The contrasts between dark and light areas in the sky, clouds, foreground, and dust kicked up by the horses have been strengthened. Further flashes of radiance have been extended along the horizon to the left, the shadow areas on the Tabard darkened, and most of the hatching on the pilgrims' clothing and faces augmented. Chaucer's horse has

[3] In the same note, Keynes states that, at the time of writing (1956), this impression was destined for the Ashmolean Museum, Oxford, but this is no longer the case. The 28 Broad Street, Golden Square, address in the imprint was the residence of Blake's father and brother from 1753 to 1812 (see Bentley, *Blake Records*, pp. 552-556). Blake's tempera painting "Sir Jeffery Chaucer and the nine and twenty Pilgrims on their journey to Canterbury" was exhibited at this home in 1809.

been further darkened; the dark patches on the other horses have been deepened to create bolder contrasts with the light areas, such as the neck of the Parson's mount. A small building has been added to the fold in the hill just above the flat building above the head of the Priest closest to the Nun. See Fig. 36.

Inscriptions and dimensions: same as in second state

IMPRESSIONS

3D.
Ashmolean Museum, Oxford. Darkly printed on wove paper, folded vertically down the center. Image 30.1 × 92.8 cm; plate mark 35.4 × 94.8 cm; sheet 42.6 × 98 cm. Bequeathed to the Museum in 1834 by Francis Douce, whose collection stamp is on the verso.

3E.
Bancroft Library, University of California, Berkeley. Darkly printed on wove paper, the lower left corner creased diagonally just below the image by an old fold line. Framed and matted within the plate mark. Image 30.2 × 94.5 cm. Given to the Library in 1977 by Norman Strouse, who believes he acquired it either in Detroit, *c.* 1952, or from Mrs. Stanley Resor in New York, *c.* 1956. See also impression 5XX.

3F.
Boston Museum of Fine Arts. Printed on wove paper, trimmed within the plate mark on the right and lower edges. Museum of Fine Arts collection stamp on verso. Image 30.1 × 93.8 cm; sheet 35.6 × 96.1 cm. Ragged edges and corners, with two repaired tears in the left margin and two more extending vertically from the lower edge of the sheet into the image. Light brown stain above the Parson's head. Given to the Museum in April 1923 by William Norton Bullard.

3G.
British Museum. Printed on wove paper pasted to the mat. Image 30 × 93.2 cm; plate mark 35.3 cm × trimmed off; sheet 36.5 × 94.3 cm. Acquired by the Museum on 9 February 1846 from R. H. Evans. This is the same date on which the Museum acquired from Evans "Albion rose," impression 1A, and other Blake works sold at auction on 15 June 1846 from the collection of William Upcott. There is no "Chaucers Canterbury Pilgrims" listed in the Upcott sale catalogue, but it may have been included in any of several miscellaneous lots of unidentified prints. Exhibited at the British Museum in 1957, no. 22(2) in the catalogue; and lent to the Hamburg Kunsthalle and Frankfurt am Main Kunstinstitut in 1975, no. 159 in the exhibition catalogue. Reproduced here, Fig. 36.

3H.
Cleveland Museum of Art. Printed on heavy wove paper, trimmed inside the plate mark on the right and left to 38.4 × 96.5 cm. Vertical

center fold. Given to the Museum by Leonard C. Hanna, Jr., in 1924. Not seen; information supplied by Louise Richards of the Cleveland Museum.

3I.

Merlin Cunliffe, Dixon's Creek, Australia; on deposit at the National Gallery of Victoria, Melbourne. Printed on wove paper, 48.2 × 100.5 cm, time stained to a yellow brown. Plate mark 35.5 × 96.4 cm. Tears in the margins; skinned spot lower left on the old man's gown; small horizontal tear in the Knight's saddle. Probably acquired *c.* 1860-1880 by Henry Cunliffe, who owned several of Blake's illuminated books, and bequeathed by him to his great-nephew Rolf, second Baron Cunliffe (1899-1963), on whose death it passed to his second son, the present owner. Not seen (see note 20).

3J.

Edwin K. Delph, Phoenix, Arizona. Printed on wove paper pasted to canvas, framed. Water stained on the left and right and lower left, a few worm holes and rubbed patches on the left edge, and a repaired tear running from the lower left edge into the image. Sold from "the Property of a Lady" at Christie's, 6 February 1979, lot 13, reproduced (£2,100 to Christie's for Delph). According to the auction catalogue, the plate mark measures 35.5 × 96.1 cm. Not seen; information supplied by the owner.

3K.

Mrs. Seth Dennis, New York. Printed on wove paper pasted to a linen-covered board. Cut to the edge of the image on the right and left and within the plate mark at the bottom. Worm holes in the lower margin and repaired tears on the left and right. Image 29.9 × 96 cm; sheet remargined on the left and right edges to 38.3 × 104.8 cm. Acquired early in this century from an unknown source by the present owner's father, who was for many years the owner of E. Weyhe, Inc., book and print dealers of New York.[4]

3L.

Fitzwilliam Museum, Cambridge. Printed on wove paper trimmed within the plate mark. A considerable amount of water damage, staining, and rubbed spots mar the right quarter of the image. The right quarter of the sheet has been mounted on another sheet of paper and the tears repaired. Image 30.3 × 93.6 cm; sheet 35.2 × 95.5 cm. Probably the impression sold from the collection of Thomas Butts at Sotheby's, 26 March 1852, lot 167 (misprinted "157"), state not given (12s. to "Palgrave"). The purchaser was probably Francis Turner Palgrave (1824-1897), and the print apparently passed to his heirs. Given to the Fitzwilliam in December 1941 by the Rev. Francis M. T. Palgrave and Miss Annora Palgrave, as indicated by a label pasted to the verso. Listed in Bindman, *Blake: Catalogue of the Collection in the Fitzwilliam Museum*, no. 32. Reproduced in Michael Davis, *William Blake: A New Kind of Man*, London: Paul Elek, 1977, fig. 44 (image only).

[4] Weyhe has no available records of its Blake purchases and sales.

3 M.

Hunterian Art Gallery, University of Glasgow. Printed on wove paper laid on to a larger sheet. Vertical fold down middle, slight damage lower left corner. Image 30.1 × 92.8 cm; sheet 36.2 × 95.8 cm. Acquired at an unknown time by J. A. McCallum, whose collection stamp appears below the image, and given by him to the University of Glasgow sometime between 1939 and 1948 along with about 3,500 prints from his collection. Lent to the National Library of Scotland, Edinburgh, in 1969, no. 111 in the exhibition catalogue; and to the Whitworth Art Gallery, Manchester, in 1978. Reproduced in *Art History*, 3 (December 1980), fig. 11.

3 N.

Herbert F. Johnson Museum of Art, Cornell University, Ithaca, New York. Printed on heavy wove paper trimmed inside the plate mark on the left and right to 40.7 × 96.3 cm. Acquired by the Museum in 1967 from an unidentified print dealer. Not seen; information supplied by Barbara Blackwell of the Johnson Museum.

3 O.

Sir Geoffrey Keynes, Suffolk. Printed on laid India paper, framed and matted within the plate mark. Image 30.2 × 94.3 cm. Purchased from a London dealer sometime during World War II; perhaps the impression offered by C. A. Stonehill, described in their April 1939 catalogue, item 14, as a second (Keynes) state on India paper (£20).[5] For the only other recorded third-state impression on laid India, see untraced impression 27. Listed in Keynes, *Bibliotheca Bibliographici*, no. 560i, and in Bindman, *Blake: Catalogue of the Collection in the Fitzwilliam Museum*, no. 560ii, as part of Keynes' bequest to the Museum.

3 P.

Mrs. Gerard B. Lambert, Princeton, New Jersey. Well printed on wove paper, framed and matted just outside the image at the top, below the address at the bottom, and slightly within the image, left and right. Lightly tinted in flesh pink on all exposed human skin except the old man's hand on the far left, Chaucer's right hand, the Cook's right hand, the Host's hands, and the Citizen's neck. According to the owner, the print was acquired *c.* 1944 from Mr. Swann at Parke-Bernet. Lent to Princeton University in 1969, no. 84a in the exhibition catalogue. Perhaps the impression sold at Sotheby's, 20 May 1942, lot 179, described as a first (Binyon?) state with faces tinted (£52 to Colnaghi). The print will probably be given to Princeton University after the present owner's death.

3 Q.

Los Angeles County Museum of Art. Printed on wove paper, trimmed inside the plate mark. Image 30.2 × 93.8 cm; sheet 33.9 × 94.4 cm. There is a small rubbed spot in the sky above the Friar and the lower edge is damaged with loss of paper. Purchased by the Museum for $300 in 1953 from the collection of Louise Ward Watkins, San Ma-

[5] In 1939, C. A. Stonehill was located in London. The present firm in New Haven, Connecticut, has no record of this or other Blake sales by the London store.

rino, California. Mrs. Watkins was a friend of Mrs. George M. Millard of Pasadena (contiguous to San Marino), and this may be the same impression (state not identified) exhibited by Mrs. Millard in 1936 at her Little Museum of La Miniatura, Pasadena, no. 11 in the catalogue. Reproduced in the *Los Angeles County Museum Bulletin*, 4 (Spring 1954), 10.

3R.

The Lutheran Center for Education and the Arts at Glen Foerd, Philadelphia. Well printed on wove paper, framed and matted within the plate mark to approximately 33 × 93 cm. According to their records, Sessler acquired this impression from "Kennedy" (Kennedy Gallery?) in February 1937 for $466.67 and sold it in the same month to Mrs. William T. Tonner for $750. Bequeathed to The Lutheran Center by Mrs. Tonner in 1971. The present owner has tentative plans to sell the print in the near future.

3S.

National Gallery of Art, Rosenwald Collection, Washington, D.C. Printed on wove paper, trimmed inside the plate mark, and with the National Gallery and Rosenwald collection stamps on the verso. Image 30.1 × 93.1 cm; sheet 34.4 × 94.4 cm. Two repaired tears, lower margin; paper slightly and evenly browned with age. Acquired by Lessing J. Rosenwald in June 1937 from C. A. Stonehill (with impression 5QQ; see note 5). Lent by Rosenwald to the Philadelphia Museum of Art in 1939, no. 123 in the exhibition catalogue; to Cornell University in 1965, no. 34 in the exhibition catalogue; and to Illinois State University, Normal, and the University of Kansas, Lawrence, in 1971, no. 13 in the exhibition catalogue. Given by Rosenwald to the National Gallery in 1945 and moved from the Alverthorpe Gallery, Jenkintown, Pennsylvania, to Washington in 1980. Reproduced in Bentley, *Blake Records*, pl. xxxiib; Keynes, *Engravings by Blake: The Separate Plates*, pls. 29 (left one quarter), 32 (right one quarter).

3T.

National Gallery of Victoria, Melbourne, Australia. Poorly printed on thin paper, 35.9 × 97 cm, pasted to a piece of linen. Water stained; badly foxed and scuffed with a large branching tear extending from the lower center margin through the image. Presented to the gallery in 1967 by Haughton James. Not seen; see note 20.

3U.

Philadelphia Museum of Art. Printed on (wove?) paper trimmed within the plate mark and pasted to a cardboard backing. Image 30.2 × 92.6 cm; sheet 35.6 × 95 cm. Paper very browned with age; scuffed, with a vertical tear just left of Chaucer. Ragged edges right and left, with a large repaired tear in the top left corner and tears in the lower margin, one extending into the image on the left. Acquired in 1953 from the Philip H. and A.S.W. Rosenbach Foundation. See also untraced impression 23.

3V.

R. Rosszell, Sweden. Blake's tempera painting of the Canterbury Pilgrims was sold from the collection of Thomas Butts at Foster and Son, 29 June 1853, lot 93 (£10 10s. to Stirling). According to a manuscript note in the handwritten copy of the auction catalogue in the Huntington Library, this lot included a "Print" of the subject. Probably the impression lent by Sir William Stirling Maxwell to the Burlington Fine Arts Club in 1876, no. 291 in the exhibition catalogue (state not recorded), and sold from the Stirling Maxwell collection, Christie's, 18 April 1978, lot 128, described as Keynes' second state on wove paper, plate mark 35.5 × 95.4 cm, reproduced, with an impression of Stothard's "Pilgrimage to Canterbury" (£2,800 to Rosszell). Not seen.

3W.

Johan Stray, Oslo, Norway. Sold at Sotheby's, 28 March 1974, lot 67, reproduced (£2,100 to Stray). According to the auction catalogue, the image measures 30.2 × 92.7 cm; there is a vertical center fold, some foxing, and tears in the margin. According to Colnaghi's notes on the sale of this impression, apparently made just prior to the auction, there is a "bad tear" at the bottom, two on the sides, and the image has been "touched up with white lead." Not seen.

3X.

Yale Center for British Art, New Haven, Connecticut. Printed on wove paper trimmed inside the plate mark. A little yellow with age and with a vertical fold down the center, some brown spots upper right, and a brown (ink?) line and rubbed spot in the clouds upper left above the black birds. Image 30.3 × 93.8 cm; sheet 34.9 × 95.6 cm. Purchased by the Center in August 1971 from Christopher Mendez, London printseller, who acquired the print from a private customer and has no further knowledge of its provenance.

3Y.

Private collection, Great Britain. Well printed on wove paper pasted to a larger sheet, framed. Image 30 × 93 cm; plate mark 35.3 × 96 cm; sheet 37 × 97 cm. Purchased at an unknown time by W. Graham Robertson. After his death in 1948, lent to the Bournemouth Arts Club, Southampton Art Gallery, and Brighton Art Gallery in 1949, no. 53 in the exhibition catalogue. Listed in Preston, ed., *Blake Collection of Robertson*, no. 130. Sold by Robertson's executors at Christie's, 22 July 1949, lot 89 (£42 to Agnew's). Sold shortly thereafter by Agnew's to the present owner. See also impression 4AA.

3Z.

Private collection, New York; on deposit at the Houghton Library, Harvard University, in 1980. Printed on wove paper, framed.[6] The owner has not responded to my inquiries and I have not been permitted to inspect the print.

[6] According to David P. Becker, formerly of the Houghton Library, who inspected the impression for me and identified its state.

Fourth state: c. 1820-1823

Blake has worked over the plate in detail once again, darkening some areas and lightening others, apparently with the intention of alleviating the excessive darkness of the third state and increasing contrasts. On the right shoulder of the small child closest to the lower left corner, he has added the right hand (previously not represented) of the taller boy to the right. Many areas on the left side of the plate have been lightly burnished, most noticeably the taller boy's shirt and woman's left arm in the family group, lower left; the portal in the inn just to the left of the Reeve's hand; Chaucer's right knee and shoulder; the Clerk's collar and right arm; the Miller's right shoulder; the Wife of Bath's left knee; the dust kicked up by the right front hoof of Chaucer's horse; and the ground below his horse's rear hoof and in front of the front hoof of the Clerk's mount. The neck of Chaucer's horse has been darkened further, except for a small area just below the reins that has been burnished. Two streaks of light, running diagonally from the center horizon to the left, have been burnished into the sky, which elsewhere above the Parson and Plowman has been darkened with fine lines. The dust and ground below the Host's horse have been highlighted with patches of burnishing. Further work with the burnisher has been added to the Host's horse, his saddle left of the Host's thigh, the Host's chest, the Pardoner's right arm and the dust behind his horse's left front hoof, the legs of the Abbess's horse, and the scarf dangling from the Knight's right shoulder. The Knight's horse has been burnished, particularly on his neck, chest, and rump. In contrast, the Squire's horse has been darkened with additional hatching and crosshatching, particularly apparent on his face and forelegs. The shadows on the right side of the Squire's neck and in the landscape behind the Knight and Squire have been darkened with crosshatching. The sunrise has been changed considerably with the extension of fine horizontal lines through the shafts of radiance and into the light areas just above the horizon, the addition of more diagonal lines near the upper right corner, and further burnishing in a horizontal band roughly halfway between the horizon and the top edge of the image. See Figs. 37-39.

Signature and imprint: Painted in Fresco by William Blake & by him Engraved & Published October 8. 1810. Ye gon to Canterbury God mote you spede.

Additional inscriptions (Fig. 40) in two columns to the left of the title, lightly scratched in drypoint: A morrow when the day began to spring | Up rose our Host and was our alder cocke || The Use of Money | & its Wars

Additional inscriptions (Fig. 41) in two columns to the right

*of the title, lightly scratched in drypoint: An Allegory of |
Idolatry or Politics ‖ And gadrid us together on a flock- |
Let see now: Who shall tell the first Tale*

Other inscriptions and dimensions: same as in third state

IMPRESSIONS

4AA.
Douglas Cleverdon, London. Printed on India paper, re-laid (and hence without plate mark) on heavy wove. Image 30.3 × 93.6 cm; India sheet 34.1 × 94.4 cm; wove sheet 39.4 × 106.1 cm. Some light foxing, a printing crease runs vertically through the A of "CHAUCERS" and into the image, and there is a small rubbed spot on the Knight's left wrist. The drypoint inscriptions are very faint, particularly on the right. "An Allegory of Idolatry or Politics" is indistinct. Inscribed in pencil on the verso, "Stick down . . . Preston." Sold as additional lot 91 (not in the catalogue) at the W. Graham Robertson auction, Christie's, 22 July 1949 (£12 12s. to Cleverdon). The verso note suggests that this impression was at one time in the possession of Kerrison Preston and that he had the India paper relaid. This impression may have also been in the Robertson collection (see impression 3Y), for Preston was his close friend and editor of the catalogue of his collection.[7] Perhaps the impression sold at the W. E. Moss auction, Sotheby's, 2 March 1937, lot 198, described as a "second state, having various half-legible remarks (e.g. 'The Use of Money and its Wars'), by the engraver in the lower margin" (£17 to Rimell). See untraced impression 32 for another from the Moss collection.

4BB.
Huntington Library, San Marino, California. Printed on wove paper, now evenly browned with age, framed and matted within the plate mark. Image 30.5 × 94.9 cm. The drypoint inscriptions are faint, but more legible than in any other impression seen. To the right of *on a flock-* in the drypoint inscriptions right of the title are the words *one of us*. Like the illegible scratches elsewhere in this area of the plate, these words are probably remnants of an earlier version of the drypoint inscriptions (see also impression 4CC). The Library has no accession records for this impression, which was probably acquired by Henry E. Huntington prior to World War I. There are detail reproductions of Chaucer, Wife of Bath, Miller, Parson, and Man of Law in *Blake: An Illustrated Quarterly*, 13 (1980), cover and pp. 62-63. Reproduced here, Figs. 37-41.

4CC.
Yale University Art Gallery, New Haven, Connecticut. Printed on thin, hard, parchment-like paper trimmed inside the plate mark. Small hole, upper center, in the clouds above the Pardoner; scuffed in both drypoint inscription areas. In 1980, the ragged left edge of the sheet was remargined, and the damage, lower left, repaired at the Yale Center for British Art. Image 30.7 × 94.3 cm; remargined sheet 35 × 95.9

[7] Neither the published catalogue of 1952 nor Robertson's holograph manuscript of it, now in my collection, mentions this impression.

cm. The drypoint inscriptions are faint but legible. To the right of *on a flock-* in the drypoint inscriptions right of the title are fragments of indistinct letters (see impression 4BB). Similar fragments, including perhaps the letter *L*, appear under *now* in the last line of the drypoint inscriptions. Acquired by the Yale Art Gallery in May 1954 from Harry Shaw Newman of the Old Print Shop, New York. The present firm has no record of the purchase or sale of the print, but it may be the impression sold at Sotheby's, 21 January 1953, lot 180, described as a "second state, also with scratched lettering in inscription" (£9 10s. to "Reader").

Fifth state: *c.* 1820-1823 or later
The faint drypoint inscriptions added in the fourth state have either been removed from the plate or simply worn away. If the latter is the case, then this is not a distinct state and the fifth-state impressions listed here should be considered as late impressions of the fourth state. See the discussion, below, of the copperplate and late-nineteenth- and twentieth-century impressions from it.

IMPRESSIONS

5DD.
Arkansas Arts Center, Little Rock, Arkansas. Matted and framed to the plate mark. Paper stained. Very probably a Colnaghi or Sessler restrike.[8] Given to the Arts Center in October 1941 by Mr. and Mrs. F. W. Allsopp of Little Rock. Not seen; information supplied by Thom Hall of the Arts Center.

5EE.
Boston Museum of Fine Arts. Darkly printed on India paper laid on heavy wove with the Museum of Fine Arts collection stamp on the verso. Perhaps a Colnaghi restrike. Due to the heavy inking, fragments of the Broad Street address and marks left by the burnisher used to remove it are visible beneath *Ye gon to Canterbury God mote you spede*. Image 30.1 × 94.4 cm; plate mark 35.4 × 96.5 cm; sheet 58.8 × 112.5 cm. Given to the Museum by George Peabody Gardner in December 1921.

5FF.
Maxine S. Cronbach, Westbury, New York. Printed on laid India paper, framed. Probably a Colnaghi restrike. According to the owner, the sheet measures 55.2 × 116.8 cm. Acquired by the present owner's parents prior to 1911. Lent to Adelphi University in 1977, no. 1 in the exhibition catalogue in which the size (apparently of the plate mark) is given as 35.5 × 97.5 cm. Not seen.

5GG.
Robert N. Essick, Altadena, California. A Sessler restrike, darkly printed on wove paper, watermarked FRANCE, lower right, matted and framed. Image 30 × 93.8 cm; plate mark 35.2 × 96.1 cm; sheet 41 × 101.3

[8] See the discussion, below, for information on the Colnaghi and Sessler restrikes.

cm. Fragments of the Broad Street address are visible beneath *Ye gon to Canterbury God mote you spede.* Acquired in the late 1940s by Thomas Gomez, Hollywood, California, and sold by his widow in July 1972 to the Heritage Bookshop. Purchased in the same month by Essick for $500. Lent to the University of California, Santa Barbara, in 1976, no. 15 in the exhibition catalogue (reproduced). Left half reproduced in Essick, *William Blake, Printmaker*, fig. 190.

5HH.

Professor Roland M. Frye, University of Pennsylvania, Philadelphia. A Sessler restrike on consignment from "Park" at Sessler's in August 1967; sold in that month to Frye for $65. Framed and matted. The owner believes that this is one of the restrikes originally purchased by Newton (see untraced impressions 39-123). Not seen.

5II.

Henry E. Gerstley, Philadelphia. A Sessler restrike on wove paper, framed and matted inside the plate mark. Image 30 × 93.9 cm. Purchased by Gerstley from Sessler's in May 1941 for $35.

5JJ.

Donald A. Heald, London. A Colnaghi restrike, lightly printed on India paper laid on heavy wove, cleaned and with a repaired tear extending 2 cm into the inscription area left of the title. Plate mark 35.5 × 96.5 cm; sheet 41.2 × 99.8 cm. Sold Sotheby's, Belgravia rooms, 19 July 1977, lot 136, reproduced (£150 to Heald). On deposit at the William Weston Gallery, London, in July 1981. Perhaps now sold through Weston.

5KK.

Sir Geoffrey Keynes, Suffolk. Printed on India paper laid on wove, matted and framed. Image 30.2 × 94.3 cm; plate mark 35.8 × 96.3 cm. Perhaps a Colnaghi restrike, as is the case with most of the fifth-state impressions on laid India, or an earlier impression acquired by George Richmond and passed by inheritance to Mrs. John Richmond. Lent by Mrs. Richmond to the Bibliothèque Nationale, Paris, in 1937, no. 62 in the exhibition catalogue. Sold with her household effects by Lofts and Warner, 14 July 1952, lot 289a (£16 to Keynes). Listed in Keynes, *Bibliotheca Bibliographici*, no. 560ii; and in Bindman, *Blake: Catalogue of the Collection in the Fitzwilliam Museum*, no. 560iii, as part of Keynes' bequest to that Museum. For other impressions once owned by the Richmond family, see impressions 16 and 128.

5LL.

University of Leeds, Brotherton Library, Leeds, England. A Sessler restrike on wove paper, 43.8 × 101.5 cm, damaged in the top and bottom margins and mounted on a large card. Given in 1947 by Charles Sessler to Ruthven Todd,[9] who bequeathed the print to the University of Leeds in 1979. Not seen; information kindly supplied by P. S. Morrish of the Brotherton Library.

[9] According to Todd in *Blake: An Illustrated Quarterly*, 11 (1977), 31.

Part One.
*Plates Designed and Executed
by Blake*

5MM.

McGill University, Montreal. A Sessler restrike on wove paper, framed and matted. Purchased from Sessler's by Herman Cohen of the Chiswick Book Shop in April 1950 for $35. Acquired shortly thereafter by Lawrence M. Lande of Montreal, who gave it to the University in 1953. Reproduced in *Eighteenth-Century Studies*, 12 (1979), facing p. 490.

5NN.

Mills College, Oakland, California. A Colnaghi restrike on laid India paper, framed and matted. This impression has hung in various English Department offices at the College for many years, and there is no record of its acquisition.

5OO.

Minneapolis Institute of Arts. Printed on India paper, now lightly and evenly browned, laid onto a heavy wove sheet, 57.8 × 110.5 cm. Probably a Colnaghi restrike. Acquired by the Institute in 1979 from a New York dealer. Not seen; information supplied by R. Louis Bofferding of the Minneapolis Institute.

5PP.

Mount Holyoke College, South Hadley, Massachusetts. A Sessler restrike on wove paper, watermarked FRANCE lower right. Framed without mat; stained brown, particularly at the edges. Plate mark 35.6 × 96.2 cm; sheet 40.6 × 101 cm. Purchased by the college from Sessler's in January 1943 for $20. Not seen; information kindly supplied by Anne C. Edmonds of Mount Holyoke College.

5QQ.

National Gallery of Art, Rosenwald Collection, Washington, D.C. Printed on wove paper with a few light-brown stains, particularly on the large spire above the Wife of Bath and above the Knight. Heavily inked and printed with considerable ink printed from the surface of the plate and small fragments of the fourth-state drypoint inscriptions visible right of the title. The shadow of the original drypoint "PILGRIM" inscription prints slightly above and to the left of the engraved letters. The presence of the drypoint fragments suggests that this impression was probably pulled prior to the Colnaghi restrikes. Image 30.4 × 93.7 cm; plate mark 35.5 × 95.8 cm; sheet 41.4 × 100.6 cm. Rosenwald and National Gallery of Art collection stamps on verso. Brown stain lower and top margin of recto outside the plate mark; large brown stains on verso. Acquired by Lessing J. Rosenwald from C. A. Stonehill, London, in June 1937 (with impression 3S). Lent by Rosenwald to the Philadelphia Museum of Art in 1939, no. 123 in the exhibition catalogue; probably the impression (state not given) lent to the University of Iowa in 1961, no. 24 in the exhibition catalogue. Given by Rosenwald to the National Gallery of Art in 1945 and moved from the Alverthorpe Gallery, Jenkintown, Pennsylvania, to Washington in 1980. Reproduced in Bindman, *Blake as an Artist*,

fig. 120 (image only); and in Keynes, *Engravings by Blake: The Separate Plates*, pls. 30 (left one third) and 33 (right one third), where the print is incorrectly identified as a Keynes third state (fourth state as enumerated here).

5RR.
National Gallery of Canada, Ottawa. Lightly printed on laid India paper. Very probably a Colnaghi restrike. Included in the Blake exhibition (*William Blake 1757-1827*) at the National Gallery in 1969-1970, no. 3 (reproduced) in the catalogue, where the size (apparently of the plate mark) is given as 35.2 × 96.2 cm. Acquired from E. Weyhe of New York in 1921. Not seen; information kindly supplied by Douglas Druick of the National Gallery.

5SS.
New York Public Library. Printed on thin laid paper with chain lines 2.9 cm apart. Pasted down and discolored when first received by the library,[10] but now removed from the mount and cleaned. Image 30.5 × 94.6 cm; plate mark 35.4 × 96.4 cm; sheet 50.8 × 106.4 cm. Ragged lower edge of sheet and with old paste on the verso showing through on the recto along all edges. Printing creases just below and above the Wife of Bath; small abrasion right of the Yeoman's bow. Perhaps a Colnaghi restrike in spite of the unusual paper and heavy inking, including considerable residual ink printed from the plate's surface. Given to the library by Claude P. Marsh in November 1941. Reproduced in two sections, image only, as the endpapers in James Daugherty, *William Blake*, New York: Viking Press, 1960.

5TT.
Jeremy M. Norman, San Francisco. A Colnaghi restrike, rather flatly printed on India paper laid on wove, framed and matted. Sold at Sotheby's, Los Angeles, 29 June 1975, lot 82 ($2,200 to Jeremy Norman & Co.).

5UU.
Philadelphia Museum of Art. A Sessler restrike on wove paper watermarked FRANCE, lower right. Image 30.5 × 94.5 cm; plate mark 35.7 × 96.6 cm; sheet 44.1 × 101.7 cm. Purchased from Sessler's in August 1941 by Staunton B. Peck for $35; given by him to the Museum in 1941.

5VV.
Princeton University Library, Princeton, New Jersey. Darkly printed on wove paper, framed and matted within the plate mark. Small fragments of the drypoint inscriptions added in the fourth state, right of the title, are visible. Probably one of the five Sessler restrikes purchased, according to their records, from Sessler by "Newton" in May 1941 for $35 each, or one of the two bought by "Newton" in February 1946 for $35 each. Lent by Miss Caroline Newton to Princeton University in 1968 and again in 1969, no. 84b in the exhibition catalogue,

[10] According to Elizabeth E. Roth of the New York Public Library.

and given by her to the University Library shortly thereafter. For an impression once in the collection of Miss Newton's father, see untraced impression 38.

5 WW.
Dr. David Shneidman, Midland, Texas. A Colnaghi restrike, lightly printed, matted and framed. Acquired by Erwin H. Furman, Los Angeles print dealer, *c.* 1925-1940, and given by his wife to Professor and Mrs. Edward Hooker *c.* 1940. Given by Mrs. Hooker in 1975 to the present owner. Not seen; information supplied by Mrs. Evelyn Hooker and the present owner.

5 XX.
Norman H. Strouse, Saint Helena, California. Framed to 42.5 × 94.3 cm. Mr. Strouse believes he acquired the print either in Detroit, *c.* 1952, or from Mrs. Stanley Resor in New York, *c.* 1956. Not seen; information kindly supplied by the owner. See also impression 3E.

5 YY.
University of Texas, Austin. A Colnaghi restrike, flatly printed on India paper laid on wove, foxed and browned. Image 30.2 × 93.9 cm; plate mark 35.3 × 96 cm; sheet 50.3 × 118.2 cm. Purchased by the University in 1965 as part of the collection of T. Edward Hanley. Not seen; information kindly supplied by Kathleen Gee of the University of Texas.

5 ZZ.
Professor Richard A. Vogler, Northridge, California. Well printed on India paper laid on heavy wove. Perhaps a Colnaghi restrike. Image 30.4 × 93.9 cm; plate mark 35.6 × 95.8 cm; sheet 49.6 × 111.1 cm. Acquired by Erwin H. Furman, Los Angeles print dealer, *c.* 1925-1940. Acquired by Professor Vogler in May 1981 from Furman's widow, Vivien d'Estournelles de Constant.

5 AAA.
Wesleyan University, Davison Art Center, Middletown, Connecticut. Printed on wove paper, framed and matted to the plate mark. The penultimate word in the quotation from Chaucer (*you*) prints very faintly and the final word (*spede*) prints only as a slight blind embossment in the paper. Given to the University's Art Center by George W. Davison in 1937. Davison acquired many of his engravings from the New York dealer M. A. McDonald, but it is not known if this print came from that source. Not seen; information supplied by Ellen D'Oench, Davison Art Center, Wesleyan University.

This is very probably the impression described "in the collection of George W. Davison" by Robert McDonald (a relative of the dealer M. A. McDonald?) in "William Blake's Canterbury Pilgrims," *Print Collector's Quarterly*, 25 (1938), 199 n.1. McDonald calls it a "unique impression," with the quotation from Chaucer "incomplete." It is not, however, a separate state (between the third and fourth enumerated

here) but only an impression of the fifth state with the inscription poorly inked.

5BBB.

Wilson College, Chambersburg, Pennsylvania. A Sessler restrike on wove paper, matted and framed. According to their records, Sessler sold the print to the College in May 1944 for $23.50. Not seen; information supplied by Alice L. Ingraham of Wilson College.

UNTRACED IMPRESSIONS of all states

Most of the following records, arranged in chronological order, of untraced impressions are taken from sales and exhibition catalogues. The large number of impressions, both traced and untraced, makes it extremely difficult to construct provenances with any degree of assurance. Some of the untraced impressions listed below are no doubt the same as the traced prints, and there are in all probability other extant impressions not recorded here in either category. The state designations given in the pre-1960 catalogues cited here generally follow the two-state system of Russell and Binyon (see note 2).

1.

Sold from the collection of Henry Fuseli, Sotheby's, 25 July 1825, lot 248, state not identified, with an impression of Stothard's "Pilgrimage to Canterbury" (£1 10s. to "Wainewright"). The purchaser was probably Thomas Griffiths Wainewright (1794-1852), a pupil of Fuseli's and a casual friend of Blake's (see Bentley, *Blake Records*, pp. 265-266).

2.

According to Henry Crabb Robinson's diary, Blake visited the home of Charles Aders and his wife, Elizabeth, and "brought with him an engraving of his Canterbury pilgrims for Aders" on 10 December 1825 (see Bentley, *Blake Records*, pp. 309-310). This is probably the impression for which John Linnell paid Blake £2 2s. on 17 August 1826 "for Aders Cant Pilgrims." See Linnell's general account books in Bentley, *Blake Records*, p. 592.

3 (and others?).

John Linnell records in his general account books the sale of "a print. Cant Pilgrim's, India-" to "Mr. Flowers" for £12 12s. 6d., and the transfer of this amount to Mrs. Blake, on 29 September 1827. Linnell made a further payment to Mrs. Blake "for proofs of the Canterbury Pilgrims" in September 1827 and perhaps other payments for "Proofs" through January 1828 but it is not possible to determine how many impressions were sold. See Bentley, *Blake Records*, pp. 594-595, 605. The print sold to Flowers might be the same as impression 3O or 4AA, the only impressions on India paper unquestionably printed prior to the Colnaghi restrikes in the late nineteenth century. In an undated letter to Linnell of 1825, Blake wrote that he had sent Linnell "the

Pilgrims [an impression of the print?] under your Care with the Two First Plates of Job," but it is unclear whether this was a sale, gift, or loan (see Keynes, ed., *Letters of Blake*, p. 156). One of these impressions acquired by Linnell may be the print once owned by Samuel Palmer; and another the impression which his son, A. H. Palmer, saw hanging in Linnell's home at Redstone Wood, Surrey.[11] One of these, or a further impression first acquired by Linnell, may be the one sold from the collection of John Giles, Samuel Palmer's cousin, at Christie's 4 February 1881, lot 483, with the copperplate (£35 to Colnaghi). See also impressions 7 and 18 and the history of the copperplate discussed below.

4-6.
According to Crabb Robinson's diary, on 8 January 1828, Mrs. Blake sold three impressions for £2 12s. 6d. each. A "proof" went to "Field" (Barron Field, 1786-1846) and two "prints" went to Robinson, one of which he intended to give to Charles Lamb. He did not deliver it to Lamb until 22 May 1828. See Bentley, *Blake Records*, pp. 362, 367-368.

7.
John Linnell records in his general account books the sale of "a proof of Blake's Canterbury pilgrims" to Samuel Boddington for £3 3s. on 30 March 1835. See Bentley, *Blake Records*, pp. 404, 597. The print sold to Boddington may be one of those acquired by Linnell in 1827 and 1828—see impression 3.

8.
Offered by Evans & Sons, 1857 catalogue, item 648, state not given (£2 2s.).

9.
Sold from the collection of the Rev. Samuel Prince, Sotheby's, 11 December 1865, lot 269, state not recorded (£3 5s. to Timmins).

10.
Lent by Horace E. Scudder to the Boston Museum of Fine Arts in 1880 and 1891, nos. 10 and 113a in the exhibition catalogues (state not recorded), and by Mrs. Scudder to the Fogg Art Museum in 1924 (state not recorded in the typescript handlist of the exhibition).

11.
Offered for £7 10s. on p. 2 of Quaritch's advertising flyer, "William Blake's Original Drawings," dated May 1885. The Broad Street address is quoted from the imprint, and thus this must have been a first, second, or third state. The size is given as 37 inches (94 cm, apparently the width of the image or the sheet cut close) by 22 inches (55.9 cm, apparently the exceptional height of the sheet). The same impression, with the same dimensions, is offered for £7 10s. in Quaritch's *General Catalogue of Books* of 1887, item 13,846; and again in Quaritch's February 1891 catalogue, item 99 (£5).

[11] In a letter to Edwin Wilkins Field (1804-1871) of October 1864 Samuel Palmer writes, "I have an impression of Blake's Canterbury Pilgrimage but otherwise should have been anxious to avail myself of your very kind offer" [apparently to give an impression to Palmer or at least let him study one]. See Lister, ed., *Letters of Palmer*, II, 710. E. W. Field is apparently not related to Barron Field (see untraced impressions 4-6), who died childless. For A. H. Palmer's reference to the "Canterbury Pilgrims . . . hanging in one of the bedrooms at Red Stone wood when I was staying there [as] a little child," see Bentley, *Blake Records*, p. 292 n.2.

12.
Lent in 1893 by Edward J. Shaw to the Art Gallery and Museum, Walsall, Staffordshire, no. 32 in the exhibition catalogue, state not recorded. Not in the sale of Shaw's collection of works by Blake, Sotheby's, 29 July 1925, lots 141-67.

13.
Offered by Maggs Bros., December 1910, catalogue no. 263, item 35, "with margins," state not recorded (£11 11s.).

14.
Offered by Maggs Bros., December 1911, catalogue no. 277, item 179 (£38). The reproduction in the catalogue indicates that this is a third state; the price suggests that it is not the same as impression 13.

15.
Sold from the collection of R. A. Potts, Sotheby's, 18 June 1912, lot 238, state not given (£8 8s. to E. Parsons). Perhaps the impression offered by E. Parsons & Sons, June 1918, catalogue no. 282, item 472, "first state, large margins" (£45); and again in their November 1920 catalogue, item 537 (£45).

16.
Lent by "Miss Richmond" to the National Gallery, London, in 1913, no. 75 in the exhibition catalogue; and in 1914 to the Whitworth Institute, Manchester, no. 46A in the exhibition catalogue, the City of Nottingham Art Museum, no. 65 in the exhibition catalogue, and the National Gallery of Scotland, Edinburgh, no. 115 in the exhibition catalogue. In the first two catalogues this impression is described as "an example of the original issue." Perhaps acquired from Blake by George Richmond, and passed by inheritance to Miss Richmond. See impressions 5KK and 128 for others owned by the Richmond family.

17.
Sold from the collection of Frederic R. Halsey, Anderson Galleries, 26 February 1917, lot 20, "final state" ($32.50).

18.
Sold from the collection of John Linnell, Christie's, 15 March 1918, lot 5, state not recorded, with three prints not by Blake (£26 5s. to "Pausern," perhaps the dealer Palser). A note in the file copy of the catalogue in Christie's possession indicates that the vendor was "Lord Lamington" (acting for the Linnell estate?). Perhaps one of the impressions listed under no. 3 above.

19.
Lent (anonymously) by George A. Plimpton to the Grolier Club, New York, in 1905 and 1919, nos. 45 and 30 in the exhibition catalogues. The 1905 catalogue quotes the inscription "Ye gon to Canterbury . . . ," and thus the impression must have been in the fourth or fifth state. Plimpton's ownership is noted in records at the Grolier Club.

20.
Offered at auction "by order of Frederick H. Evans of London" at Anderson Galleries, 8 March 1920, lot 21, state not given (no information available on price or purchaser).

21.
Sold from the collection of Sidney Style, Sotheby's, 23 March 1922, lot 1170, state not given (£13 to Maggs). Perhaps the same as impression 25.

22.
Offered by Robson & Co., May 1925, catalogue item 48, state not recorded (£50).

23.
A typescript, written *c.* 1929 for the Philadelphia dealer A.S.W. Rosenbach, and now in the Rosenbach Library, lists an impression, state not recorded, in the W. A. White collection. Most of White's Blake collection was acquired *c.* 1890-1905. Perhaps the same as impression 3U.

24.
Sold from the collection of Hugh Campbell, Halifax, at Sotheby's, 10 March 1927, lot 270, state not recorded (£18 to Maggs).

25.
Listed in the 1927 catalogue of the collection of George C. Smith, no. 39. The impression is described as "11 ¾ inches by 37 inches, cut close and the title separated from the engraving. The address is cut away." Probably acquired by Smith from Maggs' 1924 catalogue no. 456, item 53, "fine impression, but cut close," with the "Order" of the *Songs* and the manuscript of Cunningham's life of Blake extra-illustrated with "Albion rose," impression 2D, "The Accusers of Theft Adultery Murder," impression 3G, and other works by Blake (£630). The print had not previously been part of this large collection of Blake materials; it may be the same as impression 21. Sold from Smith's collection, Parke-Bernet, 2 November 1938, lot 55, "height 12; length 35½ inches. Cut close. The engraving is attached to another engraving entitled 'The Canterbury Pilgrimage' after Stothard published July 1, 1836. The Blake engraving has no borders with the exception of one quarter of an inch at the bottom wherein the names of the characters represented appear. Attached to the engraving is a fragment of the title reading 'Chaucer's Canterbury. Painted in Fresco by William Blake & by him Engraved & Published October 8, 1810.' The remainder is lacking" ($15). Parke-Bernet has no record of the purchaser.

26.
Sold by G. C. Willoughby, London, at Sotheby's, 8 July 1929, lot 170, "the first issue with the address following the date" (£115 to Parsons). The catalogue notes an ink inscription below the imprint, "W^m Winfield, Esq., with C. H. Tatham's respects—Feb 1834."

27.
Sold at Sotheby's, 18 November 1929, "first state" (£50 to Maggs). Probably the impression offered by Maggs Bros., 1931, catalogue no. 558, item 141, "fine impression . . . , with margin" (£85). The illustration in the Maggs catalogue shows that the impression is in the third state (as enumerated here), has three small tears in the top edge extending just into the image, is cut unevenly along the lower edge, and is probably on laid India paper. Trimmed inside the plate mark. For the only traced third-state impression on laid India, see impression 30.

28.
Sold Sotheby's, 2 April 1930, lot 92, "first state, with the address following the date" (£75 to Manning).

29.
Sold Sotheby's, 1 March 1933, lot 157, "second state" (£9 5s. to "Neodle," perhaps Knoedler Gallery).

30.
Sold from the collection of the late Willis Vickery, American Art Association, Anderson Galleries, 1 March 1933, lot 25, "fine impression of the first state . . . on watermarked paper dated 1808, . . . full margin, partly folded under" ($130, no information available on purchaser).

31.
Sold Sotheby's, 25 May 1936, lot 204, "first state" (£9 to Maggs). Perhaps the same as impression 35.

32.
Sold from the collection of W. E. Moss, Sotheby's, 2 March 1937, lot 197, "framed and glazed . . . first state" (£58 to Rimell). This may be the impression acquired by Sessler, according to their records, from "Rimell" in March 1939 for $117.80 (although the price seems very low, given Rimell's cost). Sessler's sales records indicate the print was sold at Parke-Bernet on 28 May 1948 ($70 less 22 percent). See impression 4AA for another perhaps from the Moss collection.

33-34.
Sold Sotheby's, 1 June 1937, lot 282, "1st state, with the address following the date" (£31 to "NAGG"); and lot 283, "second state, on india paper" (£4 10s. to "Gaydon"). The second is probably a Colnaghi restrike.

35.
Offered by Maggs Bros., 1937, catalogue no. 651, item 5, "fine impression of the First State" (£52 10s.). Perhaps the same as impression 31.

36.
Sold Sotheby's, 8 March 1938, lot 178, "second state" (£9 10s. to Stonehill).

37.

Offered by E. Weyhe, December 1938 catalogue, item 130, "first state" ($150). Perhaps not sold, and thus the same as impression 3K.

38.

Sold from the collection of A. E. Newton, Parke-Bernet, 17 April 1941, lot 151, "height 13¼ inches; length 37⅜ inches. Matted and framed. A rare engraving in exceptionally fine state in spite of the tiny, light fox marks that appear in the margins" ($160 to Gannon). The auction catalogue quotes *Ye gon to Canterbury . . .* , and thus this must have been a fourth or fifth state. According to Newton, *A Magnificent Farce*, p. 215 n.1, the print was "on India paper," "a Christmas present from [his] wife several years ago," and was purchased by her from Rosenbach. Apparently the impression reproduced, image only, in *A Magnificent Farce*, facing p. 206. For an impression once owned by Newton's daughter, see impression 5VV.

39-123.

On 16 April 1941, the Philadelphia book and print dealer Charles Sessler purchased the original copperplate of "Chaucers Canterbury Pilgrims" at the A. E. Newton sale, Parke-Bernet, lot 150, for $2,300 on behalf of Charles J. Rosenbloom. Rather than delivering it directly and promptly to Rosenbloom, Sessler had restrikes taken from the plate by "Ernest D. Roth under the supervision of James McBey."[12] Sessler's purchase and sale records list sales of ninety-one restrikes, not counting the resale of returned impressions, those on consignment from earlier purchasers, or gifts. Among these sales are the Sessler restrikes listed individually (impressions 5HH [on consignment from an earlier purchaser], 5II, 5MM, 5PP, 5UU, 5BBB, and 132) which can be traced back to Sessler, leaving the eighty-five untraced impressions recorded here.[13] The Sessler restrikes (5GG, perhaps 5DD and 127) which cannot be traced back to Sessler are probably among those listed below. For all the restrikes, "Roth" was paid a total of $440.50 on a per copy basis on five dates: $200 on 15 May 1941 for forty impressions at $5 each; $85.50 on 28 May 1941 for nineteen impressions at $4.50 each; $45 on 18 June 1941 for ten impressions at $4.50 each; $90 on 2 July 1941 for eighteen impressions (on silk) at $5 each; and $20 on 14 February 1942 for four impressions at $5 each. Apparently as a commission for the use of his copperplate, Rosenbloom received, on 25 June 1941, $5 for each of thirty-five impressions sold. The eighteen impressions printed on silk were sold to "Cox" (Warren E. Cox), twelve at $20 each on 27 June 1941 and six at $12.50 each on 24 April 1942.[14] The remaining impressions were apparently printed on paper—very likely the wove paper of traced Sessler restrikes, showing a "FRANCE" watermark in impressions 5GG, 5PP, and 5UU, which Keynes has described as a Rives hand-made paper (see note 12). The Sessler restrikes I have seen are darkly and evenly printed. Their appearance suggests that a few of the finest lines have worn off the plate but that it was still in good condition and had been thoroughly cleaned and inked for these impressions. Payment dates, purchasers,

[12] According to Keynes, *Engravings by Blake: The Separate Plates*, p. 48, who also writes that Sessler "had thirty-five proofs pulled on French hand-made paper (Rives)." This number corresponds to the impressions for which Rosenbloom was paid a fee and not to the total printed and sold. The information given here on the Sessler restrikes, and a discussion of the possibility that some fifty-six pulls were not authorized by the owner of the plate, were first presented in Robert N. Essick and Michael C. Young, "Blake's 'Canterbury' Print: The Posthumous Pilgrimage of the Copperplate," *Blake: An Illustrated Quarterly*, 15 (1981), 78-82.

[13] Impression 5LL can be traced back to Sessler, but since it was a gift it does not appear in their sales records. There may have been other impressions printed but not recorded by Sessler.

[14] Sessler's records apparently give date of payment, not delivery. Some, perhaps all, of the impressions printed on silk and sold to Cox, a dealer in porcelains and other decorative goods, were made into lampshades by him. Examples are owned by John Fleming, New York, and Lucile Johnson Rosenbloom (widow of Charles J. Rosenbloom), Pittsburgh. Fleming originally purchased his lamp and shade in the 1940s for the great antiques dealer Philip Rosenbach for $500; he recalls that twelve were offered at that time for the same price each. I cannot bring myself to describe these curiosities in detail as "impressions" of the plate, although in a purely technical sense they are.

and prices for these untraced restrikes are as follows: 24 April 1941: Beadle, $35, returned 4 November 1941, resold Robinson, $50, 9 June 1942, returned 22 July 1942, resold Plaza, $23, 4 April 1944. 10 May 1941: Goodspeed, $20. 12 May 1941: Harlow Keppel, $20; McDonald, three at $20 each; Thomas, $35. 14 May 1941: Neilson, $35. 15 May 1941: Kidd, $20. 19 May 1941: Newton, five at $35 each (two of these, or the two sold to Newton on 12 February 1946 are probably impressions 5HH and 5VV); Hill, $20; Wells, $20, returned 10 June 1941; Mayer, $20; Keppel, three at $20 each. 26 May 1941: Rosenfeld, $35. 7 June 1941: Wells, two at $20 each. 1 July 1940 (error for 1941?): Shapiro, $20. 8 July 1941: Schapiro, three at $20 each, one at $35; Levering, $20, returned 17 July 1941, resold Newton, 12 February 1946, $35. 9 July 1941: Schapiro, $20. 11 July 1941: A. Rosenbloom, $35. 16 July 1941: Cox, two at $20. 14 August 1941: Burr, $35. 8 September 1941: Doubleday Doran, two at $35 each, returned 21 October 1941, one resold 12 December 1941, Holman, $20, the other resold 25 September 1942, Knoedler, $20. 8 October 1941: Sterne, $35. 4 November 1941: Russell, $50. 25 November 1941: Doubleday Doran, $20.75. 29 November 1941: Knoedler, $20. 14 February 1942: Cox, four at $10 each. 31 October 1942: Serinson, $20. 4 February 1943: Castle, $35. 29 December 1943: Kelleher, $25. 21 April 1944: Jennson, $20. 27 April 1944: Duschnes, $20. 12 May 1944: Harlow and Co., $20, returned 22 May 1944, resold Arthur H. Harlow, 10 February 1947, $20. 24 May 1944: Duschnes, $20. 5 June 1944: Duschnes, $20. 11 December 1944: Shapiro, $20. 6 January 1945: Duschnes, $20. 12 April 1945: Kleeman, $20. 12 February 1946: Newton, $35. 13 August 1946: Closson, $20, returned 13 September 1946, resold Freeman, 4 February 1947, $9.35. 4 November 1946: Shapiro, $20. 21 November 1946: Richard Ellis, $45. Not dated, but grouped with 1946 sales: Shapiro, $20. 25 April 1947: to cash, $35. 19 January 1948: Jones, $35, repurchased 9 December 1954 for $15, resold same day, Duschnes, $35. 17 April 1948: Knoedler, $20. 14 December 1948: Woodruff, $35. 10 February 1949: Parke-Bernet, $46.80. 12 November 1949: to cash, $35. 15 May 1953: C. C. Savage, $35.

124.
Sold from the collection of William H. Woodin, Parke-Bernet, 6 January 1942, lot 59, "fourth [i.e., final] state" on "India paper," matted and framed (no information on price or purchaser available). Probably a Colnaghi restrike.

125.
Sold Sotheby's, 20 May 1942, lot 179, "first state" (£52 to Colnaghi).

126.
Sold Sotheby's, 8 July 1942, lot 202, "first state with the address" (£40 to McDonald). Perhaps the impression received on consignment by Sessler (according to their records) from McDonald at $265 on 22 May 1943; returned 20 March 1945.

127.
Allan R. Brown, in a letter of 25 October 1942 to Ruthven Todd, mentions a "late impression" (i.e., a Colnaghi or Sessler restrike?) then in his collection. A copy of the letter is in the Brown Collection at Trinity College, Hartford, Connecticut; the print is not.

128.
Sold from the estate of R. T. Richmond, Sotheby's, 6 February 1946, lot 59, described as Russell's "second state" (£46 to Colnaghi). Colnaghi's has no record of this purchase, probably executed for a private client. For other impressions owned by the Richmond family, see impressions 5KK and 16.

129.
Offered by W. C. Elly, Liverpool, October 1947 catalogue, "first state" (£58). On his clipping from the catalogue, Keynes has noted that this is a "second state."

130.
Sold Sotheby's, 27 April 1949, lot 268, "second state" (£8 to "Com[yg?]min," perhaps the Bournemouth bookdealer Horace G. Commin).

131.
Offered at Sotheby's, 30 April 1953, lot 365, state not recorded (withdrawn from the auction).

132.
A Sessler restrike purchased from Sessler's by Henry S. Borneman on 3 May 1941 ($35); sold from Borneman's collection, Parke-Bernet, 1 November 1955, lot 231 ($55; no record available of purchaser).

133.
Sold Sotheby's, 22 January 1958, lot 52, "second state" (£24 to Craddock & Barnard). Probably the impression offered by Craddock & Barnard, October 1959, catalogue no. 93, item 50, fifth state on laid India paper (£50). Probably a Colnaghi restrike. On his clipping from the catalogue, Keynes has noted that the impression was from the collection of Sir Russell Brain.

134.
Sold Sotheby's, 8 March 1965, lot 84, Binyon's "first state with margins, four vertical folds, time-stained," image 30 × 92.2 cm (£150 to Craddock & Barnard). Probably the impression offered by Craddock & Barnard, November 1965 catalogue, item 248, Keynes' "second state" (£250); offered again, June 1969 catalogue, item 92 (£250).

135.
Sold Sotheby's, 31 May 1965, lot 57, Binyon's "first state (with added verse in pen and ink), with margins, broken along the right plate mark," image 30 × 94.4 cm (£120 to F. Salamon).

136.
Offered by Craddock & Barnard, November 1965 catalogue, item 249, Keynes' "fourth state" on "Japan paper" (£120). Probably a Colnaghi restrike. Now (1982) in the collection of Raymond Lister, Cambridgeshire.

137.
Sold Sotheby's Belgravia, 29 October 1971, lot 128, Keynes' "fourth state," image 30.7 × 95 cm (£110 to Christianson).

138.
Offered by Colnaghi, November-December 1972 catalogue, *Original Printmaking in Britain 1600-1900*, item 127, Keynes' fourth state, an "impression taken between 1880 and 1941 while the plate was in the possession of Colnaghi's" (£120). The separate price list describes this as "a very good impression on laid India paper, three long printer's creases at the left, some repaired tears in the margins." Plate mark 35.1 × 95.3 cm. Sold to a private customer; no further information available.

139.
Sold Christie's, 6 December 1973, lot 9, fifth state, "damaged at the edge of the subject at both ends, margins on two sides, damp-stains in the title margins, framed" (£136 10s. to Morris Ayres). Sold by Ayres (now deceased) to an unknown collector.

140.
Sold Sotheby's Belgravia, 15 April 1975, lot 16, Keynes' fourth state "on thick wove, a good impression though worn in the lettering, with margins, slightly foxed, and with two small tears in the lower margin," plate mark 35.1 × 96.2 cm, reproduced (£280). Probably a restrike.

141.
Sold by Lowell Kerr of New York at Sotheby's New York, 23 June 1976, lot 318, final state, some foxing and staining ($175). Very probably a restrike. Mrs. Kerr believes that her late husband acquired the print at Parke-Bernet, New York, in 1948 for $60.

142.
Sold Christie's, 18 April 1978, lot 129, Keynes' fourth state on wove paper, plate mark 35.7 × 96.4 cm, reproduced (£240 to "Garton"). Probably a restrike.

In May 1809, Blake opened an exhibition of his paintings at his brother's house, 28 Broad Street, Golden Square. Included as the third painting, according to *A Descriptive Catalogue* Blake wrote to accompany the exhibit, was "Sir Jeffery Chaucer and the nine and twenty Pilgrims on their journey to Canterbury."[15] This "tempera"[16] painting (Fig. 42), 46.7 × 137 cm and now in the Stirling Maxwell Collection, Pollok House, Glasgow, is the basis for the etching-engraving. The

[15] Erdman, ed., *Poetry and Prose of Blake*, p. 523. Blake exhibited the painting again at the 1812 exhibition of the Associated Painters in Water Colours, 16 Old Bond Street, London, no. 254 in the catalogue.

[16] It is unlikely that this or other so-called tempera paintings by Blake were painted in true egg tempera. The pigments were probably suspended in a glue or low-solubility gum medium, sometimes called "size-colour" or "distemper" in Blake's time.

Part One.
Plates Designed and Executed by Blake

[17] See Butlin in the 1978 Tate Gallery exhibition catalogue, p. 108.

[18] Smith, *Nollekens and His Times*, II, 467. John Linnell, in his annotations in his copy of this book, disputes much in Smith's account, but not the time when Cromek saw these designs (see Bentley, *Blake Records*, p. 464 n.1). Gilchrist, *Life of Blake* (1863), I, 203-204, places the incident slightly later in 1806, "while Schiavonetti was at work on his etchings from the Designs to Blair."

[19] *Life of Blake* (1863), I, 230. As is usually the case, Gilchrist does not cite his evidence for this statement.

[20] Michael Phillips very generously informed me of the present location of this drawing. The photograph and information about the drawing and impressions 3I and 3T have been supplied by Irena Zdanowicz of the National Gallery of Victoria.

[21] The only extant copy of the prospectus, now in the British Library, is on paper watermarked 1807. Two of the three extant copies of the advertisement of four pages are on paper watermarked 1810 (see Bentley, *Blake Books*, pp. 110-111). There is also a draft of the advertisement in Blake's *Notebook*, pp. 117-119. For texts, see Bentley, ed., *Blake's Writings*, II, 823-824, 863-866, 1004-1006. Gilchrist, *Life of Blake* (1863), I, 204, mentions that "a subscription paper for an engraving of the *Canterbury Pilgrims* had been circulated by Blake's friends" in 1806. Crabb Robinson also refers to such a "subscription paper" (Bentley, *Blake Records*, p. 538), but none earlier than the 1809 prospectus has survived.

[22] W. M. Rossetti, in his list of Blake's engravings in Gilchrist, *Life of Blake* (1863), II, 257, and (1880), II, 279, dates the plate 1817, but this is probably a simple error.

date on the painting is now obscured, but has in the past been read as 1808.[17] It seems likely, however, that Blake began work on the design as early as 1805. According to John Thomas Smith, R. H. Cromek saw "designs sketched out for a fresco picture; the subject Chaucer's 'Pilgrimage to Canterbury,' " during the time he employed Blake to illustrate Blair's *Grave*.[18] This commission began in September or early October 1805, and by the end of that year Cromek had taken away from Blake the potentially lucrative task of engraving the *Grave* designs and had delivered them to Louis Schiavonetti for their rendering in copper. The execution of the engraving of the Chaucer design must have also taken a good deal of time, considering the size of the plate. Gilchrist states that "in September or October 1809, the engraving of [Blake's] *Canterbury Pilgrimage* was commenced."[19]

One customary step in the translation of a large painting to a somewhat smaller plate was the preparation of a "reduced" drawing. The pencil sketch of the design (Fig. 43), now on deposit at the National Gallery of Victoria, Melbourne, from the collection of Merlin Cunliffe, very probably fulfilled this purpose. At 34.3 × 95.4 cm it is close to the size of the engraving.[20] On the verso of the sheet, watermarked J WHATMAN, are a number of swirling pencil lines, not clearly related to the recto design, and a pencil inscription by Frederick Tatham: "The Original reduced Drawing | made to reduce the Picture of the Canter | -bury Pilgrims to the size of the Plate Blake | afterwards engraved." There are also three pen inscriptions, the last initialled "H. C." (Henry Cunliffe), which repeat Tatham's note, refer to Cunningham's life of Blake, and record Cunliffe's purchase of the drawing at Sotheby's, 28 April 1862, lot 161. Keynes, *Engravings by Blake: The Separate Plates*, p. 49, states that the drawing has been "squared" for engraving, but there is no evidence of this on the now rather dirty and faded sheet. This or a more finished drawing preliminary to either the engraving or the painting must have been the "original design which Blake hung over a door in his sitting-room" (according to Gilchrist, *Life of Blake* [1863], I, 225). When taken down it was "nearly effaced," which Blake believed to have been caused by "some malignant spell." When told of this, Flaxman "mildly expostulated, 'Why! my dear sir! as if, after having left a pencil drawing so long exposed to air and dust, you could have expected otherwise!' " This is one of Gilchrist's stories which cannot be accepted without question, but it would explain the present condition of the drawing reproduced here, Fig. 43.

Blake issued a broadsheet prospectus for his print dated 15 May 1809. The price to subscribers is given as four guineas, reduced to three guineas in an undated advertisement apparently issued at about the same time as the engraving.[21] The first state of the plate was probably completed by October 1810 as indicated in the imprint.[22] The second and third states probably followed shortly thereafter. The paleness and rarity of the first two states suggest that they may have been intended primarily for hand coloring, and the considerable darkening added in the third state was intended to make the plate suitable for uncolored impressions. The extensive use of burnishing as an ele-

ment of composition in the fourth state is typical of Blake's nineteenth-century revisions of earlier plates. He may have done such work on other plates as early as 1804 (see "Albion rose," second state), but it is also possible that he did not learn how to use burnishing so skillfully until he met John Linnell in 1818 (see "Job," second state). The drypoint inscriptions (Figs. 40, 41) added to the fourth state provide a better key to its date.[23] The quotations from Chaucer ("A morrow when . . ." and "And gadrid us . . .") are taken from the end of the General Prologue to *The Canterbury Tales* and simply indicate the event portrayed, the pilgrims' leaving the Tabard Inn to begin their journey to Canterbury. The other drypoint inscriptions, "The Use of Money & its Wars" and "An Allegory of Idolatry or Politics," are Blake's own inventions and bring to the print language and concepts found in his writings of *c.* 1820-1827. In *On Homers Poetry* [and] *On Virgil* and the inscriptions on his "Laocoön" separate plate (*c.* 1821 and *c.* 1820), Blake implies similar connections between money and the wars of empire that destroy true art. In his annotations to Thornton's *The Lord's Prayer* (1827), Blake parodies Thornton's version of the prayer as an idolatrous allegory of war and politics: "For thine is the Kingship or Allegoric Godship & the Power or War & the Glory or Law Ages after Ages in thy Descendents for God is only an Allegory of Kings & nothing Else."[24] It seems unlikely that Blake would return to "Chaucers Canterbury Pilgrims" to add extensive burnishing and new inscriptions in the last few years of his life when he was occupied with the *Job* and Dante designs, and thus a date of *c.* 1820-1823 is probable for the fourth state.[25]

According to Henry Crabb Robinson, the "print of Chaucers pilgrimage" belonged to Mrs. Blake in January 1828.[26] By this he probably meant that the copperplate (Fig. 44) and impressions still in stock were her property. After Mrs. Blake's death in 1831, the plate may have passed to Frederick Tatham, who died in 1878. At an unknown time it was seen in a "shop window" by John Giles, Samuel Palmer's cousin and a friend of George Richmond's, and purchased by Giles "for the rapturous 'old song' so dear to the true Londoner of those days of amazing bargains."[27] Giles died in 1880 and the plate was sold with his collection at Christie's, 4 February 1881, lot 483, "Chaucer's Canterbury Pilgrims, by W. Blake; and the engraved steel [*sic*] plate" (£35 to Colnaghi). According to a brief announcement in *Notes and Queries*, 6th ser., 3 (5 March 1881), 200, Colnaghi's had impressions taken from it "on Japanese paper" (i.e., laid India). The present firm has no records about the number of impressions taken or over how long a time the plate was used. All of these Colnaghi restrikes are of course in the final, fifth state; most of those recorded are on laid India paper and are rather flatly printed, as though the plate had not been sufficiently cleaned and properly inked.[28] A few fifth-state impressions, well inked and printed on wove or laid India paper, may be another group of Colnaghi restrikes pulled at a different time than the India paper impressions with light inking and/or weak printing. A few of these good fifth-state impressions, such as 5ZZ, may have been printed in a very dark-brown ink, for they have a general brown

[23] These inscriptions, partly taken with minor variations from the 1687 issue of Thomas Speght's edition of Chaucer's *Works*, were first transcribed (inaccurately) in Robert McDonald, "William Blake's Canterbury Pilgrims," *Print Collector's Quarterly*, 25 (1938), 185-199. McDonald does not indicate the impression from which he is quoting, and only states that the print "appeared recently" (p. 197). Perhaps it was the copy from the Moss collection that passed through Sotheby's sales rooms in March 1937—see impression 4AA.

[24] Erdman, ed., *Poetry and Prose of Blake*, p. 659.

[25] A date in the early 1820s was first suggested in Bindman, *Complete Graphic Works of Blake*, p. 482.

[26] Bentley, *Blake Records*, p. 362.

[27] According to A. H. Palmer in his "Princess" Notebook No. 7, p. 352, now in the collection of Joan Linnell Ivimy. I am grateful to Raymond Lister for this information, first noted in his *Samuel Palmer, A Biography*, London: Faber and Faber, 1974, p. 52. Palmer does not indicate when Giles purchased the plate, but Lister believes it to have been sometime in the 1860s or 1870s.

[28] The complete cleaning of an old copperplate, etched and engraved in intaglio, is a laborious task. All the solidified ink deposited from previous printings must be removed from each line. I have found that the only way to accomplish this is to clean each line, no matter how small, with a sharp splinter of pine (or some other soft wood that will not scratch the copper) dipped into kerosene or some other solvent. Most of those impressions very likely printed by Colnaghi bear all the hallmarks of pulls from an improperly cleaned plate.

tonality when seen in natural light. For Colnaghi restrikes, see impressions 5DD-5FF, 5JJ, 5KK, 5NN, 5OO, 5RR-5TT, 5WW, 5YY, 5ZZ, 34, 124, 127, 133, 136, and 138 recorded here.

The copperplate next passed into the hands of the New York dealer Gabriel Wells no later than April 1940. Early in that month, William Hobart Royce, one of Wells' representatives, sold the plate to Mrs. A. Edward Newton, who presented it to her husband on their fiftieth wedding anniversary, 7 April 1940.[29] After Newton's death, it was sold with his collection at Parke-Bernet, 16 April 1941, lot 150 ($2,300 to Sessler's on behalf of Charles J. Rosenbloom, Pittsburgh). Before delivery to Rosenbloom, Sessler's reprinted the plate—see impressions 39-123 for details, plus impressions 5DD, 5GG-5II, 5LL, 5MM, 5PP, 5UU, 5VV, 5BBB, 127, and 132. Like the Colnaghi restrikes, the Sessler impressions have image and plate-mark dimensions somewhat larger than the prints of states one through four. The plate-mark width of the earlier states averages about 95 cm, whereas most of the restrikes range between 96 and 97 cm. Since this last figure exceeds the size of the copperplate itself, the paper used for the restrikes must have stretched a little in all directions. This was probably caused by the way the paper was dampened and dried just before and after printing. The older papers, which show some shrinkage in comparison to the copperplate, may have been treated differently during printing, were simply more resistant to stretching, or have shrunk over the years more than the recent impressions.

In October 1973, Rosenbloom bequeathed the copperplate to the Yale University Art Gallery, New Haven, Connecticut. The copper has crystallized, as is to be expected, but the plate is in good condition without much evidence of wear and no damage. The lines are clogged with old, solidified ink which permits one to see the image clearly (Fig. 44). The areas where the drypoint inscriptions were added in the fourth state are now smooth and bare, showing no evidence of inscriptions, scraping, or burnishing. This suggests that the drypoint inscriptions, typical of preliminary trial lettering of the sort not intended to appear in published impressions without deeper and more careful engraving, were never purposely removed and simply wore off the plate after a small number of pulls were taken. Thus, the fourth state may have been the last executed by Blake. The verso of the plate shows a number of impressions from a ball peen hammer and chisels. None of these marks correspond to areas on the recto that could have required knocking-up from the back during the reworking of the design; they were probably made as part of the original planishing of the copper before Blake began work on the image. There are two plate maker's marks on the verso, top right and bottom left. Both read HARRIS | N° 31 SHOE LANE | LONDON.[30]

"Chaucers Canterbury Pilgrims" was one of Blake's major attempts at building a reputation as a painter-engraver and achieving the sort of critical and financial success that had escaped him for so many years. In the previous century, Joshua Reynolds, Benjamin West, and their engravers and publishers had become famous by publishing prints after large paintings of historical or literary subjects. James Barry, whom Blake admired, and George Stubbs had tried, with less success,

[29] The story is recounted in the Parke-Bernet sale catalogue of the Newton Collection, I, 77.

[30] This firm's plate mark (G. HARRIS | N° 31 SHOE LANE | LONDON) also appears on the copperplate of the title page to Blake's *Job* engravings. The address is incorrectly recorded as N° 3 in Bentley, *Blake Books*, p. 618.

to engrave and publish their own designs and avoid the conventional method of publication in which artists had to share their profits with copy engravers and publishers. The Chaucer plate—by far the largest Blake ever executed—comes near the end of this tradition and follows the precedent of complete artistic and financial control established by Barry and Stubbs.

The importance Blake placed on his Chaucer design is demonstrated by the extended consideration he gave to it in his writings of *c.* 1809-1812. In the *Descriptive Catalogue*, Blake devoted twenty-seven pages of his sixty-eight-page booklet to a description of the painting. Here, and more briefly in the 1810 advertisement for the print (see note 21), he describes each pilgrim in turn, much as Chaucer had in his General Prologue, and stresses the ways in which they are eternal archetypes of human character, "the physiognomies or lineaments of universal human life, beyond which Nature never steps."[31] In the prospectus of 1809, Blake places his print in the tradition of original graphic art represented by the "finished Line manner of Engraving, similar to those original Copper Plates of Albert Durer, Lucas [van Leyden], Hisben [i.e., Hans Sebald Beham], Aldegrave [i.e., Heinrich Aldegrever] and the old original Engravers, who were great Masters in Painting and Designing, whose method, alone, can delineate Character as it is in this Picture, where all the Lineaments are distinct."[32] "Chaucers Canterbury Pilgrims" is the nominal subject of several passages of the *Public Address* which Blake began to write in his *Notebook, c.* 1810, but this work expands into a more general defense of Blake's style of engraving and an attack on the domination of reproductive engraving over original graphics.

In light of Blake's comments on Chaucer's poem and his own print, in which both are extolled as examples of true art, the drypoint inscriptions about war, money, and politics added to the fourth state would seem to indicate a major reinterpretation of both text and design. In *On Homers Poetry* [and] *on Virgil* and the "Laocoön" inscriptions, war and money are associated with classical civilization, the enemy of the "Living Form" of Gothic art. Thus, it is more than a little disconcerting to find Blake applying, however tentatively, these concepts to England's greatest medieval poet. With his drypoint inscriptions, Blake directs our attention away from Chaucer's genius, stressed in the *Descriptive Catalogue*, and toward the economic motives so important to many of the pilgrims, the Knight's involvement in war, and the irreligion of Church politics.

Blake made a final attempt, in 1812, to bring his print before public notice in a sixty-two-page reprint, *The Prologue and Characters of Chaucer's Pilgrims, Selected from His Canterbury Tales; Intended to Illustrate a Particular Design of Mr. William Blake, Which is Engraved by Himself.* The preface contains an advertisement for the print; and for the frontispiece Blake engraved, rather crudely, a reduced version of a section from the large plate extending from the Parson to the Merchant.[33] A notice on the title page indicates that Blake continued to try to sell the print at his brother's Broad Street address, and at the print and book shops of both Colnaghi and Harris, but from all appearances with little success. Most contemporary connoisseurs

[31] Erdman, ed., *Poetry and Prose of Blake*, pp. 523-524.

[32] Erdman, ed., *Poetry and Prose of Blake*, p. 556. For a discussion of the style of the print, its debt to Basire's "antiquarian" style of etching-engraving, and its appropriateness for illustrating medieval poetry, see Essick, *William Blake, Printmaker*, pp. 188-192.

[33] For reproductions of the frontispiece (dated 26 December 1811) and an unsigned vignette of Canterbury Cathedral, see Easson and Essick, *Blake: Book Illustrator*, I, figs. IX(1-2). The preface is signed by "the Editor," who may have been Blake's friend Benjamin Heath Malkin (as Gilchrist tentatively suggests, *Life of Blake* [1863], I, 243).

Part One.
Plates Designed and Executed by Blake

[34] For Lamb's comments in a letter to Bernard Barton of 15 May 1824, now in the Huntington Library, see Bentley, *Blake Records*, pp. 284-286. Gilchrist, *Life of Blake* (1863), I, 231, indicates his agreement with Lamb. Binyon, *Engraved Designs of Blake*, p. 6, characterizes the plate as "mannered in drawing and heavy in execution," and Newton, *A Magnificent Farce*, p. 215, alludes to the "faulty technique."

[35] Smith, *Nollekens and His Times*, II, 467-471; Cunningham, *Lives of British Painters*, II, 163; Linnell, annotations to Smith's account in Bentley, *Blake Records*, p. 464 n.1; Gilchrist, *Life of Blake* (1863), I, 203-205, 223.

[36] Smith, *Nollekens and His Times*, II, 469, tells Stothard's version of the incident in which Blake visited Stothard while the latter was working on his Chaucer design. The implication is that Blake stole the concept from Stothard and rushed to finish his plate by 1810. Cunningham, II, 163, repeats this story, and Gilchrist, I, 204, tells a slightly different version without any implication that Blake took the idea for his picture from Stothard. The key to the affair would seem to be Cromek's involvement, which Stothard did not deny (see Bray, *Life of Stothard*, p. 130). Cromek's version is that he thought of the idea of a picture of Chaucer's pilgrims after reading *The Canterbury Tales*—see the "Biographical Sketch of Robert Hartley Cromek" in Robert Blair, *The Grave*, London: R. Ackermann, 1813, p. xlviii.

[37] An example with dated imprint is in the Yale Center for British Art, New Haven, Connecticut. George Cumberland, Jr., in a letter to his father of November 1809, noted that "the etching of Mr Stothard Pilgrims . . . is finished" (see Bentley, *Blake Records*, p. 220). Either he was mistaken or simply referring to the preliminary etching of the plate prior to any work with the graver.

[38] The involvement of Engleheart and N. Schiavonetti is described in Coxhead, *Stothard*, pp. 23-24. For a reproduction of the finished plate of Stothard's design, see *Blake in the Art of His Time*, University of California, Santa Barbara, 1976 exhibition catalogue, p. 29.

[39] Erdman, ed., *Poetry and Prose of*

probably found the print old-fashioned and "Gothic" in the pejorative sense. Even Charles Lamb, who praised Blake's comments on Chaucer in the *Descriptive Catalogue* and was generally sympathetic to the design, found the picture "hard, dry," and similar evaluations have been made in this century.[34] The record of prices brought by the print at auction indicates that it has attracted strong interest from collectors only in the last few years.

From its very inception, "Chaucers Canterbury Pilgrims" was embroiled in a controversy that deeply disturbed Blake. The story is confused by differences among the early accounts by John Thomas Smith, Allan Cunningham, Linnell, and Gilchrist,[35] but all agree that R. H. Cromek saw Blake's design early in its development and was attracted to the project of finishing such a composition and publishing it as an etching-engraving. In later years, Blake seems to have believed that Cromek commissioned him to complete the design, although Cromek denied this. Both Linnell and Gilchrist assert that Cromek tried to acquire Blake's design with the intention of having it engraved by William Bromley (1769-1842), much as he had purchased Blake's illustrations to Blair's *Grave* very cheaply and given them to Schiavonetti for their execution. Negotiations evidently broke down and Cromek went to Thomas Stothard and commissioned from him a panoramic view of the pilgrims. This Stothard began to do, perhaps unaware that his old friend Blake was working on a similar composition. According to Gilchrist, Stothard exhibited his painting in May 1807. Cromek issued a prospectus for the print, to be engraved by Schiavonetti, and bound it at the end of his 1808 edition of Blair's *Grave* containing Blake's illustrations. By this time, Blake was well aware of this rival to his own project.[36] In the *Descriptive Catalogue* of 1809, Blake harshly criticized the presentation of the pilgrims in Stothard's design and in Cromek's prospectus. At his death in 1810, Schiavonetti had completed only an etched proof of the plate, dated in the imprint 1 August 1810.[37] The copperplate was turned over to Francis Engleheart (1775-1849) for completion, but the death of Cromek in March 1812 interrupted progress. His widow next gave the plate to Niccolò Schiavonetti, Louis's younger brother and journeyman, but he too died. The plate was finally completed by James Heath and published 1 October 1817.[38] At 26.5 × 95.8 cm, the dimensions of the image are very close to Blake's plate. Stothard's design was a great popular success, but Blake believed that he had some revenge. In a *Notebook* verse beginning "And his legs carried it . . . ,"[39] Blake, speaking as though he were Death personified, takes ghoulish delight in the fact that so many of those who he believed had cheated him had died within a few years of one another. But Blake could not forget this thwarting of his hopes for "Chaucers Canterbury Pilgrims," and he apparently never forgave Stothard. Perhaps Blake's view of the entire affair is best represented by a mock title for his engraving that he jotted in pencil on page 51 of his *Notebook*: "The Canterbury Pilgrims | Engraved by William Blake tho Now Surrounded | by Calumny & Envy."

In recent years, "Chaucers Canterbury Pilgrims" has received more scholarly attention than any of Blake's other separate plates. The first

Part One.
Plates Designed and Executed by Blake

Blake, pp. 494-495. For an interpretation of this poem, see Essick and Paley, *Blair's Grave*.

[40] "William Blake as an Intellectual and Spiritual Guide to Chaucer's *Canterbury Pilgrims*," *Blake Studies*, 1 (1969), 139-190.

[41] Stevenson, "Interpreting Blake's *Canterbury Pilgrims*," *Colby Library Quarterly*, 13 (1977), 115-126; Allen, "Blake's Archetypal Criticism: *The Canterbury Pilgrims*," *Genre*, 2 (1978), 173-189.

[42] "The Artistic and Interpretive Context of Blake's 'Canterbury Pilgrims,'" *Blake: An Illustrated Quarterly*, 13 (1980), 164-190. The eighteenth-century background is also treated in Alice Miskimin, "The Illustrated Eighteenth-Century Chaucer," *Modern Philology*, 77 (1979), 26-55, but this essay contains numerous factual errors.

[43] "A Tentative Note on the Economics of The Canterbury Pilgrims," *Blake: An Illustrated Quarterly*, 11 (1977), 30-31. Todd's estimates are £1 10s. for the copperplate, 12s. 6d. for a sheet of paper adequate for two prints, and £2 for commercial printing of twenty-five impressions. Blake may have printed the plate in the rolling press he owned.

[44] "Blake and Chaucer: 'infinite variety of character,'" *Art History*, 3 (1980), 388-409.

[45] "Effigies of Power: Pitt and Fox as Canterbury Pilgrims," *Eighteenth-Century Studies*, 12 (1979), 481-502. Kiralis, p. 147, suggests that the Plowman looks a good deal like Blake himself. One possible reason for Blake to portray himself as the Plowman is that, as an engraver, he was a "plowman" in copper. According to Gilchrist, *Life of Blake* (1863), I, 204, Stothard "talked of introducing Blake (a good subject, by the way) into the Procession" in his version of the pilgrims. None of the figures in Stothard's painting or the print after it looks like Blake.

extended study, by Karl Kiralis, considers the design and descriptions Blake wrote about it as penetrating interpretations of Chaucer's poem.[40] Essays by Warren Stevenson and Orphia Jane Allen deal with the conception of character presented in the design and its relationship to ideas in Blake's poetry.[41] Betsy Bowden's informative article surveys the traditions of Chaucer illustration and commentary standing behind Blake's portraits of the pilgrims.[42] In the only recent essay to deal specifically with the print, Ruthven Todd offers some speculations on the price Blake paid for the Canterbury copperplate and his printing costs.[43] Claire Pace has discussed the faithfulness of Blake's design to the text, the background of Chaucer illustration and criticism, and Blake's "theories of characterization" in his writings on the design.[44] M. E. Reisner argues persuasively that Blake's presentation of the Pardoner is based on eighteenth-century portraits and caricatures of William Pitt the Younger, and his portrayal of the Summoner on pictures of Charles James Fox.[45] This previously unexplored political dimension to the iconography of "Chaucers Canterbury Pilgrims" may take on particular significance in the fourth state because of the references to "Money," "Wars," and "Politics" in its drypoint inscriptions.

XVII.
The Chaining of Orc

FIGURES 45-47

Relief etching (?)

One state: 1812 or 1813

Signature and date near right edge of the image, just right of the standing male's left knee: Type by | W Blake | 1812 [the last digit is unclear and the date may be 1813]

Image and plate mark: 11.1 × 8 cm

IMPRESSIONS

1A.
National Gallery of Art, Rosenwald Collection, Washington, D.C. Delicately printed on a sheet of wove paper, 11.5 × 8.6 cm, with the National Gallery of Art collection stamp on the verso. Possibly tinted with thin wash, upper left, although this gray area may be only ink printed from the surface of the plate. Mounted in a window cut in a sheet of paper bearing stab holes along the left edge. The last digit in the inscribed date is obscured by interference from the background. It was read by Russell and Binyon as 1813, and by Keynes, Bindman, and Essick as 1812.[1] For the history of this impression, see "Albion rose," impression 2D. Listed by George C. Smith in the anonymous catalogue of his collection in 1927, no. 40. Lent by Rosenwald to the Philadelphia Museum of Art in 1939, no. 225 in the exhibition catalogue; in 1957 to the National Gallery of Art, no. 73 in the exhibition catalogue; and in 1961 to the University of Iowa, no. 2 in the exhibition catalogue. Reproduced here, Fig. 45.

UNTRACED IMPRESSIONS

1.
Probably acquired by Alexander Gilchrist (died 1861), and lent by Mrs. Gilchrist to the Boston Museum of Fine Arts in 1880, no. 84 in the exhibition catalogue. As in W. M. Rossetti's description of this impression in Gilchrist, *Life of Blake* (1863), II, 258, the print is entitled in this Boston catalogue "Adam and Eve" and the date given as 1817. Acquired by E. W. Hooper, who lent it to the Boston Museum of Fine Arts in 1891, no. 10 in the exhibition catalogue, where it is noted that the date "is quite clearly 1813." Untraced since 1891.

Blake's earliest presentation of this subject is the design in the upper margin of pl. 3 of *America* (1793), where the postures and expressions of the figures are generally similar to those in "The Chaining of Orc." The design in *America* does not directly illustrate a passage in that poem, but the same or a very similar event is described on pl. 20 of *The Book of Urizen* (1794):

They [Los and Enitharmon] took Orc [their offspring]
 to the top of a mountain.
O how Enitharmon wept!
They chain'd his young limbs to the rock

[1] Russell, *Engravings of Blake*, p. 93 (where the print is entitled "The Chaining of Orc" for the first time); Binyon, *Engraved Designs of Blake*, p. 120; Keynes, *Engravings by Blake: The Separate Plates*, p. 50; Bindman, *Complete Graphic Works of Blake*, p. 482; Essick, *William Blake, Printmaker*, p. 163.

90

With the Chain of Jealousy
Beneath Urizens deathful shadow[2]

There is a brief reference to "Orc on Mount Atlas . . . chain'd down with the Chain of Jealousy" on pl. 3 of *The Song of Los* (1795), but the fullest description of this crucial event in Blake's mythology appears in "Night the Fifth" of *The Four Zoas* (c. 1795-1804), pp. 62-63 of the manuscript. Here, the "Chain of Jealousy" becomes one with Orc and enroots itself in the "rock & round the Cave." Los and Enitharmon attempt in vain to free "the terrible fiery boy." The large pencil sketch on p. 62 of *The Four Zoas* directly illustrates the passage. Los and Orc remain in the basic postures they assume in all versions of the subject, but Enitharmon bends over toward Orc on one knee and holds her hands on either side of her head rather than over her face. The final, brief references to Orc in chains appear on pls. 20 and 22 of *Milton* (c. 1804-1808).

Two pencil sketches, both in the British Museum, are probably preliminaries for the separate plate. The first (Fig. 46), only 2.8 × 2.1 cm, is in the upper right corner of an ungathered sheet (18.7 × 28.5 cm) from *Designs to a Series of Ballads, Written by William Hayley* (1802). Blake designed, engraved, and printed the illustrations for this work and frequently used sheets from it as sketching paper. The two versions of a design showing two twisting figures, just left of center on the *Ballads* sheet, the sketch of a running figure just left of the twisting figures, and the sketch of two figures either side of a serpent-entwined tree, lower left, were later used as marginal vignettes on pl. 2 of *The Ghost of Abel* (1822). The second pencil drawing, inscribed by Blake "Chaining of Orc" (Fig. 47), is about the same size (11.1 × 7.4 cm on a sheet 16.8 × 12.7 cm) as the plate.[3] The halo around Los's head, the dome surmounted by a cross, lower right, and the sketchy outlines of a Gothic cathedral, lower left, are added to the design for the first time. These are retained in the print, with right and left reversed; but the Gothic spires are hardly visible, Los's halo has been greatly enlarged, and a halo has been added to Enitharmon. The dome now has a lantern as well as the cross, making it look like St. Paul's Cathedral, London. A similar juxtaposition between the worldly church, which will be destroyed at the Last Judgment,[4] and the eternal, spiritual form of Gothic art is pictured on pl. 32 of *Jerusalem* (c. 1804-1820). The presence of these motifs in "The Chaining of Orc" suggests that the elemental psychological conflicts within the family group underlie the divisions between true and false religion.

It is extremely difficult to determine precisely the technique (or techniques) by which the print was executed. The word "Type" in the inscription is very good evidence that "The Chaining of Orc" is basically a copperplate relief etching because Blake calls the plates for his illuminated books "types" on pl. 3 of *Jerusalem* and refers to his first relief etching as a "Stereotype" at the end of *The Ghost of Abel*. Further, some of the darker areas left of Orc's head appear to be embossed into the paper, suggesting that these were printed from small relief plateaus. None of Blake's other relief etchings, however, show the fine, stipple-like texture visible in both bitten and relief areas on

[2] Erdman, ed., *Poetry and Prose of Blake*, p. 79. The other passages cited in this discussion can be found on pp. 66, 114, 116, 335-336.

[3] "Theotormon Woven," a pencil drawing in the Victoria and Albert Museum, London, is very close in style, size, and placement of the title inscription to this drawing of "The Chaining of Orc." This companion sketch (reproduced in Keynes, *Drawings of Blake*, pl. 23) may have been executed with the intention of eventual development into a print, but no such print has ever been recorded.

[4] See the dome, bearing a bent and broken staff which must have been a cross, in the background, lower right, of "The Day of Judgment," pl. 8 of Blake's illustrations to Robert Blair, *The Grave* (1808).

Part Two.
*Plates by Blake after Designs
by Others*

this plate. The 1891 Boston Museum of Fine Arts exhibition catalogue offers the intelligent speculation "that the stipple might have been produced by dry ground aquatint etched into relief, but the grain is too regular and too open" (p. 8). If Blake were experimenting with aquatint, the regularity of the patterns might be explained by sand-grain aquatinting after the basic forms were etched in relief. In this technique, which does not require the special dusting apparatus of most aquatinting methods, the plate is covered with the usual acid resist, a sheet of sandpaper placed face down upon it, and the plate run through a rolling press to make pits in the resist through which an acid can etch the copper.[5] But this process requires inking and printing in intaglio, and the print does not show the strong plate mark produced by intaglio printing. Thus, an alternative possibility suggests itself: the plate is an extremely shallow relief etching inked in both relief and intaglio areas with an inking ball lightly charged with very thick, tacky ink.[6] Such an inking method (combined with printing at light pressure) accounts for the relatively heavy deposits of ink on outlines, presumably standing above the plate in relief, and the absence of droplets of ink from several areas in the lower part of the image, presumably etched deeply enough to prevent the inking ball from touching them. Conversely, the whitest areas may be the relief plateaus, wiped clean of ink, and the dark areas very shallow depressions which retained the ink. It is also possible that the only extant impression is a maculature (i.e., a second impression without additional inking) and the odd stipple-like effects result from the removal of most of the ink during the first pull from the plate. Whatever the specific combination of etching, inking, and printing techniques Blake used to produce "The Chaining of Orc," the plate demonstrates his continued graphic inventiveness.

[5] I have not been able to find early descriptions of this technique; but like other aquatint and soft-ground etching processes, it was probably known by the late eighteenth century.

[6] The only extant copperplate etched in relief by Blake, a small fragment of rejected pl. a of *America*, is etched only .12 mm. I have been able to re-create some of Blake's reticulated or droplet inking effects, but nothing as delicate as those in "The Chaining of Orc." See Essick, *William Blake, Printmaker*, pp. 92, 101-103.

92

XVIII. Mirth

FIGURES 48-50

First state: c. 1816-1820

No inscriptions

Image: 16.1 × 12.2 cm

Plate mark: 23.2 × 20.7 cm[1]

IMPRESSIONS

1A.

British Museum. Printed on thin wove paper, 24 × 21.4 cm, pasted to a larger sheet which in turn is pasted to the mat. The whiteness of the paper and the faintness of the plate mark suggest that this impression was bleached and blotted flat before it was pasted down. Acquired at an unknown time by John Linnell, probably directly from Blake. After Linnell's death in 1882, it passed to a member of his family and then to the Trustees of the Linnell estate by 1913. Lent in that year by the Trustees to the National Gallery, London, no. 76 in the exhibition catalogue; and in 1914 to the Manchester Whitworth Institute, the Nottingham Art Museum, and the National Gallery of Scotland, Edinburgh, nos. 85, 69, and 49 in the respective exhibition catalogues. Sold by the Linnell Trustees at Christie's, 15 March 1918, lot 190, with "The Accusers," impression 3E, and "a parcel" of other plates by Blake (£54 12s. to A. Martin for the British Museum, which accessioned the print in April 1918). Exhibited at the British Museum in 1957, no. 60(1a) in the catalogue; and at the Tate Gallery in 1978, no. 251 in the catalogue. Reproduced here, Fig. 48.

Second state, c. 1820-1827

Inscriptions added within the image:
 upper left: SPORT | that wrinkled | CARE derides
 around the head of the figure holding his sides on the right: LAUGHTER holding both his sides

Inscription added in drypoint below the image: Solomon says Vanity of Vanities all is Vanity & what can be Foolisher than this

Dimensions: same as in first state. Framing lines have been incompletely scratched around the image to form a rectangle of 17.6 × 13.8 cm.

Blake has thoroughly scraped and burnished away all but the outlines of some of the figures and the lines and dots delineating the landscape in order to transform his stipple and line plate into a line and burnishing print. The linear patterns and illumination in the image have been completely and dramatically altered. The most significant changes are the use of burnishing to create great bursts of light just above the horizon and around the head of the central figure, the lowering of her left forearm and hand so

[1] Keynes, *Engravings by Blake: The Separate Plates*, p. 54, and Martin Butlin in the 1978 Tate exhibition catalogue, p. 123, give the plate mark as 17.5 × 13.8 cm. This is the (approximate) size of the rectangle formed by framing lines added in the second state that are well within the plate mark.

93

that it now appears below (rather than above) the soaring figure with his back to the viewer, the raising of her right arm at the elbow so that it now touches the gown of the figure above it, the darkening of the landscape with a shadow extending right and left from her right foot, the darkening of many areas in the sky with hatching and cross-hatching, the greater tilt down and to the right given to her head, the elimination of the curls of hair to the right and left of her face, and the addition of curls on top of her head and extending on her right side almost to the hem of her gown. The only known impression (2B) is probably a working proof pulled before Blake had completed his revisions, although there is no evidence that they were ever completed. The right foot of the central figure is unfinished and the inscription below the image is lightly scratched in drypoint, as is typical of trial lettering which is engraved more carefully and deeply in a published plate. It was also the usual practice in Blake's time to remove from a finished plate any burr of the sort visible as dark, velvety patches of ink left of the right foot and just right of the left thigh of the central figure.

IMPRESSIONS

2B.
Sir Geoffrey Keynes, Suffolk. Printed on wove paper, framed and matted within the plate mark. Seen by A.G.B. Russell, apparently in the shop of Mr. Robson and Co., 23 Coventry Street, London, and listed and reproduced by Russell in *Engravings of Blake* (1912), pp. 93-94 and pl. 14. Acquired from Robson in June 1916 by W. E. Moss,[2] and sold with his collection at Sotheby's, 2 March 1937, lot 200, where the size of the sheet is given as 21.5 × 17.5 cm (£70 to Keynes). Lent by Keynes to the British Museum in 1957, no. 60(lb) in the exhibition catalogue; and in 1978 to the Tate Gallery, no. 252 in the exhibition catalogue. Listed in Keynes, *Bibliotheca Bibliographici*, no. 561, where the sheet is described as "22 × 17.5 cm. without watermark." Reproduced here, Fig. 49.

The first state of the plate is based on Blake's first watercolor illustration to Milton's *L'Allegro* (Fig. 50), now in the Pierpont Morgan Library, New York. This carefully finished pen and watercolor drawing, 16.1 × 12.1 cm, is on paper watermarked M & J LAY 1816, thus providing a *terminus a quo* for the design. The year of the watermark has generally been taken as the approximate year in which the series of illustrations to *L'Allegro* and *Il Penseroso* were executed, but Martin Butlin has recently suggested that "there is no reason why they should not have been painted five or so years later."[3]

In the first state of the print, probably executed within a year or two of the watercolor, Blake has moved Mirth's left hand slightly to the right, turned the face of the figure just left of Mirth's right leg

[2] The date of acquisition is given in Keynes, *Engravings by Blake: The Separate Plates*, p. 54.
[3] "Thoughts on the 1978 Tate Gallery Exhibition," *Blake: An Illustrated Quarterly*, 13 (1979), 21.

from profile to three-quarter view, added cat-like whiskers and ears to the figure, lower right, eliminated the curl on top of her head, and added to and rearranged the groups of small figures, upper right, and those forming a halo around Mirth's head. The line and stipple technique of the first state is basically similar to many of the copy engravings Blake executed in the 1780s. Although "Mirth" is more energetic and open in its patterns than these reproductive prints, its style is well within the compass of early-nineteenth-century tastes in "fancy" prints of feminine subjects. The conventionality of the first state suggests that Blake intended it to be a commercially viable production, perhaps as the first in a series of prints reproducing all twelve of his *L'Allegro* and *Il Penseroso* illustrations.[4]

The changes wrought in the second state of "Mirth" are the most dramatic to be found among Blake's graphic revisions. The vitality of the design has been greatly heightened, both through stylistic alterations and such subtle revisions as the change in the position of Mirth's arms so that they now extend in direct counterpoise to each other. Ruthven Todd has suggested that the second state shows the influence of Giulio Bonasone on Blake's graphic style.[5] The only significant parallel would seem to be in the presentation, through the careful orchestration of lines and intervening white spaces, of bursts of illumination. For this technique one could also point to Albrecht Dürer's engravings, such as "The Virgin with the Swaddled Child" of 1520. These similarities, along with the provenance of the only known impression of the first state, suggest the possibility that John Linnell, who did not meet Blake until 1818, influenced the revision of "Mirth." According to Gilchrist and Alfred T. Story, Linnell directed Blake's attention to both Dürer and Bonasone.[6] Blake would have been long familiar with their work, but it is possible that Linnell's admonitions stimulated a renewed interest in the masters of pure engraving whose presence is felt in the *Job* engravings (1823-1826) even more forcefully than in "Mirth." The closest stylistic parallels are with the Dante engravings of 1826 which also show evidence of work with the dry-point needle. The figure of Francesca in the first Dante plate, "Paolo and Francesca in the Circle of the Lustful," is particularly similar to "Mirth" in the execution of outlines and hatching defining the figure and her swirling garment. It is possible that the second state of "Mirth" was not completed because of Blake's death on 12 August 1827. These associations suggest that the second-state revisions were made *c.* 1820-1827.

On a separate sheet accompanying the watercolor (Fig. 50), Blake inscribed the following explanation and lines quoted from Milton's *L'Allegro*:

> Mirth. Allegro
> Heart easing Mirth.
> Haste thee Nymph & bring with thee
> Jest & Youthful Jollity
> Quips & Cranks & Wanton Wiles
> Nods & Becks & wreathed Smiles
> Sport that wrinkled Care derides

[4] These have been reproduced in color, plus Blake's holograph descriptions, in Adrian Van Sinderen, *Blake the Mystic Genius,* [Syracuse, New York]: Syracuse University Press, 1949. For a detailed discussion of the watercolor series, see John E. Grant, "Blake's Designs for *L'Allegro* and *Il Penseroso*, with Special Attention to *L'Allegro* 1, 'Mirth and Her Companions,'" *Blake Newsletter*, 4 (1971), 117-134 (reprinted in Essick, ed., *The Visionary Hand*, pp. 419-448); continued, with particular reference to the separate plate, in Grant, "The Meaning of Mirth and Her Companions in Blake's Designs for *L'Allegro* and *Il Penseroso*," *Blake Newsletter*, 5 (Winter 1971-1972), 190-202.

[5] In his edition of Gilchrist, *Life of Blake* (1945), p. 368.

[6] Gilchrist, *Life of Blake* (1863), I, 284; Story, *The Life of John Linnell*, London: Richard Bentley, 1892, I, 225. For a more thorough discussion of Linnell's influences on Blake, see Essick, *William Blake, Printmaker*, pp. 219-223, 242.

And Laughter holding both his Sides
Come & trip it as you go
On the light phantastic toe
And in thy right hand lead with thee
The Mountain Nymph Sweet Liberty

These Personifications are all brought together in the First Design.
Surrounding the Principal Figure which is Mirth herself

There can be no question as to the identity of the central figure, and the inscriptions added in the second state indicate the personifications of Sport, Care, and Laughter. The figure, lower left, must be the "Mountain Nymph Sweet Liberty" pictured as a Diana-like huntress with open-toed boots, bow, arrow, and quiver. The identity of the other figures is not altogether certain. Keynes, *Engravings by Blake: The Separate Plates*, p. 53, makes the reasonable suggestion that the boy on Mirth's right is Jest and the girl on her left is Youthful Jollity. The two grotesques along the right margin, one with asses' ears and the other with spiked, bat-like wings or fins, are probably Quips and Cranks. Their contorted postures and odd combinations of human and animal parts suggest the conceits and twisted forms of speech they personify. Nods, Becks, and wreathed Smiles are probably the clusters of small figures in the upper part of the design, some arranged around Mirth's head like a wreath. Following Blake's statement on the verso of the watercolor that he has pictured "all" the personifications in the passage illustrated, we are left with the figure, lower right, as Wanton Wiles. Her ears, eyes, whiskers, and bonnet make her look very similar to Blake's anthropomorphic portrayal of the cat, Selima, in his third watercolor illustration to Thomas Gray's "Ode on the Death of a Favourite Cat" (*c.* 1797-1798).[7] The wantonness (i.e., unmanageability) and willfulness of cats are of course both traditional and true. The landscape does not directly illustrate the poem, although the buildings, left and right, may have been inspired by Milton's "Battlements" and "Towers" named later in the poem.

The portrayal of Mirth or Euphrosyne was a typical feature of eighteenth- and early-nineteenth-century illustrations to *L'Allegro*. One version that Blake probably knew was Richard Westall's, engraved by Thomas Kirk and published in volume III of *The Poetical Works of John Milton* (1797), edited by Blake's onetime patron William Hayley. Like Blake's Mirth, Westall's is a youthful girl skipping on tiptoe, right foot extended forward and left foot back, just above a low landscape. Her arms are raised, her long hair is loose, and she wears a diaphanous gown that swirls behind her. Two scholars have pointed to Henry Fuseli's oil painting of "Euphrosyne" (*c.* 1800) as another possible influence.[8] Fuseli, like Blake, pictures personifications of the types of humor named by Milton arranged around a large, central figure of Mirth. Laughter in this painting, and in Fuseli's pencil drawing of Mirth, Sport, Care, and Laughter (*c.* 1780-1785), has an oddly animal-like face similar to Blake's Laughter, particularly as he appears in the second state of the print.[9]

The inscription below the image added in the second state, taken in part from Ecclesiastes 1:2 or 12:8, adds further complexities, per-

[7] Reproduced in Irene Tayler, *Blake's Illustrations to the Poems of Gray*, Princeton: Princeton University Press, 1971.

[8] Gert Schiff, *Johann Heinrich Füsslis Milton-Galerie*, Zürich: Fretz & Wasmuth Verlag, 1963, p. 91; Marcia R. Pointon, *Milton & English Art*, Manchester: University Press, 1970, p. 165.

[9] For reproductions, see Schiff, *Füssli*, II, Figs. 907, 1757. Peter Tomory, in *The Poetical Circle*, p. 28, finds the parallels between Fuseli's drawing and the print "so similar" that he claims that Blake "had [Fuseli's] drawing by him." The evidence is not sufficient to support this conclusion.

Part One.
Plates Designed and Executed
by Blake

haps even ironies, to the meaning of the print. It is unclear whether the last word ("this") refers to the image or to the preceding words of the inscription. If the former, then Blake is proposing a Solomonic judgment on the vanity (i.e., worthlessness or foolishness) of mirth. If the latter, then the design comments on Solomon's words, and the foolishness is to be found in his solemnity when confronted with the energies of mirth. Something of the same complexity can be found in Blake's comments on humor in his letter to John Trusler of 23 August 1799: "Fun I love, but too much Fun is of all things the most loathsom. Mirth is better than Fun, & Happiness is better than Mirth. I feel that a Man may be happy in This World. And I know that This World Is a World of IMAGINATION & Vision."[10]

A pencil sketch of a floating female figure (15.2 × 9.3 cm, collection of Sir Geoffrey Keynes) is inscribed "Mirth" in Blake's hand.[11] This drawing of *c.* 1820-1825 would seem to be part of a group of at least four related compositions (inscribed "The Three Tabernacles," "The Church Yard," "Death," and "Hope") and is not directly related to the etching/engraving.

[10] Keynes, ed., *Letters of Blake*, p. 9. For further discussion of "Mirth," see Pamela Dunbar, *William Blake's Illustrations to the Poetry of Milton*, Oxford: Clarendon Press, 1980, pp. 122-125. Several errors in describing the small figures in the print mar this otherwise intelligent commentary.

[11] Reproduced in Keynes, ed., *Blake's Pencil Drawings, Second Series*, [London]: Nonesuch Press, 1956, pl. 19.

XIX.
Laocoön

FIGURES 51-53

One state: c. 1820

Signature, on the pedestal: Drawn & Engraved by William Blake

Other inscriptions: see the reproduction, Fig. 51. A complete text is printed in Erdman, ed., *Poetry and Prose of Blake*, pp. 270-272.

Image: 26.2 × 21.6 cm

Plate mark: 27.6 × 22.9 cm

IMPRESSIONS

1A.

Sir Geoffrey Keynes, Suffolk. Very well printed on wove paper, 38.2 × 27.7 cm.[1] Acquired at an unknown time by John Linnell, possibly from Blake himself. After Linnell's death in 1882 the impression passed to a member of his family and then to the Trustees of the Linnell estate. Sold by the Trustees at Christie's, 15 March 1918, lot 199 with *On Homers Poetry* [and] *on Virgil*, copy B, and *The Ghost of Abel*, copy B (£37 16s. to Quaritch for Keynes). Lent by Keynes to the British Museum in 1957, no. 61(1) in the exhibition catalogue. Described in Keynes, *Bibliotheca Bibliographici*, no. 562; Bentley, *Blake Books*, pp. 268-269, copy A. Reproduced here, Fig. 51.

1B.

Mrs. Lucile Johnson Rosenbloom, Pittsburgh. Printed on a sheet of laid paper with unevenly cut edges averaging 28.1 × 24.4 cm. Another impression, with the ink still wet, was apparently laid face down on this impression. Offsets from the right side of the damp impression are clearly visible as lines and letters, in reverse, along the left side of impression 1B, as a borderline along the bottom, and as reverse letters along the top just above the top line of the inscription.[2] The position of these offsets indicates that the wet impression rested at an angle of about two degrees relative to impression 1B, rising from left to right, with the framing lines matched at their upper left corner. Acquired at an unknown time by Emma W. Bucknell, who sold it at the American Art Association, New York, 2 April 1928, lot 76, described as framed and "laid down" ($610). Acquired by Paul Hyde Bonner, who lent it, still "mounted," to the Fogg Art Museum in 1930 for an exhibition in that year. Offered for sale with Bonner's library by Dutton's, New York, for $1,750. Purchased by George C. Smith and sold with his collection at Parke-Bernet, 2 November 1938, lot 57, "laid down on cardboard . . . in a full red levant morocco case" ($475 to Sessler's for Charles J. Rosenbloom). According to Sessler's records, Rosenbloom paid the auction price plus a 10 percent commission on 7 November 1938. It is probably at this time that the impression was removed from the mount, cleaned, and perhaps repaired.[3] After Mr. Rosenbloom's death in 1973 the print was inherited by his widow, the present owner, who lent it to the Tate Gallery in 1978, no. 315 in the exhibition catalogue. Described in Bentley, *Blake Books*, pp.

[1] Keynes, *Engravings by Blake: The Separate Plates*, p. 56, states that the print is on "Whatman paper without watermark." The sheet is certainly similar to Whatman paper, but since it lacks a watermark I am unable to identify its manufacture beyond reasonable doubt.

[2] These offset letters are incorrectly described as "traces of incompletely erased lettering," indicating that impression 1B "appears to be earlier" than impression 1A, in Bindman, *Complete Graphic Works of Blake*, p. 486.

[3] Keynes, *Blake's Laocoön*, p. 56, notes that this impression was "damaged, varnished, and laid down (though more recently cleaned and restored)." The print does not presently show any evidence of prior damage, except to the edges of the sheet, or varnishing.

268-269, copy B, where the print is described as having an "invisible" watermark. Reproduced in Bindman, *Complete Graphic Works of Blake*, fig. 623.

At an unknown time, probably late in 1814 or early in 1815, Blake was commissioned to engrave seven plates for Abraham Rees, *The Cyclopaedia; or, Universal Dictionary of Arts, Sciences, and Literature*. These plates were issued in fascicles published between 1816 and 1819. One of the four plates illustrating John Flaxman's entry on "Sculpture" was to include a picture of the late Hellenistic sculpture of the Trojan priest Laocoön and his two sons fighting with two serpents. For this purpose Blake visited the Royal Academy and made at least two drawings of the facsimile cast in the Academy's collection. The original marble sculpture, now in the Vatican Museum, lacked the right arms of the central and left figures and the fingers on the right hand of the figure on the right when it was rediscovered in the ruins of the Palace of Titus in Rome in January 1506. These had all been reconstructed on both the original and the Royal Academy cast.[4] One of Blake's pencil drawings (Fig. 52), measuring 19 × 15 cm on paper 32 × 22.8 cm, is now in the collection of Dr. and Mrs. Frederick Zimann, New York. The inscription by Frederick Tatham below the image records the circumstances of its composition: "This drawing was made by Mʳ Blake in the Royal Academy Somerset House for a small plate he made of the Laocoon for the Article in the Encyclopedia. The Article itself was on Sculpture being written by Flaxman. When Mʳ B. was drawing this his old friend Fuseli came in & said 'Why Mʳ Blake you a student you ought to teach us' in my possession from Mrs. Blake F Tatham."[5] A second pencil drawing, 53.4 × 43.8 cm and partially worked over with pen and ink, was once also in Tatham's possession. It was lent by George A. Smith to the Burlington Fine Arts Club in 1876, no. 23 in the exhibition catalogue (from which the information on size and medium is taken), and sold from the collection of William Bell Scott, Sotheby's, 21 April 1885, lot 171, described as "pen, washed with indian ink" (£2 to Pincott). I have not been able to trace this second drawing.

The extant drawing (Fig. 52) shows that Blake has already begun to modify what he saw in the Royal Academy cast. He has corrected the position of the restored right arm of the figure on the left, bending it over his head rather than reaching upward, tilted the head of the central figure a little more to his left, contracted the stomach muscles to suggest more strain and suffering, and turned the right knee further to the left to effect a wider stance. The first change was anticipated by Titian's simian caricature of the group, known through a reversed woodcut by Niccolò Boldrini of *c.* 1550, and accords with modern scholarly reconstructions.[6] The remaining alterations generally accord with Marco Dente's engraving of the original marble before restoration.[7] The change in the stomach muscles may have also been influenced by Johann Winkelmann's description, in his *Reflections on the Painting and Sculpture of the Greeks*, of the expressive force of Laocoön's body, particularly "the belly contracted by excruciating pains."[8]

[4] A photograph of the cast is reproduced in Keynes, *Blake's Laocoön*, p. 26. For an overview of opinions of the sculpture since its rediscovery, see Margarete Bieber, *Laocoon*, New York: Columbia University Press, 1942.

[5] The inscription is cropped in the reproduction. An expanded account of the meeting with Fuseli is given in Gilchrist, *Life of Blake* (1863), I, 248.

[6] Keynes, *Blake's Laocoön*, p. 27. Boldrini's woodcut is reproduced in Bieber, *Laocoon*, pl. 6.

[7] Dente's plate appears in Antonio Lafreri, *Speculum Romanae Magnificentiae*, published *c.* 1544-1577. Reproduced in Bieber, *Laocoon*, pl. 2.

[8] Translated by Henry Fuseli, London, 1765, p. 30. Blake's copy of this edition is in the collection of Sir Geoffrey Keynes. Winckelmann's possible influence on Blake's "Laocoön" is suggested in Keynes, *Blake's Laocoön*, pp. 13-14; and by Martin Butlin in the Tate Gallery 1978 exhibition catalogue, p. 146.

Blake preserved these changes in his stippled line plate, 25 × 14.8 cm and dated 1 October 1815 in the imprint, that he executed for Rees's *Cyclopaedia* (Fig. 53). A proof of this plate in the British Museum, lacking all letters and bearing on its verso an impression of Flaxman's illustration to Hesiod, pl. 27, engraved by Blake, is inscribed in pencil, "Blake went to the Royal Academy and made an original drawing of which this is a print. His interview there with his friend Fuseli was characteristic. Fred:. Tatham—." Blake also executed a large (53.7 × 43.5 cm) pencil, pen, and watercolor "Laocoön" now in the collection of Sir Geoffrey Keynes.[9] It shows Laocoön gowned[10] and the figures are disposed in ways completely unlike the sculpture and Blake's renderings of it. This drawing is not part of the development of the separate plate and was probably executed at a slightly later date, *c*. 1821-1825.

The reproductive project for Flaxman's encyclopedia article formed the basis for the separate plate, the inscriptions on which express ideas similar to those in *On Homers Poetry* [and] *On Virgil* written and etched *c*. 1821.[11] Further, both works contain explicit references to Book VI of Virgil's *Aeneid*. We know from Tatham's inscription that Blake kept the extant drawing in his possession; he probably also retained the untraced drawing. Thus, Blake could have referred back to either drawing or to an impression of the *Cyclopaedia* illustration when he was working on the separate plate. Blake has made further minor modifications in the design, partially closing the mouth of the figure on the right and altering his nose slightly, and shortening Laocoön's neck so that his beard almost touches his chest. Once again, these changes follow Marco Dente's engraving—but neither the original marble nor the Royal Academy cast. The boldly etched and engraved crosshatchings of the separate plate are reminiscent of the simple patterns used by Blake's master, James Basire, in his copies of Gothic artifacts for the Society of Antiquaries.[12] This style gives the sculpture far more solidity and volume than the delicate stipple of the *Cyclopaedia* plate. On the stone pedestal Blake has crossed his lines at right angles and added dot and flick work to suggest the rugged, chiseled texture of the stone. Burnishing adds highlights to the smoother surfaces of the figures, particularly prominent on Laocoön's left knee and thigh, chest, and face.

The most remarkable additions in the separate plate are of course the aphoristic comments engraved around and on all sides of the figures. Their presence alone transforms what might be considered a reproductive print into a work of original graphic art. The unconventional positions of the inscriptions militate against their consecutive arrangement as in a normal text, and they are best read as annotations to a central image. Their resistance to linear ordering stresses the thematic connections between each inscription and every other, even though they deal with such seemingly disparate subjects as ancient art, Jesus, and economics. Taken together they constitute one of Blake's last and most important statements on religion and the arts.

As Blake notes in the inscription below the sculpture, the original marble was executed by three artists of ancient Rhodes.[13] Far less conventional is Blake's assertion that the work is a copy of "Cherubim

[9] Reproduced in Keynes, *Blake's Laocoön*, pl. 4.

[10] In his *Descriptive Catalogue* of 1809, Blake refers to the artistic license taken by those works in which "Laocoon who, though a priest, is represented naked" (Erdman, ed., *Poetry and Prose of Blake*, p. 539).

[11] Russell, *Engravings of Blake*, p. 94, tentatively suggests a date of *c*. 1816-1817 for the separate plate, apparently on the assumption that it was executed shortly after the plate for Rees's *Cyclopaedia*. Keynes, *Engravings by Blake: The Separate Plates*, p. 56, dates the plate *c*. 1818; but in his *Blake's Laocoön*, pp. 21 and 56, Keynes suggests a date "probably about 1820." Bindman, *Complete Graphic Works of Blake*, p. 486, and Martin Butlin in the 1978 Tate Gallery exhibition catalogue, p. 145, also favor the slightly later date.

[12] For a discussion of the relationship between the graphic style of "Laocoön" and Blake's concept of Gothic art, see Essick, *William Blake, Printmaker*, pp. 195-196.

[13] According to Pliny, *Natural History*, xxxvi.37, they were Agesander, Polydorus, and Athenodorus.

of Solomons Temple." This comment is in accord with Blake's opinion that classical artifacts are copies of Hebraic archetypes. In his *Descriptive Catalogue* of 1809, Blake explains that the "Greeks and Hetrurians copied Hercules, Farnese, Venus of Medicis, Apollo Belvidere, and all the grand works of ancient art" from "those wonderful originals called in the Sacred Scriptures the Cherubim."[14] This theory is similar to the belief held by many seventeenth- and eighteenth-century linguists that Hebrew was the original language from which all others derived, to Jacob Bryant's etymological arguments about the Hebraic origins of the names of Greek gods, and to John Wood's theory that classical architecture was based on Hebrew models.[15] Such a theory necessarily leads to an ambivalent attitude toward classical works like the "Laocoön." They are worthy of careful study, which Blake has clearly given to the sculpture, but not for the sake of the "Nature & Imitation" he condemns in the inscriptions on the plate. Rather, Blake's purpose is to restore the sculpture to its original artistic and religious significance. The Rhodian copyists had reduced the group to a portrayal of "Natural Fact or History of Ilium," whereas the lost original from Solomon's Temple represented the spiritual history of Jehovah "& his two Sons Satan & Adam" as they struggle with the serpentine and destructive dualities of "Good" and "Evil" they have created. Thus, there is no reference to Laocoön on the plate, for in Blake's view the true original work had nothing to do with Trojan priests. The careful archaeological reconstruction of the sculpture presented in the design is accompanied by texts that supply a cultural and iconographic restoration.

From the inscriptions related explicitly to the "Laocoön," Blake moves outward, both spatially and thematically, to larger issues bearing on his own age as much as on the ancient past. The false dichotomy between good and evil has given birth to other dialectical struggles, such as that between "Riches & Poverty," that continue to plague the imaginative artist and true Christian. This heritage of materialism and rationalism from "Greece & Rome" has led to the belief that Adamic or "Natural Man," rather than "the Soul of Imagination," is the only mode of human existence. But "Jesus & his Apostles" are the true "Artists" who have revealed "The Divine Body" of truth. Working in the same spirit, Blake reveals the true "Laocoön." Artists and "Visionary Men" refuse to accept the "Empire" of "War and Dominion" which has as its paradigmatic foundation the epistemology of binary opposition. It is this structure that Blake finds omnipresent in European thought—whether religious, artistic, or economic. And it is this structure in its primary ethical manifestation that entraps Jehovah and his sons in the original Hebraic sculpture Blake recreates in his "Laocoön."

[14] Erdman, ed., *Poetry and Prose of Blake*, p. 522.

[15] See Gregory Sharpe, *Two Dissertations: 1. upon the Origin of Language*, 1751; Bryant, *A New System, or, an Analysis of Ancient Mythology*, 1774-1776 (for which Blake probably helped to engrave some of the plates and to which he refers in *A Descriptive Catalogue*); Wood, *The Origin of Building, or the Plagiarisms of the Heathens Detected*, 1741. For a discussion of some possible relationships among the separate plate, Bryant, and Blake's ideas about classical civilization, see Irene Tayler, "Blake's Laocoön," *Blake: An Illustrated Quarterly*, 10 (Winter 1976-1977), 72-81.

XX.
The Man Sweeping the Interpreter's Parlour

FIGURES 54-56

White-line metal cut

First state: c. 1822 (but see discussion below)

Signature, lower left: Blake's monogram, *WB in & s*, with a loop from the initials arching over the abbreviations for *invenit* and *sculpsit*.

Image and plate mark: 8 × 16.1 cm

IMPRESSIONS

1A.

Mrs. Ramsey Harvey, Somerset. Printed in very dark brown or black on wove paper, 12.3 (left side), 12.8 (right side) × 21.2 cm. Watermark E & P, upper right, just above the image. Old ink spot in margin, lower left of center. Acquired at an unknown time by John Linnell, probably from Blake himself. Sold by the Linnell Trustees, Christie's, 15 March 1918, lot 202, with impression 2G and untraced impression 1 (£35 14s. to Martin). Acquired from Martin by Frank Rinder, after whose death at least impressions 1A and 2G passed to his widow, and after her death to the Rinders' daughter, the present owner. Reproduced here, Fig. 54. The inking is heavy but somewhat maculated, giving a fuzzy appearance to the image and making it very hard to photograph well.

Second state: c. 1822

Blake has added wavy, vertical lines to the background on the right, left, and top of the plate, and to the steps on the lower left. More lines defining the swirls of dust have been added left and right of the figure with a broom. The burst of light emanating from the upper left corner has been lightened considerably and the diagonal lines extending from the top left edge of the image have been lengthened and extended farther to the right. Horizontal hatching has been added along the lower edge of the image; and white lines have been added to the outlines and hatching delineating both large figures, although the absence of some of these lines on the only impression of the first state (1A) may be the result of heavy inking that obscured lines in the plate.

Signature and size: same as in first state

IMPRESSIONS

2B.

British Museum. Printed on wove paper, 33.7 × 24.5 cm, pasted to the mat. Well printed on the right, but the ink has been smeared, or deliberately wiped, in the upper left corner. Inscribed in pencil on the lower left corner of the sheet, "Presented by H. W. Martin Esq.ir Oxford." Accessioned by the Museum in December 1853. Exhibited at the British Museum in 1957, no. 60(4) in the catalogue. Reproduced

in Bindman, *Complete Graphic Works of Blake*, pl. 619b; Essick, *William Blake, Printmaker*, fig. 165.

2 C.
Chicago Art Institute. Printed on wove paper, 12.2 × 19 cm. Darkly inked and printed, with some loss of white lines on the right side of the plate and on the large figure on the left. Purchased in 1955 from a New York art dealer. Reproduced here, Fig. 55. Perhaps the same as untraced impression 1.

2 D.
Cincinnati Art Museum. Printed in very dark brown or black on wove paper, 11.5 × 18.1 cm, pasted to a fly leaf bound facing the title page in copy D of Blake's *Poetical Sketches*, 1783. Lightly inked and printed, showing almost all the white lines on the right side but with some fading of the image, upper left, and loss of lines in the top left corner. Inscribed in pencil beneath the image, probably by George Cumberland, "The parable of the relapsed sinner & her [his?] 7 Devils."[1] Acquired, probably directly from Blake, by Cumberland and bound by him or a member of his family into his copy of *Poetical Sketches*. The volume was inherited by George Cumberland, Jr., who, according to a note on the front free endpaper, sent it to "John Linnell 1866." Sold by the Linnell Trustees, Sotheby's, 3 June 1918, lot 3 (£60 to Pickering). Acquired by Drake, the New York bookdealer, and sold by him for $450 to Beverly Chew, who added his bookplate to the inside back cover and sold it at Anderson Galleries, 8 December 1924, lot 28 ($900 to Rosenbach). Acquired by John J. Emery, who added his name to the inside front cover and lent it to the Philadelphia Museum of Art in 1939, no. 1 in the exhibition catalogue. Given by Emery to the Cincinnati Art Museum in 1971. Reproduced here, Fig. 56.

2 E.
Robert N. Essick, Altadena, California. Printed on wove paper, 12.2 × 19 cm. Lightly inked and printed, showing all the white lines on the right side but with some weakness in the image on the left. Inscribed in pencil beneath the image in an early hand, "W. Blake." Pencil sketch by Blake on the verso of a standing figure between (falling?) pillars or rocks. The drawing may represent Samson pulling down the temple. The sketch is in Blake's style of the 1790s and thus was probably executed before the print was pulled. The fact that the drawing is cut into at top and bottom indicates that the sketch was made before the paper was trimmed to its present dimensions. Sold anonymously at Christie's, 3 December 1980, lot 161, reproduced (£2,000 to Andrew Edmunds for Essick). When sold at auction, the paper was evenly stained brown, but the print has now been cleaned, matted, and framed. The previous owner has not responded to Christie's inquiries made on my behalf. Perhaps the same as untraced impression 1.

2 F.
George Goyder, Suffolk. Printed on wove paper, framed and matted.

[1] Identified by Russell, *Engravings of Blake*, p. 102, as "Blake's own hand," but in my opinion by Cumberland, whose hand shares some features with Blake's. Cumberland also added descriptions of Blake's designs in his copy (D) of *Europe*.

According to Keynes, *Engravings by Blake: The Separate Plates*, p. 31, the sheet measures 33 × 23 cm and is watermarked "J WHATMAN without date." Perhaps this or impression 2J is the one offered for sale by Francis Harvey in his catalogue of *c.* 1864 for £6 6s. with *The Ghost of Abel, On Homers Poetry* [and] *On Virgil*, and a plate (a2?) from *There is No Natural Religion*. This association with *The Ghost of Abel* may explain the faint offset from pl. 1 of that work onto this impression of "The Man Sweeping" in a position that indicates it could have been bound, like impression 2J, as a frontispiece. Perhaps acquired by the Rev. Samuel Prince, from whose collection a copy of *The Ghost of Abel* was sold, without mention of "The Man Sweeping," at Sotheby's, 11 December 1865, lot 270 (£3 18s. to Toovey). Perhaps the impression acquired at an unknown time by E. J. Shaw and sold from his collection at Sotheby's, 29 July 1925, lot 141, described as "on a folio sheet" with "watermark J. Whatman, n.d." (£31 to Maggs).[2] Acquired by 1927 by Captain George Fenwick-Owen, who in that year lent it to the Burlington Fine Arts Club, no. 69 in the exhibition catalogue. Sold Sotheby's, 4 May 1954, lot 101 (£40 to Colnaghi). Acquired shortly thereafter by the present owner.

2G.
Mrs. Ramsey Harvey, Somerset. Darkly printed, with some obscuring of white lines at the top and along the right side, on wove paper, 10.8 × 19.7 cm. For provenance, see impression 1A. Lent by Frank Rinder in 1937 to the Bibliothèque Nationale, Paris, and the Albertina Museum, Vienna, nos. 65 and 52 in the exhibition catalogues. Lent by Mrs. Rinder in 1947 to the Tate Gallery; the Galerie René Drouin, Paris; the Kunsthaus, Zurich; and the Musée Royal des Beaux-Arts, Brussels, no. 38 in the exhibition catalogue; and reproduced in all but the Paris issue. Reproduced in Binyon, *Engraved Designs of Blake*, pl. 82, where it is incorrectly described on p. 139 as a first state.

2H.
Sir Geoffrey Keynes, Suffolk. Printed on wove paper, 34.5 × 24.6 cm, watermarked J WHATMAN | 1821. Offered for sale by E. Parsons and Sons in their February 1931 catalogue, item 550, for £68 5s. Purchased by Philip Hofer and given by him *c.* 1936 to Keynes. Keynes, *Engravings by Blake: The Separate Plates*, p. 31, states that this is "probably" the impression sold from the E. J. Shaw collection in 1925, but that is more probably impression 2F (see note 2). Listed in Keynes, *Bibliotheca Bibliographici*, no. 563i; Bindman, *Blake: Catalogue of the Collection in the Fitzwilliam Museum*, no. 563i, as part of Keynes' bequest to the Museum. Reproduced in Keynes, *Engravings by Blake: The Separate Plates*, pl. 19. Perhaps the same as untraced impression 1.

2I.
Library of Congress, Rosenwald Collection, Washington, D.C. Printed on wove paper, 10 × 15.4 cm, trimmed within the image about .4 cm on each side. Rosenwald and National Gallery of Art collection stamps on verso, the latter an error. Lightly and clearly printed on the

[2] Keynes, *Engravings by Blake: The Separate Plates*, p. 311, suggests that the Shaw print is "probably" impression 2H, but that has a dated watermark. Only impression 2F among those extant is on a large sheet with an undated Whatman watermark, although the date in impression 2J is not easy to see.

right, but with some loss of lines, upper left. Inscribed in pencil, lower right, below the image, not in Blake's hand, "Bla" (remainder cut off by edge of sheet). Acquired at an unknown time by the Rev. Stopford A. Brooke, and sold from his collection at Sotheby's, 27 July 1917, lot 793 (£8 to Tregaskis). Offered by James Tregaskis in his 1918 catalogue, no. 796, item 4, for £17. Acquired by W. E. Moss and sold with his collection at Sotheby's, 2 March 1937, lot 202 (£75 to Rosenbach). Sold by Rosenbach for the auction price plus a 10 percent commission to Rosenwald on 20 March 1937 (according to an invoice in the Rosenbach Library). Lent by Rosenwald to the Philadelphia Museum of Art in 1939, no. 230 (reproduced) in the catalogue; to the National Gallery of Art in 1957, no. 71 in the exhibition catalogue; to the University of Iowa in 1961, no. 26 in the exhibition catalogue; and to Cornell University in 1965, no. 20 (reproduced) in the exhibition catalogue. Given by Rosenwald to the Library of Congress in 1943 and moved from the Alverthorpe Gallery, Jenkintown, Pennsylvania, to Washington in 1980. Listed in *The Rosenwald Collection* (1954), p. 191; *The Rosenwald Collection* (1977), p. 335. Reproduced in Klonsky, *Blake*, p. 121.

2J.

Pierpont Morgan Library, New York. Printed on wove paper, 28.8 × 23.3 cm, watermarked J WHATMAN | 1821.[3] Stab holes along the right margin of the sheet. Inscribed in pencil along the lower left edge, "The Man sweeping the Interpreters Parlor." Perhaps this or impression 2F is the one offered for sale by Francis Harvey in his catalogue of *c.* 1864 for £6 6s. with *The Ghost of Abel, On Homers Poetry* [and] *on Virgil*, and a plate (a2?) from *There is No Natural Religion*. Probably the impression acquired by Richard Monckton Milnes, Lord Houghton (died 1885). Sold by his son, the Earl of Crewe, at Sotheby's, 30 March 1903, lot 8, with *The Ghost of Abel*, copy A, and *On Homers Poetry* [and] *on Virgil*, copy A, unbound but with "The Man Sweeping" described as a "frontispiece" (£43 to Quaritch). Acquired by William A. White, who lent all three works, "sewn"[4] (thus explaining the stab holes in this impression), to the Grolier Club, New York, in 1905 and 1919, nos. 37c and 19c in the exhibition catalogues; and to the Fogg Art Museum in 1924. After White's death in 1929, acquired by Rosenbach, who included "The Ghost of Abel unbound in case" in a typescript list (now in the Rosenbach Library) of the White collection. *The Ghost of Abel* and *On Homers Poetry* [and] *On Virgil* were sold to Rosenwald in 1929, but this impression of "The Man Sweeping" was apparently retained by Rosenbach and not sold until 1938 to Mrs. Landon K. Thorne (according to her records). Exhibited at the Pierpont Morgan Library in 1971 and described on p. 33 of the catalogue. Given to the Morgan Library by Mrs. Thorne shortly thereafter.

2K.

National Gallery of Art, Rosenwald Collection, Washington, D.C. Printed on wove paper, 9.1 × 17.1 cm, laid into a window cut into a larger sheet with a brown framing line and "99" in brown ink, upper

[3] The date is obscured by the image but has been revealed by a beta-radiograph made by Thomas Lange.
[4] According to Russell, *Engravings of Blake*, p. 97, the three works were "bound up" together when he saw them sometime before 1912.

left, stab holes along the bottom margin. Rosenwald and National Gallery of Art collection stamps on verso. For the provenance of this impression, see "Albion rose," impression 2D. Listed by George C. Smith in the anonymous catalogue of his collection in 1927, no. 41. Given by Rosenwald to the National Gallery of Art in 1945 and moved from the Alverthorpe Gallery, Jenkintown, Pennsylvania, to Washington in 1980.

2L.

Michael Phillips, Edinburgh. Printed on wove paper, 9.3 × 17.5 cm, with the watermark [J W]HATM[AN] | 1821 vertically on the right, cut by the edge of the sheet. Well printed, with the lines embossed into the sheet,[5] but with some loss of white lines, lower right, just left and right of the broom, and top center. Sold from "the Property of a Gentleman" at Sotheby's, 9 November 1953, lot 116 (£25 to Craddock and Barnard for Keynes). Listed by Keynes in 1964 in his *Bibliotheca Bibliographici*, no. 563iii. Sold by Keynes in 1978 to Phillips. Listed in Bindman, *Blake: Catalogue of the Collection in the Fitzwilliam Museum*, no. 563iii, as part of Keynes' bequest to the Museum (which is no longer true). Reproduced in Lister, *Infernal Methods*, fig. 25; Michael Phillips, ed., *Interpreting Blake*, Cambridge: Cambridge University Press, 1978, frontispiece. Perhaps the same as untraced impression 1.

2M.

University of Texas, Austin. Printed on wove paper, 34.1 × 24.2 cm, deckled on two contiguous edges and thus possibly one-quarter of a larger sheet approximately 68.2 × 48.4 cm.[6] Acquired at an unknown time by D. H. Steele, from whose collection it was sold at Sotheby's, 21 July 1958, lot 85, incorrectly described as a first state (£30 to J. Schwartz). Acquired, probably soon after the auction, by T. Edward Hanley, from whose collection the University of Texas acquired the print in 1966. Perhaps the same as untraced impression 1.

2N.

Yale Center for British Art, New Haven, Connecticut. Printed in dull black on wove paper, 17.8 × 23.1 cm, mounted in a window cut in a sheet of modern paper. Title and reference to Gilchrist, *Life of Blake*, in pencil on verso. Well printed on the right, with almost all white lines visible, but with some loss in the upper left corner. Acquired at an unknown time by Greville Macdonald, and lent by him to the National Gallery, London, in 1913, no. 80 in the exhibition catalogue; and in 1914 to the Manchester Whitworth Institute, the National Gallery of Scotland, Edinburgh, and the Nottingham Art Museum, nos. 92, 77, and 73 in the respective exhibition catalogues. Offered for sale from the Macdonald collection by Francis Edwards, London, in his *William Blake* sale catalogue of 1927, item 1, for £65. Acquired by Ruthven Todd, from whose collection it was sold at Sotheby's, 11 December 1973, lot 25, reproduced (£2,100 to David Tunick). Offered for sale by Tunick in his January 1977 catalogue, no. 9, item 18, reproduced, for $7,500. The provenance given in Tunick's catalogue

[5] According to Michael Phillips, who very generously unframed the print and provided the description of it given here.

[6] Whatman's "Super Royal" size paper, at 69.8 × 49 cm, may have been the paper used for this and other impressions. The sheet sizes of impressions 2B, 2F, 2H, and 2J also approximate a quarterly division of such a sheet. For Whatman's mold sizes, see Thomas Balston, *James Whatman Father & Son*, London: Methuen, 1957, p. 61.

suggests that the print was once in the collection of Lord Crewe, apparently through confusion with impression 2J. Sold by Tunick at Christie's, 4 July 1979, lot 173, reproduced (£3,200 to Baskett & Day for Paul Mellon). Given by Mellon shortly after the sale to the Yale Center for British Art.

2 O.

Private collection, Great Britain. Printed on wove paper cut to the image at the top and bottom, and slightly within the image left and right, to 7.9 × 15.9 cm. Well printed, with some loss of white lines on the right and slight loss of relief areas, upper left. Framed and matted just beyond the edge of the sheet. Probably the impression sold at Sotheby's, 30 July 1946, lot 465, "cut close" (£22 to Quaritch). Acquired by Arthur Randle, from whose collection it was sold at Sotheby's, 19 December 1949, lot 29, "cut close," with H. H. Gilchrist's drawing of Blake's cottage at Felpham (£34 to B. M. Williams). The label of the print dealer R. H. Baynton-Williams, 27 Bute Street, London, is pasted to the back of the frame. Baynton-Williams, no relation to "B. M. Williams," has no record of ever having this print in stock, does not deal in Blake, and suspects that he framed the print but did not sell it. Apparently in the collection of the present owner since *c.* 1950. Perhaps the same as untraced impression 1.

UNTRACED IMPRESSIONS

1.

Sold from the Linnell collection, Christie's, 15 March 1918, lot 202, with impressions 1A and 2G (£35 14s. to Martin). Probably acquired by Frank Rinder with the two other impressions. According to Keynes, *Engravings by Blake: The Separate Plates*, p. 32, this impression was exhibited at the Grolier Club, New York, in 1905 (but that is impression 2J) and acquired by the "Melbourne Art Gallery." There is no Melbourne Art Gallery, although the National Gallery of Victoria, Melbourne, is sometimes called by that name. Mr. Rinder made arrangements for shipping other works by Blake from the Linnell sale to the National Gallery of Victoria (according to Irena Zdanowicz, Curator of Prints and Drawings), but the Gallery has no record of ever having the print. Mrs. Ramsey Harvey, the Rinders' heir and owner of impressions 1A and 2G, has no record of this impression. Perhaps the same as impression 2C, 2E, 2H, 2L, 2M, or 2O.

W. M. Rossetti, in his list of Blake's "Engravings" in Gilchrist, *Life of Blake* (1863), II, 258, was the first to identify the subject of this plate as "Sweeping the Interpreter's House, from the *Pilgrim's Progress*." The passage illustrated is as follows:

> Then he [the Interpreter] took him [Christian] into a very large *Parlour* that was full of dust, because never swept; the which, after he had reviewed a little while, the *Interpreter* called for a man to *sweep*: Now when he began to sweep, the dust began so

abundantly to fly about, that *Christian* had almost therewith been choked: Then said the *Interpreter* to a *Damsel* that stood by, Bring hither Water, and sprinkle the Room; which when she had done, was swept and cleansed with pleasure.

Then said Christian, *What means this?*

The *Interpreter* answered; This Parlor, is the heart of a Man that was never sanctified by the sweet Grace of the Gospel: The *dust*, is his Original Sin, and inward Corruptions that have defiled the whole Man. He that began to sweep at first, is the Law; but She that brought water, and did sprinkle it, is the Gospel: Now, whereas thou sawest that so soon as the first began to sweep, the dust did so fly about, that the Room by him could not be cleansed, but that thou wast almost choaked therewith, this is to shew thee, that the Law, instead of cleansing the heart (by its working) from sin, doth revive, put strength into, and increase it in the soul, even as it doth discover and forbid it, for it doth not give power to subdue.

Again, as thou sawest the *Damsel* sprinkle the Room with Water, upon which it was cleansed with pleasure: This is to shew thee, that when the Gospel comes in the sweet and precious influences thereof to the heart, then I say, even as thou sawest the Damsel lay the dust by sprinkling the Floor with Water, so is sin vanquished and subdued, and the soul made clean, through the Faith of it; and consequently fit for the King of Glory to inhabit.[7]

In Blake's design, the personification of Law is the bearded man with bat-like wings; the Damsel sprinkling the dust with water from a bowl is the Gospel of forgiveness. The small figures hovering in the air and clustered on the floor, including a face just left of the sweeper's right knee whose beard merges with the white lines defining the dust, apparently represent Sins. Cumberland's title inscribed on impression 2D (Fig. 56) is taken from Christ's parable in Luke 11:24-26: "When the unclean spirit is gone out of a man, he walketh through dry places, seeking rest; and finding none, he saith, I will return unto my house whence I came out. And when he cometh, he findeth it swept and garnished. Then goeth he, and taketh to him seven other spirits more wicked than himself; and they enter in, and dwell there: and the last state of that man is worse than the first." The design fits this passage only in the most general way. Such a careless relationship between text and illustration is completely unlike Blake's practice, and Cumberland's inscription cannot be given any credence despite his many direct contacts with Blake.

There are good reasons for dating the first state of the plate at two different periods in Blake's career separated by more than twenty years. He appears to have used in his illuminated books paper made by Edmeads and Pine and watermarked E & P, as in impression 1A, only during the mid-1790s.[8] He used the monogram signature appearing lower left in both states of "The Man Sweeping" in the engraved *Night Thoughts* illustrations of 1796-1797 and, in his drawings and paintings, in few if any works clearly datable after 1806.[9] The second state, however, is in all probability a production of *c.* 1822, as indicated by

[7] John Bunyan, *The Pilgrim's Progress*, ed. James Blanton Wharey, second edition revised by Roger Sharrock, Oxford: Clarendon Press, 1960, pp. 29-30. It is not known which of the many editions of *Pilgrim's Progress* Blake used.

[8] Keynes, *Engravings by Blake: The Separate Plates*, p. 32, states that "Blake used this paper only for a short time about the year 1794"; but the table of watermarks in the illuminated books given in Bentley, *Blake Books*, p. 71, suggests that Blake may have used the E & P paper from *c.* 1793 to as late as 1800.

[9] For information on the monogram in drawings and paintings, see Martin Butlin, "Cataloguing William Blake," in Essick and Pearce, eds., *Blake in His Time*, pp. 82-84.

Part One.
*Plates Designed and Executed
by Blake*

the 1821 watermark on impressions 2H, 2J, and 2L, the early association of impressions 2F and 2J with *The Ghost of Abel* (1822), and the provenances of impression 2G and untraced impression 1 (and possibly others) that lead back to John Linnell, who did not meet Blake until 1818 and who may have stimulated Blake's revisions of other plates first executed many years before.[10]

Other evidence indicates a date of *c.* 1822 for the first as well as second state. Impression 1A is probably a working proof, lacking basic requirements of a finished plate such as distinct definition lines on the figures, and thus may have immediately preceded the second-state revisions. If he never intended to issue impressions in the unfinished state, it can be argued that Blake used an old scrap of E & P paper to pull a single, rough, over-inked working proof.[11] This impression (1A) also has a provenance leading back to Linnell; and it seems unlikely that, if it were pulled before 1800, Blake would have retained a poor working proof until at least 1818 and then given it up. Further, the *Night Thoughts* monogram does not provide incontrovertible evidence of an early date for the first state because Blake scratched an almost identical monogram into plate 51 of *Jerusalem*. This was added in white line to the plate *after* Blake pulled an impression without the monogram on paper watermarked 1820 and included it in copy C of *Jerusalem*.

Although Blake used sophisticated white-line techniques in his relief etchings of the early and mid-1790s, such as "The Approach of Doom" (*c.* 1792) and the *America* frontispiece (1793), his first purely white-line metal cuts are the head- and tailpieces to William Hayley's "Little Tom the Sailor" of October 1800. These are rather crude works; the more sophisticated handling of white lines found in "The Man Sweeping" does not appear until "Deaths Door" of 1805 (Fig. 25). The subtle and haunting light effects displayed even in the first state of "The Man Sweeping" (although somewhat obscured by the careless inking of impression 1A) are not found in any of Blake's uncolored relief plates of the 1790s, but are reminiscent of his wood engravings illustrating Robert John Thornton's edition of *The Pastorals of Virgil*, 1821. The emblematic meaning of the subject of the plate, described so clearly in Bunyan's text, quoted above, accords with Blake's condemnation of moral law and his faith in Christ's forgiveness expressed in works such as the annotations to Berkeley's *Siris* (*c.* 1820), the "Laocoön" (*c.* 1820), *The Ghost of Abel* (1822), and the *Job* engravings (1823-1826) with their central theme that "The Letter Killeth The Spirit giveth Life" (pl. 1). There may have been a personal reason for Blake's choice of this unusual subject from *Pilgrim's Progress* because the young artists, including Palmer, Calvert, and Richmond, who so admired Blake in his last years, referred to his dwelling as "The House of the Interpreter."[12] This engagement with Bunyan's allegory may have led directly to Blake's watercolor illustrations to *Pilgrim's Progress*, 1824-1827.[13]

Thus, there is a considerable accumulation of evidence supporting the later date for the first state, in spite of the E & P paper. The second state is in all probability a work of the 1820s and most of the evidence suggests that the plate was first executed in the same period.

[10] Possibly "Job," "Ezekiel," "Chaucers Canterbury Pilgrims," and "Mirth." See Essick, *William Blake, Printmaker*, pp. 219-220.

[11] This view was first presented in Bindman, *Complete Graphic Works of Blake*, pp. 485-486.

[12] Gilchrist, *Life of Blake* (1863), I, 300. These artists probably gathered at Blake's house, *c.* 1824, and thus if their presence was a crucial stimulus it would push the date of the first state of "The Man Sweeping" even later into the 1820s. It is of course possible that their name for Blake's house suggested the revision, not the original execution, of the plate. A date of *c.* 1824 for the second state is suggested in Bentley, *Blake Records*, pp. 295 n.4, 614.

[13] Twenty-eight of the twenty-nine designs are reproduced in color in Bunyan, *The Pilgrim's Progress*, ed. G. B. Harrison, Introduction by Geoffrey Keynes, New York: Limited Editions Club, 1941. None of these watercolors, now in the Frick Museum, New York, bears any similarity in composition or subject to "The Man Sweeping."

"The Man Sweeping" was described by W. M. Rossetti as an example of "Woodcut on Copper," and David Bindman has recently called the plate a "relief-etching and white-line engraving" and stated that "there is no reason to doubt that it is engraved on copper."[14] Russell and Keynes believed that the plate is a "Woodcut on Pewter."[15] Blake described this pewter technique on p. 4 of his *Notebook*: "lay a ground on the Plate & smoke it as for Etching, then trace your outline(s) [*& draw them in with a needle*]. and beginning with the spots of light on each object with an oval pointed needle scrape off the ground. [*& instead of etching the shadowy strokes*] as a direction for your graver then proceed to graving with the ground on the plate being as careful as possible not to hurt the ground because it being black will shew perfectly what is wanted."[16] The description makes it clear that this is an engraving process; the etching ground and needle are used only to trace in an outline as a guide to work with the graver.

"The Man Sweeping" is clearly a metal cut printed in relief, but I can see no way of determining beyond reasonable doubt whether the medium is copper or pewter, and whether it was incised with acid, graver, drypoint needle, or all three. The wavy lines with blunt ends and the twisting lines just left of the sweeper's left knee look like etching, although such work can be done with a blunt drypoint needle or lozenge graver if the metal is soft enough. The relief areas along the edge of the plate on both sides and at the bottom suggest that Blake employed his usual dike method of etching, which requires a wax border to be placed around the margins of the plate to hold the acid. But the white lines added at top left in the second state extend to the very edge of the plate, and these at least must have been made with a tool. The finest lines on the two largest figures were probably also engraved, not etched. The crosshatching below the upper left corner has broken down into a large white area with scattered fragments of relief plateaus. Such surface decay occurs more readily in a soft metal, such as pewter, than in copper; but it is generally a greater problem in etching processes (such as woodcut on copper) than in engraving processes (such as woodcut on pewter). No single extant impression is inked and printed in such a way as to reveal all the white, incised lines on the right and all the fragmentary relief surfaces, upper left. These inking and/or printing difficulties suggest that the plate was warped or that the surface was inadvertently lowered on the left. Either flaw is, again, more likely to occur in a soft metal plate than in copper.

In order to show the variations in inking and printing, two impressions of the second state have been reproduced here. Fig. 55 is a richly inked impression showing all relief surfaces, upper left (or at least all that appear in any impression); Fig. 56 is lightly inked and shows almost all the fine white line work throughout the image.

[14] Gilchrist, *Life of Blake* (1863), II, 258; Bindman, *Complete Graphic Works of Blake*, pp. 485-486. For Blake's description of his technique of "Woodcut on Copper," see "Deaths Door."

[15] Russell, *Engravings of Blake*, pp. 32-33, 101; Keynes, *Engravings by Blake: The Separate Plates*, p. 33.

[16] Erdman, ed., *Poetry and Prose of Blake*, p. 672. The date of this *Notebook* "Memorandum" is uncertain. On 12 April 1813, George Cumberland wrote in his diary that he had seen "Blake who recommended Pewter to Scratch on with the Print" (Bentley, *Blake Records*, p. 232). This must be a reference to the same technique Blake describes in his *Notebook*.

XXI.
George Cumberland's Card

FIGURE 57

One state: 1827

Central inscription in pseudo-gothic letters: **M: Cumberland.**

Signature, lower right: W Blake inv & sc: | A Æ 70 1827

Image: 3.1 × 7.8 cm

Plate mark: 3.3 × 8.1 cm

IMPRESSIONS

1A.
Avon County Library, Bristol. Printed on a card, 3.4 × 8 cm, trimmed to the plate mark and pasted to the mount. Acquired, probably from George Cumberland, by the Bristol antiquary George Weare Braikenridge, active as a collector *c*. 1820-1840. The card passed, apparently by inheritance, to W. Jerome Braikenridge, who in 1908 gave the card as part of the family collection to the Bristol City Library (which became the Avon County Library in 1974).[1]

1B.
R. John Blackley, New York. Printed in brown on laid paper, 15.6 × 10.1 cm. Fragment of a watermark, either ND or MD with the first letter cut in half by the edge of the sheet. Purchased by Blackley, *c*. 1972, from the Victoria Book Shop, New York, and lent by him to Adelphi University in 1977, no. 41 in the exhibition catalogue.

1C.
Boston Museum of Fine Arts. Printed on laid paper, 9.6 × 14.7 cm, of the same type as impression 1D. Boston Museum of Fine Arts collection stamp on verso. Given to the Museum in December 1914 by Andrew Adams of Hawaii. This or impression 1D reproduced in Todd, *Blake the Artist*, p. 149.

1D.
Boston Museum of Fine Arts. Printed on laid paper, 9.6 × 14.5 cm, of the same type as impression 1C. Boston Museum of Fine Arts collection stamp on verso. Given to the Museum by Miss Ellen Bullard in November 1925. This or impression 1C reproduced in Todd, *Blake the Artist*, p. 149.

1E.
British Museum. Printed on wove paper, 14.9 × 21.5 cm. "M: Cumberland" was not inked and prints only as a blind embossment. Pasted at the top of a mat also bearing impressions 1F and 1G. All three impressions were acquired or printed at an unknown time by John Linnell, who may have received these impressions or had them pulled before he delivered the plate to Cumberland (see discussion below). This impression only lent by the Linnell Trustees in 1913 to the National Gallery, London, no. 85 in the exhibition catalogue, where it is described (incorrectly) as a "proof, with Cumberland's name blocked out with Chinese white"; and in 1914 to the Manchester Whitworth

[1] Information supplied by Geoffrey Langley of the Avon County Library.

111

Institute; the National Gallery of Scotland, Edinburgh; and the Nottingham Art Museum, nos. 144, 81, and 74 in the respective exhibition catalogues. All three impressions were sold by the Linnell Trustees at Christie's, 15 March 1918, lot 196 (£33 to A. Martin for the British Museum, which accessioned the prints on 13 April 1918). Perhaps the impression very convincingly reproduced, with a (false?) plate mark and lacking Cumberland's name, on the title page of Keynes, *Bibliography of Blake*.

1F.
British Museum. Printed on wove paper, 13.8 × 25.5 cm, pasted to the middle of the mat also bearing impressions 1E and 1G. For provenance, see impression 1E.

1G.
British Museum. Printed on wove paper, 15.7 × 24.9 cm, pasted at the bottom of the mat also bearing impressions 1E and 1F. For provenance, see impression 1E. Reproduced here, Fig. 57.

1H.
Cincinnati Art Museum. Printed on laid paper, 9.5 × 12.5 cm, pasted to the front paste-down endpaper as a bookplate in George Cumberland's copy of Blake's *Poetical Sketches*, 1783. Well printed; paper slightly browned with age, and foxed. Direct comparison indicates that the paper is the same as impression 1J. The sheet appears to have been trimmed in width to fit exactly the width of the endpaper. Thus, the print must have been pasted in the volume after it was bound in quarter leather with marbled paper boards and before it was presented to John Linnell in 1866. For the provenance of this book, see "The Man Sweeping the Interpreter's Parlour," impression 2D.

1I.
Robert N. Essick, Altadena, California. Printed in brown on laid paper, 10 × 16 cm. In the upper right corner is slightly less than one-quarter of a crown and Britannia watermark. The letter "g." has been written upside down in pale-brown ink above the lower edge of the sheet. Acquired with impression 1J by Maggs Bros. in June 1978 as part of a large collection of bookplates, and sold to Essick in July 1978 for £85.

1J.
Robert N. Essick, Altadena, California. Printed on laid paper, 5.7 × 10.5 cm. Remains of old paste on three corners of the verso. Acquired with impression 1I by Maggs Bros. in June 1978 as part of a large collection of bookplates, and sold to Essick in August 1978 for £125.

1K.
Fitzwilliam Museum, Cambridge. Printed on a card, 4.3 × 9 cm, pasted to the recto of the second leaf of Blake's letter to Cumberland of 12 April 1827 (see Keynes, ed., *Letters of Blake*, pp. 168-169). Just

above the card Cumberland writes of Blake's death and place of burial, refers to John Thomas Smith's *Nollekens and His Times* (1828), and notes that "my little message card was the last thing he [Blake] executed." Blake clearly did not send this impression with his letter, for he states in it that he "will do" the "Little Card," and Cumberland did not have an impression from the plate until 27 January 1828 (see discussion below). Cumberland probably attached the impression when he wrote his note at some time after reading Smith's book, the Preface of which is dated October 1828. The letter with the card attached was acquired at an unknown time by Thomas Glen Arthur, who sold it at Sotheby's, 11 April 1893, lot 188 (£5 5s. to Pearson). Acquired by Charles Fairfax Murray and sold from his collection at Sotheby's, 5 February 1920, lot 21 (lots 1-163 to Morton for £2,000). Offered by Maggs Bros. in their Summer 1934 catalogue, no. 597, item 287 (£150), and sold by them on 17 October 1935 to the Fitzwilliam Museum. Lent to the Whitworth Art Gallery, Manchester, in 1969, no. 21 in the exhibition catalogue. Listed in Bindman, *Blake: Catalogue of the Collection in the Fitzwilliam Museum*, nos. 42 (letter) and 43 (card). Reproduced in Bindman, *Complete Graphic Works of Blake*, pl. 654.

1L.

Folger Shakespeare Library, Washington, D.C. Printed on laid paper cut irregularly to about 9.5 × 14.9 cm. Slight discoloration at right edge. No information on provenance available.[2]

1M.

Joseph Holland, Los Angeles. Printed in brown on laid paper, 16 × 9.9 cm, with one-fourth of a crown and Britannia watermark in the lower left corner. According to Sessler's purchase and sale records, acquired by Sessler in March 1938 from Maggs Bros. for $22.09. In September 1938, Sessler paid "Fehr" $9.50 in connection with this impression, probably for removal from a mount (old paste is still present along the top margin of the verso) and/or for making the one-quarter morocco case in which the impression is still contained. Sold by Sessler's in June 1942 to Henry S. Borneman for $50. Sold from Borneman's collection at Parke-Bernet, 1 November 1955, lot 230 ($65 to Sessler). Sold by Sessler's on 11 November 1955 to Holland for $75. Mr. Holland has made reproductions of this impression, printed in reddish-brown on heavy wove paper and with Cumberland's name removed, for his private use.

1N.

Sir Geoffrey Keynes, Suffolk. Printed in green-gray on a card, 3.4 × 8.3 cm, the plate mark visible only at the top and right. Acquired by Keynes at an unknown time from a bookdealer. Listed in Keynes, *Bibliotheca Bibliographici*, no. 564i; Bindman, *Blake: Catalogue of the Collection in the Fitzwilliam Museum*, no. 564i, as part of Keynes' bequest to the Museum. Reproduced in Keynes, *Engravings by Blake: The Separate Plates*, pl. 38.

[2] The print has no accession number, and thus, according to the Folger staff, the provenance cannot be traced through their records.

10.

Sir Geoffrey Keynes, Suffolk. Printed on a card, 5.8 × 10.2 cm, pasted on the recto of the front free endpaper of an album, 22.5 × 30.3 cm, bound in dark-green cloth, once owned by George Cumberland and/or members of his family and containing etchings and drawings by him. G. E. Bentley, Jr., *A Bibliography of George Cumberland*, New York: Garland, 1975, pp. 117-118, suggests that this volume was put together after Cumberland's death, perhaps by his daughter Eliza Martha Cumberland. Acquired by Keynes many years ago from a bookdealer. Listed in Keynes, *Bibliotheca Bibliographici*, no. 564ii; Bindman, *Blake: Catalogue of the Collection in the Fitzwilliam Museum*, no. 564ii, as part of Keynes' bequest to the Museum.

1P.

Sir Geoffrey Keynes, Suffolk. Printed on laid paper, 9.6 × 14.6 cm, with a fragment of an unidentifiable watermark on the right side. Acquired by Keynes at an unknown time from a bookdealer. This or impression 1Q or 1Z is probably the one exhibited at the National Library of Scotland, Edinburgh, in 1969, no. 84 in the catalogue (ownership not given). One of the impressions listed in Keynes, *Bibliotheca Bibliographici*, nos. 564iii-v; Bindman, *Blake: Catalogue of the Collection in the Fitzwilliam Museum*, nos. 564iii-v, as part of Keynes' bequest to the Museum. Probably the impression reproduced in *The Book Collector*, 19 (Spring 1970), pl. XVI.

1Q.

Sir Geoffrey Keynes, Suffolk. Printed in brown on laid paper, 10.2 × 16.1 cm. A fragment of a watermark consisting only of the number 96 appears on the lower left. There is a large *H* in brown ink at the top of the sheet. Perhaps the impression offered by Thomas Thorp, October 1909 catalogue of bookplates, printed in "sepia," 8 s. This or impression 1P or 1Z is probably the one exhibited at the National Library of Scotland, Edinburgh, in 1969, no. 84 in the catalogue (ownership not given). One of the impressions listed in Keynes, *Bibliotheca Bibliographici*, nos. 564iii-v; Bindman, *Blake: Catalogue of the Collection in the Fitzwilliam Museum*, nos. 564iii-v, as part of Keynes' bequest to the Museum.

1R.

Metropolitan Museum of Art, New York. Printed on a card, 3.3 × 8.2 cm, the plate mark visible only on the right. Given to the Museum in 1925 by William E. Baillie as part of his extensive collection of bookplates. Not in the volume containing impressions 1S-1V.

1S.

Metropolitan Museum of Art, New York. Printed on a card, 3.3 × 8.2 cm, the plate mark visible only on the right. Pasted in a scrapbook on the left side of leaf 73 verso, with impressions 1T (73 verso, right), 1U (74 recto, top), and 1V (74 recto, bottom). This full red-leather volume is volume I of an extensive collection of bookplates given to the Museum in 1925 by William E. Baillie.

Part One.
*Plates Designed and Executed
by Blake*

1T.

Metropolitan Museum of Art, New York. Printed on laid paper, 4.1 × 9 cm, pasted down. See impression 1S.

1U.

Metropolitan Museum of Art, New York. Printed on laid paper, 4.2 × 9 cm, pasted down. See impression 1S.

1V.

Metropolitan Museum of Art, New York. Printed in brown on laid paper, 4.3 × 8.7 cm, pasted down. See impression 1S.

1W.

Pierpont Morgan Library, New York. Printed on laid paper, 9.6 × 14.9 cm. Acquired at an unknown time prior to 1930 and kept in recent years in a portfolio with *The Book of Thel*, copy a, and some forty-eight other etchings and engravings by or attributed to Blake. According to the list of the early contents of this collection in Bentley, *Blake Books*, p. 131, there was no copy of this print included in the bound collection when it was sold at Sotheby's, 15 December 1906, lot 482 (£155 to Abbey for Morgan). It may have been part of this group, extending back to at least the collection of Robert Arthington (sold in 1866), but not recorded (because of its size or location in the volume?) in any of the catalogues of auctions through which it passed. Lent by the Morgan Library to the Fogg Art Museum in 1930 and to the Philadelphia Museum of Art in 1939, no. 235 in the exhibition catalogue, where this or untraced impression 5 is reproduced.

1X.

National Gallery of Art, Rosenwald Collection, Washington, D.C. Printed on laid paper, 10 × 15.9 cm, with a countermark as in impression 1CC, upper right. Rosenwald and National Gallery of Art collection stamps on the verso. This and impression 1Y were acquired at an unknown time by J. E. Hodgkin, who mentions one impression in his *Rariora, Being Notes on Some of the Printed Books, . . . Engravings, . . . Etc. Collected (1858-1900) by John Eliot Hodgkin*, London: Sampson Low, Marston & Company, [1902], I, 62. Both impressions were acquired by W. E. Moss and sold from his collection at Sotheby's, 2 March 1937, lot 208 (£12 to Rosenbach). Acquired shortly thereafter by Lessing J. Rosenwald, who gave both impressions to the National Gallery of Art in 1945. Moved from the Alverthorpe Gallery, Jenkintown, Pennsylvania, to the National Gallery of Art, Washington, in 1980.

1Y.

National Gallery of Art, Rosenwald Collection, Washington, D.C. Printed in brown on laid paper, 10.3 × 16.1 cm, with a fragment of a crown watermark, upper right. Rosenwald and National Gallery of Art collection stamps on verso. For provenance, see impression 1X.

115

1Z.

Charles Ryskamp, Princeton, New Jersey. Printed in brown on laid paper, 16 × 10 cm. The letters are slightly blurred. In the lower left corner of the sheet is one-quarter of a Britannia watermark below which is the number 17 (perhaps a date, cut off by the edge of the sheet). Acquired at an unknown time by Sir Geoffrey Keynes from a bookdealer, and listed by him in 1964 in his *Bibliotheca Bibliographici* as one of the impressions grouped under nos. 564iii-v. This or impression 1P or 1Q is probably the one exhibited at the National Library of Scotland, Edinburgh, in 1969, no. 84 in the catalogue (ownership not given). Given by Keynes to Ryskamp sometime between 1964 and 1974 and exhibited by Ryskamp at the Grolier Club, New York, in 1974. Listed in Bindman, *Blake: Catalogue of the Collection in the Fitzwilliam Museum*, one of the impressions grouped under nos. 564iii-v, as part of Keynes' bequest to the Museum (which is no longer the case).

1AA.

University of Texas, Austin. Printed on a card, 3.4 × 8.2 cm. Sent with a letter from William Edkins to William George, dated 7 November 1883, in which Edkins writes, "Herewith I enclose you [*sic*] the 'book-plate and address card' of the late George Cumberland etched by W. Blake in 1827 and also an etching by Stothard—subject 'Robin hood' from a plate in the possession of Cumberland." This "Robin Hood" etching measures 5 × 7.5 cm and is not the same as Blake's "Robin Hood and Clorinda" after Meheux. Acquired by Texas in the spring of 1960 as part of the manuscript collection of William George (1830-1900), a bookdealer and antiquary of Bristol. The card was removed from the letter and transferred to the print collection in June 1980.

1BB.

Yale University, Beinecke Library, New Haven, Connecticut. Printed in brown on laid paper, 9.2 × 12 cm, cut unevenly along the lower edge and with a very small fragment of an unidentifiable watermark in the upper right corner. Very lightly printed in the upper right corner. Acquired at an unknown date by Chauncey Brewster Tinker. According to a clipping from an unidentified dealer's catalogue kept with the print, the price was £3 3s. Given by Tinker to Yale no later than March 1963. Listed in *The Tinker Library*, compiled by Robert F. Metzdorf, New Haven: Yale University Press, 1959, no. 288.

1CC.

Yale University, Beinecke Library, New Haven, Connecticut. Printed on laid paper, 10 × 15.9 cm, pasted along the top edge to a slightly larger piece of machine-made paper. A countermark, in the form of a crude capital A with the left diagonal extended into a loop below the letter, appears lower right. Lightly printed in the upper right and lower left corners. Purchased by the Beinecke Library in December 1959 from Mrs. Claire Talbot.

1DD.

Private collection, New Jersey. Printed on a card, 4.1 × 8.1 cm, trimmed just outside the plate mark on the right and left. Minor skinning of the surface and rust stains in the right side of the image. The image has been repaired with Chinese white or gesso and pen and ink work on the head of the figure, lower right, holding a distaff, and in a small area .5 cm to the left of this figure's extended left foot. Skinned on the verso where it was once pasted to a mat still with the card. The owner believes that the print was acquired by his father in England, *c.* 1905-1912. Examined while this impression was on temporary deposit at the Pierpont Morgan Library, New York, in July 1980.

UNTRACED IMPRESSIONS

1.

Sold from the collection of William Bell Scott, Sotheby's, 7 March 1890, lot 192, "Inventions of G. Cumberland, 24 plates engraved by himself and W. Blake, in a vol. with Cumberland's book-plate designed and engraved by Blake, . . . 1793-95" (15s. to Garrett). This volume was very probably a copy of Cumberland's *Thoughts on Outline* (1796), apparently bound without the text.

2.

Acquired *c.* 1890-1905 by William A. White. Lent by him (anonymously) to the Grolier Club, New York, in 1919, no. 35 in the exhibition catalogue, and to the Fogg Art Museum in 1924. Listed on a typescript of the White collection, written by Rosenbach *c.* 1929 and now in the Rosenbach Library, Philadelphia, where it is given a value of $20 by "Swann" and a price of $100 and stated to be "desired" by "Mrs. James B. Murphy, Seal Harbor, Maine." It seems likely that Mrs. Murphy never received the print, for the other Blake works she "desired" (*The Book of Urizen*, copy G, *Europe*, copy G, and *Visions of the Daughters of Albion*, copy H) went to Rosenwald or Frances White Emerson (W. A. White's daughter). In his copy of the A. E. Newton sale catalogue, Parke-Bernet, 17 April 1941, lot 158, Rosenbach or one of his employees noted that there is an impression "in stock." If Mrs. Murphy did not acquire this impression, it may be the one still in the stock of Rosenbach and Company in 1941. For other impressions that passed through Rosenbach's hands, see impressions 1X and 1Y.

3.

Sold at Hodgson's, 27 June 1918, lot 487, "printed on paper of a larger size" than the image (£4 12s. 6d.)

4.

Sold from the collection of E. Jackson Barron, Sotheby's, 21 October 1918, lot 968, as part of a large collection of visiting cards, newspaper advertisements, trade labels, early valentines, etc., collected over many

years by Barron (£6 5s. to Tregaskis). Offered by Tregaskis in his June 1919 catalogue, no. 815, item 5, "in sepia on paper 4 × 5 ⅛ in." for £14.

5.

Acquired from Geoffrey Keynes, prior to 1933, by A. Edward Newton, who lent this impression to the Philadelphia Museum of Art in 1939, no. 234 in the exhibition catalogue, where it is described as in "sepia" and (or impression 1W) is reproduced. Sold from Newton's collection at Parke-Bernet, 17 April 1941, lot 158 ($40 to an unidentified private buyer). Described in the auction catalogue as printed on a sheet "3 7/8 by 6¼ inches" and contained in a "quarter half morocco volume" with a letter from "Mr. Keynes . . . laid in" and "a reproduction of the engraving with [a] . . . note by Mrs. Newton written beneath it." Apparently the impression reproduced, very poorly, in Newton, *A Magnificent Farce*, p. 221.[3]

6.

According to his receipt, Allan R. Brown purchased an impression from E. Weyhe, the New York print and book dealer, on 8 February 1937 for $35. In a letter from Brown to Ruthven Todd dated 25 October 1942, he describes this impression as a "proof from the Palmer collection, on paper about 3½ × 6½ in." This description is repeated in Keynes, *Engravings by Blake: The Separate Plates*, p. 38. The receipt and a copy of the letter are now in the Watkinson Library, Trinity College, Hartford, Connecticut. I have not been able to locate the print, although it may be pasted into one of Brown's books now at Trinity College.

7.

According to their records, Sessler's purchased an impression from "Massey" on 7 January 1938 for $15.75 and sold it to "Bol" (or perhaps "Bok") on 20 January 1938 for $25.

8.

In 1976, the Pierpont Morgan Library, New York, acquired an extra-illustrated copy of Allan Cunningham's "Blake," 1830. At some point prior to its acquisition, an impression of the Cumberland card was removed from leaf 124 of the volume, as indicated by offsetting on the facing leaf. For the provenance of this collection, see "Joseph of Arimathea Among the Rocks of Albion," impression 2G.

9.

Sold in a collection of approximately 3,670 bookplates at Sotheby's, Hodgson's rooms, 25 May 1979, lot 506 (£1,650 to Thomas Thorp for a private customer). Thorp, the London bookdealer, reports that the impression is printed on paper, but has refused to identify the collector for whom he purchased the lot or pass on an inquiry to him.

[3] In a letter to C. B. Tinker of 24 October 1933, Newton refers to this impression and describes it as "printed upon a scrap of hand-made paper 6¼ inches wide, 2 7/8 inches [*sic*?] high." Newton's letter is kept in the folder also containing impression 1BB.

Part One.
Plates Designed and Executed
by Blake

The early history of this plate is well documented. The first reference to it appears in Blake's letter of 12 April 1827 to George Cumberland, his friend of many years. In this letter, to which impression 1K is now affixed, Blake writes, "The Little Card I will do as soon as Possible but when you Consider that I have been reduced to a Skeleton from which I am slowly recovering you will I hope have Patience with me."[4] After Blake's death on 12 August 1827, Mrs. Blake went to live for a short time with John Linnell. On 12 November 1827, Linnell wrote to Cumberland's son, George Jr., that Mrs. Blake "has the small card Plate ready for you whenever you will call for it."[5] George informed his father, then living in Bristol, that the "Card is ready" in a letter of the same month. On or about 27 November, George Jr. wrote Linnell, telling him it was inconvenient to call for the card and asking him to send it to "the Army Pay Office." George Jr. included with his note a letter from his father to Mrs. Blake, dated 25 November, which mentions Linnell's statement that the card plate was ready. Cumberland wrote his son on 3 December asking him to "bring the Plate—which I sent up [to Blake in London] to have a few ornaments engraved or etched round my Name." The father wrote to his son again on 26 December asking him to call on Mrs. Blake to pick up "the copper Plate" and a receipt for it. Cumberland also states that "as to the Plate you will say I have never received it or any proof of it, or notice & till Mr Linel [sic] demanded the money I knew not it was ever done at all. . . . I suppose by her [Mrs. Blake's] charging 3 Gui. he [Blake] has made a new Plate instead of my old one which I sent to be ornamented on the Margin—and if so you will take that I sent back as a plain one may be more useful—[6] I long much to see what he has done—but if it is ever so trifling take it at her price." Cumberland entered the amount of £3 3s. in his account book on 16 January 1828, "for the Card." The payment was made to Mrs. Blake, "through Sydney," Cumberland's other son, but George Jr. reported on 15 January that "Syd gave me the money [for the card plate and a copy of Blake's *Job* engravings] for Mrs Black [sic] too late in the day for me to attend to it." But payment was made by 17 January, for on that day Linnell wrote in his journal that "Mr Cumberland [i.e., George Jr.] came & paid Mrs Blake for the card plate 3gns."

Shortly after he received the plate, George wrote his father that "Mrs Blake sends her Compts with many thanks; she tells me that the Card would have been more finished if WB had lived, that it was the last thing he attempted to engrav." In another letter of about the same time, his son told Cumberland that "the Card which I had not time to get printed represents the Seasons. I shall only give them to those likely to serve Mrs B. it might be as well to reserve them till the Widow has printed her late husbands works which She intends to do and then send it to your friends." On 20 January, Cumberland wrote his son, complaining again about his failure to receive the card plate: "As you have sent me no proof of Blakes engraving I cannot tell what to make of it—and here [in Bristol] we have no one who could make a proof without Spoiling the Engraving—I expected you would have taken off a few for yourself, and shall give you some when I can get them printed

[4] Keynes, ed., *Letters of Blake*, p. 169.
[5] Bentley, *Blake Records*, pp. 357-358. All other documents cited here are quoted from *Blake Records*, pp. 359-361, 365-367, 583, 595.
[6] This elliptical phrase means that Cumberland wants his son to retrieve the plain card plate he had sent Blake, if indeed the artist *had* made a new one. The old, plain card might prove the more useful of the two.

Part One.
Plates Designed and Executed
by Blake

off—as I wish by means of it to spread my old friends fame and promote his wifes Interest."

Cumberland finally received the plate, or at least some impressions from it, by 27 January 1828, for on that day he entered in his diary, "Wrote to Sydney, & sent Card a proof of Blake." On 1 February, Cumberland wrote his son George, "I send you and Syd half a Dozen of the Cards—I could only get 20 Printed since I got it—they cost near 1d each here for fast [?] Prints; do you know what it means?"[7] Cumberland's last recorded comment about the card is the note he wrote on Blake's letter of 12 April 1827—see impression 1K.

Cumberland's name on the card may not have been engraved by Blake. As Cumberland's letter of 3 December 1827 makes clear, he had sent a plain card plate to Blake for embellishment. This plate must have already had Cumberland's name engraved on it; there would have been no reason for him to send a blank piece of copper from Bristol to London. His conjecture of 26 December that Blake engraved an entirely new card, based on the price asked by his widow, is not necessarily accurate; elsewhere in his correspondence of this period Cumberland complains of his financial difficulties and Blake's high prices. The lettering of the name on the card is unlike Blake's pseudo-gothic upright hand on the "Laocoön" (*c.* 1820), but does share some features with the slanted gothic letters of "Ye gon to Canterbury God mote you spede" added to "Chaucers Canterbury Pilgrims" in the fourth state, *c.* 1820-1823.

Russell, *Engravings of Blake*, p. 119, states that the "Linnell collection contains some trial proofs of the plate in an unfinished state," and Binyon, *Engraved Designs of Blake*, p. 79, describes impression 1E as a "first state." However, the three impressions (1E-1G) in the British Museum from the Linnell collection are in the same state as all others I have seen. The failure to ink Cumberland's name and the thin inking of the strings holding the birds to the left and below the name do not, of course, signify that impression 1E was pulled from an early state of the copperplate.[8]

Extant impressions recorded here are printed on at least four types of paper. The three British Museum impressions (1E-1G) are printed in black on the same type of wove paper. They were probably pulled by Blake or Linnell before the plate was delivered to Cumberland. Eight impressions are in black on a thick card, similar to a modern business card. Impression 1O is on a card 5.3 × 10.2 cm and was probably given to its first owner by Cumberland himself. Impressions 1A, 1K, 1N, 1R, 1S, 1AA, and 1DD are on cards averaging 3.6 × 8.3 cm (i.e., just a little larger than the copperplate). Some of these impressions on cards were probably pulled for Cumberland as part of the printing of twenty he mentions in his letter of 1 February 1828; others may have been printed later as Cumberland, who died in the 1840s, needed more cards. All other impressions are on at least two varieties of laid paper.[9] One type, represented by impressions 1C, 1D, 1H, 1J, 1L, 1T, 1U, and 1W, is a thin stock with a comparatively rough texture. The chain lines are not very clear, but would seem to range between 1.2 and 2.4 cm apart. I suspect that this variation results from differences between two molds used by the same paper maker.

[7] The final clause is no doubt a query about the meaning of Blake's apparently symbolic design.

[8] On this matter I agree with Keynes, *Engravings by Blake: The Separate Plates*, p. 58 n.2.

[9] It is difficult to make exact paper identifications when the examples are so small and cannot be brought together for direct comparisons. These comments on the laid papers used for the plate must be considered provisional.

120

The other laid paper, used for impressions in brown ink (1B, 1I, 1M, 1Q, 1V, 1Y, 1Z, and 1BB) as well as black (1P, 1T, 1X, 1CC, and perhaps others), is somewhat thicker, considerably smoother, and with prominent wire and chain lines, the latter about 2.5 cm apart. Six examples (1I, 1M, 1P, 1Y, 1Z, and 1BB) contain fragments of a watermark which, when assembled together, form a figure of Britannia in a circle surmounted by a crown.[10] The watermarks in impressions 1Q and 1Z form a date of 1796 beneath the circle, and impressions 1X and 1CC show a countermark. All the impressions on laid paper were probably printed on small pieces between about 10 × 16 cm (1B, 1I, 1M, 1Q, 1X, 1Y, 1Z, and 1CC) and about 9.5 × 14.5 cm (1C, 1D, 1L, 1P, 1W, and 1BB).

Keynes, *Engravings by Blake: The Separate Plates*, p. 59, claims that "the plate is believed to be still in existence" and that "many of the existing impressions on paper [as distinct from a card] were taken from it in recent times." This is by no means certain. Impression 1H is on laid paper of the first type, described above, and it was probably pasted into *Poetical Sketches* by Cumberland or a member of his family. He may have printed the plate on paper shortly after receiving it to use as a bookplate. There is no clear evidence that the plate still existed into the middle years of the nineteenth century. Some impressions are thinly printed, with some appearance of wear or poor inking in the fine horizontal hatching lines, upper right, but this occurs in impressions on cards as well as laid paper. The best impressions are 1G, on wove paper (Fig. 57), and 1N, uniquely printed in green-gray ink on a card.

The design was probably executed with the graver and drypoint needle without preliminary etching. The short, delicate strokes on the figures and the lines of radiance, upper left, are similar to Blake's technique in the second state of "Mirth" (*c.* 1820-1827) and "Paolo and Francesca in the Circle of the Lustful," the first of the Dante engravings (1827). Like "Mirth" and all the Dante plates, Cumberland's card was probably left unfinished at Blake's death (as his widow told Cumberland's son), and thus its open, uncluttered style may not represent the artist's final intentions.

Keynes has suggested that Blake inscribed the plate with his age (A Æ 70) because he took pride in still being able to execute such fine work in his seventieth year.[11] At least when considered in retrospect, this most unusual inscription contributes to the elegiac and prophetic theme of the design. Some motifs recall Blake's early career as an original graphic artist. The boy bowling a hoop through the sky takes us back to the similar scene in the first plate of "The Ecchoing Green" in *Songs of Innocence* (1789); the boys trapping and snaring birds suggest the child reaching after a bird on pl. 5 of *There is No Natural Religion* (*c.* 1788) and on p. 12 of the *Night Thoughts* engraved illustrations (1796). But these energetic youths are caught in the skein of mortality. The Clotho-like figure on the right holds aloft the thread of life to be cut by the radiant angel holding a sickle. Yet this potentially deadly instrument can also harvest the life-giving wheat below the Fate and release the birds to soar above with the company of haloed angels.

[10] The watermark is similar, but clearly not identical, to no. 209 in Edward Heawood, *Watermarks Mainly of the 17th and 18th Centuries*, Hilversum: Paper Publications Society, 1950. All the crown and Britannia watermarks listed by Heawood date from *c.* 1765 to *c.* 1799. W. A. Churchill, *Watermarks in Paper*, Amsterdam: Menno Hertzberger, 1935, p. 43, points out that most papers with a Britannia watermark were foolscap size (about 42.5 × 34.5 cm).

[11] *Engravings by Blake: The Separate Plates*, p. 59.

The symbolic implication that physical death is a passage to spiritual life accords with some of Blake's most deeply held beliefs, also embodied by the rising youth above the grave in "Deaths Door" (Fig. 25). As he told Cumberland in April 1827, "I have been very near the Gates of Death & have returned very weak & an Old Man feeble & tottering, but not in Spirit & Life, not in the Real Man The Imagination which Liveth for Ever."[12] The final testament of this faith is provided by George Richmond's description of Blake's death: "He said He was going to that Country he had all His life wished to see & expressed Himself Happy, hoping for Salvation through Jesus Christ—Just before he died His Countenance became fair. His eyes Brighten'd and He burst out into Singing of the things he saw in Heaven."[13]

[12] Keynes, ed., *Letters of Blake*, p. 168.
[13] Ibid., p. 171.

Part Two. *Plates Executed by Blake after Designs by Other Artists*

XXII.
Morning
Amusement

(after Jean-Antoine Watteau)

FIGURE 58

First state: 1782

Signature, left: Watteau Pinx.

Signature, right: W., Blake sculp.

Title, open letters: MORNING AMUSEMENT

Inscription below title: From an Original Picture in the Collection of M., A., Maskins

Imprint: Pubd August 10th 1782 by Thos Macklin No 39 Fleet Street

Oval image, including border: 25.4 × 30.3 cm

Plate mark: 32.9 × 35.8 cm

IMPRESSIONS

1A.

Martin Butlin, London. Printed in sanguine on paper approximately 38.5 × 42.4 cm, framed. Purchased by Butlin, with "Evening Amusement," impression 1A, *c*. 1963 at a country auction in Devonshire for about £4 the pair. Both prints exhibited at the Tate Gallery in 1978, nos. 37 and 38 in the catalogue. "Morning Amusement" reproduced here, Fig. 58.

1B.

Sir Geoffrey Keynes, Suffolk. Printed in brown on laid paper, 37.2 × 41.7 cm, with repaired tears in the left edge and a pencil inscription, "In Alb Birket," lower left. Delicately hand tinted with watercolors (dark rose, blue, yellow, flesh tones). Acquired at Sotheby's, 21 December 1950, lot 479 (£3 to Colnaghi for Keynes). Listed in Keynes, *Bibliotheca Bibliographici*, no. 565ii; Bindman, *Blake: Catalogue of the Collection in the Fitzwilliam Museum*, no. 565ii, as part of Keynes' bequest to the Museum.

1C.

Sir Geoffrey Keynes, Suffolk. Printed in sanguine on laid paper trimmed to 28.8 × 35.4 cm, thereby cutting off the imprint. Traces of an unidentifiable watermark. The collector's stamp on the verso, a "W" printed over "AA" in a circle, indicates that the print was once in the collection of Alexander Anderdon Weston, London, who died in 1901.[1] Acquired by Keynes many years ago; no information on provenance available. Lent by Keynes to the British Museum in 1957, no. 61(4) in the exhibition catalogue. Listed in Keynes, *Bibliotheca Bibliographici*, no. 565i; Bindman, *Blake: Catalogue of the Collection in the Fitzwilliam Museum*, no. 565i, as part of Keynes' bequest to the Museum. Reproduced in sanguine in Keynes, *Engravings by Blake: The Separate Plates*, pl. 39.

[1] See Louis Fagan, *Collectors' Marks*, London: n.p., 1883, no. 532; Fritz Lugt, *Les Marques de Collections de Dessins & D'Estampes*, Amsterdam: n.p., 1921, no. 65.

Second state: 1782
The letters of the title have been "closed" with horizontal lines of hatching as in the second state of "Evening Amusement" (see Fig. 59).

IMPRESSIONS

2D.
McGill University, Montreal. Printed in dark brown on laid paper trimmed to 27.6 × 35.6 cm, thereby cutting off all inscriptions below the title except for the top of the C of *Collection*. A repaired tear extends from the top edge to 1 cm within the image. Three stab holes at the top edge correspond to three of the four stab holes in "The Fall of Rosamond," impression 2D. This and impression 2C of "Evening Amusement" and impression 2D of "The Fall of Rosamond" were acquired by McGill in August 1979 from Simon Kevan, who inherited them from his grandmother, Mrs. Gwyneth Kevan, who in turn acquired them *c.* 1920-1930 from her great-aunt Mary, the wife of Sir Matthew Digby Wyatt, the Victorian architect (1820-1877).

2E.
Pierpont Morgan Library, New York. Printed on heavy wove paper trimmed to 29.7 × 33 cm, thereby cutting off the imprint. Numbered in pencil "96," upper left, stab holes along the top edge, and two creases running horizontally in the lower margin, 5.6 and 7.1 cm above the bottom edge. Acquired by the Library in 1976 as part of an extra-illustrated copy of Cunningham's "Blake," in which the print was formerly bound as leaf 126. For provenance, see "Joseph of Arimathea Among the Rocks of Albion," impression 2G.

2F.
Mrs. Lucile Johnson Rosenbloom, Pittsburgh. Printed on heavy wove paper trimmed inside the plate mark to 32.7 × 35.5 cm. Purchased, with "Evening Amusement," impression 2F, from Stevens & Brown by Sessler's in June 1949 for $13.33 the pair. Sold by Sessler's, according to their records, for $750 the pair in October 1949 to Charles J. Rosenbloom, who placed his collection stamp on the verso of both prints. Bequeathed by Rosenbloom in 1973 to his widow, the present owner. These two prints may be the pair in black sold from the Moss collection in 1937—see untraced impression 7.

2G.
Victoria and Albert Museum, London. Printed on paper trimmed within the plate mark to 30.2 × 31.4 cm, pasted to the mat. Acquired at an unknown time, probably early in this century, by Miss A. M. Butterworth and given by her to the Museum in 1938.

IMPRESSIONS, state unidentifiable

Part Two.
Plates by Blake after Designs by Others

H.

British Museum. Printed on wove paper, 26 × 31 cm, trimmed to an oval close to the border, thereby cutting off all inscriptions except for the signatures. Tears upper right and on the left extending slightly into the image; paper browned with age. Acquired in June 1929 with "Evening Amusement," impression G, from Miss I. C. Napiar-Hardy.

UNTRACED IMPRESSIONS, including early sales of large lots[2]

1.

Offered in *Poetic Description of Choice and Valuable Prints, Published by Mr. Macklin, at the Poet's Gallery, Fleet Street*, London, 1794, p. 70, "Morning Amusements [*sic*]. Painted by Watteau, and Engraved by W. Blake. Size 12 inches by 10, oval; Price 7s.6d. Plain, and 15s. in Colours. Evening Amusements [*sic*]. Painted by Watteau, and Engraved by W. Blake. Size 12 inches by 10, oval; Price 7s.6d. Plain, and 15s. in Colours."

2.

Sale of the Property of Mr. Macklin by Peter Coxe, Burrell, and Foster, 6 May 1800, lot 1, "Morning and Evening Amusement," 165 "Plain" (i.e., uncolored) impressions (£1 12s. to Brydon).[3] This auction catalogue does not make it clear, but the lot probably included 165 *sets* of these companion prints. The title page to the auction catalogue states that the sale was for "the Purpose of facilitating the Adjustment of Partnership Accounts." Joseph Farington noted in his diary on 11 May 1800 that "Macklin's pictures painted by English Artists have been put up for sale by the Trustees for Mr. Rogers of Liverpools estate, who has a claim of £11,000 on Macklin.—The pictures sold at such low prices that the sale is stopped."[4] The halt was evidently not called until after the sale of lot 1 on the second day of the auction.

3.

Sale of works of art from the collection of Mrs. Macklin, deceased, by Peter Coxe, 2 April 1808, lot 64, "Morning Amusements [*sic*]," 18 prints and one colored example, with "Evening Amusements [*sic*]," 19 prints and one colored example (8s.). This auction catalogue, p. 21, indicates that the copperplates for these two prints were also sold in lot 64. Same sale, lot 29, on 31 March, "Morning Amusement," with three other prints (4s. 6d.).

4.

Offered by Tregaskis, February 1913 catalogue, item 70, "Morning" and "Evening Amusement," a pair (£17 17s.). Perhaps the same as the impressions in black later in the Moss collection; see no. 7, below.

5.

Sold from the collection of Sir Lionel Phillips, Christie's, 21 April 1913, lot 11, "Fetes Champêtres, after Watteau, by W. Blake, a pair,

[2] The number given to each entry in this section does not correspond to the number of copies grouped under each entry. Nos. 1-3 probably cover the majority of all impressions pulled.

[3] Neither the designer nor engraver is identified in this Coxe auction or the one listed here as no. 3. But since the prints came from Macklin's stock in both cases, there can be no doubt that they were the plates engraved by Blake.

[4] *The Diary of Joseph Farington*, ed. by Kenneth Garlick and Angus Macintyre, New Haven: Yale University Press, 1979, vol. IV, p. 1394.

ovals, in colours" (£31 10s. to Sand). Perhaps the impressions in colors later in the Moss collection; see no. 7, below.

6.

Sold from the collection of the late Mr. Vaughan of Brighton, Sotheby's, 2 July 1913, lot 97*, "Morning Amusement and Evening Amusement, . . . a pair, ovals, in red, one an open-letter proof [i.e., first state], both with full untrimmed margins" (£29 to Maggs). Same sale, lot 98, "a similar lot, a pair, cut to the ovals" (£6 5s. to Meatyard). The pair sold as lot 97* was offered by Maggs Bros. in their October 1913 catalogue, no. 315, item 232, "in red . . . with large margins" (£45). The reproduction of "Morning Amusement" in this catalogue indicates that it was the first state in the pair. The pair of prints sold as lot 98 were offered for sale by F. R. Meatyard in his August 1913 catalogue, item 223, both in "red" with "slight margins" (£10 10s.).

7.

Two sets of "Morning" and "Evening Amusement," one pair printed in colors and the other in black, were acquired by W. E. Moss by 1914 and lent by him in that year to the Manchester Whitworth Institute, nos. 114 and 115 in the exhibition catalogue. The pair in black are described as having "shaded title lettering," thus indicating that they were in the second state and, by implication, that the color-printed pair were in the first state. The pair printed in colors may be those first sold in 1808 (see no. 3, above) and/or those offered for sale by Henry Young & Sons, bookdealers of Liverpool, in their September 1913 catalogue, item 72, described as color printed and cut to the oval image (£47). According to Russell, *Engravings of Blake*, p. 137, Young offered a pair in colors in a catalogue of 7 October 1911. However, "Young" purchased a "pair, in colours" at Christie's, 8 July 1913, lot 103 (£23 2s.). Thus if Russell's information is correct there were two sets of color prints, but which set Moss may have purchased cannot be determined. See also nos. 4 and 5, above.

The Moss impressions were exhibited at the Whitworth Institute with three photographs of Watteau's paintings of the same and similar subjects in the Wallace Collection, London. Sold from the Moss collection at Sotheby's, 2 March 1937, lot 139, "Morning Amusement, and Evening Amusement, a pair, stipples, printed in colours, cut close and laid down, [with] another pair, in black," and three more unidentified works (£8 to Dulau). Both sets offered by Dulau & Co., April 1937 catalogue, item 20, with "three large photographs of Watteau's in the Wallace collection" (£14). These three photographs were no doubt those exhibited in 1914 and also the three unidentified works in the Sotheby auction of 1937. Same group offered by Dulau, 1940 catalogue no. 281, item 9 (£10 10s.). The pair in black may be the same as impression 2F of "Morning Amusement" and impression 2F of "Evening Amusement."

8.
Sold Sotheby's, 14 June 1928, lot 277, "Morning Amusement and Evening Amusement, by W. Blake, after A. Watteau, a pair, late impressions," with three other plates (5s. to "cash").

9.
Sold Sotheby's, 11 March 1930, lot 267, "Morning and Evening Amusement by W. Blake . . . , a pair, printed in colours" (£10 to Walter T. Spencer). The prints were no longer in Spencer's stock by 1971.

"Morning Amusement" and its companion, "Evening Amusement," are the first separate prints Blake executed after his release from apprenticeship in August 1779. Both plates reproduce paintings by Jean-Antoine Watteau (1684-1721). Keynes, *Engravings by Blake: The Separate Plates*, pp. 63-64, has identified Watteau's "Le Rendez-vous de Chasse" and "Les Champs Elysées" as the paintings reproduced in "Morning Amusement" and "Evening Amusement." However, both of these oil paintings,[5] now in the Wallace Collection, London, are rectangles, not ovals, and show considerable landscape as well as figures on the right and left that are not in Blake's prints. Further, "Le Rendez-vous de Chasse" has no dead game, lower right, as in "Morning Amusement," but the painting does have a rather differently arranged group of animals on the left. Neither painting has a provenance that includes "Mr. Maskins" (or "Maskin," as inscribed on "Evening Amusement"). "Le Rendez-vous de Chasse" was probably not in England until 1865, and "Les Champs Elysées" was, in 1782, still in the Blondel collection in France.[6] The paintings owned by Maskins were very probably modified copies after Watteau's originals.

Blake executed both plates in a delicate combination of short lines, flick work, and stipple. The border and perhaps some of the image were probably created with the roulette. The plates were printed on both wove and laid paper, the latter of high quality with faint wire and chain lines. The felt side of this laid paper (on which impressions were generally pulled, leaving the mold side for the versos) is very smooth and shows no wire or chain lines. Thus, in prints framed or pasted down, such as impression 1A of both plates and impression 2G of "Morning Amusement," the paper type cannot be determined with any certainty. After the death of the publisher Thomas Macklin in October 1800, the copperplates passed to his widow, who carried on the family business until about 1808.[7] The plates were sold after her death to an unknown purchaser—see untraced impression 3, above.

[5] Reproduced in color in Anita Brookner, *Watteau*, London: Hamlyn, 1971, pls. 39, 41.

[6] Martin Butlin, "The Inscriptions on *Evening Amusement*," *Blake Newsletter*, 6 (Winter 1972-1973), 74, writes that neither painting "left France till 1787 at the earliest." For descriptions and provenances, see Hélène Adhémar, *Watteau, sa vie—son oeuvre*, Paris: Pierre Tisné, 1950, pp. 225, no. 184; 228, no. 198.

[7] See William T. Whitley, *Art in England, 1800-1820*, Cambridge: University Press, 1928, p. 11.

XXIII.
Evening
Amusement

(after Jean-Antoine Watteau)

FIGURE 59

First state: 1782

Signature, left: Watteau pinx!

Signature, right: W„ Blake fecit

Title, open letters: EVENING AMUSEMENT

Inscription, below title: From an Original Picture in the Collection of M^r„ A„ Maskin.

Imprint: Pub^d„ as the Act directs August 21„ 1782 by T„ Macklin, N°„ 39 Fleet Street..

Oval image, including border: 25.2 × 30.3 cm

Plate mark: 33.1 × 35.9 cm

IMPRESSIONS

1A.

Martin Butlin, London. Printed in sanguine on paper approximately 38 × 42 cm, framed. Reproduced in the 1978 Tate Gallery exhibition catalogue, no. 38. For provenance and exhibition, see "Morning Amusement," impression 1A.

Second state: 1782
The letters of the title have been "closed" with horizontal lines of hatching (see Fig. 59).

IMPRESSIONS

2B.

Robert N. Essick, Altadena, California. Printed in sanguine on laid paper trimmed inside the plate mark to 30.4 × 31.4 cm. Sold Sotheby's, 27 July 1976, lot 40 (£240 to Andrew Edmunds for Essick). Reproduced here, Fig. 59.

2C.

McGill University, Montreal. Printed in sanguine on laid paper trimmed within the plate mark to 28.3 × 35.9 cm, cutting off the imprint. Vague indications of a watermark, lower center, obscured by the image. For provenance, see "Morning Amusement," impression 2D.

2D.

Pierpont Morgan Library, New York. Printed on heavy wove paper trimmed to 29.7 × 32.9 cm, thereby cutting off the imprint. Numbered in pencil "97," upper left, stab holes along the top edge, and two creases running horizontally in the lower margin, 5.7 and 7.4 cm above the bottom edge. Acquired by the Morgan Library in 1976 as part of an extra-illustrated copy of Cunningham's "Blake," in which the print was formerly bound as leaf 127. For provenance, see "Joseph of Arimathea Among the Rocks of Albion," impression 2G.

2E.
Philadelphia Museum of Art. Well printed on heavy wove paper, 39.2 × 43.6 cm, mounted in a window cut in a large sheet of paper and bound as the twenty-seventh print in a volume of prints after Watteau, labeled on the spine "Oeuvres de Watteau." According to a loose note in this volume, the prints were collected (and bound?) by "the Earl of Dudley" (apparently John William Ward, 1781-1833, first Earl of Dudley). Acquired at an unknown time by Lessing J. Rosenwald and given by him to the Museum in 1953.

2F.
Mrs. Lucile Johnson Rosenbloom, Pittsburgh. Printed on heavy wove paper trimmed inside the plate mark to 32.6 × 35.5 cm. Collection stamp of Charles J. Rosenbloom on verso. For provenance, see "Morning Amusement," impression 2F.

IMPRESSIONS, state unidentifiable

G.
British Museum. Printed on wove paper, 25.6 × 30.8 cm, trimmed to an oval close to the border, thereby cutting off all inscriptions except for the signatures. Some loss of image at the torn top edge of the sheet. Paper browned with age; many tears, some extending into the image at the top and left side; signatures torn. For provenance, see "Morning Amusement," impression H.

UNTRACED IMPRESSIONS (see "Morning Amusement," untraced impressions and early sales)

For discussion, see "Morning Amusement."

XXIV.
Robin Hood
& Clorinda

(after J. Meheux)

FIGURE 60

One state: 1783

Signature, left: J„ Meheux delin!

Signature, right: W. Blake sculp!

Title, letters with horizontal hatching: Robin Hood & Clorinda

Inscription, below title:

> Says Robin Hood, fair Lady, whether away
> O whether fair Lady, away,
> And she made him answer, to kill a fat buck
> For to morrow is tilbury [or *titbury*] day.

Imprint: London Pub„ᵈ March 30, 1783 by T„ Macklin N„º 39 Fleet Street

Circular image, including border: 21.4 × 21.5 cm

Plate mark: 27.7 × 23 cm

IMPRESSIONS

1A.

British Museum. Printed in dark brown on (wove?) paper, 42 × 28.7 cm, pasted to the mat. Hand tinted with thin watercolor washes (pink, green, blue, brown). Perhaps the impression sold Christie's, 16 December 1902, lot 23, "printed in colours [*sic?*]" (£6 6s. to Maggs). Acquired by W. E. Moss by 1914, and lent by him in that year to the Manchester Whitworth Institute, no. 107 in the exhibition catalogue, where the print is correctly described as "hand coloured." Sold from the Moss collection, Sotheby's, 2 March 1937, lot 140, "printed in colours [*sic*], full margins" (£6 10s. to Maggs for the British Museum, which accessioned the print 10 April 1937). Reproduced here, Fig. 60.

1B.

Victoria and Albert Museum, London. Printed in red-brown on laid paper, 39.1 × 28.9 cm, with fragments of an unidentified watermark in the right margin. The imprint and inscription below the title are faint. Bequeathed to the Museum in 1948 by H. H. Harrod. Perhaps the impression sold at Christie's, 31 March 1903, lot 30, "in bistre" (£1 12s. to Rimell).

UNTRACED IMPRESSIONS

1.

Offered in *Poetic Description of Choice and Valuable Prints, Published by Mr. Macklin, at the Poet's Gallery, Fleet Street,* London, 1794, p. 68, "Robinhood and Clorinda. Painted by J. Meheux, and Engraved by W. Blake. Size eight inches and a half, circle; Price 4s. Plain, and 7s. 6d. in Colours," followed by the four lines of verse quoted on the plate.

Part Two.

Plates by Blake after Designs by Others

2.

Sale of the Property of Mr. Macklin by Peter Coxe, Burrell, and Foster, 7 May 1800, lot 3, "Robin Hood," seventy-nine plain impressions and twenty-two in "colours" (£1 7s.). No designer or engraver is named, but these may be impressions of Blake's plate. Lot 15 on the same day was comprised of three drawings, including "Robin Hood, and Clorinda," all attributed to "Harding" (probably Sylvester Harding, 1745-1809). Perhaps this was the drawing Blake engraved.

3.

Sale of works of art from the collection of Mrs. Macklin, deceased, by Peter Coxe, 31 March 1808, lot 96, "Robin Hood and Clorinda," a print "in colours," with seven others. No designer or engraver is named, but this is very probably an impression of Blake's plate.

Blake executed "Robin Hood & Clorinda" in a delicate combination of short lines, flick work, and stipple. The thin border, and perhaps some of the image, were probably created with the roulette. It is possible that the plate was first issued by Macklin as an open-letter "proof," as is the case with "Morning Amusement" and "Evening Amusement," but no such state is known. The similarities in format and date suggest that "Robin Hood & Clorinda" is a companion print to, or part of the same series as, "The Fall of Rosamond" (Fig. 61).

The lines inscribed beneath the title are from "The Pedigree, Education, and Marriage of Robin Hood with Clorinda, Queen of Titbury-Feast," the first poem in the many eighteenth-century editions of the ballads pamphlet *Robin Hood's Garland*.[1] In this poem, Clorinda is described as holding a bow; the figure left of Robin Hood is probably Little John, holding Robin Hood's bow, and the group in the distance on the left is the "forty and three" yeomen standing "under the green wood tree." A likely source for the inscription is *Old Ballads, Historical and Narrative* [ed. Thomas Evans], London: T. Evans, 1777, vol. I, pp. 86-95, where the poem is set in quatrains for the first time. The first word in the second line of the quatrain is "O" in this text, whereas it is "Oh" in most eighteenth-century printings of *Robin Hood's Garland*. In all printed texts I have surveyed, the words are "whither" (not "*whether*," first and second lines of the inscription) and "Titbury." It is unclear, in the last line of the inscription, whether the place name is "*tilbury*" or "*titbury*" with the second "*t*" not crossed. Both variants may be simple errors.

Nothing is known of "J. Meheux" other than his designing "Robin Hood and Clorinda."[2] The name might be a pseudonym, perhaps for Harding (see untraced impression 2). The figures in the print are not at all like the work of Stothard, the designer of "The Fall of Rosamond."

[1] The title varies, and was published as "A New Ballad of Bold Robin Hood" in *Robin Hood: A Collection of All the Ancient Poems, Songs, and Ballads* [ed. Joseph Ritson], London, 1795, vol. II, p. 7. For a complete list of editions, see Harris Gable, "Bibliography of Robin Hood," *University of Nebraska Studies in Language, Literature and Criticism*, no. 17, 1939.

[2] Samuel Redgrave, *A Dictionary of Artists of the English School*, 2d ed., London, 1878, p. 292, gives the artist's name as "John Meheux."

XXV.
The Fall
of Rosamond

(after Thomas Stothard)

FIGURE 61

First state: 1783

Signature, left: Stothard Delin.

Signature, right: Blake Sculpt

Circular image, including border: 30.7 × 30.7 cm

Plate mark: probably the same as in the second state, 39.3 × 33.2 cm

IMPRESSIONS

1A.

Sir Geoffrey Keynes, Suffolk. Printed in brown and pink (for flesh tones) on laid paper, 35.8 × 32.8 cm. Carefully hand tinted with watercolors (dark and light brown, green, yellow, dark red, blue, gray). The sheet is trimmed 2.8 cm below the image, thereby showing that neither the title nor the quotation beneath (see second state) had been executed on the plate. Large repaired tear in left margin; second-state title and quotation beneath written in pencil on the verso. According to Ruthven Todd's letter of 31 March 1941 to Allan R. Brown (now in the Watkinson Library, Trinity College), Todd was given this impression by a "printseller friend." Given by Todd sometime after 1956 to Douglas Cleverdon, who sold it to Keynes in 1978.

1B.

Raymond Lister, Cambridgeshire. Printed in brown and pink (for flesh tones) on laid paper (as in impression 1A), 30.4 × 30.3 cm. The signatures are intact, but the edge of the sheet touches the image on all four sides, cutting into the border on three sides. Acquired in the 1950s from the London bookdealer E. Seligmann. Reproduced in Lister, *Infernal Methods*, fig. 18.

Second state: 1783

The title and quotation from Hull's play have been added to the plate. The area where the imprint appears in the second state has been trimmed off the only known impressions of the first state, but the imprint may be another second-state addition. The signatures have been engraved more darkly with a period added after *Sculpt*.

Title, letters with horizontal hatching: THE FALL OF ROSAMOND

Inscription below title:

Queen,	Drink; or this Poinard searches every Vein.
Rosamond,	Is there no Pity; none, this awful silence
	Hath answer'd me, and I intreat no more,
	Some greater Pow'r than thine demands
	my life;
	Fate summons me; I hear, and I Obey—

Part Two.
Plates by Blake after Designs
by Others

O, heav'n; if crimes like mine may hope
 forgiveness,
Accept a contrite heart.
[to the right] Vide Hull's fall of Rosamond
 Act 5

Imprint: London Publish'd Oct.ʳ 1„ 1783 by Tho.ˢ Macklin
 N.ᵒ„ 39 Fleet Street

Dimensions: same as in first state

2C.
Sir Geoffrey Keynes, Suffolk. Printed in brown on laid paper, 43.4 ×
34.9 cm. Foxed, with a tear in the right margin extending into the
image. Sold from the collection of E. J. Shaw, Sotheby's, 29 July 1925,
lot 157, with five other prints by Blake, including "Enoch," impression
1C, and "Rev. John Caspar Lavater," impression 2B (£11 to Keynes).

2D.
McGill University, Montreal. Printed on laid paper trimmed just within
the plate mark to 39 × 33.1 cm. Watermark in center consisting of
two lines of letters, obscured by the image. Four stab holes in left
edge, three of which match the three stab holes at the top edge of
"Morning Amusement," impression 2D. For provenance, see "Morn-
ing Amusement," impression 2D.

2E.
New York Public Library. Printed in very dark brown or black on
wove paper 34.7 × 34.7 cm. Hand tinted with watercolors (green,
black, light brown, blue). The title and quotation beneath it have been
cut off and pasted to the verso. Very worn, torn, stained; repaired
with linen on the verso. Acquired by the Library in 1915 as part of
the collection of Anna Palmer Draper.

2F.
Royal Academy, London. Printed in dark brown on (wove?) paper
trimmed inside the plate mark to 38.8 × 32.4 cm and pasted down.
Some spotting in the margins. Mounted on the seventeenth leaf of
volume IX of a twelve-volume collection of prints after Stothard. The
title page in volume I reads, "Engravings, from the Works of Thomas
Stothard, R.A. . . . Collected by W. E. Frost, A.R.A, . . . together with
selections from those of I. Rogers, W. Pickering, R. Cook, H. Burke,
DuRoveray, C. R. Leslie, C. Price, E. V. Utterson, C. Heath, etc.
London, 1861." Given to the Royal Academy by William Edward
Frost, c. 1861. Reproduced here, Fig. 61.

UNTRACED IMPRESSIONS

1.
Offered in Poetic Description of Choice and Valuable Prints, Published
by Mr. Macklin, at the Poet's Gallery, Fleet Street, London, 1794, p.

62, "The Fall of Rosamond. Painted by T. Stothard, R.A. and Engraved by W. Blake. Size 12 inches, circle; Price 7*s*. 6*d*. Plain, and 15*s*. in Colours," followed by the lines from Hull's play quoted on the plate.

2.
Sale of the Property of Mr. Macklin by Peter Coxe, Burrell, and Foster, 8 May 1800, lot 8, "Rosamond," eighty-seven plain impressions and sixty-four in "colours." No designer or engraver is named, but these may be impressions of Blake's plate. Lot 38 on 6 May, the second day of this sale, comprised two drawings by "Stothard," "Elfrida's Vow, and the Fall of Rosamond," a pair (£1 19s. to Heath). The latter is probably the drawing Blake engraved.

3.
Sale of works of art from the collection of Mrs. Macklin, deceased, by Peter Coxe, 1 April 1808, lot 18, "one pair, Elfrida's Vow, and Fall of Rosamond, proofs," with four others (6s.). No designer or engraver is named, but this is very probably an impression of Blake's plate.

4.
Offered for sale at auction from the collection of Thomas Edwards by Winstanley, Manchester, 15 May 1826, lot 48, four plates including "The Fall of Rosamond."

5.
Acquired by W. E. Moss by 1914 and lent by him in that year to the Manchester Whitworth Institute, no. 113 in the exhibition catalogue. According to Keynes, *Engravings by Blake: The Separate Plates*, p. 65, this impression was printed in sanguine. Sold at Sotheby's, 20 December 1938, lot 459, with "Beggar's Opera" by Blake after Hogarth (with the next lot, 8s. to Maggs). This is very probably the impression that Sessler's, according to their sales and purchase records, received "on consignment" from Maggs on 12 January 1939 at a "cost" of $16.79, and returned to Maggs on 18 April 1940.

Blake executed "The Fall of Rosamond" in a delicate combination of short lines, flick work, and stipple. The thin border, and perhaps some of the image, were probably created with the roulette. It is possible that the plate was first issued by Macklin as an open-letter "proof," as is the case with "Morning Amusement" and "Evening Amusement," but no such state (between the first and second recorded here) is known. The similarities in format and date suggest that "The Fall of Rosamond" is a companion print to, or part of the same series as, "Robin Hood & Clorinda" (Fig. 60) and "Elfrida's Vow" (see untraced impressions 2 and 3).

"The Fall of Rosamond" is the first separate plate Blake engraved after a design by his friend Thomas Stothard (1755-1834). Between 1780 and 1785, Blake engraved at least thirty-three book illustrations and separate plates after Stothard's designs. Because this represents

Part Two.
Plates by Blake after Designs
by Others

over half of Blake's known graphic productions during that period, his early income and reputation as a copy engraver must have been heavily dependent on commissions from Stothard and his publishers. For all documents concerning the relationship between Blake and Stothard, see Bentley, *Blake Records.*

According to an "Account of some of the Prices paid to Engravers by the late Mr. Macklin," published in the *Monthly Magazine* of 1801, Blake received £80 for his etching/engraving of "The Fall of Rosamond."[1] The plate also received notice in an article "On Splendour of Colours" in *The Repository of Arts, Literature, Commerce* for September 1810. This essay, signed "Juninus," is in the form of a dialogue between "Miss Eve" and "Miss K." The latter selects "The Fall of Rosamond" for discussion, briefly tells her story, and comments that Blake's "print is solid, well drawn, and varied with much taste. How simple is the design, and yet what elegance and feeling it displays!" Curiously, Blake is named as the engraver of the plate, but no mention is made of Stothard. "Miss K" next speaks of Blake's "The Beggar's Opera," engraved by Blake after Hogarth, and reports that "This artist [Blake] seems to have relinquished engraving, and to have cultivated the higher departments of designing and painting with great success. His works shew that he must have studied the antique with considerable attention." To this "Miss Eve" replies, "If those ingenious men, the engravers, were to ask the man of genius why he abandoned his profession, he might with truth answer to most of those by whom it is followed, in the words of the poet:

> I hear a voice you cannot hear,
> That says I must not stay:
> I see a hand you cannot see,
> That beckons me away."[2]

It is remarkable that Juninus quotes the same lines from Thomas Tickell's "Lucy and Colin" that Blake himself quotes in a letter to Thomas Butts of 10 January 1803.[3] Although he writes the four lines as two, Blake also substituted "That" for "Which," the word beginning the second and fourth lines of this quatrain in all other printed texts I have seen.[4] "Juninus" has never been identified, but he may have become aware of Blake's activities as an artist by attending his exhibition, which opened in May 1809, and this led Juninus to an interest in Blake's early engravings.

Stothard's design illustrates the lines quoted on the plate from Thomas Hull's *Henry the Second; or the Fall of Rosamond: a Tragedy.* The play was first performed at Covent Garden on 1 May 1773 and was popular enough to warrant three editions in the next year. In the fifth act, Rosamond, mistress to King Henry, has sequestered herself in an "apartment" (the building on the right in the print?) in a "bower" to avoid the wrath of jealous Queen Eleanor. Just after Rosamond sends Ethelinda, her friend and attendant, to fetch Henry's love letters, the Queen enters with a dagger and cup of poison. Rosamond is contrite and the Queen tempted by pity, but the injured wife forces the mistress to drink the poison immediately after the lines quoted on the plate. The King enters with attendants (the soldiers far left in the print?) and

[1] "Monthly Retrospect of the Fine Arts," *Monthly Magazine*, 11 (April 1801), 246 (Bentley, *Blake Records*, p. 569).

[2] *The Repository*, pp. 130-131. Some of these references to Blake were first noted by Janet Warner, "A Contemporary Reference to Blake," *Blake Newsletter*, 9 (1976), 122.

[3] Keynes, ed., *Letters of Blake*, p. 49.

[4] Blake may have been quoting from memory, but a likely printed source is [Thomas Percy, ed.], *Reliques of Ancient English Poetry*, London: J. Dodsley, 1765, vol. III, p. 308. Blake's copy of this book is in the Wellesley College Library, Wellesley, Massachusetts.

Part Two.
Plates by Blake after Designs by Others

⁵ Erdman, ed., *Poetry and Prose of Blake*, p. 205, lines 8-9; p. 212, lines 39-40.

⁶ 30.2 × 43.3 cm, collection of George Goyder. Reproduced and discussed by Martin Butlin in the 1978 Tate Gallery exhibition catalogue, no. 256. Butlin dates the drawing *c.* 1815.

Rosamond expires operatically some 150 lines later. In the print, the Queen is on the left holding a dagger and Rosamond kneels in the center with the cup of poison; the woman entering the doorway may be Ethelinda. The play makes no specific reference to the four other women Stothard pictures.

The plate is mentioned by Gilchrist in his *Life of Blake* (1863), I, 51, as "a circular plate in a book published by Macklin (1783)." No such "book" is known, and in all probability Gilchrist is simply mistaken. "The Fall of Rosamond" is also listed by Rossetti in his "Works Engraved but not Designed by Blake" in Gilchrist, *Life of Blake* (1863), II, 259.

On plate 57 of *Jerusalem* (*c.* 1804-1820), Blake refers to "Rosamonds Bower" and asks, "What is a Wife & what is a Harlot? What is a Church? & What/Is a Theatre?" This passage clearly recalls Hull's play and the design based on it Blake had engraved many years earlier. "The Fall of Rosamond" may also stand behind the images of the "Knife of Revenge & the Poison Cup/Of Jealousy"⁵ on plate 63 of *Jerusalem*.

Sometime in the nineteenth century, Blake made a pencil sketch now known as "The Fall of Rosamund."⁶ The subject is probably the same as the print, but the design bears no resemblance to Stothard's. Nothing is known of Stothard's drawing after its sale in 1800 (see untraced impression 2).

XXVI.
Zephyrus and Flora

(after Thomas Stothard)

FIGURE 62

First state: 1784

Signature, left: Stothard. del.

Signature, right: W. Blake. sc.

Title, open letters: ZEPHYRUS AND FLORA

Inscription below title in two columns:

> The gentle God flew ur [or?] th'inchanting Ground,
> Where Flora slept, & breath'd Perfumes around:
> Waking she smil'd, by Loves soft Pow'r imprest;
> He calmly sighing, hover'd o'er her Breast.

Imprint: Published as the Act directs Dec' 17. 1784 by Parker & Blake N° 27 Broad S' Golden Square.

Oval image, including border: 17.4 × 20.5 cm

Plate mark: 25.3 × 25.3 cm

IMPRESSIONS

1A.

Sir Geoffrey Keynes, Suffolk. Printed on laid paper, 27 × 25.3 cm, with a faint, unidentifiable watermark. Purchased by Keynes many years ago from a dealer. Perhaps this or impression 2C, 2E, or untraced impression 2 was the one offered by J. G. Commin, Exeter, January 1921 catalogue, item 62 (£3 3s., changed by hand to £2 13s. in Keynes' clipping from the catalogue). Listed in Keynes, *Bibliotheca Bibliographici*, no. 567ii; Bindman, *Blake: Catalogue of the Collection in the Fitzwilliam Museum*, no. 567ii, as part of Keynes' bequest to the Museum. Reproduced here, Fig. 62.

1B.

Sir Geoffrey Keynes, Suffolk. Printed in sanguine on laid paper, 25.7 × 25.8 cm, with a small fragment of an unidentifiable watermark. Both the ink color and the paper are the same as "Calisto," impression F, with which this impression has been associated since at least 1914. Acquired by W. E. Moss by 1914 and lent by him in that year to the Manchester Whitworth Institute, no. 105-II in the exhibition catalogue. Sold from the Moss collection at Sotheby's, 2 March 1937, lot 142, with "Venus dissuades Adonis from Hunting," impressions 2B, E, and F; "Calisto," impressions 2C and F; and "Zephyrus and Flora," impression F (£10 10s. to Keynes). Listed in Keynes, *Bibliotheca Bibliographici*, no. 567iii; Bindman, *Blake: Catalogue of the Collection in the Fitzwilliam Museum*, no. 567iii, as part of Keynes' bequest to the Museum.

Second state: 1784

AND in the title inscription has been changed to "and." The other letters in the title have been strengthened; some lines

139

Part Two.
Plates by Blake after Designs
by Others

delineating the letters have been widened so that the letters now have a difference between thick and thin elements.

2C.

Robert N. Essick, Altadena, California. Printed on wove paper, 25.6 × 25.9 cm, with a repaired tear 3 cm long in the top left margin. Imprint very faint. Acquired many years ago from a dealer by Sir Geoffrey Keynes; for a possible provenance, see impression 1A. Listed by Keynes in his *Bibliotheca Bibliographici*, no. 567i. Sold by Keynes at Sotheby's Belgravia, 3 February 1976, lot 1 (£75 to Andrew Edmunds for Essick). Listed in Bindman, *Blake: Catalogue of the Collection in the Fitzwilliam Museum*, no. 567i, as part of Keynes' bequest to the Museum (which is no longer the case). Reproduced in Keynes, *Engravings by Blake: The Separate Plates*, pl. 40 (imprint not shown).

2D.

Royal Academy, London. Printed on (wove?) paper, 23.2 × 25.2 cm, foxed in the margins. The inscription below the title and imprint are faint. Pasted on to the forty-eighth leaf of vol. IX of a bound collection of prints after Stothard. For provenance, see "The Fall of Rosamond," impression 2F.

2E.

Staatliche Graphische Sammlung, Munich. Printed on wove paper, 27.8 × 30.2 cm. Acquired by the Museum in 1947 by bequest from the provincial estates court, Munich. For a possible provenance, see impression 1A. Not seen; information supplied by Dr. Gisela Scheffler of the Staatliche Sammlung.

IMPRESSIONS, state unidentifiable

F.

Sir Geoffrey Keynes, Suffolk. Color printed in dark brown, blue, and reddish brown (for flesh tones) on laid paper trimmed close to the oval image, 19.4 × 22.5 cm. All inscriptions except for the signatures have been trimmed off. Hand tinted with blue watercolor. Inscribed "1807" in pencil on the verso. The color printing, hand tinting, and verso inscription are very similar to "Calisto," impression 2C, with which this impression has been associated since at least 1914. This association suggests that this impression, like its companion, is in the second state. However, the laid paper associates it with the first-state impressions (1A, 1B) recorded above. Lent by W. E. Moss to the Manchester Whitworth Institute in 1914, no. 105-I in the exhibition catalogue. For provenance, see impression 1B. Listed in Keynes, *Bibliotheca Bibliographici*, no. 567iv; Bindman, *Blake: Catalogue of the Collection in the Fitzwilliam Museum*, no. 567iv, as part of Keynes' bequest to the Museum.

140

UNTRACED IMPRESSIONS

1.
The collection of James Parker, the co-publisher of the print, was offered at auction by Thomas Dodd, 18-19 February 1807. "Zephyrus and Flora" and its companion, "Calisto," may have been included in lot 157, "Eighteen ditto [various], by *Blake, Tomkins*, Ryland, &c.," lot 159, "Six Circles [*sic*?], by *Blake*, in colours," or in one of the many lots described as "various" or "Ditto."

2.
Acquired by George C. Smith at an unknown time, perhaps from Commin (see impression 1A). Listed by Smith in 1927 in the anonymous catalogue of his collection, no. 42, with the inscription below the title but "no publisher's imprint." Sold from Smith's collection at Parke-Bernet, 2 November 1938, lot 10, with "Calisto," untraced impression 2 ($37.50). Parke-Bernet has no record of the purchaser of this lot.

3.
According to Keynes, *Engravings by Blake: The Separate Plates*, p. 67, there is an impression in the British Museum, printed "in grey." I have not been able to find this impression or any other references to it.

Blake executed "Zephyrus and Flora" and its companion print, "Calisto," in a delicate combination of short lines, flick work, and stipple. The borders, and perhaps some areas of the designs, were probably created with the roulette. These two prints are the only ones known to have been published by the partnership of Blake and James Parker (1750-1805), another former apprentice to James Basire.

Stothard's design, typical of late-eighteenth-century "fancy" subjects based on classical myths, shows Zephyrus, god of the west wind, embracing his lover and future wife, on whom he bestowed the gifts of perpetual youth and dominion over the world of flowers. The main source for the story is Ovid's *Fasti*, Book V. I have not been able to trace a printed source for the lines quoted on the plate.

Gilchrist, *Life of Blake* (1863), I, 55, mentions "Zephyrus and Flora." Rossetti lists the print and its companion in his catalogue of Blake's engravings in Gilchrist, *Life of Blake* (1863), II, 259.

XXVII.
Calisto

(after Thomas Stothard)

FIGURE 63

First state: 1784

Signature, left: Stothard. del.

Signature, right: W. Blake. sc.

Title, open letters: CALISTO.

Inscription below title in two columns:

> *The Grove around a grateful Shadow cast;*
> *She dropt her Arrows, & her Bow unbrac'd;*
> *She flung her self on the cool grassy Bed;*
> *And on the painted Quiver rais'd her Head.*

Imprint, lightly scratched into the plate: Published as the Act directs, Dec[r] 17: 1784. by Blake & Parker N[o] 27 Broad S[t] Golden square.

Oval image, including border: 17.2 × 20.3 cm

Plate mark: not present on any impression recorded here. Probably about the same size as the companion print, "Zephyrus and Flora," 25.3 × 25.3 cm

IMPRESSIONS

1A.

Huntington Library, San Marino, California. Printed on laid paper, 25.2 × 22.4 cm. A faint, indecipherable watermark, probably composed of letters, appears in the upper margin. Mounted in a window cut in a larger sheet and bound as the fifty-first leaf of vol. III of an extra-illustrated copy of Mrs. [A. E.] Bray's *Life of Thomas Stothard*, 1851. The free endpaper of vol. I of this work is inscribed "1870"; acquired by the Library or its founder, Henry E. Huntington, at an unknown time, probably prior to World War I. Reproduced here, Fig. 63.

Second state: 1784

The scratched letters of the title have been re-engraved in open letters with thick and thin elements. All but the first letter are in small capitals (CALISTO) and there is no period after the title.

IMPRESSIONS

2B.

Robert N. Essick, Altadena, California. Printed on wove paper, 24.9 × 24.6 cm. The sheet extends into the part of the plate where the imprint appears, but none can be seen in this impression; see also impression 2D. This might indicate a further state of the plate in which the imprint was removed, but it is much more probable that the faint imprint was not inked or wore off the copperplate before this and impression 2D were pulled. Purchased by Essick from Andrew Ed-

munds, the London print dealer, in October 1977, for $142. Edmunds has no record of his source. Perhaps the same as the impression offered by Commin in 1921 (see impression 2D) and/or untraced impression 2.

2C.

Sir Geoffrey Keynes, Suffolk. Color printed in dark brown, blue, and reddish brown (for flesh tones) on laid paper trimmed to an oval, 19.1 × 22.4 cm. The signatures and title are still present, but other inscriptions have been trimmed off. The cloak beneath the figure's hand has been hand tinted in blue. Inscribed "1808" in pencil on the verso. The color printing, hand tinting, and verso inscription are very similar to "Zephyrus and Flora," impression F, with which this impression has been associated since at least 1914. Lent by W. E. Moss to the Manchester Whitworth Institute in 1914, no. 106-I in the exhibition catalogue. For provenance, see "Zephyrus and Flora," impression 1B. Listed in Keynes, *Bibliotheca Bibliographici*, no. 568iii; Bindman, *Blake: Catalogue of the Collection in the Fitzwilliam Museum*, no. 568iii, as part of Keynes' bequest to the Museum.

2D.

Sir Geoffrey Keynes, Suffolk. Printed on wove paper, 24.3 × 25 cm. The sheet extends into the part of the plate where the imprint appears, but none can be seen in this impression—see impression 2B. Purchased by Keynes many years ago from a dealer. Perhaps this or impression 2B or untraced impression 2 was the one offered by J. G. Commin, Exeter, January 1921 catalogue, item 60, described as an open letter "proof" (£2 5s., changed by hand to £1 15s. in Keynes' clipping from the catalogue). Listed in Keynes, *Bibliotheca Bibliographici*, no. 568i; Bindman, *Blake: Catalogue of the Collection in the Fitzwilliam Museum*, no. 568i, as part of Keynes' bequest to the Museum. Reproduced in Keynes, *Engravings by Blake: The Separate Plates*, pl. 41.

2E.

Royal Academy, London. Printed on (wove?) paper, 23.2 × 25.3 cm. The right end of the inscription below the title and imprint are very faint. Pasted onto the forty-eighth leaf of vol. IX of a bound collection of prints after Stothard. For provenance, see "The Fall of Rosamond," impression 2F.

IMPRESSIONS, state unidentifiable

F.

Sir Geoffrey Keynes, Suffolk. Printed in sanguine on laid paper trimmed to an oval, 17.9 × 20.8 cm. All inscriptions except for the signatures have been trimmed off. The ink color and paper are the same as in "Zephyrus and Flora," impression 1B, with which this impression has been associated since at least 1914. Lent by W. E. Moss to the Manchester Whitworth Institute in 1914, no. 106-II in the exhibition catalogue. For provenance, see "Zephyrus and Flora," impression 1B. Listed in Keynes, *Bibliotheca Bibliographici*, no. 568ii; Bindman, *Blake:*

Catalogue of the Collection in the Fitzwilliam Museum, no. 568ii, as part of Keynes' bequest to the Museum.

UNTRACED IMPRESSIONS

1.
See "Zephyrus and Flora," untraced impression 1.

2.
Acquired by George C. Smith at an unknown time, perhaps from Commin (see impression 2D). Listed by Smith in 1927 in the anonymous catalogue of his collection, no. 43. Sold from Smith's collection at Parke-Bernet, 2 November 1938, lot 10, with "Zephyrus and Flora," untraced impression 2 ($37.50). This auction catalogue indicates that the imprint was not present. Parke-Bernet has no record of the purchaser of this lot; perhaps the same as impression 2B or 2D.

3.
According to Keynes, *Engravings by Blake: The Separate Plates*, p. 68, there is an impression printed in "grey" in the British Museum. I have not been able to find this impression or any other reference to it.

The lines inscribed below the title are quoted from Joseph Addison's translation of Book II of Ovid's *Metamorphoses*, first published by Samuel Garth in 1717. Calisto (usually spelled "Callisto"), a huntress in Diana's entourage, is shown resting just before she is raped by Jove. The dogs pictured by Stothard are not described by Ovid in this scene, but they are mentioned later in the story of Calisto. Her posture in the design was probably influenced by a recumbent figure on the famous Portland vase.

For further comments on "Calisto," see its companion print, "Zephyrus and Flora."

XXVIII.
Venus dissuades Adonis from Hunting

(after Richard Cosway)

FIGURE 64

First state: 1787

Signature, left: R^{dus} Cosway RA. et Primarius Pictor Serinis-simi Walliæ Principis, Pinxt.

Signature, right: Guliel: Blake sculp.

Title: Venus dissuades Adonis from Hunting

Inscription below title:

> Then sweetly smiling with a raptur'd mind,
> On his lov'd Bosom she her head reclin'd,
> And thus began;———[to the right] Ovid Met: B.X.

Imprint: Publish'd by G. Hadfield. No. 67 Charlotte Street Portland Chapel Nov^r 21st 1787.

Image, central design: 9.9 × 13.4 cm

Image, including borders: 13.9 × 17.3 cm

Plate mark: see second state

IMPRESSIONS

None located. The information on the signatures, title, inscribed verse below title, and image sizes recorded above is taken from the second state in which the image and these inscriptions were apparently not changed. The imprint is taken from the transcription in Keynes, *Engravings by Blake: The Separate Plates*, p. 69. I have seen all impressions recorded by Keynes except for untraced impression 2, which may be his source for the first-state imprint. The first state was first recorded by Russell, *Engravings of Blake*, pp. 149-150, where the imprint is given as "Publish'd by G. Hatfield [*sic*?]. No. 67, Charlotte Street Portland Chapel Nov^r. 21^st, 1787." A first-state impression was exhibited at the Philadelphia Museum of Art in 1939—see untraced impression 1.

Second state: 1823

Imprint: London, Published June 2^nd 1823 by H. Gibbs 23 G^t Newport St.

Plate mark: 22.3 × 26 cm.

Other dimensions and inscriptions: Russell, *Engravings of Blake*, p. 150, and Keynes, *Engravings by Blake: The Separate Plates*, p. 69, indicate that only the imprint was changed in the second state. Frederick B. Daniell, *A Catalogue Raisonné of the Engraved Works of Richard Cosway*, London, 1890, p. 51, no. 211, gives the "size" (apparently of the plate mark) of the first state as 22.9 × 26 cm and states that the "plate" was "reduced in size" when "republished" in 1823. The difference of .6 cm between Daniell's plate "size" and that of the second-state plate

145

mark is so small that it is probably the result of faulty measurement or paper shrinkage.

IMPRESSIONS

2A.
Sir Geoffrey Keynes, Suffolk. Color printed in dark brown, flesh color, and black on wove paper, 29.9 × 40.3 cm. Hand tinted with watercolors (blue, green); Adonis's cloak in blue. No record of provenance; perhaps the impression offered by A. Mathews, Bournemouth, October 1953 catalogue, item 603, described as a color-printed impression dated 1823 (£2 10s.). Listed in Keynes, *Bibliotheca Bibliographici*, no. 569ii-iv; Bindman, *Blake: Catalogue of the Collection in the Fitzwilliam Museum*, no. 569ii-iv, as part of Keynes' bequest to the Museum. Reproduced here, Fig. 64.

2B.
Sir Geoffrey Keynes, Suffolk. Color printed in dark brown, blue, flesh color, and perhaps black on wove paper, 22.6 × 26.6 cm. Hand tinted with watercolors (red, blue, green, light brown); Adonis's cloak in red. This or impression 2E was lent by W. E. Moss to the Manchester Whitworth Institute in 1914, no. 111-II in the exhibition catalogue. For provenance, see "Zephyrus and Flora," impression 1B. Listed in Keynes, *Bibliotheca Bibliographici*, no. 569ii-iv; Bindman, *Blake: Catalogue of the Collection in the Fitzwilliam Museum*, no. 569ii-iv, as part of Keynes' bequest to the Museum.

IMPRESSIONS, state unidentifiable

According to the 1969 Princeton University Library exhibition catalogue, pp. 57-58, the first state was printed in black and the second in colors. This is also implied, through the sequence in which impressions are listed, in Keynes, *Engravings by Blake: The Separate Plates*, p. 69, and Keynes, *Bibliotheca Bibliographici*, p. 63. If this is true, then impressions C, F, and untraced impressions 1 and 2 are in the first state and impressions D and E are in the second state. I am unable to confirm the state designation based on black vs. colored inks.

C.
Asmolean Museum, Oxford. Printed on wove paper trimmed close to the border to 14.6 × 18 cm. All inscriptions except for the signatures have been trimmed off. A piece 1.5 × 9.1 cm has been cut out of the lower border and the notch filled with a piece of plain paper. Perhaps acquired by Dawson Turner (1775-1858) or, more probably, by his grandson Francis Turner Palgrave (1824-1897), from whom this impression passed to his heirs. Given to the Ashmolean Museum in 1941 by Rev. F.M.T. Palgrave and Miss Annora Palgrave.

D.
G. E. Bentley, Jr., Toronto. Color printed in dark brown, blue, green, and reddish brown on wove paper, 19.2 × 18.8 cm. The imprint is

cut off. Slightly browned with age; slight damp-staining. Hand tinted with watercolors, Adonis's cloak in blue. What looks like a plate mark extends at a slight angle near the lower edge of the sheet, .7 cm below "*Ovid Met: B.X.*" This might indicate a further state with the copperplate cut off above the imprint, but it is more probable that this apparent plate mark is not related to the copperplate from which the image was printed. Sold at Sotheby's, 25 November 1963, lot 19 (£2 to Mrs. Wagner). Acquired shortly after the auction by Bentley for £4 4s. Lent by Bentley to Princeton University Library in 1969, no. 90 in the exhibition catalogue.

E.

Robert N. Essick, Altadena, California. Printed in dark brown, blue, green and reddish brown on wove paper, 15.3 × 18.7 cm. Inscriptions trimmed off except for the signatures and the tops of some of the letters of the title. Slightly browned with age, particularly on the edges; strip of paper from an old mount along the top edge of the verso. Hand tinted with watercolors (red, brown, blue); Adonis's cloak in red. This or impression 2B lent by W. E. Moss to the Manchester Whitworth Institute in 1914, no. 111-II in the exhibition catalogue. For provenance to 1976, see "Zephyrus and Flora," impression 1B. Sold by Sir Geoffrey Keynes at Sotheby's Belgravia, 3 February 1976, lot 2 (£135 to Andrew Edmunds for Essick). Listed in Keynes, *Bibliotheca Bibliographici*, no. 569ii-iv, as a "second state"(?); Bindman, *Blake: Catalogue of the Collection in the Fitzwilliam Museum*, no. 569ii-iv ("second state"), as part of Keynes' bequest to the Museum (which is no longer the case).

F.

Sir Geoffrey Keynes, Suffolk. Printed on laid paper, 16.4 × 21.8 cm. The inscriptions are trimmed off except for the signatures, title, and tops of three letters from the first line of the inscribed verse. Lent by W. E. Moss to the Manchester Whitworth Institute in 1914, no. 111-I in the exhibition catalogue. For provenance, see "Zephyrus and Flora," impression 1B. Listed in Keynes, *Bibliotheca Bibliographici*, no. 569i, as a "first state" (?); Bindman, *Blake: Catalogue of the Collection in the Fitzwilliam Museum*, no. 569i ("first state"), as part of Keynes' bequest to the Museum.

UNTRACED IMPRESSIONS

1.

An uncolored impression was lent by Allan R. Brown to the Philadelphia Museum of Art in 1939, no. 219 in the exhibition catalogue. Part of the first-state imprint is quoted from the print, described as a "fine copy of the first state." Not part of the Brown collection now in the Watkinson Library, Trinity College, Hartford, Connecticut, although it might be pasted into a book in that collection.

2.

According to Keynes, *Engravings by Blake: The Separate Plates*, p.

69, there is an impression printed in black in the British Museum. I have not been able to find this impression or any other reference to it, although it may be the impression described (p. 150) and reproduced (image only, pl. 28) in Russell, *Engravings of Blake*.

Blake executed "Venus dissuades Adonis from Hunting" in a combination of lines (mostly in the foreground and landscape background) and several gradations of stipple—coarsest in the background foliage, finest on the figures, and a middle tone in the sky. The designer, Richard Cosway (1740-1821), was well known as a miniature painter and fashionable portraitist. He became a member of the Royal Academy in 1771. In 1799 he exhibited a painting of "Venus and Adonis" at the Academy, no. 165 in the catalogue,[1] but it seems unlikely that this was the same work Blake had engraved a dozen years earlier. Like Blake, Cosway was interested in Emanuel Swedenborg's writings and other mystical doctrines, although not until "his later years" according to the *Dictionary of National Biography*. The two artists may have met while Cosway was an instructor at Henry Pars' drawing school, which Blake attended as a young boy, *c.* 1767. "Mr. Jacko" in Blake's *An Island in the Moon* (*c.* 1784-1785) may be a caricature compounded of a well-known circus monkey and Cosway, famous for his dandyism.[2] In a letter of 27 December 1795, Cosway recommended to George Cumberland that Blake should be commissioned to engrave a picture, then in Cumberland's collection, he attributed to Leonardo da Vinci. Joseph Farington recorded in his diary for 19 February 1796 that "[Benjamin] West, Cosway & [Ozias] Humphry spoke in favour of the designs of Blake the Engraver, as works of extraordinary genius and imagination." In November of the same year, Cumberland gave Cosway a copy of his *Thoughts on Outline* containing eight plates engraved by Blake. In 1805, Cosway was one of eleven members of the Royal Academy who allowed their names to appear as subscribers and patrons in prospectuses for Cromek's edition of Blair's *Grave* with Blake's illustrations.[3] The publisher of the first state of "Venus dissuades Adonis," George Hadfield (*c.* 1764-1826), was Cosway's brother-in-law and the engraver of five of his paintings.

These associations suggest some direct contact between Blake and Cosway at least as early as 1785, and normal printmaking procedure would have required Cosway to inspect proofs of Blake's engraving of "Venus dissuades Adonis" and probably consult with him about its execution. Whatever Blake's relationship with Cosway had been in the late 1780s, it seems to have ended, like so many of Blake's friendships, between 1805 and 1810. Sometime during that period, he jotted in his *Notebook* that "Cosway Frazer & Baldwin of Egypts Lake/Fear to associate with Blake."[4] This denial of a present association suggests that one had previously existed.

The inscribed lines from Book X of Ovid's *Metamorphoses* are quoted from Laurence Eusden's translation, first published by Samuel Garth in 1717. Venus and Adonis have sequestered themselves in the shade of a poplar. She has already warned him of the dangers of hunting and is about to tell him the story of Atalanta. Neither the dog

[1] I am indebted to Diana Wilson of the Huntington Library for this reference.

[2] Erdman, *Prophet Against Empire*, pp. 96-97. Other contemporaries made unkind comparisons between Cosway and monkeys.

[3] All these direct references to Cosway are recorded in Bentley, *Blake Records*, pp. 49-50, 55, 169, 193, 247.

[4] Erdman, ed., *Poetry and Prose of Blake*, p. 496. "Baldwin" is probably George Baldwin (died 1826), a writer on mysticism and magic (another of Cosway's interests), who had traveled to and written about Egypt. "Frazer" has never been identified.

nor Cupid are present in this scene in the text; but the "panting hound" is mentioned earlier, and Cupid plays an important role at the beginning of Ovid's story. He had accidentally grazed Venus's breast with one of his arrows (note the bow and quiver full of arrows, lower right, in the print), thereby causing her passion for Adonis.

A reduced, unsigned re-engraving (8.1 × 11.5 cm) of "Venus dissuades Adonis" was published as the frontispiece to the *Rambler's Magazine; or Fashionable Emporium of Polite Literature*, 2 (1 August 1823). The plate is entitled "Venus dessuading [*sic*] Adonis from the Chase" and the accompanying text, pp. 351-352, tells their story.

Hand-colored impressions fall into two groups, identifiable by the color of Adonis's cloak: red (impressions 2B, E) or blue (impressions 2A, D). All recorded hand-colored impressions are also color printed.

XXIX.
Rev. John Caspar Lavater

(after an unknown artist)

FIGURES 65-67

First state: 1787

Inscriptions: only the imprint is in the plate. See pencil inscriptions on impression 1A (Fig. 65).

Imprint, scratched letters: Published Decembr 26: 1787 by J: Johnson St Pauls Church Yard

Image, including border: 27.7 × 23.9 cm

Plate mark: 36.7 × 30.2 cm

IMPRESSIONS

1A.

Leo Steinberg, New York. Printed on laid paper, 38.7 × 31.4 cm. Horizontal ruled lines have been scratched into the plate, two as guides for the imprint letters 3.4 cm below the image; three others are .1, .3, and 1.2 cm below the image. Between the last two of these lines, *LAVATER* has been lightly written in pencil in a fine hand. Below the imprint in pencil is *Engraved by William Blake* in semi-cursive letters. Acquired by Steinberg from the London print dealer John Suckling in the early 1960s. Mr. Suckling has no information about the earlier provenance of this impression. Reproduced, image only, in *The Print Collector's Newsletter*, 6 (September-October 1975), fig. 12. A detail of the inscription area is reproduced here, Fig. 65.

Second state: 1801

A line has been engraved around the image, touching the rectangular frame on three sides and about .05 cm from the frame on the right. The scratched imprint has been removed and the following inscriptions added.

Signature, right: Blake sculpt

Title: REV. JOHN CASPAR LAVATER.

Inscription below title: of Zurick born 1741, died 1801.

Imprint: Pubd May 1. 1800, by J. Johnson, in Saint Paul's Church Yard, London, from a Drawing in his possession, taken in 1787

Dimensions: same as in first state

IMPRESSIONS

2B.

Sir Geoffrey Keynes, Suffolk. Printed on wove paper, 38.1 × 31.2 cm, foxed in the margins and with a few abrasions on the image. "Mrs. Gilchrist" is written in pencil on the verso in an unidentified hand. Apparently acquired by Alexander Gilchrist or his wife (died 1885) and inherited by their son, H. H. Gilchrist, who lent the print to the Pennsylvania Academy of Fine Arts in 1892, no. 136 in the

150

exhibition catalogue. H. H. Gilchrist is probably the "descendant" of Alexander Gilchrist from whose collection the impression was sold at Sotheby's, 24 June 1903, lot 35 (10s. to Tregaskis). Acquired by E. J. Shaw, and sold from his collection at Sotheby's, 29 July 1925, lot 157, "formerly in the possession of Mrs. Gilchrist," with five other prints by Blake, including "Enoch," impression 1C, and "The Fall of Rosamond," impression 2C (£11 to Keynes). This or impression 3J or 3K lent by Keynes to the British Museum in 1957, no. 61(5) in the exhibition catalogue. Listed in Keynes, *Bibliotheca Bibliographici*, no. 574i; Bindman, *Blake: Catalogue of the Collection in the Fitzwilliam Museum*, no. 574i, as part of Keynes' bequest to the Museum. Reproduced here, Fig. 66.

2C.

McGill University, Montreal. Printed on wove paper framed and matted to the edge of the image at the sides and top and just below the imprint at the bottom. Acquired, probably in the early 1950s, from Anderson Galleries, New York, by Herman Cohen of the Chiswick Book Shop. Sold to Lawrence M. Lande and given by him to McGill in 1953.

Third state: 1801

The period after the title and the inscription below the title have been removed. The latter has been replaced with the following: *of Zurich. Born 1741. Died 1801.*

IMPRESSIONS

3D.

David Bindman, London. Printed on wove paper trimmed within the plate mark to 35.4 × 24.3 cm, pasted to the mat and framed. Bleached clean in recent years. Acquired by Bindman, *c.* 1976, from a Fleet Road, Hampstead, junk dealer for £1.

3E.

Boston Museum of Fine Arts. Printed on wove paper, 41.1 × 30.5 cm, trimmed along the plate mark on the right, left, and top. Repaired tear, extending into the image, on the right edge. Collection stamps of the Boston Museum and Henry F. Sewall ("H.F.S.") on verso. Acquired by the Museum, *c.* 1897, as part of Sewall's collection of approximately 23,000 prints. Perhaps the same impression of the second or third state lent by R. C. Waterston to the Boston Museum of Fine Arts in 1880 and 1891, nos. 90 and 134 in the exhibition catalogues.

3F.

British Museum. Printed on wove paper, 42.2 × 30.3 cm, watermarked 1794 | J WHATMAN.[1] Acquired by the Museum from R. H. Evans in July 1859. Reproduced, image only, in Charles Gardner, *William Blake the Man*, London: Dent, 1919, facing p. 50.

[1] In 1794, James Whatman sold his paper mill to Hollingworth and Balston, who continued to produce wove paper with a 1794 Whatman watermark until about 1804. See Thomas Balston, *James Whatman Father & Son*, London: Methuen, 1957, pp. 113, 139.

3G.

Robert N. Essick, Altadena, California. Printed on wove paper trimmed within the plate mark to 33.5 × 26.2 cm. Acquired prior to World War I by the London book and print dealer Walter T. Spencer, and sold to Essick in August 1973 for £20. Reproduced in Essick, *William Blake, Printmaker*, fig. 53.

3H.

Folger Shakespeare Library, Washington, D.C. Printed on wove paper trimmed within the plate mark to 34.6 × 25.7 cm. Mounted in a window in a sheet of paper with a red ink framing line. Two brown stains in right margin. No information on provenance presently available.

3I.

Donald A. Heald, London. Printed on wove paper trimmed within the plate mark on the right and left to 44 × 29.8 cm. Paper rubbed on the subject's cheek. In Heald's stock of prints in August 1981; perhaps now sold. Acquired, *c.* 1977, from a private collector; perhaps once in the collection of Leonard Baskin (according to Heald).

3J.

Sir Geoffrey Keynes, Suffolk. Printed on wove paper, 35.6 × 28.1 cm, the plate mark showing only at the bottom. Keynes' note on the mat indicates that this impression once belonged to Miss A. M. Butterworth, who acquired it by 1914 and lent it in that year to the Manchester Whitworth Institute, no. 101 in the exhibition catalogue. Offered from her collection at Sotheby's, 6 May 1936, lot 722 (not sold). According to Keynes, *Engravings by Blake: The Separate Plates*, p. 79, this is the impression acquired by Frederick Izant and sold from his collection at Sotheby's, 14 December 1939, lot 5, one of twenty unnamed prints by and after Blake sold with "Joseph of Arimathea Among the Rocks of Albion," impression 1A (£2 10s. to Keynes). This or impression 2B or 3K lent by Keynes to the British Museum in 1957, no. 61(5) in the exhibition catalogue. Listed in Keynes, *Bibliotheca Bibliographici*, no. 574ii-iii; Bindman, *Blake: Catalogue of the Collection in the Fitzwilliam Museum*, no. 574ii-iii, as part of Keynes' bequest to the Museum.

3K.

Sir Geoffrey Keynes, Suffolk. Printed on laid paper, 36.7 × 29.3 cm, the plate mark visible only at the bottom. Fragments of a watermark, probably composed of letters (see impression 3F), extend along the left edge of the sheet. No information available on provenance; perhaps the impression offered by Charles Meuel, the London bookseller, November 1910 catalogue, for 6s. (a clipping from the catalogue is in Keynes' collection). This or impression 2B or 3J lent by Keynes to the British Museum in 1957, no. 61(5) in the exhibition catalogue. Listed in Keynes, *Bibliotheca Bibliographici*, no. 574ii-iii; Bindman, *Blake: Catalogue of the Collection in the Fitzwilliam Museum*, no. 574ii-iii, as part of Keynes' bequest to the Museum.

3L.

Thomas V. Lange, New York. Printed on wove paper, 38.2 × 29.3 cm, trimmed within the plate mark on the left and with a deckled edge inside the plate mark on the right. Slight printing flaw just left of the figure's nose. A watermark, except for the last letter, is obscured by the image; but a beta-radiograph made by the owner shows the watermark as J Ruse | 1800. Purchased by Lange from the Argosy Bookstore, New York, in 1973.

3M.

Library of Congress, Rosenwald Collection, Washington, D.C. Printed on wove paper trimmed within the plate mark on the right and left to 43.4 × 29.5 cm. Three repaired tears in right margin. Acquired at an unknown time by Lessing J. Rosenwald and given by him to the Library of Congress in 1943. Perhaps the same as untraced impression 3. Moved from the Alverthorpe Gallery, Jenkintown, Pennsylvania, to Washington in 1980. Listed in *The Rosenwald Collection* (1954), p. 191; *The Rosenwald Collection* (1977), p. 335.

3N.

Raymond Lister, Cambridgeshire. Printed on wove paper, 27.7 × 24 cm, trimmed to the edge of the image. Acquired by Lister in the 1950s from the London book and print dealer E. Seligmann.

3O.

Pierpont Morgan Library, New York. Printed on wove paper, 33.1 × 24.5 cm, trimmed to the image on the right. Numbered in pencil "88," left of the title inscription. Acquired by the Library in 1976 as part of an extra-illustrated copy of Cunningham's "Blake" in which the print was formerly bound as leaf 117. For provenance, see "Joseph of Arimathea Among the Rocks of Albion," impression 2G.

3P.

Pierpont Morgan Library, New York. Printed on wove paper, 28.1 × 24.3 cm, trimmed close to the image with a .3 cm margin at the bottom. Skinned upper left and on the verso; repairs on verso. Acquired by the Library from Miss Louise Crane in September 1978.

3Q.

National Gallery of Art, Rosenwald Collection, Washington, D.C. Printed on wove paper trimmed inside the border on the left and right to 29 × 22.7 cm. All inscriptions, except for *Blake*, trimmed off. Lessing J. Rosenwald and National Gallery of Art collection stamps on verso. Acquired at an unknown time by W. E. Moss, and sold from his collection at Sotheby's, 2 March 1937, lot 218, with a large group of other prints by Blake including "Edmund Pitts," impression 2E, "Rev.ᵈ Robert Hawker," impressions 1B and 1C, and "Wilson Lowry," impressions 4K and/or 4L (£11 to Rosenbach for Rosenwald). Given by Rosenwald to the National Gallery of Art in 1945 and moved from the Alverthorpe Gallery, Jenkintown, Pennsylvania, to Washington in 1980.

3 R.

New York Public Library. Printed on wove paper trimmed within the plate mark on the left and right to 44.6 × 29.3 cm. Pasted to the mat on three corners. Inscribed in pencil below the plate mark, "Cat. W.R. Feb. 1918." Bequeathed to the Library by the editor Evert Augustus Duyckinck (1816-1878); accessioned in 1903.

3 S.

Princeton University, Princeton, New Jersey. Printed on wove paper trimmed within the plate mark to 32.5 × 24.7 cm. The ragged right edge cuts into the frame almost to the oval, thereby trimming off the signature. Foxed and with stains on the verso. Acquired by Princeton in 1969 from Grinke and Rogers, London bookdealers, with the drawing (Fig. 67) for the plate discussed below. Exhibited at Princeton in 1969, no. 61 in the catalogue.

3 T.

Victoria and Albert Museum, London. Printed on wove paper trimmed just within the plate mark to 36.6 × 28.1 cm. Acquired by the Museum in 1889 from "R. Jackson" (perhaps the Blake enthusiast Richard C. Jackson). Reproduced, image only, in Thomas Wright, *The Life of William Blake*, Olney: Wright, 1929, vol. I, pl. 4.

3 U.

Yale Center for British Art, New Haven, Connecticut. Printed on wove paper, 36.8 × 29.5 cm, with a ragged left edge and light foxing in the margins. Inscribed in pencil "10," lower left, "fine" and "Blake," lower right. Acquired in 1970 from the Pierpont Morgan Library as part of a large group of prints.

UNTRACED IMPRESSIONS, probably all third state

1.

Offered for sale by Edward Evans, London, *Catalogue of a Collection of Engraved Portraits*, 1835, item 6316, "very fine" (3s.).

2.

Lent by Henry Vaughan to the Burlington Fine Arts Club in 1876, no. 308 in the exhibition catalogue.

3.

Acquired *c.* 1890-1905 by William A. White and lent by him (anonymously) to the Grolier Club, New York, in 1905, no. 75 in the exhibition catalogue. Listed on a typescript of the White collection, written by Rosenbach, *c.* 1929, and now in the Rosenbach Library, Philadelphia. The print is given an evaluation or price of $10. Perhaps the same as impression 3M.

4.

Sold from the collection of R. A. Potts at Sotheby's, 18 June 1912, lot 239 (11s. to Clay).

5.

A print simply listed as "Lavater" was sold from the collection of E. J. Shaw at Sotheby's, 29 July 1925, lot 154, with ten book illustrations by Blake (15s. to Mathews). Perhaps this was not the separate plate but the frontispiece by Blake after Fuseli to Lavater's *Aphorisms on Man* (1788, 1789, 1794). See also impression 2B.

6.

According to Keynes, *Engravings by Blake: The Separate Plates*, p. 79, an impression was then (1956) in the collection of Charles Ballantyne. The print was given to Ballantyne many years ago by Sir Geoffrey Keynes. I have not been able to locate Mr. Ballantyne.

7.

According to Keynes, *Engravings by Blake: The Separate Plates*, p. 79, an impression was then (1956) in the collection of Ruthven Todd. According to G. E. Bentley, Jr., the print is not to be found among the Todd papers now in the Brotherton Library, University of Leeds.

Blake skillfully executed the face, coat, and hat of "Rev. John Caspar Lavater" in a variety of crosshatching generally called dot and lozenge, a conventional eighteenth-century technique composed of crosshatching at acute angles with a dot or flick in each interstice. Blake also used this technique in his portrait of "The Right Honourable Earl Spencer" (1813). The pencil inscriptions (Fig. 65) on the only known impression (1A) of the first state[2] were very probably written by Blake himself in preparation for engraving the title and signature on the copperplate. Note that the ruled lines for the lettering have already been scratched lightly into the plate. The title letters are similar to those in "Edward & Elenor" (Fig. 6) and "Job" (Fig. 8), both of 1793. It seems unlikely that the print was ever published in this first state; indeed, there is no evidence that the plate was completed or published until 1801. In spite of the 1 May 1800 date in the imprint, the second and third states could not have been completed until the inscribed date of Lavater's death. The famous Swiss-German poet and physiognomist was mortally wounded by a grenadier during the French occupation of Zurich. The print was probably published (or reissued) to memorialize Lavater's death and profit from anti-French sentiments in England. The only apparent reason for the third-state changes is the correction in the spelling of the city's name from *Zurick* to *Zurich*. Impressions 3N, 3P, and 3Q, all with inscriptions trimmed off, might be in the second state; but the rarity of that state and the slight wear in the images make it far more likely that they are in the third.

The artist who drew this portrait of Lavater is not known. A portrait drawing of Lavater was recently rediscovered and offered for sale by the London bookdealers Grinke and Rogers in their 1969 catalogue, item 175 ("sold," not priced). This unsigned pencil drawing (Fig. 67), cut to an oval like the inner frame of the print and measuring 40.9 × 33.2 cm, is now in the Manuscript Division, Princeton University

[2] This state was first described in Leo Steinberg, "Remarks on Certain Prints Relative to a Leningrad Rubens on the Occasion of the First Visit of the Original to the United States," *The Print Collector's Newsletter*, 6 (September-October 1975), p. 102 n.11. I am indebted to Professor Steinberg for his assistance.

Library, Princeton, New Jersey. It is very close to Blake's etching-engraving and has right and left in the same direction. This drawing was probably made *after* the print by a skilled copyist, but it does not follow Blake's work line for line, and its dimensions indicate that it could not be a tracing or transfer.

The publisher of this print, Joseph Johnson (1738-1809),[3] published many of Blake's commercial book illustrations, including the frontispiece to Henry Fuseli's translation of Lavater's *Aphorisms on Man* (1788, 1789, 1794). Fuseli's pen and ink drawing for the frontispiece to this work contains on its left margin two sketches of profiles, at least the lower of which probably represents Lavater.[4] Fuseli may have also designed the separate plate, although he was in London, not Zurich, when the portrait was "taken" in 1787 (see second-state inscriptions). Yet it remains a distinct possibility that Johnson's plan to publish the print grew out of his involvement with Fuseli, Blake, and Lavater's *Aphorisms*.

An alternative hypothesis worthy of consideration is that the plate had some connection with the 1789-1798 edition of Henry Hunter's translation of Lavater's *Essays on Physiognomy*, for which Fuseli provided several illustrations and Blake engraved four plates.[5] These large quarto volumes could have accommodated "Rev. John Caspar Lavater" as one of its many finely engraved full-page portraits or as an appropriate frontispiece to the first volume. None of the three volumes, usually bound as five, contains a frontispiece. One of the closer parallels to Blake's separate plate is the profile of Fuseli in vol. II, facing p. 280, of the *Essays*, engraved in dot and lozenge within an oval frame by William Bromley after an unidentified artist. The *Essays*, however, were published by a consortium of three men (Murray, Hunter, Holloway) which did not include Johnson. But the "Lavater" separate plate, with its meticulous representation of facial details and the highlighting of bone structure, is generically a physiognomic portrait even if it is not an illustration to the most famous book on the subject. For another plate perhaps originally intended as an illustration for Lavater's *Physiognomy*, see "Head of a Damned Soul in Dante's *Inferno*."

Another engraving, 9.1 × 7.1 cm, of the Lavater portrait was published in the *European Magazine*, 15 (January 1789), facing p. 5, where it illustrates a three-page "Account of John Caspar Lavater." This plate is inscribed *Engraved by* [William] *Bromley from an original Drawing Done at Zurich, in March 1787*. A stipple re-engraving, reversed and reduced to 11.5 × 9.5 cm, is in the Rosenwald Collection of the Library of Congress. It is signed *J Chapman sculp*; below is a vignette (3.4 × 5.6 cm) in line etching/engraving of a man (Lavater, no doubt) seated at a table. These two images are on one plate (plate mark 17.6 × 11.2 cm) with the imprint *London, Published, Jan. 30, 1813, by C Jones*. Yet a third re-engraving, only 4.9 × 3.8 cm, is signed *Holl sculp*—probably William Holl, who died in 1838, or his son of the same name (1807-1871). It was no doubt published as a book illustration; the impression in my collection is printed above a type-printed summary of Lavater's life and has stab holes along the left edge.

[3] For a full survey of the career of this important bookseller and publisher, see Gerald P. Tyson, *Joseph Johnson: A Liberal Publisher*, Iowa City: University of Iowa Press, 1979.

[4] Sheet 22.6 × 18.3 cm, collection of Robert N. Essick. Reproduced in Essick, *William Blake, Printmaker*, fig. 35. The eyes and mouth, but not the nose, are very similar to Lavater's in the separate plate.

[5] This second possibility was suggested to me by David Bindman.

"Rev. John Caspar Lavater" is included in W. M. Rossetti's list of Blake's engravings in Gilchrist's *Life of Blake* (1863), II, 260. Rossetti comments as follows: "A Superb and masterly example. As an Engraver merely, Blake ranks high, on the strength of this Plate alone. The lines of the face are especially noteworthy for their skilful play, firmness, and delicacy."

XXX.
The Idle Laundress

(after George Morland)

FIGURES 68-70

First state: 1788

Signature, left: Printed by g [G?] Morland.

Signature, right: Engrav'd by William Blake

Title, open letters: THE IDLE LAUNDRESS.

Imprint: London Published May 12, 1788. by IR. Smith, King Street, Covent Garden.

Image, including framing line: 21.1 × 26.1 cm

Plate mark: 27.1 × 30.3 cm

IMPRESSIONS

1A.

John DeMarco, Saratoga, New York. Color printed in reddish brown, blue (perhaps in two shades), dark brown, and black on wove paper, 27.9 × 38.7 cm. No clear evidence of hand tinting. Streaks of stippled lines descend from the image into the inscription area, lower right. These were probably made by a roulette used to execute patterns in the image and accidentally run into the inscription area. Acquired by DeMarco at a Glen Falls, New York, auction in 1975. Lent by DeMarco to Skidmore College and Union College in 1980, no. 22 in the exhibition catalogue. Not seen; information and a color slide kindly supplied by the owner.

Second state: 1788

Signature, left: same as in the first state, but re-engraved in stippled letters

Signature, right, stippled letters: Engraved by W: Blake

Title, stippled and closed letters: THE IDLE LAUNDRESS.

Imprint, stippled letters: London publish'd May 12\underline{th} 1788 = by J. R: Smith. № 31 = King Street Covent Garden:

Image and plate mark: same as in the first state

IMPRESSIONS

2B.

British Museum. Printed in brown on laid paper trimmed inside the plate mark to 26 × 28.3 cm. Surface scuffed in several areas outside the image; several repaired tears in left margin. Acquired by 1914 by W. E. Moss and lent by him in that year to the Manchester Whitworth Institute, no. 109-II in the exhibition catalogue. Sold from the Moss collection at Sotheby's, 2 March 1937, lot 160, with "Industrious Cottager," impression 3B, both described as "probably Macklin's issue" (an error?) yet with the J. R. Smith, 1788, imprint (£4 10s. to

Maggs for the British Museum, which accessioned both prints on 10 April 1937). Reproduced here, Fig. 68.

2 C.
Sir Geoffrey Keynes, Suffolk. Printed in brown on a sheet 30.1 × 33.4 cm, pasted to the mat. Some foxing. Perhaps the impression with the 1788 imprint offered by D. A. Pratt of Southampton, May 1962 catalogue, with "Industrious Cottager" (impression 3D?), for £10 10s. A clipping from this catalogue is in Keynes' collection. Listed in Keynes, *Bibliotheca Bibliographici*, no. 571i; Bindman, *Blake: Catalogue of the Collection in the Fitzwilliam Museum*, no. 571i, as part of Keynes' bequest to the Museum.

Third state: 1803

The image shows wear, only moderate in some impressions but extensive in others. Russell, *Engravings of Blake*, p. 151 n.2, states that the 1803 "reissue is worked up with line and otherwise retouched," but I can find no clear evidence of such reworking in the image. The second-state imprint has been replaced with the following, engraved in line: *London, Publish'd Jan.ʸ 1. 1803, by H. Macklin, Poets Gallery, Fleet Street.*

IMPRESSIONS

3 D.
British Museum. Printed on wove paper trimmed within the plate mark to 25.6 × 28.8 cm. Acquired, with "Industrious Cottager," impression 4F, by the Museum from "Mr. Halsted" (according to the Museum's accession records) in May 1877. Reproduced here, Fig. 69.

3 E.
Sir Geoffrey Keynes, Suffolk. Color printed in brick red, brown, blue, and black on wove paper trimmed within the plate mark to 25.7 × 27.9 cm. Hand tinted with watercolors (brown, green). No information available on provenance; perhaps the impression sold at Christie's, 25 May 1909, lot 65, with "Industrious Cottager" (impression 4G?), both described as "printed in colours" (£30 9s. to Tregaskis). Both prints were offered by Tregaskis in his 1909 catalogue, item 59, both described as color printed (£52 10s.). A clipping from this catalogue is in Keynes' collection. Listed in Keynes, *Bibliotheca Bibliographici*, no. 571ii; Bindman, *Blake: Catalogue of the Collection in the Fitzwilliam Museum*, no. 571ii, as part of Keynes' bequest to the Museum.

3 F.
Sir Geoffrey Keynes, Suffolk. Printed on heavy wove paper, 38.1 × 42.9 cm, hand tinted (dark blue, light blue, brick red, red, light and dark brown, flesh tones, gray, gray-green). No information available

on provenance; perhaps acquired with "Industrious Cottager," impression 4H. Listed in Keynes, *Bibliotheca Bibliographici*, no. 571iii; Bindman, *Blake: Catalogue of the Collection in the Fitzwilliam Museum*, no. 571iii, as part of Keynes' bequest to the Museum.

IMPRESSIONS, state not positively identifiable

G.
British Museum. Printed on wove paper trimmed to 24.4 × 27.9 cm, thereby cutting off the imprint. Signatures and title in stippled letters. The considerable wear in the image suggests that this is a late printing of the third state. Acquired by the Museum from G. Ellis in May 1875. Reproduced here, Fig. 70.

H.
Robert N. Essick, Altadena, California. Printed in brown on wove paper trimmed within the plate mark to 21.6 × 26 cm, thereby cutting off the title and imprint. Signatures in stippled letters. The paper and patterns of moderate wear in the image suggest that this is an early printing of the third state. Sold at Sotheby's, 11 December 1973, lot 28, with "Industrious Cottager," impression I (£80 to Baskett & Day for Essick).

I.
The Free Library of Philadelphia. Color printed in black, dark blue, and flesh color; hand tinted with watercolors (pink, yellow, light blue, brown, bistre). Pasted to the backing mat with the front mat also pasted down and covering the sheet below the signatures in stippled letters. Slight tears. Probably third state. No provenance records available, but Robert Luney of the Free Library believes this and impression K of "Industrious Cottager" were given to the Library by Mabel Zahn of Sessler's, the Philadelphia book and print dealer, *c.* 1972-1973.

J.
Sir Geoffrey Keynes, Suffolk. Printed in brown on laid paper, 22.4 × 25.7 cm, cut within the framing line on the right and left and with a .9 cm margin at the bottom. All inscriptions, except for the signatures in stippled letters, trimmed off. Inscribed in brown ink in the lower margin, "T B. 1795." Well printed; probably second state. No information available on provenance. Not listed in Keynes, *Bibliotheca Bibliographici*, no. 571; perhaps confused with "Industrious Cottager" and listed under that title as no. 570ii. Listed as a "first state" (second state as enumerated here) in Keynes, *Engravings by Blake: The Separate Plates*, p. 72.

K.
Philadelphia Museum of Art. Color printed in reddish brown, blue (perhaps in two shades), dark brown, and black on wove paper trimmed just below the stippled signatures to 23.6 × 30 cm. Hand tinted with watercolors. Very foxed, particularly on verso; edges on verso skinned. The color printing is similar to impression 1A; but the signatures

Part Two.
Plates by Blake after Designs
by Others

indicate that it must be a later state, probably second. Bequeathed to the Museum in 1949 by George W. Childs Drexel, the gift of Mary S. Drexel.

L.
Mrs. Lucile Johnson Rosenbloom, Pittsburgh. Printed in blue, green, reddish brown, and black on (wove?) paper framed to 24.2 × 29.6 cm. The title in stippled letters has been cut out and pasted back on; imprint trimmed off. Perhaps some touches of hand coloring on the lips and eyes of the figures and on the boy's right hand. The moderate wear in the image suggests that this is a late printing of the second state, with color printing as in impression K, or early printing of the third state. With A. E. Newton's bookplate pasted to the back of the frame. Perhaps the impression acquired by 1914 by W. E. Moss and lent by him in that year to the Manchester Whitworth Institute, no. 109-I in the exhibition catalogue. Sold from the Moss collection at Sotheby's, 2 March 1937, lot 159, with "Industrious Cottager" (impression L?), both described as color printed with the "imprints cut off" (£6 10s. to Sawyer). Perhaps these are the impressions acquired by A. E. Newton, who lent them to the Philadelphia Museum of Art in 1939, no. 220 in the exhibition catalogue. Both prints sold from Newton's collection at Parke-Bernet, 17 April 1941, lot 154, described as "for many years on loan [to the] South Kensington Museum" and to the "Pennsylvania Museum" in 1931 ($150 to a "private buyer," according to Parke-Bernet's records). The purchaser was apparently Charles J. Rosenbloom, from whom his widow, the present owner, inherited both prints in 1973.

UNTRACED IMPRESSIONS of all states, including early sales of large lots

1.
Offered in *A Catalogue of Prints Published by J. R. Smith* (c. 1800?), items 195, "Industrious Cottager," and 196, "The Idle Laundress," both by "W. Blake" after "G. Morland" (4s. each).[1]

2.
Sale of works of art from the collection of Mrs. Macklin, deceased, by Peter Coxe, 2 April 1808, lot 96, "Idle Laundress," one print and four colored examples, with "Industrious Cottager," one print and four colored examples (£6 6s.). This auction catalogue, p. 21, indicates that the copperplates for these two prints were also sold in lot 96. Same sale, lot 169, on 31 March, "Idle Laundress, and Industrious Cottager," with two other prints.[2]

3.
Sold Sotheby's, 3 March 1903, lot 11, with "Partridge Shooting," Catton after Morland (£2 14s. to Sabin).

4.
Sold Christie's, 27 June 1912, lot 103, with "Industrious Cottager,"

[1] Known to me only through a facsimile edited by E. E. Leggatt in 1914 (See Bentley, *Blake Books*, p. 651).
[2] Neither the designer nor engraver is identified for lots 96 and 169 in this Coxe auction, but since the prints came from Macklin's stock there can be little doubt that they were the plates engraved by Blake.

161

both printed in colors (£52 10s. to Pollard). Same sale, lot 108, both plates but only one (unidentified) printed in colors (£8 18s. 16d. to Jacobson). The prints in lot 103 sold from the "Stock of Frederick Pollard" at Christie's, 28 November 1916, lot 309 (£77 14s. to Ellis Smith).

5.
Sold as part of the collection of "Engravings in Colours from the superb collection of the late T. J. Barratt, Esq., of Bell Moor, Hampstead," at Sotheby's, 31 July 1917, lot 41, with "Industrious Cottager" (£49 to F. B. Daniell).

6.
Sold from the collection of Henry William Bruton, Sotheby's, 8 June 1921, lot 183, with "Industrious Cottager," both printed in colors (£26 to Neville).

7.
Sold Christie's, 18 June 1923, lot 78, with "Industrious Cottager" (£7 7s. to Hastings).

8.
Sold Sotheby's, 7 February 1928, lot 305, with "Industrious Cottager" (£20 to Ayres).

9.
Offered by Puttick & Simpson, 14 March 1930, lot 125, with "Industrious Cottager," both printed in colors (no information available on price or purchaser).

10.
According to their records, Sessler's acquired impressions of "The Idle Laundress" and "Industrious Cottager" for $75 from Freeman in September 1934; sold in the same month to Richardson for $100 the pair.

11.
According to their records, Sessler's purchased "Morland-Blake Pair of Engravings" (no doubt "The Idle Laundress" and "Industrious Cottager") from Frost & Reed in April 1944 for $101. Sold to Kearsley for $250 in the same month; returned May 1944. Sold to Williams for $300 in March 1945; returned April 1945. Sold to Rosenfeld for $165 in July 1945.

12.
Sold from the property of Mrs. Harold Shepherd, Sotheby's, 16 July 1947, lot 299, printed in colors (£14 to F. Saker).

13.
Sold Sotheby's, 30 April 1953, lot 401, with "Industrious Cottager," both printed in colors (£9 to B. Barnett).

14.

Sold Sotheby's, 28 October 1954, lot 532, with "Industrious Cottager," both printed in colors (£9 to Hackforde).

15.

According to their records, Sessler's received an impression on consignment for $20 from Berwind in May 1959; sold to Norman H. Deere for $40 in August 1962. See also "Industrious Cottager," untraced impression 4.

16.

Keynes, *Engravings by Blake: The Separate Plates*, p. 72, states that an impression of the "first state" (second state as enumerated here) "printed in colours" is in the British Museum. I have not been able to find this impression or any other reference to it; perhaps confused with impression 3D or G, only one of which is listed by Keynes.

Blake executed "The Idle Laundress" and its companion print, "Industrious Cottager," in a combination of stipple and line. The framing lines, and probably some areas in the images (see impression 1A), were very probably executed with the roulette. Both designs are by George Morland (1763-1804), one of the most popular painters of rural subjects of the late eighteenth century. The two designs engraved by Blake are typical of Morland's work, combining picturesque settings and characters with a rustic moral. While the laundress slumbers, a poorly dressed boy steals her wash and a pig gobbles up potatoes spilling from an overturned basket. In contrast, the cottager and child bear their fagots with good cheer (first state) or at least admirable fortitude (third and fourth states). Morland painted a number of companion scenes of this type, linked through contrast, including a pair entitled "Industry" and "Idleness" engraved by Charles Knight. William Hogarth was the first to popularize prints on this theme in England with his "Industry and Idleness" series of 1747. Morland painted "The Idle Laundress" and "Industrious Cottager" soon after his return to London from France early in 1786.[3] The latter was exhibited at the Burlington Fine Arts Club in 1910, lent by H. Darrell Brown and described in the catalogue as measuring 35.6 × 44.5 cm.[4] Both oil paintings are now apparently lost.[5]

The publisher of the 1788 states of both plates, John Raphael Smith (1752-1812), was a leading mezzotint engraver and print seller. He was a close friend of Morland's and published many of his prints as part of a "Morland Gallery." The plates were subsequently acquired by Thomas Macklin (died 1800) or his widow, who continued his print-selling business and is probably the "H. Macklin" named in the 1803 imprints on both plates. For the sale of the copperplates in 1808, see untraced impression 2 of "The Idle Laundress."

The printing history of these two plates is complex. Both were probably issued in 1788 as open-letter "proofs," at least some color printed (see impression 1A, above), and then with the letters re-en-

[3] According to George Dawe, *The Life of George Morland*, London, 1807, p. 62.

[4] *Catalogue of a Collection of Pictures Including Examples of the Works of the Brothers Le Nain and Other Works of Art*, London: Burlington Club, 1910, no. 22.

[5] According to David Winter, *George Morland 1763-1804*, unpublished dissertation, Stanford University, 1977, pp. vi, 33.

graved in stipple (second state of "The Idle Laundress" and third state of "Industrious Cottager"). All recorded impressions with stippled letters and the 1788 imprint are printed in brown on laid paper or are color printed on wove (impression 3E of "Industrious Cottager" and perhaps impressions K and L of "The Idle Laundress"). The recorded impressions of the 1803 states are on wove paper of at least two weights, and all but impression H of "The Idle Laundress" (the state of which is conjectural) are printed in black (some hand colored) or color printed (impression 3E of "The Idle Laundress"). The variations in wear in 1803 impressions, ranging from moderate (Fig. 69) to extensive (Fig. 70), suggest that many pulls were taken. It is of course possible that badly worn impressions are reprints made later in the century after the plates were sold from Mrs. Macklin's stock in 1808.

Sometime after August 1811, Blake made reference to his two plates after Morland on p. 59 of his *Notebook*. He quotes a paragraph from *Bell's Weekly Messenger* of 4 August 1811 describing the legal difficulties of Peter le Cave, a former assistant of Morland's who claimed to have executed many drawings his employer signed as his own. Below, Blake writes that the story "confirms the Suspition I entertaind concerning those two [Prints *del*] I Engraved From for J. R. Smith, That Morland could not have Painted them as they were the works of a Correct Mind & no Blurrer."[6]

"The Idle Laundress" and "Industrious Cottager" are briefly described in J. Hassell, *Memoirs of the Life of the Late George Morland; with Critical and Descriptive Observations on the Whole of His Works*, London: James Cundee, 1806, p. 78. The description of "Industrious Cottager" concludes as follows: "Few of Morland's works have had a better sale than this and the preceding, its companion." In the catalogue at the end of Hassell's book, Blake is named as the engraver and the (1803 publication?) price of each print is given as 6s.

The two plates are recorded by W. M. Rossetti in Gilchrist, *Life of Blake* (1863), II, 261. Russell, *Engravings of Blake*, p. 194, quotes a passage from "Art Sales of the Year 1902" in which both plates are listed as ovals, and the "Industrious Cottager" is described as a completely different design from the plate recorded here. Neither Russell nor any other authority knows of any such plates; the description he quotes is no doubt erroneous.

[6] Bentley, ed., *Blake's Writings*, II, 957-958. For further comments on this passage in Blake's *Notebook*, see Essick, *William Blake, Printmaker*, pp. 56-57.

Industrious Cottager

(after George Morland)

FIGURES 71-72

First state:[1] 1788

Signature, left: Morland pinx

Signature, right: Blake sculp

Title and imprint: trimmed off in the only known impression

Image, including framing line: 21.3 × 26 cm

Plate mark: trimmed off in the only known impression; probably the same as in the third state, 27.3 × 30.5 cm

IMPRESSIONS

1A.

Robert N. Essick, Altadena, California. Printed on wove paper trimmed within the plate mark to 22.2 × 27 cm. Scuffed, and with repaired tears in the left margin, one extending into the image in the upper left corner. Perhaps a pre-publication proof. Acquired, with impression J, in 1977 from an Essex bookdealer by Donald A. Heald, who sold both impressions to Essick in January 1978 for $195. Reproduced here, Fig. 71.

Second state: 1788

Companion prints were of course originally sold in pairs, and thus any published state of one print would require a similarly finished and inscribed state of the other. Such correspondence exists between the final two states of "The Idle Laundress" and "Industrious Cottager." Thus, it seems probable that there is an open-letter state of "Industrious Cottager" corresponding to the open-letter first state of its companion. This is probably the state sold from the collection of Henry William Bruton at Sotheby's, 8 June 1921, lot 174, "open-letter proof, printed in brown, from the Walker collection" (£7 15s. to F. B. Daniell); and offered again, from the property of Mrs. M. E. Walter and Mrs. O. T. Walter, at Sotheby's, 11 January 1961, lot 150, "open letter proof, in brown, framed" (£2 to Sinclair). I have not been able to locate an impression of such a state. It might correspond to the first state recorded here; but this seems unlikely because the signatures in impression 1A are faint and hesitant, as in a pre-publication proof, and do not correspond in lettering style or wording to the signatures in open-letter impression 1A of "The Idle Laundress." The image in this conjectural second state probably corresponds to the third state.

Third state: 1788

In comparison to the first state, the faces of the two figures have been altered considerably. The child's smiling mouth

[1] First described, with a discussion of motifs Blake may have borrowed from Morland, in Jenijoy La Belle, "Blake and Morland: The First State of "The Industrious Cottager,'" *Blake: An Illustrated Quarterly,* 12 (1979), 258-261.

has been drawn into a pucker, the lower part of her cheeks and chin have been filled out and rounded, her nose shortened and widened, her eyes made smaller and softened with stipple, and her hair has been augmented with a few more strands on the top and brought lower onto her forehead. The woman's almost oriental eyes in the first state have been softened with stipple, the line defining the upper lid of her left eye shortened on its right end, her mouth shortened and drawn into a slight pucker, and her nose straightened and sharpened. These changes may have been made to bring the plate into conformity with Morland's painting.[2]

Signature, left, stippled letters: Painted by g [G?] Morland

Signature, right, stippled letters: Engraved by W: Blake

Title, stippled letters: INDUSTRIOUS COTTAGER.

Imprint, stippled letters: London Publish'd May 12th 1788: by J. R. Smith No: 31 = King Street Covent Garden

Image: same as in the first state

Plate mark: 27.3 × 30.5 cm

IMPRESSIONS

3B.

British Museum. Printed in brown on laid paper trimmed within the plate mark to 25.6 × 28.8 cm. Dust stained on the recto; skinned on the verso. Acquired by 1914 by W. E. Moss and lent by him in that year to the Manchester Whitworth Institute, no. 110-II in the exhibition catalogue. For further provenance, see "The Idle Laundress," impression 2B. Reproduced here, Fig. 72.

3C.

Hamburg Kunsthalle, Hamburg. Printed in brown on laid paper, 29.3 × 33.8 cm. Purchased from the London dealer Andrew Edmunds in 1978 for £75. Not seen; information supplied by Dr. Hanna Hohl of the Hamburg Kunsthalle.

3D.

Sir Geoffrey Keynes, Suffolk. Printed in brown on a sheet 29.8 × 33.5 cm, pasted to the mat. For a possible provenance, see "The Idle Laundress," impression 2C. Listed in Keynes, *Bibliotheca Bibliographici*, no. 570i; Bindman, *Blake: Catalogue of the Collection in the Fitzwilliam Museum*, no. 570i, as part of Keynes' bequest to the Museum.

3E.

Philadelphia Museum of Art. Color printed in dark brown, reddish brown, and blue on wove paper, 26.9 × 30 cm, with an indecipherable watermark of three lines of letters (and numbers?) in the center of the

[2] As La Belle argues, ibid., p. 260.

sheet. Extensively, and rather poorly, hand tinted. Imprint faint. Paper evenly browned with age, trimmed within the plate mark except at the bottom. Torn upper margin; scuffed. Bequeathed to the Museum in 1954 by Anne Thomson.

Fourth state: 1803

The image shows wear, only moderate in some impressions but extensive in others. Russell, *Engravings of Blake*, p. 151 n.1, states that the 1803 "reissue is worked up with line and otherwise retouched," but I can find no clear evidence of such reworking in the image. The third-state imprint has been replaced with the following, engraved in line: *London Published Jan.ᵉ 1ˢᵗ 1803, by H. Macklin, Poets Gallery Fleet Street.*

IMPRESSIONS

4F.

British Museum. Printed on wove paper trimmed inside the plate mark to 25.5 × 28.1 cm. For provenance, see "The Idle Laundress," impression 3D.

4G.

Sir Geoffrey Keynes, Suffolk. Printed on wove paper, 34.2 × 41.3 cm, hand colored (blue, flesh tones, brick red, light brown, dark brown, red). No information available on provenance; perhaps acquired with "The Idle Laundress," impression 3E. Listed in Keynes, *Bibliotheca Bibliographici*, no. 570iii; Bindman, *Blake: Catalogue of the Collection in the Fitzwilliam Museum*, no. 570iii, as part of Keynes' bequest to the Museum.

4H.

Sir Geoffrey Keynes, Suffolk. Printed on heavy wove paper, 38.1 × 43 cm, hand colored (blue, brick red, light brown, blue-green). No information available on provenance; perhaps acquired with "The Idle Laundress," impression 3F. Listed in Keynes, *Bibliotheca Bibliographici*, no. 570iv; Bindman, *Blake: Catalogue of the Collection in the Fitzwilliam Museum*, no. 570iv, as part of Keynes' bequest to the Museum.

IMPRESSIONS, states not positively identifiable

I.

Robert N. Essick, Altadena, California. Printed in brown on laid paper trimmed to the framing line and just below the signatures (stippled letters) to 21.6 × 25.9 cm. The laid paper and patterns of slight wear in the image suggest that this is a late printing of the third state. For provenance, see "The Idle Laundress," impression H. Reproduced in *Blake: An Illustrated Quarterly*, 12 (1979), p. 259.

J.

Robert N. Essick, Altadena, California. Printed on wove paper, 22.5 × 25.8 cm, with the imprint trimmed off. Signatures and title in stippled letters. A rectangle, about 5.5 × 3 cm, has been cut from the upper left part of the image and replaced with a piece cut from another stipple print. The considerable wear in the image suggests that this is a late impression of the fourth state. For provenance, see impression 1A.

K.

The Free Library of Philadelphia. Pasted to the backing mat with the front mat also pasted down and covering the sheet below the signatures in stippled letters. Hand tinted with watercolors (rose, yellow, light blue, bistre, brown). The black ink suggests that this is probably a fourth-state impression. For provenance, see "The Idle Laundress," impression I.

L.

Mrs. Lucile Johnson Rosenbloom, Pittsburgh. Printed in blue, green, reddish-brown and black on (wove?) paper framed to 24.2 × 29.6 cm. The title (stippled letters) has been cut out and pasted back on; imprint trimmed off. The moderate wear in the image suggests that this is a late printing of the third state or an early printing of the fourth. Perhaps some touches of hand coloring on the lips and eyes of the figures. Pasted to the frame are A. E. Newton's bookplate and a note by him indicating that this print and impression L of "The Idle Laundress" were "for many years on loan [to the] South Kensington Museum" and at one time loaned to the "Pennsylvania Museum" (Philadelphia Museum of Art). A price of $175 is recorded on this note, apparently for both prints. Perhaps the impression acquired by 1914 by W. E. Moss and lent by him in that year to the Manchester Whitworth Institute, no. 110-I in the exhibition catalogue. For further provenance and exhibition, see "The Idle Laundress," impression L.

UNTRACED IMPRESSIONS of all states

1.

Sold Sotheby's, 6 March 1905, lot 6, "in brown" (£7 to Vaughan). Keynes, *Engravings by Blake: The Separate Plates*, p. 71, lists this as a "first state" (third state as enumerated here). Probably the same impression sold from "the stock of the late Mr. Vaughan of Brighton," Sotheby's, 3 July 1913, lot 269, "in brown" (£12 to Maggs).

2.

Sold from the collection of Edward Walter, Christie's, 8 July 1913, lot 51, "printed in colours" (£32 11s. to B. L. Dighton).

3.

According to their records, Sessler's purchased an impression from Frost & Reed in April 1947 for £3; sold to Schofield for $65 in November 1972.

4.

According to their records, Sessler received an impression on consignment for $20 from Berwind in May 1959; sold to "Norman H. Dern" (perhaps "Deere"—see "The Idle Laundress," untraced impression 15) for $40 in August 1962; returned later in the same month; sold to Bershad in March 1966 for $42.50.

5.

Keynes, *Engravings by Blake: The Separate Plates*, p. 71, lists a "first state" (third state as enumerated here) in the British Museum, "printed in colours." I have not been able to find such an impression or any other reference to it; perhaps confused with impression 4F, not listed by Keynes.

6.

Keynes, *Bibliotheca Bibliographici*, no. 570ii, and Bindman, *Blake: Catalogue of the Collection in the Fitzwilliam Museum*, no. 570ii, list an impression of the "second state" (fourth state as enumerated here) in Keynes' collection, printed in brown on a sheet 27.5 × 30.5 cm. I have not been able to locate this impression; perhaps confused with "The Idle Laundress," impression J.

7.

According to its records, the Philadelphia Museum of Art has an impression acquired at the same time, and probably from the same source, as "The Idle Laundress," impression K. The Museum's staff has not been able to locate the print.

See also the description of the conjectural second state. For sales of untraced impressions of both companion prints, see "The Idle Laundress."

For discussion, see the companion print, "The Idle Laundress."

XXXII.
Head of a Damned Soul in Dante's Inferno

(after Henry Fuseli)

FIGURE 73

First state: c. 1789

Inscriptions: none in the plate. See pencil inscriptions on impressions 1A, 1D, and 1E.

Image: 35.1 × 26.5 cm

Plate mark: 43.3 × 33.1 cm

IMPRESSIONS

1A.

British Museum. Printed on (wove?) paper pasted to the mat with the upper framing mat also pasted down. Inscribed in pencil, below the image on the left, *Fuseli Pinxit*; below the image on the right, *W. Blake*, followed by an illegible word. The unidentified hand appears to be the same as on impression 1D. The mat covers the accession number. Reproduced here, Fig. 73. One British Museum impression, accession number 1856.7.12.209, was acquired in July 1856 from Evans. The other, accession number 1874.7.11.149, was presented to the museum in July 1874 by John Defett Francis. The latter may have once been in the collection of Frederick Tatham, from whom Francis acquired several other works by Blake. One of these impressions was exhibited at the British Museum in 1957, no. 22(5) in the catalogue. See also the description of the second state.

1B.

Hunterian Art Gallery, University of Glasgow. Printed on wove paper trimmed inside the plate mark to 39.4 × 28.7 cm. Repaired tear, about 2.5 cm, upper center of sheet. Paper browned with age; slight stains. Inscribed in ink below the image, "A most remarkable etching by Blake—wonderfully bold & clear." Acquired by Professor W. R. Scott of the University of Glasgow sometime between 1920 and 1940 and bequeathed by him to the Hunterian Art Gallery in 1941. Lent to the National Library of Scotland, Edinburgh, in 1969, no. 95 in the exhibition catalogue; and to Colnaghi's, London, in 1973, no. 151, reproduced, in *Glasgow University's Pictures*, exhibition catalogue, London: Colnaghi, 1973.

1C.

Huntington Library, San Marino, California. Printed on wove paper trimmed inside the plate mark to 38.8 × 30.8 cm. A typed description of the plate is taped to the verso. Right edge somewhat ragged, other edges gilt. Formerly bound in a copy of Edward Young, *The Complaint, and the Consolation; or, Night Thoughts*, London: R. Edwards, 1797, with Blake's illustrations hand colored, now also in the Huntington Library. This volume is inscribed in pencil on the fly-leaf "Pearson '86/ris—," indicating that it was once in the possession of the dealer Pearson. Acquired (in 1886?) by Thomas Glen Arthur, and sold from his collection at Sotheby's, 17 July 1914, lot 848, "proof print of a large head inserted" (£83 to G. D. Smith). Acquired by Henry E. Huntington in October 1914 and bequeathed by him to the

Huntington Library. This impression was removed from the volume by 1929.

1 D.

Sir Geoffrey Keynes, Suffolk. Printed on wove paper, 47.2 × 37.9 cm. Inscribed in pencil, below the image on the left, *H. Fuseli*; below the image on the right, *W Blake*. The unidentified hand appears to be the same as on impression 1A. No information available on provenance; probably acquired many years ago from a dealer. Listed in Keynes, *Bibliotheca Bibliographici*, no. 572; Bindman, *Blake: Catalogue of the Collection in the Fitzwilliam Museum*, no. 572, as part of Keynes' bequest to the Museum.

1 E.

Charles Ryskamp, Princeton, New Jersey. Printed on wove paper trimmed inside the plate mark to 42.5 × 31.7 cm. Inscribed in ink, now brown with age, *H. Fuseli R. A. Pinx*, lower left; *W. Blake Sculp.*, lower right; and *Satan*, center of the margin below the image. Some letters have been gone over in blue pencil. Blind indentations in the paper, lower center, may be fragments of further handwritten inscriptions. Acquired by Sir Geoffrey Keynes, probably many years ago from a dealer, and listed by him in *Bibliotheca Bibliographici*, no. 572. Given by Keynes to Ryskamp between 1964 and 1969 and lent by Ryskamp in 1969 to Princeton University, no. 28 in the exhibition catalogue; and in 1974 to the Grolier Club, New York. Listed in Bindman, *Blake: Catalogue of the Collection in the Fitzwilliam Museum*, no. 572, as part of Keynes' bequest to the Museum (which is no longer the case). Reproduced in Keynes, *Engravings by Blake: The Separate Plates*, pl. 42, image only.

Second state: c. 1789.

Russell, *Engravings of Blake*, p. 155 n.1, states that the British Museum has "a later impression" with "the name *Blake* very faintly engraved at the right hand lower corner." Keynes, *Engravings by Blake: The Separate Plates*, p. 76, makes the same claim. The Museum's records indeed show that it has two impressions, but in a thorough search I have been able to find only impression 1A, without the inscription in the plate. For provenance and exhibition, see impression 1A. It is possible that this "second" state is the first state of the plate and all impressions recorded above were pulled after the faint signature was removed or simply wore off the plate.

UNTRACED IMPRESSIONS, probably first state

1.

According to Keynes, *Engravings by Blake: The Separate Plates*, p. 76, an impression was then (1956) in the collection of "Philip Hofer,

Harvard College Library (from the Aspland collection)." According to Mr. David P. Becker, formerly of the Houghton Library, Harvard University, no impression is at Harvard or presently in Mr. Hofer's private collection. No impression is specifically listed in the sale catalogue of Alfred Aspland's collection, Sotheby's, 27 January 1885, but the print may have been one of the six works included in lot 11, only three of which are named (1s. 6d. to Oliver).

The attribution of "Head of a Damned Soul in Dante's *Inferno*" to Blake as the etcher/engraver and Henry Fuseli as the designer is based on the inscriptions recorded above (impressions 1A, 1D, 1E, and second state) and the general similarities between this print and their other works. The design is very similar to one of "four faces the idea of which has been taken from Dante's Hell," engraved by Thomas Holloway after Fuseli and published in Henry Hunter's translation of John Caspar Lavater's *Essays on Physiognomy*, vol. II (1792), p. 290. Bindman, *Complete Graphic Works of Blake*, p. 79, claims that "Head of a Damned Soul" was "almost certainly connected with the publication" of Lavater's *Essays* and notes the similarity in dot and lozenge technique between this plate and a head in profile in vol. I, p. 225, of the *Essays*, also engraved by Blake. If "Head of a Damned Soul" was intended as an illustration for the *Essays*, its exclusion may be accounted for by the fact that the image is almost as large as uncut copies of the book (35.3 × 28.5 cm) and larger than any illustration in the book. For another dot and lozenge plate perhaps associated with Lavater's book, see "Rev. John Caspar Lavater."

The print was first described by W. M. Rossetti in Gilchrist, *Life of Blake* (1863), II, 261, as "Head of a Man in Fire. Fuseli. Life size. Vigorously and grandly engraved." Russell, *Engravings of Blake*, p. 155, titles the plate "Head of a Man Tormented in Fire," and Keynes, *Engravings by Blake: The Separate Plates*, p. 76, calls it "Satan," apparently because of the pencil inscription on impression 1E. The present title is used in Schiff, *Füssli*, I, 528 ("Kopf eines Verdammten aus Dantes Inferno"), and by Bindman, *Complete Graphic Works of Blake*, p. 469. Fuseli's original drawing has not been traced.

Blake used a similar tortured visage seen from below in several of his own designs: "Lucifer and the Pope in Hell" of *c.* 1794 (see the head just left of the Pope's right foot, Fig. 20); watercolor no. 432 among the *Night Thoughts* illustrations (*c.* 1796); "Moses Erecting the Brazen Serpent" (*c.* 1805; falling figure, upper left); the head of the falling Satan in the *Job* engravings, pl. 16 (published 1825), and the earlier *Job* watercolor series (*c.* 1805 and *c.* 1821-1822); and lower right in "The Circle of the Falsifiers" among the Dante engravings (1827).

XXXIII.
Timon and Alcibiades

(after Henry Fuseli)

FIGURES 74-75

One state: 1790

Imprint: Publishd by W Blake Poland S^t July 28: 1790

Image: 20.2 × 29.6 cm

Plate mark: trimmed off, except at the top, in the only known impression[1]

The only known impression of "Timon and Alcibiades," now in the *British Museum*, is printed on laid paper, 21.3 × 30.5 cm, with the corners cut off diagonally (Fig. 74). The tattered condition of the corners and the fact that the paper is skinned near them on the verso suggest that the impression was once pasted down on the corners and the diagonal cuts were made to free it from the backing. Purchased by the Museum from Colnaghi's in January 1863 and exhibited at the British Museum in 1957, no. 22(4) in the catalogue.

"Timon and Alcibiades" is freely etched with very little, if any, engraving.[2] Although the plate is signed by Blake only as the publisher,[3] not the etcher, it has generally been considered to have been executed by him after Fuseli. The plates of *For Children: The Gates of Paradise* (1793) are similarly signed by Blake as the publisher only, even though they were without doubt designed and executed by him. The graphic style exhibited by the print is a considerable departure from Blake's usual practice in his reproductive plates, *c.* 1780-1790, but is generally similar to *The Gates of Paradise.* Except for the short, squiggle lines of hatching, this style is close to that used by Fuseli in some of his own etchings, such as "Sleeping Woman on a Divan."[4] The lettering style in the imprint is typical of Blake's hand, not Fuseli's, but one cannot completely rule out the possibility that Fuseli etched the plate. Another possibility is that Fuseli etched the major outlines and Blake added the squiggle lines, hatching, and crosshatching to complete the image. For what may be a companion to this print, see "Falsa ad Coelum."

Two drawings by Fuseli of this design have survived. One is in the British Museum, executed in pen and ink and sepia wash on a sheet 22 × 32.5 cm. The other, somewhat more finished, now in the Auckland City Art Gallery, New Zealand, is executed in pen and brown ink with brown, yellow, and pink wash (Fig. 75). It measures 20.5 × 29.9 cm and is inscribed, lower right, "Lon: March 83" and vertically along the right margin, in Greek, "Man is the dream of a shadow" (from Pindar, *Pythian*, viii: 135-136).[5] The figure of Timon has been drawn through the design on the verso. The Auckland drawing is the basis for the print, for the design and its size are closer to the print and the drawing has been "fixed" with wash or wax—a procedure often used to prepare a design for tracing or transfer to a copperplate. Peter Tomory has claimed, partly on the basis of the provenance of the Fuseli drawings now in Auckland, that the drawing of "Timon and Alcibiades" was once in Blake's possession.[6]

The design is based on Act IV, Scene iii, lines 49ff., of Shakespeare's *Timon of Athens.* Alcibiades, wearing a warrior's helmet, has just entered on the left with his mistresses Phrynia and Timandra. Timon

[1] Keynes, *Engravings by Blake: The Separate Plates*, p. 75, records a plate mark of 21.5 × 30.5 cm. The evidence for this is unknown to me.

[2] For a discussion of the "sublime" style of etching exemplified by this print, see Essick, *William Blake, Printmaker*, pp. 61-63.

[3] Blake lived at 28 Poland Street from the autumn of 1785 until the late summer or early autumn of 1790 (see Bentley, *Blake Records*, pp. 558-560).

[4] Reproduced in Schiff, *Füssli*, II, fig. 842a.

[5] Both drawings are reproduced in Schiff, *Füssli*, II, figs. 468, 1755. Schiff, I, 633, describes the British Museum drawing as a "calque" (i.e., tracing or imitation) of the New Zealand drawing.

[6] See Tomory, *The Poetical Circle*, p. 15.

173

Part Two.
Plates by Blake after Designs
by Others

lounges sullenly in his cave; to his left is the shovel he had been using to dig for roots, but instead found gold. The dark patch in front of the cave probably represents the hole where he uncovered the treasure. A few coins lie just below the shovel.

A pen, ink, and pencil drawing, probably of the same scene from Shakespeare's play, shows Timon alone and seated, looking left but reaching back to the right toward a bag of gold, and with a large shovel at his feet.[7] Arching trees frame the figure, as in the separate plate. This drawing is crude and amateurish, but may be in part by Blake. A similar figure, but partly bald and with small winged figures springing from the bag of gold, personifies Ambition in Blake's watercolor no. 115 illustrating Young's *Night Thoughts* (*c.* 1795-1796). The bald figure with a bag also appears, top left, on a sheet of pencil sketches (20.8 × 31.7 cm) in the Houghton Library, Harvard University.[8] It is inscribed "Avarice" (not in Blake's hand) immediately above the small sketch. This sheet of studies has sometimes been attributed to D. G. Rossetti, but it may be by Blake himself rather than modified copies of figures from his designs.

[7] 11.7 × 13.4 cm, Beinecke Library, Yale University. Inscribed "Timon," lower left, and "By Wͫ Blake," lower right, perhaps in John Linnell's hand. Reproduced in *William Blake's Designs for Edward Young's Night Thoughts*, ed. John E. Grant, Edward J. Rose, Michael J. Tolley, and David V. Erdman, Oxford: Clarendon Press, 1980, I, 44.

[8] Reproduced in *The Notebook of Blake*, ed. Erdman, p. 87.

174

XXXIV.
Falsa ad Coelum

(after Henry Fuseli)

FIGURE 76

One state: *c*. 1790

Inscription on the floor beneath the seated figure, open letters: FALSA AD COELUM MITTUNT INSOMNIA MANES

Image: 22.2 × 35.8 cm

Plate mark: 25.8 × 37.9 cm

The only known impression of "Falsa ad Coelum," now in the *British Museum*, is printed on laid paper, 30.8 × 38.8 cm, with a fragment of an unidentified crown watermark at the top edge (Fig. 76). Acquired in August 1883 from "Mr. Fawcett" (according to the Museum's accession records). Exhibited at the British Museum in 1957, no. 22(8) in the catalogue.

The dating and attribution of "Falsa ad Coelum" to Blake as its etcher are based on the great similarity between its graphic style and that of "Timon and Alcibiades" (which see, for further discussion).[1] Schiff, however, attributes both the design and execution of the plate to Fuseli because of the similarity in graphic style to Fuseli's "Sleeping Woman on a Divan" and the presence of lefthanded hatching and crosshatching.[2] But a lefthanded etcher will produce righthanded hatching, as in "Sleeping Woman on a Divan," because an impression from a plate reverses its direction. "Falsa ad Coelum" contains both left- and righthanded patterns, as is the case with a great many etchings and engravings,[3] and the presence of any one "direction" of hatching in a print cannot be used as evidence for attribution. One can claim with a good deal of confidence that the same hand that etched "Timon and Alcibiades" also etched "Falsa ad Coelum," but one cannot completely rule out the possibility that Fuseli, or Fuseli and Blake working together, executed both plates.

The inscription ("false the visions that the nether powers speed therefrom to the heaven above") is quoted from Virgil's *Aeneid*, Bk. VI, line 896. In Dryden's translation, the complete sentence reads as follows:

> Two Gates the silent House of Sleep adorn;
> Of polish'd Iv'ry this, that of transparent Horn:
> True Visions through transparent Horn arise;
> Through polish'd Iv'ry pass deluding Lyes.[4]

Fuseli's design is a further allegorization of Virgil's two gates. Fuseli associates false dreams with the demonic and erotic, as indicated by the nakedness and posture of the sleeping woman, the flying cupids, and the butterfly or moth on the woman's thigh.[5] In contrast to these motifs are the sun, rising just above the wall on the left, and the term in the shadows behind the woman. His gesture of a single finger resting on his lips indicates that he is Harpocrates, the Egyptian god of the morning sun. These representatives of truth and enlightenment, and therefore of the gate of horn, seem to be dispelling the nocturnal creatures associated with the gate of ivory: one cupid has turned to leave and the other appears to be following in the same direction.

Ganesa, the Hindu god of knowledge and prudence, is represented

[1] The attribution was first made by Russell, *Engravings of Blake*, p. 155.

[2] *Füssli*, I, 582. Fuseli was lefthanded and characteristically used bold, lefthanded hatching in his drawings. Lefthanded hatching rises on a diagonal from right to left; righthanded hatching rises from left to right. "Sleeping Woman on a Divan" (reproduced in Schiff, *Füssli*, II, figs. 842 and 842a) is similar to "Falsa ad Coelum" because of the posture of the sleeping woman in both designs, the presence of cupids with bow and arrow, and the erotic themes.

[3] The presence of both directions of hatching in so many plates is explained by the artist turning the plate sideways and upside down as he "worked-up" the hatching and crosshatching patterns.

[4] James Kinsley, ed., *The Poems of John Dryden*, Oxford: Clarendon Press, 1958, III, 1233. Virgil's lines are based closely on Homer's *Odyssey*, Bk. XIX, lines 562-567.

[5] For Fuseli's use of the butterfly or moth as a demonic image, see Schiff, *Füssli*, I, 508 (no. 842), 582 (no. 1348). The interpretation of "Falsa ad Coelum" given here is based in part on Schiff's cogent discussion, I, 581-582. Schiff suggests that Fuseli's composition was influenced by "Cupid and the Graces Undressing Mars and Venus," engraved by Giovanni Caraglio (active 1526-1551) after Rosso.

Part Two.
Plates by Blake after Designs
by Others

in Indian art as an elephant-headed man. The similar figure in this print, lower right, points with his right hand to the inscription, a gesture that suggests the wisdom of Ganesa. But Fuseli's elephant-headed man may have less positive associations consistent with his proximity to a deeply shadowed area of the design. The elephant is a traditional symbol of concupiscence in representations of the fall of Adam and Eve, and the creature's name brings to mind the Latin word for ivory (*elephanto*) and the Greek word for deception.[6]

Blake drew a pencil sketch, about 11.5 × 8 cm, of an elephant-headed man and child on the verso of his wash drawing, "And the Spirit of God Moved Upon the Face of the Waters."[7] The verso sketch was executed in 1820 (the date of the watermark) or later, possibly as a caricature of John Varley, and is not directly related to "Falsa ad Coelum." The tone is clearly comic, not erotic. Blake pictures a winged cupid drawing a bow, very similar to the one in "Falsa ad Coelum," in watercolor no. 162 illustrating Young's *Night Thoughts* (c. 1795-1796).

[6] According to Schiff, ibid., 582. Schiff does not consider the possible relevance of Ganesa.

[7] Abbot Hall Art Gallery, Kendal. Recto and verso reproduced in the 1978 Tate Gallery exhibition catalogue, p. 134.

XXXV.
An Estuary with Figures in a Boat

(after Thomas Stothard?)

PLATE 9

Relief etching with color printing?

One state: c. 1790-1794?

Inscriptions: none in the plate

Image: 9 × 8.8 cm.

Plate mark: all but a fragment upper left trimmed off in the only known impression

The only known impression of this print (Pl. 9), now in the collection of *Sir Geoffrey Keynes*, Suffolk, is printed (or hand tinted and blotted) in brown, blue, and green on wove paper, 9.4 × 9.4 cm, mounted on a sheet of brown paper. On the verso of the mounting sheet is inscribed, in an early hand, "Rupert Kirk's Collection N⁰ 975," and below, in ink over pencil, "By Wᵐ Blake (Mʳ Stothard.)." At one time in the collection of Rupert Kirk, Australia, and purchased from the London print dealers Craddock and Barnard by Keynes in 1959 (as he notes on the mat). Listed in Keynes, *Bibliotheca Bibliographici*, no. 553.

The very tentative attribution of this curious print to Stothard as the designer and Blake as the etcher and color printer is based on the early inscription noted above and the similarity between the techniques probably used to execute the print and Blake's experiments in relief etching and color printing, *c.* 1788-1794. A slight indentation in the paper above the upper left corner of the image and the indented borders between brown areas and contiguous unprinted whites in the lower part of the image suggest that at least part of the design was printed from a metal plate, probably etched in relief. Almost the entire image contains patterns made by the wire lines of laid paper. Since the printed sheet itself is wove, laid paper must have been used to apply, or at least blot, some of the colors.[1] The clouds and sky show no evidence of printing from a plate, and these areas may have been entirely executed with watercolors transferred from the laid sheet or applied directly to the impression and blotted. Thus the print would appear to combine the relief etching techniques Blake used in his illuminated books, beginning in about 1788, and the planographic transfer method probably used in "Charity" (Fig. 3). "An Estuary with Figures" may be an early experiment in color-printing processes that ultimately evolved into the techniques Blake used to print relief etchings in opaque pigments, *c.* 1794-1796, and to create the large color-printed drawings of 1795.

Bindman, *Complete Graphic Works of Blake*, p. 473, suggests that this print may be connected in some way with a sketching expedition on the Medway taken by Blake, Stothard, and "Mr. Ogleby" in about 1780.[2] An intaglio etching associated with this trip,[3] which has sometimes been incorrectly attributed to Blake, is unrelated to "An Estuary with Figures" in either composition or technique.

[1] Paul Gauguin used this technique of watercolor transfer from paper in his monotypes of 1894, some of which show impressions from the wire lines of the printing sheet as in this print. See Richard S. Field, *Paul Gauguin: Monotypes*, Philadelphia: Museum of Art, 1973.

[2] See Bray, *Life of Stothard*, pp. 20-21; Bentley, *Blake Records*, pp. 19-20.

[3] See LXV, "Stothard and Friends Prisoners During a Boating Excursion," Part Seven of this catalogue.

XXXVI.
Edmund Pitts,
Esqʳ·

(after Sir James Earle)

FIGURE 77

First state: c. 1793-1796

Signature, left: ad viv: del: J Earle

Signature, right: Blake. sculp:

Title, scratched letters, the first two words in open letters:
EDMUND PITTS, Esqʳ·

Oval image, including framing line: 18.5 × 14.2 cm

Plate mark: trimmed off in the only known impression but
 probably the same as in the second state, 24.2 × 17.5 cm

IMPRESSIONS

1A.
New York Public Library. Printed on laid paper, 24.3 × 16.7 cm,
pasted to the mat on three corners. Rather lightly inked and printed;
the paper scuffed and dust stained. Bequeathed to the Library in 1878
by the editor Evert Augustus Duyckinck (1816-1878).

Second state: c. 1793-1796 or after 1802 (see discussion be-
 low)

Signature, left: ad viv: del: J Earle: Armig:

Signature, right: Guliel: Blake sculp:

Plate mark: 24.2 × 17.5 cm

Image and title: same as in the first state. It is possible that
 this is the first state of the plate and that the state de-
 scribed here as the first is later, with "*Armig:*" and "*Gu-
 liel:*" removed from the plate. However, the presence of
 very fine stipple on the face in impression 1A, absent be-
 cause of wear even in more heavily inked impressions, sug-
 gests the sequence of states enumerated here. Similarly, the
 period after the superscript *r* in "*Esqʳ*" seems to have worn
 off the plate in second-state impressions.

IMPRESSIONS

2B.
British Museum. Printed on wove paper, 25.3 × 18.7 cm. Two streaks,
running vertically across the figure's lower cheek and neck and about
one cm left of his nose, slightly mar the image. Purchased by the
Museum from Colnaghi's in August 1850. Reproduced here, Fig. 77.

2C.
Huntington Library, San Marino, California. Printed on wove paper,
28.5 × 21.5 cm, with three framing lines inscribed in pencil outside
the plate mark, the outer line partly trimmed off. Bound along the
right edge into volume 10 of an extra-illustrated copy of Daniel Lysons,

Part Two.
Plates by Blake after Designs
by Others

Historical Account of the Environs of London, London, 1796, third print after p. 562. The volumes may have been assembled by William Augustus Fraser, whose bookplate is pasted on the inside front cover of each volume. Acquired by the library in 1949 from Keith Spalding.

2D.
Sir Geoffrey Keynes, Suffolk. Printed on wove paper trimmed to 22.2 × 17.5 cm. Heavily inked, with some streaks of ink printed from the surface of the plate on the upper left arm. Acquired by Miss A. M. Butterworth by 1914 and lent by her in that year to the Manchester Whitworth Institute, no. 98 in the exhibition catalogue. Acquired by Keynes in June 1936 (as he notes on the mat). Listed in Keynes, *Bibliotheca Bibliographici*, no. 573; Bindman, *Blake: Catalogue of the Collection in the Fitzwilliam Museum*, no. 573, as part of Keynes' bequest to the Museum. Reproduced in *Blake Newsletter*, 7 (1973), 10.

2E.
Library of Congress, Rosenwald Collection, Washington, D.C. Printed on wove paper trimmed to 24.1 × 17.4 cm, the plate mark visible only near the bottom and right edges. For provenance to 1943, see "Rev. John Caspar Lavater," impression 3Q. Given by Lessing J. Rosenwald to the Library of Congress in 1943 and moved from the Alverthorpe Gallery, Jenkintown, Pennsylvania, to Washington in 1980. Listed in *The Rosenwald Collection* (1954), p. 191; *The Rosenwald Collection* (1977), p. 335. Reproduced in *Blake Newsletter*, 9 (Winter 1975-1976), 71.

2F.
McGill University, Montreal. Printed on wove paper, 29.9 × 22.6 cm. Three framing lines have been drawn in pencil outside the plate mark. Same provenance as "Rev. John Caspar Lavater," impression 2C.

2G.
Pierpont Morgan Library, New York. Printed on wove paper, 34 × 25 cm, foxed. Pasted to the mat is a printed description of the plate, numbered 76, probably clipped from a sale catalogue although no price given. Purchased in the early 1950s (probably with impression 2F) from Anderson Galleries, New York, by Herman Cohen of the Chiswick Book Shop. Acquired by the Library in late 1980.

2H.
Royal College of Surgeons of England, London. Printed on wove paper trimmed inside the plate mark to 23.3 × 16.2 cm. A blind embossed collection mark of the Royal College of Surgeons has been stamped over the lower part of the image and title; two long pencil lines run vertically through the image. Inscribed in pencil at the top "17/8," the "8" partly erased. No information available on provenance, but the print probably entered the college's collection prior to World War II.

179

UNTRACED IMPRESSIONS

1.
Offered for sale by Edward Evans, London, *Catalogue of a Collection of Engraved Portraits*, 1835, item 8385, "priv. plate" (7s.).

2.
Offered at the auction of the stock of Robson & Co., Puttick & Simpson, 2 July 1937, lot 622 (no information on price or purchaser available). Perhaps the same as impression 2F, 2G, or 2H.

Blake executed "Edmund Pitts" in stipple, and very probably used a roulette to create the framing line and the stippled lines of hatching and crosshatching on the clothes and in the background. The open-letter italic capital letters of the title inscription are a somewhat less elegant version of those in the "Edward & Elenor" separate plate of 1793 (Fig. 6) and the "Ezekiel" of 1794 (Fig. 12). The portrait of Pitts may have been a "private plate," as the Evans' catalogue notes (see untraced impression 1), intended for the use of the designer and/or the subject and not meant for general publication or sale.

Keynes, *Engravings by Blake: The Separate Plates*, p. 78, dates the plate *c.* 1790 and ascribes its design to the American portrait painter James Earle (died 1796). In "William Blake & Bart's,"[1] Keynes offers a more probable attribution. In 1793, Blake engraved two plates for James Earle's *Practical Observations on the Operation for the Stone*, published by Joseph Johnson. An unsigned plate added to the second edition of 1796 may also be from Blake's hand. Thus it seems more likely that the amateurish portrait of Pitts was drawn not by a professional artist but by the eminent surgeon Sir James Earle (1755-1817) and etched and engraved by Blake during the same period he was executing the illustrations for Earle's book. Further, both Earle and Edmund Pitts (died 1791) were surgeons at St. Bartholomew's Hospital, London, and the two men must have known each other from about 1770, when Earle was elected assistant surgeon, until Pitts' death. Earle drew the portrait *ad viv* (i.e., from the life) prior to 1791 and may have had it engraved a few years later as a memorial tribute to his deceased colleague. Keynes speculates that the plate may have been intended to illustrate a projected but never published biography of Pitts. Earle wrote a life of the surgeon Percival Pott (1790) and an account of Dr. William Austin prefixed to *Practical Observations* (1796). The abbreviation for *Armiger* following his name on the second state of the plate indicates that Earle was the bearer of a coat of arms. He may have had that right because of family connections, as Keynes suggests, or this second-state inscription was not added until after Earle was knighted in 1802. The latter possibility is lessened somewhat by the left-leaning serif on the *g* of *Armig*, a characteristic of Blake's copperplate hand only from *c.* 1791 to *c.* 1803.[2]

[1] *Blake Newsletter*, 7 (1973), 9-10. Keynes compares the graphic style of "Edmund Pitts" to the frontispieces Blake executed for *The Poems of Caius Valerius Catullus*, published by Joseph Johnson in 1795. These two book illustrations, however, do not contain the roulette work so prominent in the separate plate.

[2] See David Erdman, "Dating Blake's Script: the 'g' hypothesis," *Blake Newsletter*, 3 (1969), pp. 8-13. The third state of "The Accusers of Theft Adultery Murder" (Fig. 18) is probably an exception to this rule.

XXXVII.
The Right Honourable Earl Spencer

(after Thomas Phillips)

FIGURE 78

First state: 1813

Inscriptions: none in the plate; see pencil inscriptions on impressions 1A and 1B.

Image: 30 × 24.7 cm

Plate mark: 36.6 × 25.8 cm

IMPRESSIONS

1A.
British Museum. Printed on wove paper, 54.5 × 38.4 cm, watermarked "1811," upper left. Ragged lower edge. Inscribed in pencil, perhaps by Blake, *Blake Sculpᵗ*, on the right below the image, and *Earl Spencer*, below the image, center. Inscribed in pencil below the plate mark in a different hand, *never published*. Acquired by the Museum in May 1873 from "Mrs. Noseda" (according to the Museum's accession records).

1B.
Robert N. Essick, Altadena, California. Printed on wove paper, 50.1 × 36.5 cm, pasted to strips of an old backing sheet on the sides and bottom of the verso. Inscribed in pencil, perhaps by Blake,[1] *Blake Sculpᵗ*, below the image on the right. Inscribed in pencil in a different hand between the image and the lower plate mark, *Earl Spencer | unpublished | (from a Portrait by T. Phillips Esq. RA.)*. Acquired, probably from Blake or his printer, by Thomas Phillips, from whom it was acquired with other prints by and after Phillips by Dawson Turner (1775-1858). Subsequently acquired by the great bibliophile Sir Thomas Phillipps (1792-1872). The collection was bound, apparently by Turner or Phillipps, into a folio volume lettered on the spine "Engravings after Portraits by T. Phillips, Esq., R.A." After Phillipps' death, the volume passed by bequest to the successive life trustees of his library, John Fenwick, Thomas FitzRoy Fenwick, and Alan George Fenwick. Sold in 1946 to the London bookdealers Philip Ramsey Robinson and Lionel Robinson. Sold from "the property of the Trustees of the Robinson Trust" at Sotheby's, 12 July 1973, lot 110 (£1,100 to Andrew Edmunds). The volume was broken up and this impression purchased by Essick from Edmunds in July 1974 (£450). Reproduced, image only, in Essick, *William Blake, Printmaker*, fig. 177.

Second state: 1813

Signature, left: T Phillips R A. pinx

Signature, right: W Blake. sculp

Title: The Right Honourable | Earl Spencer

Image and dimensions: same as in the first state. All letters in this second state are scratched into the plate in drypoint.

[1] The hand is the same as the names on impression 1A.

IMPRESSIONS

2 C.

British Museum. Printed on wove paper, 55.8 × 38 cm, watermarked "1811," lower right. Purchased by the Museum from Evans in August 1863. Reproduced here, Fig. 78.

UNTRACED IMPRESSIONS

1.

Sold from the collection of Alfred Aspland, Sotheby's, 27 January 1885, lot 10, "proof" (i.e., first state?), with two other prints (8s. to Fawcett).

Blake etched and engraved "Earl Spencer" in heavy and dense patterns of dot and lozenge. The dating is based on an entry in George Cumberland's notebook for 12 April 1813: "Saw Blake who recommended Pewter to Scratch on with the Print—He is Doing Ld Spencer."[2] The plate appears never to have been published for general distribution, as noted on impressions 1A and 1B, and may have been a "private plate" executed for the use of the subject and his family.

Thomas Phillips (1770-1845) was one of the leading portrait painters of his time. He painted the portrait of Blake exhibited at the Royal Academy in 1807 and engraved by Schiavonetti and published in Robert Cromek's edition of Blair's *Grave* (1808) containing Blake's illustrations.[3] George John Spencer (1758-1834), the second Earl Spencer, was an important Whig politician of his time, Admiral Nelson's superior while First Lord of the Admiralty from 1794 to 1801, and a sponsor of many cultural projects. He rehabilitated and added to the great library at the family home, Althorp House, that now forms the nucleus of the John Rylands Library, Manchester, and was a friend of John Flaxman and Richard Edwards, the publisher of the edition of Young's *Night Thoughts* (1797) containing Blake's illustrations.[4] He is shown in this portrait wearing the star of the Order of the Garter.

I have not been able to trace an original painting by Phillips corresponding exactly to this plate. There was in recent years, however, an oil portrait by him of Earl Spencer, seated and holding a book, in the collection at Althorp House, Northamptonshire.[5] The sitter is dressed as in this print and the position of his face and upper body is the same. It is possible that Blake's plate was adapted from this painting.

[2] Bentley, *Blake Records*, pp. 231-232. The reference to Blake's method of engraving on pewter (see "The Man Sweeping the Interpreter's Parlour") is unrelated to "Earl Spencer."

[3] For information on this portrait of Blake, now in the National Portrait Gallery, London, see Bentley, *Blake Records*, pp. 182-183.

[4] Earl Spencer purchased the copy of the *Nights Thoughts*, with Blake's illustrations hand colored, now in the John Rylands Library. See *William Blake's Designs for Edward Young's Night Thoughts*, ed. John E. Grant, Edward J. Rose, Michael J. Tolley, and David V. Erdman, Oxford: Clarendon Press, 1980, I, 66, where the purchaser is incorrectly identified as the third Earl Spencer.

[5] This is the only portrait by Phillips of the second Earl listed in the *Catalogue of the Pictures at Althorp House*, London: n.p., 1851, no. 122.

XXXVIII.
The Child of Nature

(after Charles Borckhardt)

FIGURE 79

One state: 1818

Signature, left, stippled letters: Borckhardt. delin.

Signature, right, stippled letters: Blake. sculp.

Title, stippled and open letters: The CHILD of NATURE.

Imprint, stippled letters: Published by C Borckhardt March 2ᵈ 1818

Image: 38.1 × 24.8 cm

Plate mark: 43.3 × 27.5 cm

IMPRESSIONS

1A.

British Museum. Printed on (wove?) paper, 48.6 × 31.6 cm, pasted to the mat. A repaired tear extends from the bottom edge to the plate mark. Offered by E. Parsons in his February 1931 catalogue, item 551 (£10 10s.). Acquired by the Museum in February 1935 with "The Child of Art," from Parsons (£11 9s.). Reproduced here, Fig. 79.

1B.

Sir Geoffrey Keynes, Suffolk. Printed on wove paper, 43.8 × 27.5 cm, the plate mark visible only at the top and right edges. With impression 1C on the verso. Sold from the collection of H. K. Burnet of Bradford, Yorkshire, at Sotheby's, 12 February 1941, lot 95 (£5 10s. to Keynes). Listed in Keynes, *Bibliotheca Bibliographici*, no. 575; Bindman, *Blake: Catalogue of the Collection in the Fitzwilliam Museum*, no. 575, as part of Keynes' bequest to the Museum. Reproduced in Keynes, *Engravings by Blake: The Separate Plates*, pl. 44.

1C.

Sir Geoffrey Keynes, Suffolk. Printed on the verso of impression 1B, slightly lower on the sheet and to the right. See impression 1B for provenance and listings in collection catalogues.

UNTRACED IMPRESSIONS

1.

Sold from the collection of Henry Cunliffe, Sotheby's, 11 May 1895, lot 99, "fine impression" (£1 12s. to Keppel). Perhaps the same as impression 1A.

2.

According to Keynes, *Engravings by Blake: The Separate Plates*, p. 81, an impression "delicately painted with water-colours" was at one time in the collection of W. E. Moss. Not included in the sale of the Moss collection, Sotheby's, 2 March 1937.

Blake executed "The Child of Nature" in stipple and line. The graphic style is unlike any other print Blake produced, and some of the stipple work is so fine and dense that it approaches the texture of aquatint. The plate might have been etched and engraved by some other "Blake." However, there is no other printmaker of that name who was producing stipple prints, *c.* 1818, and the stippled lettering is a characteristic feature of several other plates by William Blake.

Charles Borckhardt, who both designed and published the plate, was a miniature painter who exhibited in London from 1784 to 1825, including twenty works shown at the Royal Academy. This plate and its companion, "The Child of Art," are the only records of contact between Borckhardt and Blake.

XXXIX.
The Child of Art

(after Charles Borckhardt)

One state: 1818

Signature, left, stippled letters: Borckhardt. delin[t]

Signature, right, stippled letters: Blake. sculp

Title, stippled and open letters: The CHILD of ART.

Imprint: obscured by partly erased pencil smudges in the only known impression[1]

Image: obscured in the only known impression; probably about the same size as "The Child of Nature," 38.1 × 24.8 cm

Plate mark: trimmed off × 27.9 cm in the only known impression

The existence of "The Child of Art" is known only through an impression, now in the *British Museum*, in which a mezzotint executed on the same copperplate has replaced the original image. The only remnants of Blake's work are a bottom framing line in stipple and the inscriptions recorded above extending 1 cm below the mezzotint, printed on (wove?) paper, 38.9 × 28.6 cm, pasted to the mat. It pictures a large tree arching on the right, a woman kneeling beside a pond or stream (right center foreground), two kneeling figures on the left, one clutching his head, and a figure (mid-ground, center) extending an arm into a small waterfall cascading down a cliff crowned with trees. A pencil note on the mat states, "The Engraving [i.e., the mezzotint] probably by Welby Sherman C.D."[2] Sherman was one of the young artists who gathered around Blake in the final years of his life. If this note is correct, Blake may have retained the copperplate until late in life and then passed it on to one of his young admirers for his own use. The mezzotint was acquired by the Museum in February 1935 with impression 1A of the companion print, "The Child of Nature" (which see for further discussion).

[1] Keynes, *Engravings by Blake: The Separate Plates*, p. 82, records an imprint (*Published by C. Borckhardt March 2ᵈ 1818*), perhaps on the reasonable assumption that it is substantially the same as in "The Child of Nature."

[2] Sherman executed a mezzotint after Samuel Palmer in 1834. See Campbell Dodgson, "The Engravings of George Richmond, R. A., and Welby Sherman," *Print Collector's Quarterly*, 17 (1930), 359, 361-362. The note on the mat, signed "C.D.," is very probably by Dodgson.

XL.
James Upton
(by Blake and John Linnell after Linnell)

FIGURES 80-81

First state: 1818-1819

Title in crudely scratched letters: James Upton

Image: 26.1 × 19.4 cm

Plate mark: 35.2 × 27.2 cm

IMPRESSIONS

1A.

Robert N. Essick, Altadena, California. Printed on India paper laid on to wove, 36.6 × 28.7 cm. Inscribed in pencil, probably by John Linnell, just above the lower plate mark, "march. 1819—Unfinished Proof. must be returned to M.ʳ J. Linnell." For many years in the possession of the Linnell family. Acquired, probably before World War I, by the London dealer Walter T. Spencer as part of a collection of prints and drawings by Linnell, including impression 1B.[1] Both impressions purchased from Spencer in July 1973 by Andrew Edmunds, who sold them in the same month to Essick ($3,750 the pair). Reproduced here, Fig. 80.

Second state: 1819

The mole on the figure's right cheek has been removed and a small stickpin added just below his cravat. The variations in tone between the backgrounds in impressions 1A and 1B are probably due to inking differences. The scratched letters of the first-state title have been removed and the following inscriptions added:

Signature below the image, center, open letters: PAINTED AND ENGRAVED BY J.ⁿᵒ LINNELL.

Title, open letters: JAMES UPTON

Inscription below title: Pastor of the Baptist Church Meeting in Church Street Blackfriars Road

Imprint, incomplete: London Published June 1ˢᵗ 1819 by

Image size and plate mark: same as in the first state

IMPRESSIONS

2B.

Robert N. Essick, Altadena, California. Printed on laid paper, 58.8 × 42.4 cm, slightly spotted along the edges. Perhaps the "open-letter proof in the Linnell collection" recorded by Russell, *Engravings of Blake*, p. 201 n.1. For provenance, see impression 1A. Reproduced here, Fig. 81.

2C.

Sir Geoffrey Keynes, Suffolk. Sold from "the Property of a Lady" (probably a descendant of Linnell) at Sotheby's, 19 June 1981, lot

[1] According to Miss Lydia Watkins, for many years the manager of Spencer's print department.

Part Two.
Plates by Blake after Designs by Others

406, "on laid India, with margins, the support sheet with a Dupuy Auvergne watermark, a water-stain and some creasing and soiling in margins" (£200 to Keynes). Not seen.

Although the second state of "James Upton" is signed by Linnell as both designer and engraver, there can be no doubt that Blake executed some of the lines on the plate. On 24 June 1818, Linnell wrote in his journal that he had gone "To Mr. Blake evening. Delivered to Mʳ Blake the picture of Mʳ Upton & the Copperplate to begin the engraving."[2] Years later, Linnell wrote of this commission in his manuscript *Autobiography*: "At Rathbone place 1818 . . . here I first became acquainted with William Blake. . . . We soon became intimate & I employed him to help me with an engraving of my portrait of Mr Upton a Baptist preacher which he was glad to do having scarcely enough employment to live by at the prices he could obtain." Linnell's payments to Blake for his work on the plate are recorded in receipts and account book entries made by both men. Linnell entered in his general account book a payment to Blake "on account" of £2 on 12 August 1818 (apparently an advance for the Upton plate) and on September 11 a payment of £5 for the "Plate of Mʳ Upton." Both payments are acknowledged in Blake's receipts, the second "on account of Mʳ Uptons Plate." In his journal for 12 September, Linnell wrote that "Mʳ Blake brought a proof of Mʳ Uptons plate left the plate & named £15 as the price of what was already done by him." Blake wrote a bill on 19 September giving the full amount to be paid "For Laying in the Engraving Mʳ Uptons portrait" as £15 15s., of which £7 had already been paid on 12 August and 11 September. The outstanding £8 15s. was paid in two installments, £5 on 9 November and £3 15s. on 31 December, according to Blake's receipts and Linnell's account book. Thus Blake worked on the Upton plate from 24 June to 12 September 1818, and payment for his labors was completed on the last day of that year.

It is difficult to determine the extent of Blake's work on the plate. "Laying in" an engraving might mean anything from etching the basic outlines to doing all but the finish work on the figure. The payment Blake received suggests efforts somewhere between these two extremes. If Blake's finances were as desperate as Linnell indicates in his *Autobiography*, then it is probable that Blake did considerable work on the copperplate to justify a fee of £15 15s. Blake executed John Flaxman's Hesiod illustrations in stippled outline in 1816 for only £5 5s. each, and received £20 in 1824 and 1825 from Linnell for his work on the "Wilson Lowry" portrait.[3] In the latter case, Blake's work was extensive enough to justify naming him as the co-engraver in the inscriptions. However, it seems likely that the plate as we know it is dominated by Linnell's work. Blake's "Earl Spencer" portrait of 1813 (Fig. 78) is heavily etched in dot and lozenge; the Upton portrait is mostly engraved, perhaps with some drypoint,[4] and shows the delicate flick work and burnished highlights characteristic of Linnell's engraved portraits.[5] Impression 1A could not have been the "proof" Blake delivered to Linnell on 12 September 1818. If Blake had brought the

[2] This and all following documents relating to the execution of the plate are quoted from Bentley, *Blake Records*, pp. 256-257, 258, 584, 580, 581, 585. Blake's receipt of 11 September 1818 is reproduced in Keynes, ed., *Letters of Blake*, pl. XXII.

[3] For these fees, see Bentley, *Blake Records*, pp. 579, 587-588, 604, 607.

[4] As Alfred T. Story claims in *The Life of John Linnell*, London: Richard Bentley, 1892, II, 242. Story also states (I, 159) that Linnell received "50 guineas" for the finished plate.

[5] Compare his 1813 portrait of the Rev. John Martin, reproduced in Essick, *William Blake, Printmaker*, fig. 201.

Part Two.
*Plates by Blake after Designs
by Others*

plate to such a high level of finish he surely would have received a larger fee and credit in the inscriptions in the second state. The six months between the delivery of the copperplate to Linnell and the pencil inscription on impression 1A would have given him time to do a considerable amount of work on the plate.

The incomplete imprint in the second state suggests that the plate was never published. Linnell's engraved portrait of the Baptist minister John Martin was published by the artist himself in 1813, probably for distribution among the sitter's congregation. This may have also been the intention for the Upton portrait. The only extant impressions were unknown between 1912, when Russell listed the second state in *Engravings of Blake*, p. 201, and the rediscovery of impressions 1A and 2B in 1973.[6] For a brief discussion of Linnell's influence on Blake, see the general Introduction to this volume.

[6] See Robert N. Essick, "Blake, Linnell, & James Upton: An Engraving Brought to Light," *Blake Newsletter*, 7 (1974), 76-79.

XLI.
Rev.d Robert Hawker

(after John Ponsford)

FIGURE 82

One state: 1820

Signature, left: Painted by I. Ponsford.

Signature, right: Engraved by W. Blake.

Title, open letters: REV.D ROBERT HAWKER, D.D.

Inscription below title: Vicar of Charles, Plymouth

Inscription lower left, 5.1 cm below the lower right corner of the image: Proof.

Imprint: Published 1.st May 1820. by A. A. Paris, 53 Long Acre, London.

Image: 35.1 × 27.7 cm

Plate mark: 46.5 × 34 cm

IMPRESSIONS

1A.

British Museum. Printed on wove paper, 36.7 × 27 cm, trimmed within the image about .5 cm on the left and just below the title at the bottom. According to the Museum's accession records, the print was acquired from "S. Palmer" in June 1871. This former owner may very well have been the artist Samuel Palmer (1805-1881), who could have acquired this impression directly from Blake or Mrs. Blake. Probably the impression reproduced, image only and cropped on both sides, in C. E. Byles, *The Life and Letters of R. S. Hawker* [grandson of the portrait's subject], London: John Lane, 1905, facing p. 6.

1B.

Library of Congress, Rosenwald Collection, Washington, D.C. Printed on wove paper trimmed on or just within the plate mark to 46.6 × 33.8 cm. A slip of paper, 5.3 × 10.3 cm, has been pasted just right of the title and below the image. Written on this slip in ink, now brown with age, is the following note by Blake's wife Catherine: "M.r C Tatham | The humble is formed to | adore; the loving to associate | with eternal Love. | C Blake."[1] The *Proof* inscription, if present, is covered by this note. The addressee was Charles Heathcote Tatham (1772-1842), the father of Blake's friend and biographer Frederick Tatham (1805-1878) with whom Mrs. Blake lived as his housekeeper from September 1828[2] until her death three years later. Bentley, *Blake Records*, p. 288, suggests that Blake may have given this impression to the elder Tatham at a dinner party on 4 August 1824. It seems improbable, however, that a gift from Blake to Tatham would bear a note from Mrs. Blake; it is more probable that the impression was a gift from Mrs. Blake sometime between Blake's death on 12 August 1827 and her own death on 18 October 1831. Acquired by 1914 by W. E. Moss, and lent by him in that year to the Manchester Whitworth Institute, no. 94 in the exhibition catalogue. For further provenance to 1943, see "Rev. John Caspar Lavater," impression 3Q. Given by Lessing J. Rosenwald to the Library of Congress in 1943, and moved

[1] The aphorism is taken from that part of paragraph 69 which Blake underlined in his copy (now in the Huntington Library) of John Caspar Lavater, *Aphorisms on Man*, trans. by J. H. Fuseli, London: J. Johnson, 1788, p. 28.

[2] Bentley, *Blake Records*, p. 370.

189

from the Alverthorpe Gallery, Jenkintown, Pennsylvania, to Washington in 1980. Listed in *The Rosenwald Collection* (1954), p. 191; *The Rosenwald Collection* (1977), p. 335. Reproduced in Essick, *William Blake, Printmaker*, fig. 204 (where the presentation inscription is incorrectly stated to be to Frederick Tatham).

1C.
National Gallery of Art, Rosenwald Collection, Washington, D.C. Printed on wove paper, 46.9 × 34.4 cm, with the National Gallery of Art collection stamp on the verso. For provenance, see "Rev. John Caspar Lavater," impression 3Q. Reproduced here, Fig. 82.

Blake executed "Rev.ᵈ Robert Hawker" in a wide variety of etched and engraved lines and flicks. The graphic style, particularly the use of burnished highlights on the face, shows John Linnell's influence. Blake may even have consciously imitated Linnell's style, particularly if, as Keynes suggests,[3] Linnell was instrumental in acquiring the commission to execute the plate. Linnell had many contacts with the clergy and painted and engraved similar portraits of the Revs. John Martin (1813, 1817)[4] and James Upton (1819), the latter with Blake's assistance (see XL in this catalogue).

Robert Hawker (1753-1827), a popular preacher and author of devotional works, was Vicar of Charles, near Plymouth, for forty-three years. The portraitist John Ponsford (1790-1870) was active in and around Plymouth until *c*. 1823. This plate is the only record of contact between Blake, Ponsford, and the publisher Alexander A. Paris.[5]

Impressions 1A (trimmed just below the title) and 1B (with a note pasted down, lower right) may be in a later state than impression 1C, after the removal of the *Proof* inscription, lower right.

[3] *Engravings by Blake: The Separate Plates*, p. 85.

[4] The larger, 1813, plate is reproduced in Essick, *William Blake, Printmaker*, fig. 201.

[5] According to Ian Maxted, *The London Book Trades 1775-1800*, London: Dawson, 1977, p. 169, Paris worked as a printer and bookseller at 53 Long Acre from 1820 to 1824.

XLII.
Mrs Q

(after François Huet Villiers)

FIGURE 83

Stipple etching/engraving with mezzotint

First state: 1820

Signature, left: Drawn by Huet Villiers.

Signature, right: Engraved by W. Blake.

Image and plate mark: no information available; probably the same as in the second state

IMPRESSIONS

1A.

C. A. Lennox-Boyd, London. According to Mr. Lennox-Boyd, there is in his collection a proof before title and imprint, color printed with clear evidence of mezzotint on the face, acquired in recent years from Andrew Edmunds, the London print dealer. No further information available; not seen.

Second state: 1820

Signatures: same as in the first state

Title: Mrs Q

Imprint: London, Published 1st June, 1820, by I. Barrow, Weston Place, St Pancras.

Image: 29.4 × 22.9 cm

Plate mark: 35.2 × 24.9 cm

IMPRESSIONS

2B.

Bodleian Library, Oxford. Printed in dark brown on wove paper trimmed inside the image to 29.3 × 17.8 cm. Color printed on the face, neck, and hair in brown, flesh tones, and rose red. Hand tinted with watercolors: green waist ribbon, flesh tones on hands, gray wash on the wall and dress over thigh and hip. Some hand tinting on face. Acquired at an unknown time by John Johnson (1882-1956), and acquired with his collection by the Library in May 1968.

2C.

British Museum. Printed in dark brown on wove paper, 36 × 25.2 cm, with a crease from an old fold running vertically down the middle of the sheet. Mezzotint on face worn; no clear evidence of color printing, but probably some on the face and neck obscured by hand tinting. The waist ribbon is hand tinted in green, hair light brown, face in flesh tones and rose red, eyes blue, the wall below and to the right of the figure and her dress over hip and thigh light gray. Acquired by the Museum in December 1867 from John Defett Francis.

191

2D.

Robert N. Essick, Altadena, California. Lightly printed in dark brown on wove paper, 36.6 × 26.5 cm, with six watermarks, the most legible of which seems to read "[cut by edge of sheet] ORD | [cut by edge of sheet] MILL." Title and imprint faint. Color printed on the face, hair, and neck in brown, flesh tones, and rose red. Hand tinted with watercolors: light blue waist ribbon; perhaps some brown in hair and red on face; flesh tones on hands; gray wash on wall and dress over thigh, hip, and lower edge of left sleeve. Brown stain, upper right, within framing lines. Sold anonymously at Sotheby's Belgravia, 15 December 1978, lot 61, with another print (£90 to Morris Ayres). Acquired by Essick from Ayres Bookshop, London, in June 1981 for £70.

2E.

Sir Geoffrey Keynes, Suffolk. Printed in dark brown on wove paper, 36.9 × 26.2 cm. Color printed on the face, hair, and neck in brown, flesh tones, and rose red. Hand tinted with watercolors: gray-green waist ribbon; light brown on eyes, wall, and dress over thigh and hip. Acquired by Keynes many years ago; perhaps the impression offered by A. Mathews of Bournemouth, April 1945 catalogue, item 549, with "Windsor Castle" (£10). A clipping from this catalogue is in Keynes' collection. Listed in Keynes, *Bibliotheca Bibliographici*, no. 576; Bindman, *Blake: Catalogue of the Collection in the Fitzwilliam Museum*, no. 576, as part of Keynes' bequest to the Museum.

2F.

C. A. Lennox-Boyd, London. Color printed. Acquired at Christie's, 16 July 1974, lot 174, with "Windsor Castle" ($176 to Sanders of Oxford for Lennox-Boyd). No further information available; not seen.

2G.

C. A. Lennox-Boyd, London. According to Mr. Lennox-Boyd, there is in his collection a third color-printed impression in addition to impressions 1A and 2F. No further information available; not seen.

2H.

Raymond Lister, Cambridgeshire. Printed in dark brown on wove paper, 38.2 × 29.3 cm. Color printed on the hair, face, and neck in brown, flesh tones, and rose red; perhaps green color printing on the waist ribbon. Hand tinted with watercolors: flesh tones on the face, perhaps brown in the hair, green on the waist ribbon, gray on the dress over thigh and hip, brown on the wall, pink on the left arm. Purchased by Lister in 1966 from the London print dealer Walter V. Daniell. Perhaps the impression sold at Sotheby's, 1 August 1958, lot 164, "printed in colours," with "Windsor Castle" (£20 to Daniell). Reproduced in Lister, *Infernal Methods*, fig. 17.

2I.

McGill University, Montreal. Printed in very dark brown on (wove?)

paper matted and framed within the plate mark to 34.4 × 24.1 cm. Color printed in brown, flesh tones, and rose red on the hair, face, and neck. Hand tinted with watercolors: flesh pink on hands and left nipple, brown in hair, blue on eyes, blue-green on waist ribbon, gray on wall and dress over thigh and hip. Same provenance as "Rev. John Caspar Lavater," impression 2C.

2J.
National Gallery of Art, Rosenwald Collection, Washington, D.C. Printed in dark brown on wove paper, 54.8 × 39.5 cm, with the collection stamps of the National Gallery of Art, Lessing J. Rosenwald, and C. F. Bishop on the verso. Face, neck, and hair color printed in brown, flesh tones, and rose red. Hand tinted with watercolors: brown on hair; eyes blue and black; waist ribbon green; nipples and hands pink; and gray wash on the wall, dress over arms, shoulder, thigh and hip, and right hand. Ring on left hand very faint. The entire print has been covered with transparent wash to the plate mark. Acquired at an unknown time by C. F. Bishop (1870-1935), and sold from his collection at Anderson Galleries, New York, 19-20 November 1935. Purchased by Rosenwald from Rosenbach in December 1938 for $365 (according to a check voucher now in the Rosenbach Library, Philadelphia). Given by Rosenwald to the National Gallery of Art in 1945, and lent by him to the Philadelphia Museum of Art in 1939, no. 229 in the exhibition catalogue; and to Cornell University in 1965, no. 22 (reproduced) in the exhibition catalogue. Moved from the Alverthorpe Gallery, Jenkintown, Pennsylvania, to Washington in 1980. Reproduced here, Fig. 83.

2K.
Princeton University, Princeton, New Jersey. Printed in dark brown on (wove?) paper matted within the plate mark and framed on the left side of a morocco-backed portfolio with impression 2L on the right. Color printed on the hair, face, and neck in brown, flesh tones, and rose red. Hand tinted with watercolors: flesh tones on the left arm and breast; dark brown on hair; olive green waist ribbon; and gray on eyes, wall, dress over thigh and hip. Purchased by the University in 1971 from Quaritch, who offered this and impression 2L in their 1971 catalogue, no. 910, item 70 (£50). This catalogue describes impression 2L as a "late reprint"; it is not, however, the 1906 facsimile sometimes taken for a reprint (see discussion below).

2L.
Princeton University, Princeton, New Jersey. Printed in dark brown on (wove?) paper matted within the plate mark and framed on the right side of a morocco-backed portfolio with impression 2K on the left. Skillfully repaired tear, upper right corner. Color printed on the hair, face, and neck in brown, flesh tones, and rose red. Hand tinted with watercolors: waist ribbon blue-green; hair light brown; gray on wall, dress over thigh and hip, and eyes. Ring on left hand very faint. For provenance, see impression 2K.

193

Part Two.
Plates by Blake after Designs by Others

2M.

Charles Ryskamp, Princeton, New Jersey. Printed in dark brown on wove paper, slightly yellowed with age, trimmed within the plate mark to 31.3 × 24.6 cm. Skinned on verso. Pencil note on verso: "When I bought this print, it, & its companion, 'Windsor Castle' were coloured in a very inartistic manner—apparently *printed in colours*, & Miss Kate Greenaway has been so kind as to complete the colouring & to neutralize as far as lay in her power the original brick dirty red on the face & neck." The note is signed "F. L." (Frederick Locker-Lampson) and dated "29 May 1884." Color printed on the hair, face, and neck in brown, flesh tones, and rose red. Hand tinted with watercolors: flesh tones on face and hands, brown on hair, blue eyes, olive green waist ribbon. No wash on dress or wall. Scratched letters are visible slightly offset from the engraved letters of the right signature. Acquired by 1884 by Frederick Locker-Lampson (1821-1895). Not listed in the 1886 catalogue of his collection.[1] Perhaps the impression offered from the collection of "Mrs. L. Lampson" at Christie's, 13 January 1903, lot 114 (not sold). Sold Christie's, 12 February 1963, with "Windsor Castle." Acquired by Ryskamp in May 1964 from Seven Gables Bookshop, and lent by him to Princeton University in 1969, no. 87 in the exhibition catalogue; and to the Grolier Club, New York, in 1974. According to the caption, this is the impression reproduced in *University: A Princeton Quarterly*, no. 46 (Fall 1970), 32. The identical patterns of slight stains below the left hand appear in the reproduction of the print in Todd, *Blake the Artist*, p. 119, although the caption locates the print in the "Princeton University Library." Apparently Princeton supplied Todd with a photograph of impression 2M rather than one of their own (2K and 2L).

2N.

Leo Steinberg, New York. Printed in dark brown on wove paper trimmed close, just below the signatures at the bottom, to 30 × 24 cm. At one time pasted down; now removed from the mat. Face, neck, and hair color printed in brown, flesh tones, and rose red. Hand tinted with watercolors: pink nipples; blue waist ribbon; and gray wash on wall, dress over thigh and hip, left thumb. Acquired by Steinberg at Parke-Bernet, 15 November 1966, lot 16 ($70).

2O.

Private collection, Great Britain. Printed in dark brown on (wove?) paper, matted and framed inside the plate mark and just below the signatures. Color printed on the face, neck, and hair in brown, flesh tones, and rose red. Hand tinted with watercolors: green waist ribbon, gray wash on the wall and dress over thigh and hip. Several repaired tears, one in the left arm; foxed along the margins. Image slightly smudged. Acquired, probably from a London dealer, sometime after World War II.

[1] *The Rowfant Library: A Catalogue of the Printed Books, Manuscripts, Autograph Letters, Drawings and Pictures Collected by Frederick Locker-Lampson* [compiled by A. W. Pollard and B. J. Lister], London: Quaritch, 1886.

Part Two.
Plates by Blake after Designs
by Others

UNTRACED IMPRESSIONS, all color printed[2]

1.
According to H. Mireur, *Dictionnaire des Ventes d'Art faites en France et à L'Etranger pendant les XVIII & XIX Siècles*, Paris, 1911, I, 239, an impression was offered by Augerstein and Chambers of London in their 1897 catalogue (950 francs).

2.
Sold Sotheby's, 16 February 1898, lot 246 (£45 3s. to J. Vokins).

3.
Sold Christie's, 18 April 1898, lot 138, "with full margins" (£7 17s. to Agnew's).

4.
Sold Sotheby's, 3 July 1900, lot 159, "cut to the outline of the figure," with thirteen other prints (£19 19s. to Feldwicke).

5.
Sold Christie's, 15 January 1901, lot 110 (£14 14s.).

6.
Sold Sotheby's, 19 February 1901, lot 36 (£9 9s.).

7.
Sold Sotheby's, 2 May 1901, lot 335 (£39 to Daniell).

8.
Sold Christie's, 27 November 1901, with "Windsor Castle" (£94 10s. to Sabin).

9.
Sold Christie's, 13 January 1903, lot 94, with "Windsor Castle" (£35 14s. to Agnew's).

10.
Sold Christie's, 11 March 1903, lot 147, with "Windsor Castle" (£24 3s. to "Lauser," perhaps "Palser").

11.
Sold Christie's, 12 May 1903, lot 67 (£29 8s. to J. Vokins).

12.
Sold from the collection of the late Edwin Truman, Sotheby's, 19 March 1906, lot 133 (£45 to Colnaghi's).

13.
Sold Christie's, 12 June 1906, lot 109 (£25 4s. to Weil).

[2] Some of the examples sold after 1906 may be the facsimile of that year (see discussion below) incorrectly taken to be original impressions.

14.
Sold Christie's, 17 July 1906, lot 45, with "Windsor Castle" (£9 to Feldwicke). Probably the impression sold from "the property of C. Feldwicke & Sons" at Christie's, 21 June 1909, with "Windsor Castle" (£10 10s. to Mallett). See also untraced impression 4.

15.
Offered by Maggs, 1908 catalogue 240, item 379, "with margins," reproduced (£35). Probably the same impression offered by Maggs, 1909 catalogue 245, item 184 (£35).

16.
Sold Christie's, 25 May 1909, lot 112 (£5 15s. 6d.).

17.
Sold Sotheby's, 17 December 1912, lot 152 (£35 to Agnew's).

18.
Sold Sotheby's, 4 July 1913, lot 402, with "Windsor Castle" (£76 to Knoedler).

19.
Acquired by W. E. Moss by 1914 and lent by him in that year to the Manchester Whitworth Institute, no. 112-I in the exhibition catalogue, "printed in colour, hair and waist ribbon hand-coloured." Sold from the Moss collection at Sotheby's, 2 March 1937, "top and side margins cut away, but a fine impression" (£8 10s. to Sawyer). Offered by Sawyer, 1937, catalogue no. 137, item 125, "measurements (including frame) 18 3/4 by 14 3/4 inches" (£25).

20.
Sold from the collection of Frederic R. Halsey, Anderson Galleries, 8 January 1917, lot 163, trimmed within the plate mark, reproduced ($395).

21.
Offered by Maggs, 1919 catalogue 383, item 164, "with margins," reproduced (£80). Probably the same impression offered by Maggs, 1921 catalogue 408, item 115 (£80).

22.
Sold Sotheby's, 1 November 1921, lot 79, "cut close" (£4 10s. to Paxton).

23.
Offered at auction by Walpole Galleries, New York, 12 June 1923, lot 151, "beautiful impression . . . good margin" (no information available on purchaser or price).

Part Two.
Plates by Blake after Designs
by Others

24.
Sold from the collection of Mrs. Baker, Christie's, 18 June 1923, lot 40, with "Windsor Castle" (£5 15s. 6d. to Palser).

25.
Offered by Maggs, 1923 catalogue, no. 438, item 128, reproduced (£80). Perhaps the same impression offered by Maggs, 1924 catalogue, no. 447, item 90, reproduced (£80); 1925 catalogue, no. 466, item 82 (£80).

26.
Sold Sotheby's, 18 February 1926, lot 181A, with "Windsor Castle" (£21 to Eliot).

27.
Sold Sotheby's, 21 December 1926, lot 289 (£3 15s. to Burton).

28.
Sold Sotheby's, 2 July 1929, lot 162, with "Windsor Castle" (£54 to Brall).

29.
Sold Sotheby's, 1 March 1933, lot 114 (£2 10s. to Brall).

30.
Sold Christie's, 25 June 1934, lot 148 (£10 10s. to "SM").

31.
Sold Sotheby's, 6 February 1935, lot 149, with "Windsor Castle" (£15 10s. to Mallett).

32.
Sold from the collection of the late Greville Douglas, Sotheby's, 3 July 1940, lot 56 (£2 15s. to Leven).

33.
Sold Sotheby's, 4 May 1954, lot 226, with "Windsor Castle" (£12 to Daniell).

34.
Sold Sotheby's, 16 July 1956, lot 87 (£9 to "Maglquard," perhaps the book and print dealer Murdoch MacTaggart).

35.
Sold Sotheby's, 11 April 1958, lot 142 (£13 to Schwartz).

36.
Sold Sotheby's, 1 August 1958, lot 124, with three other prints (£3 to Colnaghi's).

37.
Offered Christie's, 14 October 1958, lot 25 (not sold).

38.
Sold Sotheby's, 2 December 1958, lot 131 (£4 to Betts).

39.
Offered Christie's, 17 February 1959, lot 19 (no price or purchaser record available).

40.
Sold Sotheby's, 13 July 1959, lot 136 (£4 to E. Seligmann).

41.
Sold Sotheby's, 11 January 1961, lot 68, with "Windsor Castle" (£6 to Sawyer).

42.
Sold Sotheby's, 16 July 1963, lot 38 (£4 to Marchmont).

43.
Offered Christie's, 18 May 1976, lot 28, foxed, margins pasted down (£40 highest bid; not sold).

"M[rs] Q" is the companion print to "Windsor Castle," signed by *I. B.* (J. Barrow?) as the designer, *G. Maile*[3] as the engraver, and published by *I. Barrow* on 1 June 1821. Both plates are executed in stipple, roulette work, and mezzotint on the faces. Although the stipple work is far more "open" than Blake's early stipple plates reproduced in this catalogue, it is generally similar to some of his nineteenth-century book illustrations, particularly the 1802 portrait of William Cowper after Sir Thomas Lawrence in volume II of William Hayley's *Life of Cowper* (1803).[4] Blake is never known to have used mezzotint,[5] and it was probably added by someone else to "M[rs] Q" as the final step in the development of the plate. "Windsor Castle," actually a portrait of the Marchioness of Huntly with the castle in the distance, has sometimes been attributed to Blake in dealers' catalogues. The only possible basis for this would be to assume that Blake executed the stipple, and Maile the mezzotint, on both plates.

The subject of "M[rs] Q" is Harriet Quentin, the wife of Colonel (later Sir George) Quentin and mistress to George IV when Prince Regent. According to Russell, *Engravings of Blake*, p. 187, the view in the background "seems to be taken from the Thames at Eton, with the College chapel in the background." Blake pictures Eton Chapel as seen from a balustrade at Windsor Castle on the opposite bank of the Thames in his first watercolor illustration (*c.* 1797-1798) to Thomas Gray's "Ode on a Distant Prospect of Eton College." The compositions are very different.

François Huet Villiers (or Villiers-Huet, 1772-1813) was best known

[3] Georges Maile was a mezzotint and aquatint engraver who worked in London until about 1824 and thereafter in Paris to about 1840.

[4] Reproduced in Essick, *William Blake, Printmaker*, fig. 180.

[5] In the late eighteenth century when Blake was learning his craft, mezzotinting was a profession clearly distinct from that of line or stipple etching/engraving. Very few professional line and stipple engravers practiced the rival technique.

⁶ It seems unlikely that the publisher was the J. Barrow, printseller and publisher, who was last recorded in business near Blackfriars Bridge in 1785 (according to Ian Maxted, *The London Book Trades 1775-1800*, London: Dawson, 1977, p. 14). That Barrow produced mostly caricature and satire prints.

⁷ There are copies of Grego's book in the British Library, Harvard University Library, and at the University of Texas, Austin. Examples of "Mʳˢ Q" detached from the book, or perhaps printed and originally sold as separate facsimiles, are in the collections of the Bodleian Library (John Johnson Collection), G. E. Bentley, Jr. (acquired at Sotheby's Belgravia, 6 July 1976, lot 54), Robert N. Essick, the Philadelphia Museum of Art, The Achenbach Foundation for Graphic Arts, San Francisco, and the Victoria and Albert Museum, London (from the collection of Miss A. M. Butterworth, who lent it in 1914 to the Manchester Whitworth Institute, no. 112-II in the exhibition catalogue, "probably later imitation"). The original plate is described as having been reprinted in Grego's book in Keynes, *Engravings by Blake: The Separate Plates*, p. 84, and in Bentley, *Blake Books*, p. 568.

as a miniature portraitist patronized by the Duchess of York and her circle. Since the portrait of Mrs. Quentin must have been drawn at least seven years before the publication of the plate, it offers no evidence of contact between Huet Villiers and Blake. The publisher of both prints and probably the designer of "Windsor Castle" was either the J. Barrow who exhibited enamels and miniature portraits in London from 1797 to 1836, or John Barrow, who exhibited portraits at the Society of Artists from 1812 to 1816.⁶

All recorded impressions of "Mʳˢ Q" are printed in shades, probably of the same ink, ranging from dark sepia to medium brown. All are color printed on the hair, face, and neck (extending to the bosom) in shades of brown, flesh tones, and rose red. In the better impressions the color printing has been expertly managed with subtle blending between colors. Many impressions may also have been hand tinted in the hair and on the lips and eyes, but this is difficult to distinguish from the fine color printing. All impressions are hand tinted on the waist ribbon in blue-green, gray-green, green, or olive. All but impression 2M (which see for its unique coloring history) have wash on the dress over the hip and thigh and on the wall on which the figure sits (brown in impressions 2E and 2H, gray in all others). Impressions 2B, 2D, 2I, 2J, 2M, and 2N have additional tinting on the hands; impressions 2H-2K have flesh-tone watercolors on the left arm and breasts.

A reduced re-engraving of "Mʳˢ Q," 11.3 × 8.4 cm, appears as the frontispiece to Edward Eglantine, *Memoirs of the Life of the Celebrated Mrs Q—*, London: Benbow, [1822]. This unsigned stipple engraving is inscribed *Mʳˢ Q | Benbow, Publisher, 1822*. The pamphlet is reprinted in *Mrs. Q— and "Windsor Castle" with a Note on the Plates by Joseph Grego and Memoirs of the Life of the Celebrated Mrs. Q— by Edward Eglantine, Esq.*, London: Kegan Paul, 1906. This elegant volume contains facsimiles of both "Mʳˢ Q" and "Windsor Castle," probably reproduced in photographic chromolithography printed from a zinc plate. This reproduction of "Mʳˢ Q" has frequently been taken for a reprint from the original plate.⁷ Besides the flat and dull appearance of the 1906 facsimile when compared to an original impression, there are several features that distinguish it from originals. There is no hand coloring in the facsimile, and the absence of wash on the wall and dress is particularly noticeable. In original impressions, the ring high on the third finger of the left hand is painted on by hand; it is printed in the facsimile. In the original impressions recorded here, the image size ranges between 29.3 × 22.4 cm and 29.6 × 23 cm, and the plate mark between 35.1 × 24.8 cm and 35.4 × 25 cm. The facsimile ranges in image size between 27.6 × 21.6 cm and 27.8 × 21.8 cm, and in plate mark between 33.1 × 24 cm and 33.3 × 24.3 cm. Even allowing for paper shrinkage and stretching, this is a significant difference, between 2.3 and .6 cm for each dimension, by which one can objectively separate originals from reproductions. Most of the latter, including the example in the British Library copy of Grego's book, are on wove paper very similar to the stock used for original impressions. Some facsimiles, however, are on laid paper and have green coloring on the plant to the right of the hip and on the

Part Two.
Plates by Blake after Designs
by Others

trees on the far right.[8] These are probably proofs, or at least a variant printing, of the same lithographic plate used in Grego's book. "M^rs Q" and "Windsor Castle" were also reproduced in color in *The Connoisseur: An Illustrated Magazine for Collectors*, 29 (January-April 1911), 72, 85. These measure 22.2 × 17.2 cm; there is no danger of mistaking them for originals.

[8] Copies of this type are in the collections of Robert N. Essick and Sir Geoffrey Keynes. "Windsor Castle" was similarly reproduced on both wove and laid papers.

XLIII.
Wilson Lowry

(by Blake and John Linnell
after Linnell)

FIGURES 84-88

First state: 1824-1825

Inscriptions: none in the plate

Image: approximately 13 × 9.5 cm

Plate mark: 25.4 × 19.9 cm

IMPRESSIONS

1A.

Herbert F. Johnson Museum of Art, Cornell University, Ithaca, New York. Lightly inked and printed on laid paper, 28.3 × 22.3 cm. Acquired in 1967 from an unidentified print dealer. Perhaps one of the proofs formerly owned by Ruthven Todd—see impression 2B and untraced impressions 7-9. Information kindly supplied by Barbara Blackwell of the Johnson Museum. Reproduced here, Fig. 84.

Second state: 1824-1825

More lines have been added to the hair, particularly evident in the forelock. The background shading to the right of the face has been extended further to the right opposite the upper forehead and, most noticeably, opposite the mouth and chin. The dark shading just right of the chin seems to have been darkened (although this may simply be a difference in inking), but the shading, right of the mouth, seems to have been weakened with scraping and/or burnishing. The crosshatching, right of the chin, has been extended further down and to the right so that it now covers the hatching lines just right of the top of the ruffled cravat. A small cut has been made in the plate .9 cm left of the outer corner of the right eye, apparently to represent a mole not pictured in the drawing (Fig. 87) or subsequent states of the plate. The general differences in tone between the unique impression of the first state and both impressions of the second suggest further small additions to the latter, but these are probably due to differences in inking.

IMPRESSIONS

2B.

Sir Geoffrey Keynes, Suffolk. Printed on laid paper, 25.7 × 23.6 cm, inscribed in pencil "first state." Acquired by Keynes prior to World War II from Ruthven Todd, who owned a large group of impressions in several states (see impressions 2C, 3D, 3E, 4M, 5P and untraced impressions 7-9). Like impression 4M, all those once owned by Todd may have passed through the collection of Joseph Wilson Lowry. Listed in Keynes, *Bibliotheca Bibliographici*, no. 577i; Bindman, *Blake: Catalogue of the Collection in the Fitzwilliam Museum*, no. 577i, as part of Keynes' bequest to the Museum. Reproduced here, Fig. 85.

2C.

Charles Ryskamp, Princeton, New Jersey. Printed on laid paper, 28.5 × 21.5 cm, deckled at the top and right edges. Touched in a few places in the image with pencil, probably to indicate further work to be done on the plate. Slight pencil sketch on verso, perhaps by Linnell. Acquired from Ruthven Todd (see impression 2B and untraced impressions 7-9) by Paul Grinke, the London bookdealer, in 1967 and sold by him in July of that year to Ryskamp. Lent by Ryskamp in 1969 to Princeton University, no. 91a in the exhibition catalogue, and to the Grolier Club, New York, in 1974.

Third state: 1824-1825

Highlights have been burnished into the left cheek, chin, forehead, and around the eyes and mouth. Many small flicks and short hatching lines have been added to several areas on the face, most noticeably at the inner end of each eyebrow, on the upper eyelids and left eyeball, and beneath the right eye. Hatching and crosshatching have been added to the coat, particularly lower right, on the ruffled cravat, and to the shaded background on the right. Strands of hair have been added just above the forehead and left of the right temple. The additions to the background shading have extended the image size to about 14.5 × 10.5 cm. The mole left of the right eye has been removed.

IMPRESSIONS

3D.

Sir Geoffrey Keynes, Suffolk. Printed on wove paper, 32.3 × 23.5 cm, inscribed in pencil "2nd state." For provenance, see impression 2B. Listed in Keynes, *Bibliotheca Bibliographici*, no. 577ii; Bindman, *Blake: Catalogue of the Collection in the Fitzwilliam Museum*, no. 577ii, as part of Keynes' bequest to the Museum. Reproduced here, Fig. 86.

3E.

Sir Geoffrey Keynes, Suffolk. Printed on wove paper, 27.5 × 22.1 cm, inscribed in pencil "3rd st." Described in Keynes, *Engravings by Blake: The Separate Plates*, p. 86, as a "third state" between the third and fourth states described here. However, there is no clear evidence of additional work on the plate in this impression. The general differences in tone between this and impression 3D can be accounted for by variations in inking and printing. For provenance, see impression 2B. Listed in Keynes, *Bibliotheca Bibliographici*, no. 577iii (third state); Bindman, *Blake: Catalogue of the Collection in the Fitzwilliam Museum*, no. 577iii, as part of Keynes' bequest to the Museum.

Fourth state: 1825

Hatching lines have been added between those already in the plate on the far right in the background shading. Cross-hatching has been added to the coat on the far left just below the collar. A few hatching strokes have been added to the right side of the cravat where it covers the neck and to the left cheek just right of the nose. Some short strokes may have been added to the face and hair, although the differences in tone in these areas between impressions of the third and fourth states can be accounted for by variations in inking and printing. The following inscriptions have been added:

Title, open letters: WILSON LOWRY, | F.R.S. M.G.S. &c.

Signatures below title: *Drawn from Life by J. Linnell, & Engraved by J. Linnell, & W. Blake.*

Inscription lower right, 1.8 cm above the bottom plate mark and 2.5 cm to the left of the right plate mark: *Proof.*

Imprint: *Published as the Act directs Jan 1, 1825; by Hurst, Robinson, & C? Cheapside, London.*

Dimensions: same as in the third state

IMPRESSIONS

4F.

British Museum. Printed on laid paper, 35.9 × 26.9 cm. Acquired at an unknown time by William Meriton Eaton (1843-1902), second Baron Cheylesmore, who began forming his extensive collection of prints *c.* 1870. Acquired by the Museum as part of the Cheylesmore bequest and accessioned in October 1902.

4G.

Cleveland Museum of Art. Printed on India paper laid on wove, 35.6 × 27.9 cm. Purchased by the Museum in 1930 from Holman's Print Shop, Boston. Not seen; information supplied by Louise Richards of the Cleveland Museum.

4H.

Robert N. Essick, Altadena, California. Printed on India paper laid on wove, 33.1 × 24.3 cm, with minor foxing near the bottom plate mark. *Proof* inscription extremely faint. For many years in the stock of the London book and print dealer Walter T. Spencer, from whom it was acquired, *c.* 1977, by Andrew Edmunds, who sold it in August 1979 to Essick (£60).

4I.

Huntington Library, San Marino, California. Printed on laid paper, 37.4 × 27.9 cm, bound along the left edge into an extra-illustrated

Part Two.
Plates by Blake after Designs
by Others

copy of Samuel Redgrave, *A Dictionary of Artists of the English School*, London: Longmans, Green, and Co., 1874, vol. 7, preceding p. 265. Unidentifiable fragments of a watermark, perhaps a T above an arch, in the right margin. No information on provenance available. Reproduced here, Fig. 88.

4J.

Sir Geoffrey Keynes, Suffolk. Printed on laid paper, 30.5 × 24.1 cm. Acquired by Keynes between 1957 and 1963, probably from a book or print dealer. Listed in Keynes, *Bibliotheca Bibliographici*, no. 577iv (fourth state); Bindman, *Blake: Catalogue of the Collection in the Fitzwilliam Museum*, no. 577iv, as part of Keynes' bequest to the Museum.

4K.

Library of Congress, Rosenwald Collection, Washington, D.C. Printed on India paper laid onto wove, 43.6 × 30.7 cm. *Proof* inscription faint. For early provenance and exhibition, see impression 4L. Given by Lessing J. Rosenwald to the Library of Congress in 1943 and moved from the Alverthorpe Gallery, Jenkintown, Pennsylvania, to Washington in 1980. Listed in *The Rosenwald Collection* (1954), p. 191; *The Rosenwald Collection* (1977), p. 335.

4L.

National Gallery of Art, Rosenwald Collection, Washington, D.C. Printed on laid paper, 33.1 × 23.8 cm, with some foxing. National Gallery of Art collection stamp on verso. Inscribed in pencil, lower right, "J. L. jun.," probably by the son of the artist John Linnell. Probably in the possession of the Linnell family until its acquisition by W. E. Moss. This and/or impression 4K sold from the Moss collection with "Rev. John Caspar Lavater," impression 3Q, which see for further provenance. This or impression 4K lent by Rosenwald to the Philadelphia Museum of Art in 1939, no. 232 in the exhibition catalogue.

4M.

Princeton University, Princeton, New Jersey. Printed on laid paper, 44.1 × 28.1 cm, with unidentifiable fragments of an emblematic watermark along the left edge. Inscribed in pencil in the lower margin, "To Adam White with J. W. Lowry's regards 1854." According to a card kept with this impression, it was presented in 1854 by Joseph Wilson Lowry (1803-1879), an engraver of scientific illustrations and son of Wilson Lowry, to the naturalist Adam White (1817-1879). Acquired, probably before World War II, by Ruthven Todd, from whom it was acquired by Charles Ryskamp, who gave it to the University by 1969. Exhibited at Princeton in 1969, no. 91b in the catalogue, where the provenance is recorded. Reproduced in Todd, *Blake the Artist*, p. 135.

204

4N.

Victoria and Albert Museum, London. Printed on India paper laid onto a (wove?) sheet pasted to a backing mat with a front mat also pasted down. The window in the front mat is slightly larger than the plate mark. *Proof* inscription very faint. Stamped below the imprint is a collector's mark, "AAL," which I have not been able to identify. Acquired by the Museum in February 1875 from H. Graves and Co.

Fifth State: 1825

The *Proof* inscription, lower right, has been removed from the plate or simply worn off. The faintness of this inscription in the India paper impressions (4G, 4H, 4K, 4N) of the fourth state suggests that *Proof* was scratched very lightly into the plate and may have gradually disappeared with successive printings. If this is indeed the case, and nothing purposeful was done to the plate to remove *Proof*, then fifth-state impressions are simply late or insufficiently inked impressions of the fourth state. See discussion below for further possibilities in the printing history of the plate.

IMPRESSIONS

5O.

British Museum. Printed on laid paper, 43.4 × 29.5 cm, with unidentifiable fragments of a watermark, probably composed of letters, along the left edge. Acquired by the Museum in August 1850 from Colnaghi's. Probably the impression reproduced, image only, in Garnett, *Blake, Painter and Poet*, p. 61.

5P.

Jenijoy La Belle, Altadena, California. Printed on laid paper, 36 × 26.9 cm. Acquired from Ruthven Todd by Sir Geoffrey Keynes (see impression 2B), who listed it in his *Bibliotheca Bibliographici*, no. 577v. Sold by Keynes at Sotheby's Belgravia, 3 February 1976, lot 5 (£12 to Andrew Edmunds for Robert N. Essick). Given by Essick to La Belle in November 1980. Listed in Bindman, *Blake: Catalogue of the Collection in the Fitzwilliam Museum*, no. 577v, as part of Keynes' bequest to the Museum (which is no longer the case). Reproduced in Essick, *William Blake, Printmaker*, fig. 203.

5Q.

Pierpont Morgan Library, New York. Printed on laid paper trimmed inside the plate mark to 22.6 × 14.3 cm and mounted in a window cut in a sheet of machine-made paper. Formerly bound as leaf 125 in an extra-illustrated copy of Allan Cunningham's "Blake," 1830. For provenance, see "Joseph of Arimathea Among the Rocks of Albion," impression 2G.

Part Two.
Plates by Blake after Designs
by Others

1.
Offered for sale by Edward Evans, London, *Catalogue of a Collection of Engraved Portraits*, 1835, item 6663, "proof" (i.e., fourth state?), for 2s. 6d.

2.
Sold from the collection of William Bell Scott, Sotheby's, 21 April 1885, lot 168, with sixteen other prints (14s. to Edward Daniell).

3.
Lent by Edward W. Hooper to the Boston Museum of Fine Arts in 1891, no. 141 in the exhibition catalogue. The title and signatures are quoted from the impression, and thus this must have been a fourth or fifth state.

4.
Acquired *c.* 1890-1905 by William A. White. Listed on a typescript of the White collection, written for Rosenbach, *c.* 1929, and now in the Rosenbach Library, Philadelphia, where the print is given an evaluation or price of $10. Acquired by Miss Caroline Newton (or earlier by her father A. E. Newton) and lent by her to Princeton University in 1968, described in the exhibition notes as a "proof copy of the fourth state" (fourth state as listed here) formerly in White's collection.

5.
Lent by Miss A. M. Butterworth to the Manchester Whitworth Institute in 1914, no. 95 in the exhibition catalogue, where it is described as a "proof" (i.e., fourth state?).

6.
Sold from the stock of Robson & Co. at Puttick & Simpson, 2 July 1937, lot 624, with other prints, some described as from Thomas Butts' collection (no price or purchaser information available).

7-9.
Keynes, *Engravings by Blake: The Separate Plates*, p. 86, records three impressions then (1956) in the collection of Ruthven Todd in addition to the traced impressions, formerly in Todd's collection, listed above. These three, now all untraced, are described by Keynes as his first, second, and third (second and third as enumerated here) states. The "first" state impression may be the same as impression 1A or 2C, and one of the others may be impression 4M.

10.
According to their records, the Achenbach Foundation for the Graphic Arts, M. H. de Young Memorial Museum, San Francisco, owns an impression in the fourth or fifth state. The Foundation staff has not been able to locate the print; it is possible that it was removed from

the collection before coming under the management of the de Young Museum.

11.
Offered at auction from "the Property of a Lady" (probably a descendant of Linnell), Sotheby's, 19 June 1981, lot 410, fourth state, "on laid India, with margins, some foxing and water-staining in border and margins, just affecting inscription at right," reproduced (not sold).

"Wilson Lowry" was executed in line, crosshatching, flick work, and a considerable amount of burnishing to create highlights on the face. The extent of Blake's work on the plate, as distinct from Linnell's, is difficult to determine. By this time in Blake's career, he had absorbed much of Linnell's graphic style, including subtle flick work, burnishing as an element of composition, and the very limited use of etching or even its complete exclusion.[1] The two hands that worked on the plate are expertly coordinated; there is no hint that the plate was produced by two men of different training and sensibility. The £20 fee Blake received for his work from Linnell, as well as the appearance of his name on the plate as the co-engraver, indicate that he did somewhat more than simply "laying in" the basic image. Linnell records in his general account books that he paid Blake £5 "on account of the portrait of Mr Lowry" on 18 August 1824, made two payments of £5 each on 10 November and 25 December, and a final payment of £5 on 28 January 1825.[2] I suspect, however, that the first state of the plate recorded here has been touched by Linnell's graver and burnisher.

The two types of paper found in most impressions of the fourth and fifth states appear to correspond to three distinct press runs. After the working proofs of the first three states were pulled (impressions 1A-3E), the plate in the fourth state was first printed on laid paper with chain lines approximately 3.4 cm apart (impressions 4F, 4I, 4J, 4M). In these impressions, plus one (4L) on laid paper with chain lines approximately 3.9 cm apart, the *Proof* inscription is clearly printed. Next came impressions on laid India (4G, 4H, 4K, 4N) with *Proof* very faint, and, last, the fifth-state pulls (5O-5Q) on the same (or at least very similar) laid paper used for the fourth state. An alternative sequence might have occurred if *Proof* was simply filled with putty or varnish rather than burnished out. The filling material could have worn down or worked out of the incisions in non-proof impressions on laid paper, leaving a ghost of the letters to reappear in India paper impressions. This seems to have been the case with Blake's *Job* plates, in which the *Proof* inscriptions do not appear in the non-proof impressions of 1826 but re-emerge in some India paper impressions of 1874. Such examples at least caution one against assuming that the presence of a *Proof* inscription offers indisputable evidence of a state of the plate and a press run prior to impressions without that inscription.

Wilson Lowry (1762 to 23 June 1824) was an engraver who specialized in architectural and mechanical illustrations. He invented several instruments for the precise graphic rendering of such subjects and

[1] These stylistic characteristics are most clearly exemplified by "Revd Robert Hawker" of 1820 and, in a more personal and less directly imitative way, by the *Job* engravings of 1823-1825.

[2] See Bentley, *Blake Records*, pp. 587-588. The final payment is given as £10 in Linnell's general account books, but the *Job* accounts (*Blake Records*, p. 604) make it clear that only half of this amount was for "Wilson Lowry."

207

experimented with etching on steel. He executed many plates for Abraham Rees, *The Cyclopaedia*, 1820. Blake executed seven plates for this work, including pl. XVIII of "Miscellany. Gem Engraving" dated 1819 in the imprint and signed by Blake and Lowry as the co-engravers. Thus, the two men must have been known to each other prior to the execution of the posthumous portrait plate. Hurst, a partner in the firm that published the portrait, was also a member of the consortium that published Rees' *Cyclopaedia*.

Linnell's original brown wash and ink portrait of Lowry, 15.5 × 10.7 cm, is now in the collection of McGill University, Montreal (Fig. 87). This is probably the drawing sold by the Linnell Trustees at Christie's, 15 March 1918, lot 87, in an album of seventeen portrait sketches (£7 to Robson & Co. by 1920).

Gilchrist, *Life of Blake* (1863), I, 332, states that "Blake had, among other work, assisted, from August to December, 1824, in engraving a portrait from his friend Linnell's hand, of Mr. Lowry, and perhaps in some other plates." It is not known what "other plates" Blake may have worked on as an assistant to Linnell other than the Upton portrait some five years earlier. "Portrait of Wilson Lowry" is also included in W. M. Rossetti's list of "Works Engraved but not Designed by Blake" in Gilchrist's *Life* (1863), II, 261.

Part Three. *Plates by Blake and Thomas Butts,*
 Father and Son

Early in 1806, Blake began to teach engraving and drawing to Thomas Butts (1788-1862), the son of his patron of the same name (1757-1845). This relationship is noted in the accounting of prior dealings with the senior Butts that Blake drew up on 3 March 1806: "Decʳ 25. 1805. On Account of teaching your Son at 25 Guineas per Annum to Commence on this Day £26.5s."[1] By "this day" Blake apparently meant 3 March 1806, for exactly one year later Blake noted his receipt of £28 6s. from Butts of which £26 5s. was for "Tom"—meaning no doubt the lessons for young Butts. The next payment was made six weeks early, on 14 January 1808. There are no further payments of £26 5s. recorded in the extant receipts, although instruction might have continued for a few more years.

According to Ada E. Briggs, who apparently had access to designs and records belonging to the Butts family, "the father seems to have profited far more by the lessons than the son did, and though it is difficult, when father and son both have the same name, to be sure in every case, the drawings and engravings [c, d, and g below, plus "Lear and Cordelia"] reproduced here are all believed to be by the father."[2] Mona Wilson also writes that "there is a [Butts] family tradition that the father profited more than the son from these lessons."[3] Under these circumstances it is impossible to disentangle the father's work from the son's. Fortunately this quandary is of little consequence; the important issue is to determine the extent of Blake's involvement in the Butts family's graphic activities.

One can reasonably expect that a drawing and engraving instructor would participate directly in a new pupil's early efforts. Services such as preparing designs for the pupil, "laying in" outlines, cutting a few demonstration strokes with the graver, and correcting mistakes must have been a normal part of instruction. Thus, all of the Butts plates *may* have received attention from Blake's own hand, however slight. Briefly described below are the extant Butts plates for which there is no further evidence for Blake's direct involvement other than the reasonable expectations set forth above.

a.

Bust and large wings of an angel looking to the left. Plate mark 8 × 11.1 cm. Three impressions in the collection of Sir Geoffrey Keynes;[4] one impression (inscribed "proof" and "7" in pencil) in the collection of G. E. Bentley, Jr.

b.

Centaur in a landscape with a Lapith on his back. Plate mark 8.3 × 12.2 cm. Two impressions and the sepia drawing (7.9 × 13.8 cm) for the plate, reversed, are in Keynes' collection.

c.

Classical figure seated on a pedestal and holding a lyre. Plate mark 9.2 × 7.9 cm. An impression in Keynes' collection is inscribed in pencil, "T Butts | proof." A later state, inscribed *T Butts sc.* (apparently in the plate), is reproduced in *The Connoisseur*, 19 (September-December 1907), 94.

[1] For this and other receipts quoted here, see Bentley, *Blake Records*, pp. 574-576.

[2] "Mr. Butts, the Friend and Patron of Blake," *The Connoisseur: An Illustrated Magazine for Collectors*, 19 (September-December 1907), 92-96. Briggs, sister-in-law to the grandson of Blake's patron, also states that "the plates [for the prints reproduced] are still in existence." I have been able to trace only the plate for the "Head of a Saint" (Rosenwald Collection, National Gallery of Art, Washington).

[3] *The Life of William Blake*, ed. Geoffrey Keynes, London: Oxford University Press, 1971, p. 95. In a footnote, Wilson attributes this information to Mrs. Colville-Hyde, the widow of Captain Frederick Butts, the grandson of Blake's patron.

[4] For the provenance of all impressions listed in this group in Keynes' collection, see "Lear and Cordelia," impression 3C. They are listed in Keynes, *Bibliotheca Bibliographici*, nos. 778-783. For a list of Butts prints, drawings, and a needlework panel, see Bentley, *Blake Records*, pp. 175-176.

Part Three.
Plates by Blake and Butts,
Father and Son

d.

Head of a Saint. Plate mark 8 × 5.7 cm. Inscribed in the plate lower left, *T. Butts | sc.* Two early impressions in the Keynes collection; recent restrike on thick wove paper, 16.4 × 12.6 cm, in the National Gallery of Art, Rosenwald Collection, Washington, D.C. The engraving is on the verso of the copperplate fragment of rejected pl. a of Blake's *America* (1793), also in the National Gallery of Art.[5] Blake evidently cut up the *America* copperplate, 22 × 15.7 cm, and gave at least this one piece to his student for his own use. The subject is identified as St. Jerome in Keynes, *Bibliotheca Bibliographici*, p. 87, and as St. John the Baptist by Ruth Fine Lehrer in *Blake Newsletter*, 9 (Winter 1975-1976), 79. This plate is more skillfully executed than the others listed here. Reproduced in *The Connoisseur*, 19 (September-December 1907), 96.

e.

Satyr with a dancing figure. Circle, 1.6 cm diameter. Impression, inscribed in pencil "from Mr. Butts," in Keynes collection.

f.

A lion attacking a falling horse. Circle, 11.5 cm diameter. Impression acquired late 1980 by the Pierpont Morgan Library, New York, inscribed on mounting sheet in pencil "W. B." (lower right) and "from the Butts' Collection."

g.

"Venus Anadyomene." A nude woman on the seashore holds a strand of her long hair in her left hand and touches the top of her head with the right hand. No impression traced; reproduced in *The Connoisseur*, 19 (September-December 1907), 96. Inscribed *Venus Anadyomene Inv. et pinx | T Butts 1807*.[6] This illustration and the inscription suggest that the work is a drawing, not a print. However, Bentley, *Blake Records*, p. 176, lists it as one of Butts' "engravings" and suggests that the design was "copied from Blake's design for [Edward Young's] *Night Thoughts*, p. 46." There is a pen drawing by Butts in Keynes' collection of details from the *Night Thoughts* illustrations, but if this design is based on p. 46 it is a loose adaptation only. The torso is similar, but the arms, legs, and hair are very different. A pencil, pen and ink, and wash drawing of the same figure, on a sheet 11.5 × 7.6 cm, is now in the collection of McGill University, Montreal. This drawing contains strands of hair right of the figure's waist and two shells on the beach not in the design reproduced in *The Connoisseur*. The McGill drawing has some delicacy and charm, but the studied quality of the lines and the amateurish handling of the washes is unlike Blake's work of *c.* 1807. It is very probably by Butts, father or son, as the inscription on the design reproduced in *The Connoisseur* indicates.

There is little justification for including any of these six (perhaps seven) plates among Blake's graphic works. They belong to a sub-group of "works by Blake's students," with all that implies about the

[5] For provenance, see Bentley, *Blake Books*, p. 106. Bentley, *Blake Records*, p. 176 n.1, states incorrectly that the verso design is signed "Drawn and engraved by WB" (unless he means a pencil or ink inscription on an impression unknown to me).

[6] The *Connoisseur* illustration is in turn reproduced, without the inscription, in Bentley, *Blake Records*, facing p. 57 (set within the text panel of Blake's engraved illustration for Edward Young's *Night Thoughts*, p. 46).

212

Part Three.
Plates by Blake and Butts,
Father and Son

possibility that Blake may have participated in their production. Four further plates by Butts deserve more detailed consideration and inclusion in a catalogue covering plates executed jointly by Blake and another artist, as is the case with the "James Upton" and "Wilson Lowry" portraits described in Part Two. At least two of these Butts separate plates, "Christ Trampling on Satan" and "Lear and Cordelia," are clearly based on designs by Blake. The remainder of Part Three of this catalogue is devoted to these four works.

213

XLIV.
Christ Trampling
on Satan

(Thomas Butts after Blake)

FIGURES 89-90

One state: c. 1806-1808

Inscription: Perhaps a small *T* scratched into the plate .3 cm below the image and 1.4 cm to the left of its lower right corner (printed only in impression 1H).

Image: 24 × 13.6 cm

Plate mark: 31.5 × 16.4 cm

IMPRESSIONS

1A.
G. E. Bentley, Jr., Toronto. Printed on laid paper, 33.8 × 21.6 cm, with a blue-green tint. Ragged, perhaps deckled, right edge. Illegible watermark in center of sheet consisting of two lines of closely spaced capital letters. Oil stain in image, upper right; rust stain lower part of image. Purchased by Bentley in November 1965 from the New York book and print dealer E. Weyhe, Inc. ($25).

1B.
Birmingham Museum and Art Gallery. Printed on wove paper, 46 × 29 cm, watermarked "F J Head & Co." Inscribed in pencil on the verso, " 'Christ trampling down Satan' an impression from an unfinished Copper-plate, engraved by William Blake, in the collection of Edward J. Shaw, Walsall." Presented to the Museum in 1923 by E. J. Shaw. Not seen; information supplied by Stephen G. Wildman of the Birmingham Museum.

1C.
Birmingham Museum and Art Gallery. Same paper, sheet size, watermark, pencil inscription, and provenance as impression 1B.

1D.
R. John Blackley, New York. Printed on laid paper with a slight blue-green tint, 33.7 × 21.6 cm. Ragged right edge. A watermark, apparently a design about 7 × 5 cm, is in the middle of the sheet and thus is obscured by the image. The top of the watermark is crown-like. Purchased by Blackley, *c.* 1965, from E. Weyhe, Inc., and lent by him in 1977 to Adelphi University, no. 26 in the exhibition catalogue.

1E.
Boston Museum of Fine Arts. Printed on laid paper with a blue-green tint, 33.3 × 21 (top), 21.5 (bottom) cm. Watermark in center of sheet: Fao. Bequeathed to the Museum in June 1961 by W. G. Russell Allen.

1F.
British Museum. Printed on (wove?) paper, 39.3 × 27.2 cm, pasted to the mat. Presented to the Museum by Edward J. Shaw of Walsall in December 1903. Russell, *Engravings of Blake*, p. 118, states that this impression was printed by Shaw. Reproduced in Bindman, *Complete Graphic Works of Blake*, fig. 411.

1G.

Denison University, Granville, Ohio. Printed on laid paper, 33.7 × 21.6 cm, with a slight blue-green tint. Illegible watermark as in impression 1A. Given to the University in 1945 by Mr. and Mrs. Max Adler. Mr. Adler was a business associate of the great Blake collector Lessing J. Rosenwald; Mrs. Adler (née Sophie Rosenwald) was his aunt. Not seen; information kindly supplied by Dennis Read of Denison University.

1H.

Robert N. Essick, Altadena, California. Printed on laid paper, 33.7 × 21.5 cm, with a slight blue-green tint. Illegible watermark as in impression 1A. Tear in right margin outside plate mark. Inscribed in pencil, lower left, "P 2266 | Blake Christ Trampling on Satan." Sold Christie's, 14 October 1975, lot 258 (£189 to Edmunds for Essick). Reproduced here, Fig. 89.

1I.

Robert N. Essick, Altadena, California. Printed on wove paper, 44.5 × 30.6 cm. Sold anonymously at Christie's, 6 February 1979, lot 15 (£15 to Morris Ayres). Acquired by Essick from Ayres Bookshop, London, in June 1981 for £55.

1J.

Donald A. Heald, London. Printed on wove paper, 44.3 × 30.5 cm. Acquired in recent years from a private collector. Part of Heald's stock as a dealer in July 1981; perhaps now sold.

1K.

Sir Geoffrey Keynes, Suffolk. Printed on laid paper, 46.2 × 28.5 cm, with a large emblematic watermark obscured by the image. Inscribed in pencil in the lower margin, " 'Christ trampling down Satan.'—an impression from an unfinished Copper-plate by William Blake—in the possession of E. J. Shaw." Given to Keynes by Shaw on 31 May 1913, according to a pencil note on the verso.[1] Listed in Keynes, *Bibliotheca Bibliographici*, no. 558; Bindman, *Blake: Catalogue of the Collection in the Fitzwilliam Museum*, no. 558, as part of Keynes' bequest to the Museum. Reproduced in Keynes, *Engravings by Blake: The Separate Plates*, pl. 20.

1L.

University of Leeds, Brotherton Library, Leeds, England. Printed on an irregular sheet of laid paper, 33.7 × 21.5 cm, with a slight blue-green tint. Illegible watermark as in impression 1A. Acquired by Ruthven Todd at an unknown time and bequeathed by him to the University in 1979. Not seen; information kindly supplied by P. S. Morrish of the Brotherton Library.

1M.

Nelson Gallery of Art—Atkins Museum of Fine Arts, Kansas City, Missouri. Printed on laid paper, 33.6 × 21.8 cm, with a blue-green

[1] Keynes, in his *Engravings by Blake: The Separate Plates*, p. 34, writes that this impression was given to him "about 1921." I cannot account for the discrepancy between this published statement and Keynes' own note on the verso of the print.

tint. Illegible watermark as in impression 1A. Spot of foxing, upper right. Acquired by the Nelson Gallery from E. Weyhe, Inc., in 1932. Lent in 1971 to Illinois State University, Normal, Illinois, and University of Kansas Museum of Art, Lawrence, Kansas, no. 9 in the exhibition catalogue.

1N.
University of North Carolina, Ackland Art Museum, Chapel Hill, North Carolina. Printed on cream-colored wove paper, 44.7 × 30.6 cm. Sold Christie's, 25 May 1977, lot 307 (£65 to The Lakeside Studio). Purchased by the Museum in 1977 from Lakeside. Not seen; information supplied by Katharine Lee Keefe of the Ackland Art Museum.

1O.
Charles Ryskamp, Princeton, New Jersey. Printed on laid paper, 33.5 × 21.5 cm, with a blue-green tint. Fragments of an unidentifiable crown watermark or countermark. Deckled left edge. Acquired by Ryskamp in recent years from E. Weyhe, Inc. Lent by Ryskamp to Princeton University in 1969, no. 64 in the exhibition catalogue, described as an impression taken by E. J. Shaw after 1903; and to the Grolier Club, New York, in 1974.

1P.
Trinity College, Watkinson Library, Hartford, Connecticut. Printed on laid paper, 33.7 × 21.8 cm, with a slight blue-green tint. Illegible watermark as in impression 1A. Ragged right edge; light brown spot left of the lower figure's left arm. Watkinson Library collection stamp on verso. Probably the impression offered by E. Weyhe, Inc., December 1938 catalogue, item 129 ($10). Acquired by Alan R. Brown and lent by him to the Philadelphia Museum of Art in 1939, no. 231 in the exhibition catalogue. Given by Brown to the Watkinson Library in 1939. A clipping from the Weyhe catalogue is among the Brown papers in the Library.

1Q.
Victoria and Albert Museum, London. Darkly printed on (wove?) paper pasted to the mat with the upper mat also pasted down. Inscribed in pencil below the image, "Engraved by William Blake." Acquired by the Museum in 1928 from W. W. Winkworth (£10).

1R.
Whitworth Art Gallery, Manchester. Printed on wove paper, 44.2 × 30.6 cm. Presented to the Gallery by Edward J. Shaw in 1925.

UNTRACED IMPRESSIONS

1.
Offered at Sotheby's, 19 June 1934, lot 275, with pp. 85-88 from Edward Young's *Night Thoughts* illustrated by Blake (not sold).

2.
Sold from the collection of Rev. E. G. Burr, Sotheby's, 31 July 1945, lot 78, "proof No. 2 from an unfinished plate" (£2 5s. to McDonald).

3.
Todd, *Blake the Artist* (1971), p. 73, reproduces an impression credited to the "University of Glasgow" in the caption. Neither the Hunterian Art Gallery nor the Library at the University of Glasgow has any record of such a print.

4.
Acquired *c.* 1975 from a private collector by Christopher Mendez, the London print dealer, and sold by him, *c.* 1977, to a Japanese art dealer.

5.
Sold Christie's, 27 July 1976, lot 232 (£100).

6.
Sold Christie's, 26 October 1976, lot 237, described as an impression on Whatman paper from the E. J. Shaw collection, inscribed on the recto "Engraved by William Blake" and on the verso "Christ trampling down Satan," reproduced (£110).

7.
Sold Sotheby's, New York, 10 November 1976, lot 6, on blue-green tinted laid paper ($120 to David Tunick, who sold the print back to Sotheby's in March 1977, which in turn sold the print to a private collector).

8.
Sold Christie's, 15 February 1977, lot 349, printed in sepia (£80).

9.
Sold Christie's, 29 June 1977, lot 141 (£90).

10.
Sold Christie's, 26 July 1977, lot 328, on thick, wove paper (£45).

11.
Sold Christie's, 18 April 1978, lot 130, wove paper (£50).

12.
Sold Christie's, New York, 5 May 1978, lot 181, on thick wove paper, slight staining ($154).

13.
Sold Christie's, 6 December 1978, lot 158, on wove paper (£45).

14.
Offered by William Weston Gallery, London, in their July 1980 list of *One Hundred Prints at Prices Under £200*, no. 109, "on heavy

Part Three.
Plates by Blake and Butts,
Father and Son

cream wove paper with 2½ inch to 2 3/4 inch margins" (£200). Perhaps the same as one of the untraced impressions sold at London auctions in recent years.

"Christ Trampling on Satan" is based closely on Blake's pen and sepia wash over pencil drawing, 23.9 × 13.2 cm, now in the National Museum of Wales, Cardiff (Fig. 90). Blake apparently lent or gave this drawing to Butts, who executed the plate, perhaps with Blake's assistance. The vast majority of the etched and engraved lines in the print suggest the hand of an amateur, but it is possible that Blake helped to "lay in" the basic outlines that carefully follow his drawing.

The original copperplate of "Christ Trampling on Satan" was sold by Captain Frederick Butts, the grandson of Blake's patron, at Sotheby's, 24 June 1903, lot 20, with an impression (perhaps 1F or 1K?) from the plate (£5 to Tregaskis). The fact that the copperplate had been, apparently for many years, in the possession of the Butts family provides convincing evidence that "Christ trampling" is indeed one of the plates executed by Thomas Butts, father and son. The copperplate was acquired shortly after the June 1903 auction by Edward J. Shaw of Walsall. He apparently printed a number of impressions and began giving them to public collections and friends as early as December 1903 (see impressions 1B, 1C, 1F, 1K, 1R). Indeed, there is no record of the plate prior to the 1903 auction and no extant impression can be traced back prior to that year. Other than the single impression sold with the copperplate, all may have been printed in 1903 or later. The copperplate was sold by Shaw at Sotheby's, 29 July 1925, lot 158, with an impression and a letter from W. M. Rossetti of 23 December 1903 relating to the print (£10 10s. to Mansfield). The New York dealer E. Weyhe appears to have acquired a number of impressions (see provenances of 1A, 1D, 1M, 1O, 1P) and perhaps the copperplate as well.[2] The firm had multiple impressions available as late as 1965;[3] but the present proprietor and daughter of Weyhe, Mrs. Seth Dennis, tells me that she has no knowledge of the copperplate or impressions from it. The unusually large number of impressions that came on the auction market from 1976 to early 1979 suggests that there is a cache of prints slowly being sold off by its owner. My attempts to trace these impressions back to their source or sources have been unsuccessful.

The varieties of paper on which the plate has been printed can be divided into at least two groups, although these do not necessarily correspond to distinct press runs. Seven traced impressions (1A, 1G, 1H, 1L, 1M, 1O, 1P) are on sheets of laid paper, all cut to about 33.6 × 21.6 cm, with a blue-green tint that varies a bit from one impression to another and chain lines about 2.6 cm apart. Six of these examples (1A, 1G, 1H, 1L, 1M, 1P) show a watermark of two lines of letters in the middle of the sheet. I have been unable to read this watermark, even with the aid of several beta-radiographs taken from impression 1H.[4] Impressions 1D (with an emblematic watermark and chain lines 2.6 cm apart), 1E (Fᴀᴏ watermark and chain lines 2.9 cm apart), 1O (with a crown watermark or countermark), and untraced impression

[2] Keynes, *Engravings by Blake: The Separate Plates*, p. 35, states that the copperplate "is now [1956] in America." Sir Geoffrey has no further information about the plate.

[3] According to G. E. Bentley, Jr., who acquired impression 1A in that year. Mr. R. John Blackley, owner of impression 1D, tells me he believes one of Weyhe's employees told him, *c.* 1965, that the copperplate was in Weyhe's possession.

[4] These were expertly made by Robert Schlosser of the Huntington Library, San Marino, California.

218

7 would also seem to belong to this group because of the blue-green tint and sheet size. All these impressions can either be traced to Weyhe or may have been in that dealer's stock.

The second paper type is represented by impressions 1B, 1C, 1I, 1J, 1N, and 1R, all on untinted, rather thick, wove paper ranging between 46 × 29 cm and 44.5 × 30.6 cm. Impressions 1F (probably one of the first presented by Shaw), 1K (on untinted laid paper, about the same size as the large wove sheets), 1Q, and untraced impressions 6 and 10-14 (all on untinted wove paper) may also belong to this group.

The title "Christ trampling down Satan" was first given to the composition by W. M. Rossetti in his catalogue of Blake's drawings and paintings in Gilchrist, *Life of Blake* (1863), II, 248. This identification is repeated in the 1903 Sotheby's auction catalogue and by Russell in *Engravings of Blake*, p. 118, where the print is incorrectly dated 1827 and said to be based on the description of Christ with a bow in Milton's *Paradise Lost*, bk. VI, line 763. Binyon, *Engraved Designs of Blake*, pp. 78-79, doubts the reference to Milton, because Satan is not present in the passage cited by Russell, and titles the print "Jesus Trampling upon Urizen." This identification of the lower figure as the tyrant of reason in Blake's mythological poems, overcome in the print by the Divine Imagination, is continued in Keynes, *Engravings by Blake: The Separate Plates*, pp. 34-35. Bindman, *Complete Graphic Works of Blake*, p. 480, titles the plate "Christ or Michael trampling upon Satan."

The identification of the figure with a bow as Christ is fairly certain; the figure closely resembles the portrayal of Christ in some of the *Night Thoughts* illustrations of 1795-1797, the *Grave* illustrations of 1805 (published 1808), and the watercolor illustrations to *Paradise Lost* of 1807 and the larger series of 1808 commissioned by Butts. Blake generally pictured Satan as a youth; a much closer parallel, in both visage and posture, to the old man in the print is the figure of Death in "Michael Foretells the Crucifixion" among the *Paradise Lost* illustrations. Another possibility is that the bearded ancient is the natural man or "old Adam," the embodiment of original sin here overthrown by the new dispensation of Christ. If the drawing (Fig. 90) was executed specifically for Butts,[5] who purchased so many of Blake's biblical paintings, it seems more likely that this design is based on a traditional religious theme than on Blake's private mythology. Yet an initial, conventional subject does not exclude a further level of Blakean symbolism; as he wrote in *Milton* (c. 1804-1808), "Los & Enitharmon knew that Satan is Urizen."[6] Whether the lower figure in the print is Satan, Death, old Adam, Urizen, or a combination of all four, its meaning within the context of Blake's thought is much the same: The triumph of Christ over evil, which is for Blake the triumph of the Divine Imagination over the tyranny of fallen reason and nature.

[5] The handling of washes in the drawing suggests that it could have been executed some years before the engraving, c. 1796-1800.

[6] Erdman, ed., *Poetry and Prose of Blake*, p. 103.

XLV.
Lear and Cordelia

(Thomas Butts after Blake)

FIGURES 91-95

First state: c. 1806-1808

Inscriptions: none in the plate

Oval image: 7.4 × 9.7 cm

Plate mark: 8 × 11.2 cm

IMPRESSIONS

1A.

National Gallery of Art, Rosenwald Collection, Washington, D.C. Printed on wove paper, 11.3 × 15 cm, with the Lessing J. Rosenwald and National Gallery of Art collection stamps on the verso. Inscribed below the image in pencil, "Drawn and engraved by W. B. | from T. Butts' collection 1st proof." The initials were written with a sharper, perhaps harder, pencil than the remainder of the inscription and may be by a different hand. Perhaps one of the prints sold anonymously (but probably from the property of the Butts family) at Sotheby's, 22 March 1910, lot 447, "a number of Engravings and Drawings, by William Blake and some by T. Butts, his patron, including a tinted study by the former for the Angel on the title-page of Blair's Grave, a small water-colour drawing of a nude woman[1] and several proofs from the copper-plates sold in the last lot"[2] (£19 10s. to Robson). Acquired, with impressions, 2B, 3D, 4F, and 4G, by William A. White and lent by him (anonymously) in 1919 to the Grolier Club, New York, no. 36 in the exhibition catalogue; and to the Fogg Art Museum in 1924 (all five impressions). Included, *c.* 1929, by Rosenbach in a typescript list (now in the Rosenbach Library, Philadelphia) of the White collection, where the five impressions are given a value or price of $50. According to provenance records in the Rosenwald collection, the five impressions were given to Rosenwald by Rosenbach in July 1927. Given by Rosenwald to the National Gallery of Art in 1945 and moved from the Alverthorpe Gallery, Jenkintown, Pennsylvania, to Washington in 1980. Reproduced here, Fig. 91.

Second state: *c.* 1806-1808

A considerable amount of hatching has been added to all areas of the image and the features of the two figures, particularly the eyes, now defined in more detail. No inscriptions in the plate; dimensions same as in the first state.

IMPRESSIONS

2B.

National Gallery of Art, Rosenwald Collection, Washington, D.C. Printed on wove paper, 10.9 × 15.1 cm, with the National Gallery of Art and Lessing J. Rosenwald collection stamps on the verso. Inscribed in pencil below the plate mark, lower right, "2nd proof." For provenance and exhibition, see impression 1A. Reproduced here, Fig. 92.

[1] See item g in the Introduction to this part of the catalogue.

[2] See the discussion of the copperplate below.

220

Third state: *c.* 1806-1808

Further hatching and crosshatching patterns have been added to both figures, including work with the stipple burin on the woman's left cheek. No inscriptions in the plate; dimensions same as in the first state.

IMPRESSIONS

3C.

Sir Geoffrey Keynes, Suffolk. Printed on wove paper, 9.8 × 13.9 cm, watermarked BUTTAN[SHAW][3] upper right. Partially erased pencil inscription beneath plate mark: "proof . . . [illegible] W. B." Pasted to the sixth leaf of an album in gray paper boards measuring 22.7 × 29.5 cm and labeled on the front cover "[Wm. Blake *del*] Thomas Butts jr.—Proofs & Drawings from—Butts Collection." According to Keynes, *Bibliotheca Bibliographici*, p. 86 (where this impression is listed as no. 777i), this album "was obtained from the Butts family by the late Joseph Horne and was bought at his sale about 1954 by Mr. E. Guntrip of Maidstone, who sold it to me [Keynes] in 1961."

3D.

National Gallery of Art, Rosenwald Collection, Washington, D.C. Printed on wove paper, 11.2 × 15 cm, with the National Gallery of Art and Lessing J. Rosenwald collection stamps on the verso. Inscribed in pencil below the plate mark, lower right, "3rd proof." For provenance and exhibition, see impression 1A. Reproduced here, Fig. 93.

Fourth State: *c.* 1806-1808

Further lines have been added to the man's beard and right cheek and to the woman's hair and mantle. Crosshatching has been added to the man's left sleeve and upper arm, and flick work added to the man's brow and the woman's left cheek. No inscriptions in the plate; dimensions same as in the first state.

IMPRESSIONS

4E.

Sir Geoffrey Keynes, Suffolk. Printed on wove paper, 11.3 × 12.4 cm, inscribed "proof" in pencil. Pasted onto the eighth leaf of an album also containing impression 3C, which see for provenance. Listed in Keynes, *Bibliotheca Bibliographici*, no. 777ii. Perhaps the impression reproduced in *The Connoisseur*, 19 (September-December 1907), 94.

4F.

National Gallery of Art, Rosenwald Collection, Washington, D.C. Printed on wove paper, 11.8 × 14.8 cm, with the National Gallery of Art and Lessing J. Rosenwald collection stamps on the verso. Inscribed in pencil below the plate mark lower right, "4.th proof." Rubbed-

[3] A BUTTENSHAW watermark dated 18—appears in Blake's letter of 19 October 1801 to John Flaxman; with the date 180— in *Songs of Innocence*, copy O; and with the date of 1802 in *Songs of Innocence and of Experience*, copies P and Q. See Bentley, *Blake Books*, pp. 71, 366, 368.

out letters of a type-printed text on the verso, lower right, embossed through on the recto. Fragments of a type-printed word on the recto, lower left, only "re." legible. The size, position, and character of these text fragments indicate that the paper is a sheet from William Hayley, *Designs to a Series of Ballads*, 1802 (see also impression 4G).[4] Specifically, the sheet is from the first and fourth leaves in the F gathering in "Ballad the Third" in this quarto book. The "re." fragment of text is from the end of the first quatrain on the verso of the fourth leaf in the F gathering (p. 34 in the continuous pagination), the verso fragments from the end of the second and fourth lines in the first quatrain on the verso of the first leaf (p. 28). For provenance and exhibition, see impression 1A. Reproduced, with impressions 1A, 2B, 3D, and 4G, in *Blake Newsletter*, 9 (Winter 1975-1976), 81; and in Bindman, *Complete Graphic Works of Blake*, fig. 412b (with impression 1A, fig. 412a).

4G.

National Gallery of Art, Rosenwald Collection, Washington, D.C. Printed on wove paper, 11.7 × 14.3 cm, with the National Gallery of Art and Lessing J. Rosenwald collection stamps on the verso. Inscribed in pencil below the image, "proof Drawn and engraved by WB | From Mr Butts' collection." Fragments of an almost completely rubbed-out, type-printed text on recto and verso, only a large "L" (at the end of a line of text) and "I" legible. These letters suggest that the paper is a sheet from Hayley's 1802 *Ballads* (see impression 4F), although the "I" is (at almost 1 cm high) larger than any letters appearing in the published book. Therefore, the printed text must represent an unpublished proof setting of the *Ballads* or some entirely different work. This impression has sometimes been taken for a later state than impression 4F, but the slight differences in tone can be accounted for by variations in inking and printing. For provenance and exhibition, see impression 1A. Reproduced here, Fig. 94.

"Lear and Cordelia" is based closely on Blake's pen and watercolor drawing, 7.4 × 9.5 cm, now in the Boston Museum of Fine Arts (Fig. 95). It is one of seven small oval illustrations of scenes from Shakespeare's plays. They are all in Blake's early style of *c.* 1780-1785, but were acquired by Butts at a later date and sold from his family's collection in 1853. Two other drawings in this group are based on *King Lear*: "Lear Grasping His Sword" and "Cordelia with the Sleeping Lear." The figures in these are generally similar to the man and woman in this drawing, but it is not absolutely certain that they are Lear and Cordelia. The subject might be Prospero and Miranda in *The Tempest*. The bearded man and his gesture in the drawing and print are similar to the figure, far right (left in the plate), in "Job," the earliest drawing for which (Fig. 9) was probably executed in the same period as the Shakespeare ovals.

There is nothing in the execution of the plate, with the image the reverse of the drawing, that one can attribute to Blake with any confidence. The inscriptions in pencil on impressions 1A and 4G making

[4] Blake frequently used unbound sheets from this book as drawing paper—see, for example, fig. 46 and the list of *Ballads* sheets with sketches in Bentley, *Blake Books*, pp. 574-575.

such an attribution are problematic. With the possible exception of the initials on impression 1A, all the pencil inscriptions seem to be in the same nineteenth-century hand. It is unlikely that they are by the elder Butts—note the reference to "Mr Butts' collection" on impression 4G—and are probably by his son or grandson. If the latter, they have no authority contemporary with the execution of the plate and may be little more than wishful thinking or a sales puff. We can, however, attribute to Blake the printing of the plate with some assurance. Impressions 3C, 4F, and perhaps 4G are on papers particularly identified with Blake's work. He probably pulled the progress proofs of the plate for his patron and student on his own rolling press.

The copperplate of "Lear and Cordelia" may have been one of the plates sold anonymously (but probably from the property of the Butts family) at Sotheby's, 22 March 1910, lot 446, an apothecary's cabinet bearing the crest of the Butts family and containing "copper plates engraved by Blake with others (including two signed by Butts) probably executed by pupils under his direction" (£30 to Tregaskis). These are probably the plates acquired by W. E. Moss and sold with his collection at Sotheby's, 2 March 1937, lot 278, "six original copper plates engraved by Thomas Butts under Blake's tuition" (£1 to Last). I have not been able to trace the copperplates in this group other than the *America* fragment (see item d in the Introduction to this part of the catalogue), sold in the same lot with the cabinet in 1910 but in lot 171 in the 1937 sale.

XLVI.
Two Afflicted Children

(Thomas Butts after Blake?)

FIGURE 96

One state: c. 1806-1808

Inscriptions: none in the plate

Image: approximately 6.5 × 10.3 cm

Plate mark: trimmed off in the only known impression

The only known impression of this curious plate is in the collection of *Sir Geoffrey Keynes*, Suffolk. It is printed on wove paper, 6.8 × 12.3 cm, pasted to a card which in turn is pasted onto the third leaf from the last in an album of drawings and engravings by Butts. Inscribed in pencil "W.B.," lower right, on the card. For provenance of the album, see "Lear and Cordelia," impression 3C. Reproduced here, Fig. 96.

The clear differences between the two heads etched and engraved on the plate suggest that two children are pictured, or perhaps the same child at different stages of a disease. For further discussion, see XLVII, a similar and associated plate showing an afflicted child.

XLVII.
Two Views of
an Afflicted Child

(Thomas Butts after Blake?)

FIGURE 97

One state: c. 1806-1808

Inscriptions: none in the plate

Image: approximately 6 × 10.5 cm

Plate mark: trimmed off in the only known impression

The only known impression of this curious plate is in the collection of *Sir Geoffrey Keynes*, Suffolk. It is printed on wove paper, 6.9 × 12 cm, pasted to a card which in turn is pasted onto the last leaf in an album of drawings and engravings by Butts. Inscribed in pencil "W.B.," lower right on the card. For provenance of the album, see "Lear and Cordelia," impression 3C. Reproduced here, Fig. 97.

The presence of these two very similar plates, XLVI and XLVII, in the Butts album in Keynes' collection indicates that they were very probably executed by Thomas Butts, father or son, while the latter was receiving instruction from Blake. There is nothing in their graphic style to attribute the etching and engraving of the plates to Blake, but the mysterious and unconventional images suggest that they were designed by him. The initials on the mounting cards of both plates are similar to those on "Lear and Cordelia," impression 1A. Their authority is uncertain, but were probably written by a member of the Butts family.

Several features of these four "portraits" on two plates bear striking similarities to the "Visionary Heads" Blake drew for John Varley beginning in 1819.[1] Both the prints and the later drawings have the character of physiognomical portraiture, with its careful articulation, even exaggeration, of facial details.[2] Particularly notable in pl. XLVI (Fig. 96) is the high arch of the eyebrow in the profile and sense of a recessed area beneath. This is a distinguishing feature of many of the "Visionary Heads," such as "The Man Who Built the Pyramids," who also has a left ear similar to the child's in pl. XLVI. The shading around the eyes and on each side of the nose in both plates is also typical of the "Visionary Heads"—see for example "Blake's Instructor." The mouth, nose, and almond eyes of the child in pl. XLVII (Fig. 97) are very close to the features of the young boy, perhaps Prince Arthur, on p. 66 of the *Blake-Varley Sketchbook*, and of "Queen Eleanor."[3] It is improbable that any member of the Butts family would draw, on his own inspiration, designs with such distinctively Blakean characteristics.

Both plates are careful renderings of diseases of the sort one might find in a diagnostic text with illustrations. Blake knew several surgeons, and he engraved plates published in medical books,[4] but I am unable to explain why the Butts family would become involved in such commercial activities. Pl. XLVI (Fig. 96) shows a child on the left suffering from a complex syndrome of disorders. The evident symptoms are typical of Graves' disease, or exophthalmic goiter: "a disorder marked by an enlarged pulsating thyroid gland [note the swollen neck], marked acceleration of the pulse rate, exophthalmos [abnormal protrusion of the eyeball], a tendency to profuse sweats, nervous symptoms, including fine muscular tremors, psychic disturbances, emaciation, and

[1] See Martin Butlin, "Introduction" to *The Blake-Varley Sketchbook of 1819*, London: Heinemann, 1969, I, 1-18.

[2] See "Rev. John Caspar Lavater" (Fig. 66) for Blake's earlier associations with physiognomy. The influence of physiognomy and its sister pseudo-science, phrenology, on the "Visionary Heads" is explored by Anne K. Mellor "Physiognomy, Phrenology, and Blake's Visionary Heads," Essick and Pearce, eds., *Blake in His Time*, pp. 53-74.

[3] These "Visionary Heads" not in the *Sketchbook* are reproduced in Keynes, ed., *Drawings of Blake*, pls. 62, 63, 68.

[4] See the discussion of "Edmund Pitts" (Fig. 77).

Part Three.
*Plates by Blake and Butts,
Father and Son*

increased basal metabolism."[5] The ailment seems in this case to be complicated by lesions on the nose and jaw. The boy on the right, who may be the same child at a different stage of Graves' disease, suffers from blepharoadenoma (tumor of the lower eyelid). The child in pl. XLVII (Fig. 97) appears to have an extreme case of the mumps infecting the entire left side of his face. The odd shape below his ear in the profile view may be an (incompletely pictured?) incision to expose the lymph nodes.

The protruding eye and arched brow of the boy on the left in pl. XLVI are especially notable because they are found in so many of the "Visionary Heads." When drawing them, Blake may have recalled these strange little medical designs and borrowed features from them, transforming the diseased into the visionary eye. However, the attribution of these two plates to Blake as the designer or engraver must remain tentative at best.

[5] Also called Flajani's or Parry's disease; see *The American Illustrated Medical Dictionary*, ed. W. A. Newman Dorland, 22d ed., Philadelphia: W. B. Saunders, 1951.

Part Four. *Plates Designed by Blake*
 but Never Executed

XLVIII.
Los and
His Spectre

FIGURE 98

Pencil drawing on paper

On the sixth plate of his illuminated book *Jerusalem* (*c.* 1804-1820), Blake etched in black-line relief below the text a figure of a man, no doubt Los, at a forge over whom hovers a bat-winged spectre. A pencil drawing (Fig. 98) of this same scene, reversed and somewhat larger and narrower (17.2 × 11.1 cm) than the relief etching, is now in the *National Gallery of Art*, Rosenwald Collection, Washington, D.C. The drawing has been "squared," and the horizontals numbered upside down along the left margin, for subsequent etching or engraving in a size larger or smaller than the drawing. This is the only extant drawing of one of Blake's relief or white-line etchings that has been squared. The direct composition on copper permitted by relief etching, and Blake's aesthetic—which stressed the unity of conception and execution—make it unlikely that squared drawings were a normal requisite of his relief etching process. If we can assume that Blake knew the size of his *Jerusalem* copperplates prior to sketching out the design, there would have been no reason to draw the designs on a larger scale than the plates and then be forced laboriously to reduce them. Thus the squared drawing suggests the possibility that Blake planned to produce a separate plate, either relief or intaglio, of "Los and His Spectre" on a larger or smaller scale than both the drawing and the *Jerusalem* plate. This supposition must of course remain very tentative in the absence of further evidence for such a separate plate.

On the verso of the drawing is a pencil sketch[1] by Blake after Henry Fuseli's design, "Queen Catherine's Dream." This too has been squared and the horizontals numbered in a way almost identical to the recto design, no doubt as part of Blake's preparation for engraving the plate dated 1804 in the imprint and published in the seventh volume of *The Plays of William Shakespeare* edited by Alexander Chalmers (1805).[2] Like the verso drawing, "Los and His Spectre" probably dates from *c.* 1804.

For another drawing, generally associated with themes in *Jerusalem*, that may have been executed with the intention of eventual development into a print, see XVII, "The Chaining of Orc," note 3.

[1] Reproduced in Essick, *William Blake, Printmaker*, fig. 197.

[2] Blake refers to this plate in his letter to Hayley of 28 December 1804 (Keynes, ed., *Letters of Blake*, p. 107).

XLIX.
Isaiah Foretelling the Destruction of Jerusalem

FIGURES 99-101

India ink over pencil on a wood block

"Isaiah Foretelling the Destruction of Jerusalem," now in the *British Museum*, is a carefully executed drawing on the end grain of a hardwood, perhaps boxwood, block, 12.5 × 8 cm (Fig. 99). Blake clearly intended this design for subsequent engraving in the wood. In late 1819 or 1820, Robert John Thornton commissioned Blake to design and execute a series of small wood engravings for the third edition of his *Pastorals of Virgil*, published in 1821.[1] This project may have stimulated Blake to begin the Isaiah block, *c.* 1821. It is not known why he never completed it. The subject is taken from the prophecy of Jerusalem's ruin in Isaiah 29:1-6.

The central figure of the prophet is based closely on a pencil drawing, also in the British Museum, of "Isaiah Foretelling the Crucifixion and Ascension" (Fig. 100). This design, 12.8 × 7.7 cm on a sheet 16.6 × 11.6 cm, has been traced through on the verso and worked up in more detail (12.9 × 7.9 cm; Fig. 101). The inscription below the image ("The 'First Lines' on the preservation of which M.r Blake used so often to | insist are on the other side") is in the hand of Samuel Palmer, who onced owned the sheet of drawings.[2] These sketches date from the same period as the wood block.

The wood block was acquired by John Linnell, who may have suggested or even commissioned the work. Lent by the Linnell Trustees to the National Gallery, London, in 1913, no. 77 in the exhibition catalogue; and in 1914 to the Manchester Whitworth Institute, the National Gallery of Scotland, Edinburgh, and the Nottingham Art Museum, nos. 163, 4 in case A, and 111 in the respective exhibition catalogues. The first two catalogues note that the block is inscribed on the back, "A Drawing on Wood by Wm. Blake, for J. Linnell."[3] Sold by the Linnell Trustees at Christie's, 2 December 1938, lot 63 (£157 10s. to the National Arts Collection Fund). Presented by the Fund to the British Museum, which accessioned the block in January 1939. Lent to the Hamburg Kunsthalle and Frankfurt am Main Kunstinstitut in 1975, no. 181 in the exhibition catalogue.

[1] For a discussion of the Virgil wood engravings, see Essick, *William Blake, Printmaker*, pp. 224-233.

[2] Palmer describes the recto-verso drawings, and incorrectly suggests that the subject is "perhaps from the Pilgrim's Progress," in a letter of *c.* 1849. See *Letters of Palmer*, ed. Lister, I, 475-476; Lister, "Two Blake Drawings and a Letter from Samuel Palmer," *Blake Newsletter*, 6 (1972), 53-54.

[3] I am unable to confirm this because the block is now mounted in a glass-fronted case.

Part Five. Book Illustrations Known Only through Separate Impressions

This part of the catalogue includes only commercial book illustrations etched and engraved in intaglio. For rejected pls. a, b, and c of Blake's illuminated book *America* (1793), known only through separate impressions, see Bentley, *Blake Books*. For pl. d of *America* and Blake's white-line etching for Robert Blair's *The Grave*, also known only as separate impressions, see IX, "A Dream of Thiralatha," and XIII, "Deaths Door," in Part One of this catalogue.

L.
Four Classical Figures

(after Thomas Stothard)

FIGURES 102-103

One state, c. 1779

Inscriptions: none in the plate

Image, central design only: 15.4 × 10.8 cm

Image, including decorative frame: 19.9 × 14.5 cm

Plate mark: trimmed off in both impressions located

IMPRESSIONS

1A.

British Museum. Printed on laid paper, 20.7 × 14.6 cm. Inscribed in pencil (by Blake?), lower left, "Wm Blake 1779 engd"; lower right, "T. Stothard inv?" Inscribed in ink on verso, "Rob. Balmanno FSa London 1828." Foxed and cracked from an old fold diagonally across lower right corner. Formerly pasted down, now loose, in volume I, p. 5 of the 1780 section, no. 19, of the Balmanno Collection of the Works of Thomas Stothard. Acquired, apparently in 1828, by Robert Balmanno (1780-1861), whose great collection of Stothard's works was purchased by the Museum between May 1849 and May 1850 through Carter Hall. This print accessioned July 1849. Reproduced here, Fig. 102.

1B.

Royal Academy, London. Printed on thin paper trimmed to the narrow inner border, 15.8 × 11.3 cm, and pasted to a wove backing sheet which is in turn pasted to the seventh leaf from the end of volume VI of a bound collection of prints after Stothard. See "The Fall of Rosamond," impression 2F, for the provenance of this collection.

The attribution of this plate to Blake and its date are based on the pencil inscription on impression 1A, and thus are tentative at best. The general character of the plate, including its size and elaborate frame, indicates that it was intended to illustrate a book or periodical. This publication has never been identified, and it is of course possible that the plate was prepared for a work that never appeared. If the plate was engraved by Blake in 1779 (see pencil inscriptions on impression 1A), then it may be his first commercial book illustration after his release from apprenticeship in August of that year. The central image is only a little smaller than three designs after C. M. Metz and Stothard that Blake engraved for Edward Kimpton, *A New and Complete Universal History of the Holy Bible* (1781?).[1] However, the decorative frames in this and other books for which Blake engraved illustrations of about the same size are quite different. The only plates in such publications with even generally similar frames are those in *The Novelist's Magazine*, for which Blake engraved eight illustrations after Stothard in 1782 and 1783. These, however, are considerably smaller than the plate described here.

Stothard's preliminary drawing, 15.3 × 11 cm, of "Four Classical Figures" (Fig. 103) was recently acquired by David Bindman, London.

[1] See also LI, "The Return of the Jewish Spies from Canaan," and note 1 thereto.

This finished pen and wash drawing, signed "T. Stothard" lower right, is very close to Blake's plate, although it lacks the fresco to which the man on the right points. I cannot identify the subject of the design, although the classical costuming and architecture suggest that it illustrates a work of Roman literature or history.

LI.
The Return of the Jewish Spies from Canaan

(after Thomas Stothard)

FIGURES 104

One state: *c*. 1781-1785

Inscriptions: none in the plate

Image: 16.7 × 10.9 cm

Plate mark: trimmed off in the only traced impression

The only known impression (Fig. 104), now in the *British Museum*, is printed on very thin laid paper, 17.9 × 12.3 cm, pasted to a wove sheet, 18.3 × 12.6 cm. Now loose, but formerly pasted down as no. 594 on the thirteenth page from the end in the 1785 section of volume I of the Balmanno Collection of the Works of Thomas Stothard. Inscribed in pencil, lower left, *Stothard del*; lower right, *Blake sc*. The same signatures, faintly inscribed in pencil and partly erased, appear just below these clear signatures. Inscribed in pencil (by Balmanno?) in the lower margin, "The Return of the Jewish Spies from Canaan." Inscribed on the verso in ink, "Robert Balmanno FSa London 1828." Stained in lower margin, with a streak running diagonally through the sky. Accessioned by the Museum in July 1849; for further provenance, see L, "Four Classical Figures," impression 1A.

The attribution to Blake is based on the pencil inscriptions and thus is tentative at best. The size and general character of the design indicate that it was intended as an illustration to a Bible or other religious work in which an illustration of the return of the Jewish "spies" to Moses and Aaron (Numbers 13:26) would be appropriate. The image is very close in size and graphic style to the central designs in Blake's three plates, one of which is after Stothard, for Edward Kimpton, *A New and Complete Universal History of the Holy Bible* (1781?), reprinted in George Henry Maynard's translation of *The Works of Josephus* (several issues, *c*. 1786-1800). This plate may have been intended for Kimpton's book but never used. Its size is also close to the illustrations in *The Royal Universal Family Bible* (1781), for which Blake engraved five plates.[1] Although none of the plates in this book is known to have been designed by Stothard, it is possible that the inscribed attribution to Stothard (as well as to Blake?) on the impression described here is wrong and that it was intended for, but never used in, *The Royal Universal Family Bible*.

[1] For description and reproductions of all plates engraved by Blake referred to here, see Easson and Essick, *Blake: Book Illustrator*, I, 1-7, fig. I, pl. 1; II, 12-14, 21-26, figs. XV, pls. 1-4, XVIII, pls. 1A-3A, XIX, pls. 1B-3B.

LII.
Winged Figure
Flying through
Clouds

(after Thomas Stothard)

FIGURE 105

One state: c. 1780-1787

Signature, left, stippled letters: Stothard. del.

Signature, right, stippled letters: Blake. sc.

Image: 10.6 × 6.3 cm

Plate mark: 14.5 × 10.1 cm

IMPRESSIONS

1A.
British Museum. Printed on India paper laid onto, but now coming loose from, laid paper trimmed within the plate mark to 12.1 × 7.5 cm. Slight stains in the lower part of the print. Inscribed on verso, "Robert Balmanno FSa London 1828." Pasted down at the top corners as no. 20 on p. 6 of the 1780 section in volume I of the Balmanno Collection of the Works of Thomas Stothard. Accessioned by the Museum in July 1849; for further provenance, see L, "Four Classical Figures," impression 1A. Reproduced here, Fig. 105.

1B.
British Museum. Printed on thick wove paper, 16 × 11.6 cm, with minor foxing. Acquired by the Museum in December 1853. Reproduced in *Blake Newsletter*, 5 (1972), 237.

The size, circular form of the central image, and decorative frame indicate that this plate was intended to illustrate *Bell's Edition* [of] *The Poets of Great Britain Complete From Chaucer to Churchill* in 109 volumes, Edinburgh, 1777-1784. Impression 1A is grouped with published plates from this work, but none of the published volumes contains Blake's plate or the same design engraved by another hand. The design immediately suggests Satan in John Milton's *Paradise Lost*, and the figure is similar in position and action to Stothard's illustration of Satan flying "his oblique way/Amongst innumerable Stars."[1] Another similar composition, showing a winged Satan holding a spear and flying before flames, appears as the frontispiece to the first volume of Milton's poems in *Bell's Edition*. This plate, engraved by John Hall after John Hamilton Mortimer and dated 20 November 1777 in the imprint, illustrates lines 225-226 from Book I of *Paradise Lost* inscribed on the plate: "Then with expanded wings he steers his flight/Aloft, incumbent on the dusky Air." Blake was still an apprentice in 1777, and it is most unlikely that he would be engraving plates (even rejected plates) for a major publication at that time. If Stothard's design was intended as a substitute illustration of the same lines in the same volume of *Bell's Edition*, it was probably engraved at a later date, c. 1780-1787.[2]

An alternative possibility is suggested by A. C. Coxhead's description of Stothard's illustration to John Donne's poetry in *Bell's Edition*: "A Figure flying in a cloud, back turned to the spectator."[3] Unfortunately, Coxhead's information is not always reliable and no such

[1] *Paradise Lost*, Bk. III, lines 564-565. The design was engraved in stipple (11.5 × 25.4 cm) by Francesco Bartolozzi and published in Milton, *Paradise Lost*, London: Thomas Jeffreys, 1792-1793; reproduced in Marcia R. Pointon, *Milton & English Art*, Manchester: University Press, fig. 76.

[2] Blake finished his apprenticeship to James Basire in August 1779. That substitute or alternate plates were prepared for later issues of *Bell's Edition* is demonstrated by the appearance of a plate by Blake after Stothard, dated 1783, as the frontispiece in some copies of the thirteenth Chaucer volume, while other copies have the same design engraved by "Cooke" (probably J. Cook) and dated 1787. This situation, however, does not prove that substitute *designs* were prepared for the publication.

[3] *Thomas Stothard*, p. 84. The plate is tentatively accepted as a rejected plate for the Donne volumes by Bentley, *Blake Books*, pp. 548-549.

236

design appears in the Donne volume in any issue of *Bell's Edition* I have seen. In his list of Stothard's work for Bell, Coxhead generally quotes the lines of poetry inscribed on the plate or, in one case, notes their absence. For this "Donne" illustration he says nothing about inscriptions. Thus he may only be describing the proof before letters (except signatures) by Blake (Fig. 105) and assuming that it illustrates Donne.

LIII.
The Battle of Ai
(after Thomas Stothard)

FIGURES 106-107

One state: c. 1781

Inscriptions: none in the plate

Image, central design only: 17.4 × 10.8 cm

Image, including decorative frame: 19 × 12.3 cm

Plate mark: trimmed off in the only traced impression, which shows a line of a further decorative frame along the edges

The only known impression (Fig. 106) is now in the *Library of Congress*, Rosenwald Collection, Washington, D.C. It is printed on laid paper, 19.2 × 12.5 cm. A brown ink line has been added to the outline of clouds upper left, and a few brown ink marks are on the fallen figure, lower right, and on the foot to his right. Very probably the impression described by Keynes, *Bibliography of Blake*, p. 232: "proof of another version of the plate [in Maynard's Josephus], which is in the collection of Mr. W. E. Moss," with "the design the right way round." Probably sold from the Moss collection at Sotheby's, 2 March 1937, lot 218, a large collection of prints by Blake including some for "Maynard's Josephus" (£11 to Rosenbach for Rosenwald). Given by Lessing J. Rosenwald to the Library of Congress in 1943 and moved from the Alverthorpe Gallery, Jenkintown, Pennsylvania, to Washington in 1980. Listed in *The Rosenwald Collection* (1954), p. 195; *The Rosenwald Collection* (1977), p. 334.

The plate is based closely on Stothard's pen and gray wash drawing, 17.8 × 10.5 cm, in the Rosenwald Collection of the Library of Congress (Fig. 107). The same design with a more elaborate decorative frame was engraved by Blake on a different copperplate, with right and left the reverse of the drawing and the plate described here. This reversed plate, inscribed in the copper *Stothard del, Blake sc*, and showing an army of lefthanded soldiers, was published in Edward Kimpton, *A New and Complete Universal History of the Holy Bible* (1781?).[1] I cannot explain why two plates of this design were produced, or why what would seem to be the inferior plate was used in the book. Perhaps the righthanded plate (Fig. 106) was produced first, broken or lost after at least this one proof was pulled, and the lefthanded plate was a hurried substitute. It is of course possible that the plate described here was not engraved by Blake, although the engraving styles in the two versions are very similar. If the first plate was rendered unusable, it seems probable that the publisher would have turned to its engraver for the production of the published plate bearing Blake's signature.[2]

The two battles of the Israelites against the inhabitants of the city of Ai are described in Joshua, chaps. 7-8, and in Book Five of Josephus, *The Antiquities of the Jews*.

[1] For description and reproduction of this plate, reprinted in George Henry Maynard's translation of *The Works of Josephus*, see Easson and Essick, *Blake: Book Illustrator*, II, 21-26, fig. XVIII, pl. 2A; fig. XIX, pl. 2B. The plate was given a new frame, and the inscribed name of the city changed from "Ai" to "Ain" (following the book's text) in the various issues of Maynard's *Josephus* (c. 1786-1800?).

[2] Ruthven Todd offers further (and more dubious) speculations in *Catalogue Five*, issued in 1972 by the London bookdealer Paul Grinke, p. 18. There are at least two other cases in which Blake executed two plates of the same design: "The Temple of Mirth," after Stothard, for *The Wit's Magazine* of January 1784; and "Miscellany, Plate XVIII," for Abraham Rees, *The Cyclopaedia*, 1820 (LXXII in Part Seven of this catalogue). Careless presswork can crack or break a copperplate, particularly if its resiliency is impaired by chemical impurities.

LIV.
The Morning Amusements of her Royal Highness [and] A Lady in the full Dress

(two designs after
Thomas Stothard on
one plate)

FIGURES 108-109

First state: 1782

Inscriptions: none present in the only known impression

Images: 9.6 × 12.6 cm (right image, "The Morning Amusements"); 9.6 × 6.5 cm (left image, "A Lady in the full Dress")

Plate mark: trimmed off on all impressions, both states

IMPRESSIONS

1A.

Royal Academy, London. Printed on thin (India?) paper with the images cut apart. "The Morning Amusements" trimmed close to the image to 10 × 12.8 cm and pasted to a backing sheet inscribed in pencil on the verso, "1782." "A Lady in the full Dress" trimmed very close to the image to 9.6 × 6.6 cm and pasted to a backing sheet. In spite of the close trimming, fragments of the signatures below each image should have printed from the plate, if present. Both backing sheets are pasted down ("Morning Amusements" on three corners only) on leaf 35 of volume VIII of a collection of prints after Stothard; see "The Fall of Rosamond," impression 2F, for the provenance of this collection.

Second state: 1782

A small amount of finishing work in the form of stars has been added to the patterns on the shawl worn by the woman on the left in "A Lady in the full Dress." A small piece of the shawl now hangs below her left hand and the pattern on the hem of her dress has been strengthened. Further hatching has been added to her arms, hands, and collar, and to the arms and hands of the woman on the right. In "Morning Amusements," the crosshatching on the right side of the dress worn by the woman, far left, has been extended further toward her right arm. More hatching has been added to the mirror, the apron worn by the woman holding a child, and to the arms and collar of the woman at the spinet. Further crosshatching has been added to the tail of the man's coat. The shading on the wall has been evened out through the addition of more lines. The vertical line separating the two images present in impression 2B may be a second-state addition. The following inscriptions now appear on the plate:

Signature, below right image, left: Stothard. del

Signature, below right image, right: Blake Sc.

Title, below right image: The Morning Amusements of her Royal Highness the Princess Royal & her 4 Sisters.

239

Imprint, below right image: Published by J. Johnson S! Paul's
 Church Yard, Nov! 1. 1782.

Signature, below left image, left: T. S. d

Signature, below left image, right: W. B, sc

Title, below left image: A Lady in the full Dress, & another
in the | most fashionable Undress now worn.

Dimensions: same as in the first state

IMPRESSIONS

2B.
British Museum. Printed on laid paper with the two images side by
side on a sheet 11.6 × 22 cm, pasted down but now loose at all but
the bottom left corner. The two images are 1.8 cm apart with a dividing
line running vertically halfway between. Small tears lower center. In-
scribed in ink on verso, "Robert Balmanno FSa. London 1828." Pasted
to p. 52 in the 1781 section of volume I of the Balmanno Collection
of the Works of Thomas Stothard. Accessioned by the Museum in
July 1849; for further provenance of the collection, see L, "Four Clas-
sical Figures," impression 1A. Reproduced here, Figs. 108-109.

2C.
National Gallery of Art, Rosenwald Collection, Washington, D.C. The
right image ("The Morning Amusements") only, printed on laid paper,
11 × 12.9 cm. All but the tops of a few letters of the imprint have
been trimmed off. Inscribed in ink, lower right, "1777." Lessing J.
Rosenwald and National Gallery of Art collection stamps on verso.
Probably acquired by W. E. Moss and sold from his collection at
Sotheby's, 2 March 1937, lot 218, a large group of prints (£11 to
Rosenbach for Rosenwald). Lent by Rosenwald to the Philadelphia
Museum of Art in 1939, no. 242 in the exhibition catalogue. Given
by Rosenwald to the National Gallery in 1945 and moved from the
Alverthorpe Gallery, Jenkintown, Pennsylvania, to Washington in 1980.

2D.
Royal Academy, London. Printed on thin (India?) paper with the two
images cut apart. "Morning Amusements" trimmed just below the
signatures to 10.2 × 13.3 cm; "Lady in the full Dress" trimmed
through the signatures to 9.8 × 6.7 cm. Both images are pasted to
backing sheets which are in turn pasted to leaf 35 of volume VIII of
a collection of prints after Stothard; see "The Fall of Rosamond,"
impression 2F, for the provenance of this collection.

 A. C. Coxhead includes this "double plate" (i.e., two designs on
one plate intended for printing side by side) in his list of plates after
Stothard executed for *The Lady's Magazine; or Entertaining Com-
panion for the Fair Sex.*[1] Coxhead indicates, pp. 42-43, that he has
based his list on the collection of loose impressions in the British

[1] *Thomas Stothard*, p. 46.

Museum, including unsigned proofs, and admits that "the only copy of the magazine itself" he found had "many of the plates . . . ruthlessly torn" out, "from some volumes every one." I have not been able to find this plate in a copy of the magazine, although this may be due to the same difficulty Coxhead encountered. *The Lady's Magazine* from 1770 to 1818 included several fashion plates of the same format (two images side by side, some with a line between) and approximate size as "The Morning Amusements" and "A Lady in the full Dress." Most of the plates are unsigned and without imprint. Coxhead's supposition that the plate was at least intended for, although apparently never published in, *The Lady's Magazine* would seem eminently justified except for one significant fact: the magazine was published by G.G.J. and J. Robinson, whereas Blake's plate is clearly inscribed in the plate (at least in the second state) with the name of Joseph Johnson as the publisher.

Gilchrist notes that this plate contains "two frontispieces to [James] Dodsley's *Lady's Pocket-Book*."[2] We are confronted once again by a discrepancy between publishers' names, unless Gilchrist is indicating the editor or only one of at least two publishers. Further, it is certainly possible that Gilchrist simply got the title as well as the editor/publisher wrong. Indeed, Stothard himself made this error, and then corrected it, when he signed a receipt of 11 April 1795 for "sixteen guineas [for] two drawings for Lady's [Pocket Book *del*] Maggazien."[3] Nevertheless, Russell (*Engravings of Blake*, p. 142), Keynes (*Bibliography of Blake*, p. 226), and Bentley (*Blake Books*, pp. 591-592) accept Gilchrist's statement. No one has ever been able to find a copy of *The Lady's Pocket-Book*, in spite of a heroic, worldwide search by Elizabeth B. Bentley.

[2] *Life of Blake* (1863), I, 51. The illustrations are also listed as in the "Lady's Pocket-Book" by W. M. Rossetti in Gilchrist's *Life of Blake* (1863), II, 259.

[3] This receipt, now at Princeton University, Princeton, New Jersey, is quoted in Bentley, *Blake Books*, p. 592.

LV.
A Lady
Embracing a Bust

(after Thomas Stothard)

FIGURE 110

First state: c. 1780-1793

Inscriptions: none in the plate

Image: 12.8 × 8.1 cm

Plate mark: see impression 1B

IMPRESSIONS

1A.
Huntington Library, San Marino, California. Printed on laid paper, 13 × 8.2 cm. Although cut close to the image, the tops of the letters of the signatures (see second state) would still print if they had been present on the plate. Formerly pasted down, now loose, on p. 28 of volume II of a collection of prints after Stothard with Samuel Boddington's bookplate and a note indicating that the collection (in twelve volumes) was given to the Library by Mr. and Mrs. Carl F. Braun.

1B.
Royal Academy, London. Very well printed on (wove?) paper laid on to a (wove?) sheet, 18.2 × 12.9 cm, and pasted down on leaf 78 of volume II of a collection of prints after Stothard. The backing sheet bears a plate mark, 16.9 × 11.6 cm. Since the paper on which the image is printed is fairly thick, rather than the usual laid India, this may be a facsimile plate mark rather than an impression of the copperplate bearing the image. For the provenance of this collection, see "The Fall of Rosamond," impression 2F.

Second state: c. 1780-1793
 The following inscriptions have been added to the plate:

Signature, left: Stothard. d.

Signature, right: Blake. sc.

Dimensions: same as in the first state

IMPRESSIONS

2C.
American Blake Foundation, Memphis State University, Memphis, Tennessee. Trimmed to the image on both sides and the top and just below the signatures on the bottom. Matted and framed. Acquired, *c.* 1975, from a Canadian bookdealer. Not seen; information supplied by Professor Roger Easson of Memphis State University.

2D.
British Museum. Printed on thick wove paper, 16 × 10.6 cm, inscribed in ink on the verso, "Robert Balmanno FSA London 1828." Mounted along the left edge as number 715 on p. 29 of the 1789 section of volume II of the Balmanno Collection of the Works of Stothard. Acces-

242

sioned by the Museum in July 1849; for further provenance of this collection, see L, "Four Classical Figures," impression 1A. Reproduced here, Fig. 110.

The graphic style of this plate, predominantly etched with only a few touches of engraving, is typical of Blake's book illustrations after Stothard, *c.* 1780-1790. The proportions and size of the image are only fractionally different from those of Blake's eight plates after Stothard for *The Novelist's Magazine,* 1782-1783, although these have decorative frames in their published state. The plate may have been another (see LIV, "The Morning Amusements") intended for *The Lady's Magazine.* Many plates in this periodical generally attributed to Stothard are about the same size as this plate. Impression 1A is grouped in an album with several plates from the magazine, including the engraved title page for volume XXIV of 1793. "Virtue Sacrificed to Falsehood" in the October 1783 issue pictures a lady very similar in face and fashion to the woman embracing a bust, although it must be admitted that she is a stock type found in a number of Stothard's book illustrations. I have not been able to identify the subject of the design or the publication for which it may have been intended.

LVI.
A Frontispiece for Benjamin Heath Malkin, A Father's Memoirs of His Child

FIGURE 111

[1] See XLV, "Lear and Cordelia," impression 4F, and note 4 thereto, for Blake's use of unbound sheets from this book.

[2] Dennis M. Read, "A New Blake Engraving: Gilchrist and the Cromek Connection," *Blake: An Illustrated Quarterly*, 14 (1980), 60-64, states that "Thomas Cromek suffered paralysis in his last years, rendering him unable to write, and his daughter, Mary Cromek, therefore attended to his correspondence" (p. 64 n.4).

[3] An unfinished proof of Cromek's print is reproduced in Bindman, *Complete Graphic Works of Blake*, fig. 410; the published state is reproduced in *Blake: An Illustrated Quarterly*, 14 (1980), 62.

[4] There are two manuscript versions of this memoir, one dated 23 December 1864, the other 27 July 1865. Both are in the possession of Cromek's heirs, Paul and Wilfred Warrington (see Read's essay, p. 64 n.3). This passage is quoted from Read's essay, p. 60.

One state: 1805

Inscriptions: none in the plate

Image: 19 × 12.7 cm

Plate mark: 21.5 × 15 cm

The only known impression, now in the *British Museum*, is printed on wove paper, 22.9 × 15.2 cm (Fig. 111). Fragments of a type-printed text are on both sides of the image on the recto and on the verso. These indicate that the paper is an unused sheet from William Hayley, *Designs to a Series of Ballads* (1802).[1] Specifically, the sheet is from the first and fourth leaves in the E gathering in "Ballad the Second" in this quarto book. The fragments of text on the left side of the print ("reast," "s,") are from the ends of the first lines of the two quatrains on the verso of the fourth leaf in the E gathering (p. 26 in the continuous pagination), and the text fragments on the right side of the print ("BA," "The," "Sec," "Som," "But," "Th," "Ra") are from the running title and beginnings of the first and third lines of the three quatrains on the recto of the first leaf in the E gathering (p. 19). The verso text fragments ("t," "With") are from pp. 20 and 25. Pasted down, except for the lower right corner, as no. 91 in a bound volume of prints by Robert Hartley Cromek (1770-1812). Presented to the Museum in April 1867 by Thomas Hartley Cromek (1809-1873) as part of a collection of 119 prints and drawings by his father, R. H. Cromek. Pasted on the second leaf of the volume containing this collection are letters by Mary Cromek, Thomas Cromek's daughter, of 9 April and 13 April 1867 to W. Reid of the British Museum staff. The first letter is signed by both Thomas and Mary Cromek.[2]

Benjamin Heath Malkin's *Father's Memoirs of His Child* (1806) contains a frontispiece signed by Blake as the designer and R. H. Cromek as the engraver.[3] The central stipple portrait in this published book illustration, apparently engraved by Robert Cooper after a design by Paye (see below), is identical to the one in the separate print. The framing designs are basically the same in both prints, but the patterns of lines and dots in which they are rendered are completely different. The separate proof in the British Museum is no doubt the one to which Mary Cromek, in her letter of 9 April accompanying the collection of Cromek prints, refers to as "Blake's engraving, probably a unique impression." A more detailed description is found in a manuscript memoir of R. H. Cromek written by his son in 1864: "I have an impression of this plate [which belonged to my father *del*], with the figures round the Portrait, engraved by *Blake*. These were erased, and re-engraved by Cromek, in 1806. . . . From the fragments of lettering at the edges of Blake's print, it seems clear that he not only designed and engraved the figures, but even printed it, himself, on some peice [*sic*] of waste paper that came to his hand. It is not [in 1864] in the British Museum, and my impression is probably *unique*."[4] According to Thomas Cromek, information about the print reached Mrs. Alexander Gilchrist in about 1862 when she was editing her late husband's

biography of Blake. Cromek writes that "my friend M.ʳ Frost A.R.A. after he had seen my probably *unique* impression of it, communicated to M.ʳˢ Gilchrist the particulars relating to it, and thought that being perhaps a 'unique print,' it would be interesting to Blake's admirers to know in whose possession it was."[5] As a result, the following account appears in Gilchrist's *Life of Blake* (1863), I, 210: "Blake designed, and originally engraved, the 'ornamental device' to the frontispiece for Malkin's *Father's Memoirs of his Child*, but it was erased before the appearance of the work, and the same design re-engraved by Cromek." This statement does not indicate that an impression of Blake's work survived in Thomas Cromek's collection,[6] and its existence went unnoticed until its rediscovery by Dennis M. Read in 1979.

There is no reason to doubt Thomas Cromek's account of the history of the plate or that the impression (Fig. 111) in the British Museum was designed and engraved by Blake. The graphic style is far more sophisticated than Cromek's re-engraving, and shows the heavy worm-lines (lower right), delicate handling of the stipple burin on figures, and closely spaced ruled lines in the background characteristic of Blake's book illustrations, *c.* 1797-1810.[7] The identical rendering of the oval portraits in the two prints indicates that the same piece of copper was used by both engravers. Apparently Malkin was displeased with Blake's efforts and hired Cromek to rework the plate. He completely scraped and burnished away Blake's design and re-engraved it on a slightly smaller scale (19.6 × 13 cm) but with more of the design pictured below the figures and a different rendering of the clouds and sunbeams. The copperplate was trimmed down to 21.8 × 15 cm.

The oval portrait of Malkin's son, Thomas, is based on "a very beautiful miniature, painted by Paye"[8] (Richard Morton Paye or his daughter). According to Thomas Cromek, it was engraved by Robert Cooper, whose signature appeared on a proof of the re-engraved plate once owned by Cromek.[9] It is not unusual for one man to engrave the figures or a central portrait and another craftsman to execute the landscape or border design.

A pencil drawing (27.6 × 43.8 cm) by Blake in the British Museum, showing a woman reaching down from clouds toward a child held by another woman, is probably an alternate version for this frontispiece. Martin Butlin has suggested that the pencil sketches on the verso of Blake's "War Unchained by an Angel, Fire, Pestilence, and Famine Following" (17.7 × 22.1 cm; Steigal Fine Art, Edinburgh) may also be related.[10] Two of these are (coincidentally?) similar to Paye's portrait of young Thomas, and at least one sketch looks like the child's face and arms in Blake's framing design.

It could be argued that the plate engraved by Blake is merely an earlier state of Cromek's re-engraving of the same design on the same piece of copper, particularly if Cromek left a few of Blake's incisions on it. Yet, we know Blake's work on the plate only through this single, separate impression; I have included it here for that reason.

[5] This statement appears in a manuscript volume of Thomas Cromek's papers in the collection of Paul Warrington; see Read's essay, pp. 63-64 and n.11. William Edward Frost (1810-1877) is probably the "Mr. Frost" thanked in Gilchrist, *Life of Blake* (1863), II, 263, for helping to obtain "at the last moment" the only known copy of Blake's prospectus *To the Public* of 10 October 1793.

[6] Cromek complained about this in his private papers and took it as a personal slight. See Read's essay, p. 64 and n.11.

[7] Compare to the title page to "Night the Third" in Edward Young, *Night Thoughts* (1797); and to the general frontispiece in William Hayley, *Designs to a Series of Ballads* (1802).

[8] According to Malkin, *Father's Memoirs*, p. xliv.

[9] See Read's essay, p. 61. I have not been able to trace any proof signed by Cooper.

[10] "Five Blakes from a 19th-Century Scottish Collection," *Blake Newsletter*, 7 (1973), 5-6, fig. 3.

LVII.
Coin of Nebuchadnezzar and Head of Cancer

(*John Linnell after Blake*)

FIGURES 112-114

One state: *c.* 1828

Inscriptions: none in the plate

Images: coin 10.4 × 11 cm; head on right 9 × 7.4 cm

Plate mark: 15.8 × trimmed off in the only known impression

The only known impression (Fig. 112) is a proof before letters in the collection of *Sir Geoffrey Keynes*, Suffolk. It is printed on a sheet of wove paper, 16.2 × 25.5 cm, with the plate mark trimmed off except at the top and bottom. According to Keynes, *Bibliotheca Bibliographici*, no. 611, this impression was sold from the collection of John Linnell at Christie's, 15 March 1918, lot 190, a parcel of engravings by and after Blake (£54 12s. to Martin). Acquired by W. E. Moss, and sold from his collection at Sotheby's, 2 March 1937, lot 216 (£1 5s. to Keynes).

John Varley's *A Treatise on Zodiacal Physiognomy*, a pamphlet of sixty-four pages published in 1828, contains five plates signed by Linnell as the engraver. Three of these, although signed *J. Varley inv.*, contain (among other images) designs based on drawings by Blake: a profile, inscribed *Cancer*; two views of the "Ghost of a Flea" inscribed *from Blakes, vision*; and a crudely executed circular image inscribed *Reverse of the coin of | Nebuchadnezzar; after Blake*. The size, format, simple graphic style, and physiognomic character of this separate print indicate that it was also engraved by Linnell for Varley's pamphlet, the printed front cover of which states that the work was "to be completed in four parts." A prospectus for the *Treatise* states that "in a Memoir of the late William Blake, under the article 'Cancer,' will be found an account of some of his remarkable Visions, with engravings from some of the most curious of them, including portraits of King Edward the First, Nebuchadnezzar, &c. &c."[1] The first, published, part of the *Treatise* does include a brief account of Blake's vision of the ghost of a flea (pp. 54-55), but this hardly constitutes a memoir and there is no article on Cancer. These were very probably intended for a later part, none of which is known to have been published, with this separate plate to be included as one of the illustrations.

The image on the left is no doubt the face of the "coin of Nebuchadnezzar." Since the back of the coin was engraved "after Blake" in the published illustration, one can reasonably assume that the face was also based on a drawing by Blake. This is probably the "Visionary Head" in Linnell's collection described by W. M. Rossetti in Gilchrist's *Life of Blake* (1863), II, 245, no. 58: "Nebuchadnezzar. Vivid, and not wanting in truth to the Assyrian cast of countenance. Below the head is a 'coin' of Nebuchadnezzar, engraved in Varley's 'Zodiacal Physiognomy.'" According to Keynes, *Bibliography of Blake*, p. 318, "the original drawings for both sides of the coin were in the Linnell collection on a single piece of paper marked 'coin of Nebuchadnezzar seen by Mr Blake in a vision.'" Keynes also notes that the sheet of drawings was included in the sale of Linnell's collection at Christie's, 15 March 1918, lot 163, "Visionary Heads, including Socrates, Neb-

[1] The covers are preserved in the copy of the pamphlet in the Huntington Library, San Marino, California. A copy of the prospectus is in the British Museum; see Bentley, *Blake Records*, p. 370.

² First reproduced in *Blake: An Illustrated Quarterly,* 12 (1979), 245.

³ The "Cancer" drawing and tracing are reproduced in Geoffrey Keynes, *The Complete Portraiture of William & Catherine Blake,* London: Trianon Press for the Blake Trust, 1977, figs. 20a, b.

⁴ Compare to the self-portrait, lacking the physiognomic details and exaggeration of the "Visionary Heads," in Blake's *Notebook,* p. 67. Keynes, *Complete Portraiture,* p. 130, offers an astrological explanation of Blake's association with Cancer.

uchadnezzar," etc. (£42 2s. to Parsons). Offered by Parsons and Sons in their catalogue 282 of June 1918 for £12 12s. Lent by the American Art Association—Anderson Galleries to the Philadelphia Museum of Art in 1939, no. 209 in the exhibition catalogue, where it is noted that the paper is watermarked "*M. & J. Lay 1816.*" I have not been able to trace this drawing. A tracing of both sides of the coin on thin paper,² probably made by Linnell from the lost original, is in the collection of G. Ingli James, Cardiff, Wales (Fig. 113). It is inscribed "Nebuchadnezar [*sic*] | Coin as seen in a Vision | by Mr Blake"; the sheet measures 20.5 × 18.8 cm.

The head on the right in the plate, generally similar to the profile of "Cancer" among the published illustrations, is based on one of Blake's "Visionary Heads," also inscribed "Cancer." This pencil sketch (Fig. 114), on a sheet 18.8 × 13.9 cm, now in the collection of F. Bailey Vanderhoef, Jr., of Ojai, California, was originally part of the *Blake-Varley Sketchbook* of 1819 and was for many years in Linnell's collection. A copy on tracing paper (19.8 × 15.7 cm), formerly in Linnell's collection and probably drawn by him, is now in a private American collection.³ W. M. Rossetti, in Gilchrist's *Life of Blake* (1863), II, 245, was the first to suggest that this "Visionary Head" is similar to Blake's own visage,⁴ even though his zodiacal sign was Sagittarius, not Cancer.

Part Six. *Book Illustrations also Issued*
 as Separate Prints

It was not unusual in the late eighteenth and early nineteenth centuries for book and print publishers to sell individual impressions of book illustrations, particularly in proof states before letters. Thus, a good many of Blake's commercial book illustrations *may* have been sold as separate prints. Listed below are only those plates for which there is specific evidence of separate issue in Blake's lifetime or shortly thereafter. For more detailed information about these plates and the books they were published in, see Bentley, *Blake Books*, and Easson and Essick, *Blake: Book Illustrator*, vol. II.

LVIII.
Pages from Blake's Illuminated Books. There are a good many impressions of relief and/or white-line etchings by Blake that are not now, nor known to have ever been, a part of a copy of the illuminated book for which they were originally executed. No doubt some of these are proofs or rejected pulls never intended by Blake for separate "publication" or even sale. Others were very probably printed, or at least hand colored, and sold as separate impressions. This group includes the "Ancient of Days" (the frontispiece to *Europe*, 1794),[1] and the designs from the illuminated books, color printed with texts masked, included in the "Large" and "Small" Books of Design (*c.* 1796). Most of these separate impressions are described in Bentley, *Blake Books*, and in Martin Butlin's catalogue of *The Paintings and Drawings of William Blake*, New Haven and London: Yale University Press, 1981.

LIX.
Joseph Ayloffe, *An Account of Some Ancient Monuments in Westminster Abbey*, London, 1780; published by the Society of Antiquaries in *Vetusta Monumenta*. Seven plates in this work, all signed by James Basire, are probably based on drawings made by Blake during his apprenticeship. Plates from *Vetusta Monumenta* "may also be had separately" according to a list of "Works Published by the Society of Antiquaries" bound at the end of at least some copies of the Society's *Archaeologia: or Miscellaneous Tracts Relating to Antiquity*, vol. III-XI, 1775-1794.

LX.
The Wit's Magazine, London: Harrison and Co., vol. I, 1784. Blake engraved the folding frontispieces for the January through May issues, the first after Stothard (for which there were two different copperplates) and the remainder after Samuel Collings. According to an advertisement printed on the back paper wrapper of a copy of the November 1784 issue in my collection, "Prints of the Wit's Magazine, Finely Coloured, May now be had, (independent of the Work) Price only SIXPENCE each. . . . These Large Quarto Hogarthian COLOURED PRINTS may he [*sic*] had singly, or all together . . . of Messrs. Harrison and Co. No. 18, Paternoster Row; and of all other Booksellers, Stationers, and Newscarriers, in Town and Country." Blake's five prints are specifically listed by title without mention of the designers or engraver. I have not been able to locate any hand-colored impressions.

[1] The impression in the Whitworth Art Gallery, Manchester, is signed "Blake 1827" and is very probably the impression which, according to John Thomas Smith, Blake colored shortly before his death (see Bentley, *Blake Records*, p. 471). The separate impressions are listed in Bentley, *Blake Books*, pp. 108-110—but see LXVII, "The Ancient of Days," Part Seven of this catalogue.

LXI.

The Original Works of William Hogarth, London: John and Josiah Boydell, 1790 and n.d. (*c.* 1795?) reissue. One plate, "Beggar's Opera, Act III," was engraved by Blake after Hogarth's painting. The "Catalogue of the Original Works of William Hogarth" printed in the 1790 issue lists Blake's plate as no. 103 with a price of 15s. and indicates that "single prints are sold at the prices annexed to the above catalogue." The undated reissue offers Blake's plate, now no. 102, for 10s. 6d.

Copies of the 1790 issue contain impressions of Blake's plate (dated 1 July 1790 in the imprint) in either the third (open letter title) or fourth (closed letters) state.[2] The first, etched state of the plate bears an imprint dated 29 October 1788. Although it looks like an unfinished working proof, the presence of an imprint and the fact that several impressions of this first state have survived[3] suggest that it was also sold separately. The rare second state,[4] with the image completed and the 1788 imprint but before title, was no doubt also sold to connoisseurs who desired early and incomplete states.

The "Catalogue" in the 1790 issue of the book states that Blake's plate was "never before inserted in this Collection." Its execution was no doubt commissioned by the Boydells specifically for publication in their edition of Hogarth's works.

LXII.

David Hartley, *Observations on Man*, London: Joseph Johnson, 1791. Blake engraved the frontispiece after a portrait of Hartley by John Shackleton (or "Shackelton," as inscribed on the plate). At the beginning of a long review of the book by "QQ" in Johnson's *Analytical Review*, 9 (April 1791), pp. 361-376, it is noted that the "Head [of Hartley] is sold alone, pr. 2s. 6d." For one to be sure that an unbound impression of the plate is the separate issue, and not simply a print cut from the book, it must be on paper larger than the book or on a different stock. I have not been able to find such an example, although the proofs in the British Museum (lacking all letters), the Princeton University Art Museum, Princeton, New Jersey (lacking Blake's signature), and the Rosenwald Collection of the Library of Congress, Washington, D.C. (lacking Blake's signature) may originally have been sold as the separate prints advertised in the *Analytical Review*.

LXIII.

Boydell's Graphic Illustrations of the Dramatic Works, of Shakspeare, London: Boydell & Co., n.d. (*c.* 1803?). Blake engraved one plate, "Romeo and Juliet, Act IV. Scene V," after John Opie, dated 1799 in the imprint. The plate was also published in volume IX of *The Dramatic Works of Shakspeare Revised by George Steevens*, London: John and Josiah Boydell, 1802; and in *The Dramatic Works of William Shakspeare*, London: Moon, Boys, & Graves, 1832. In their 1829 catalogue, p. 65, Moon, Boys, & Graves advertised for sale separate

[2] Copies with the third state are in the collection of the Metropolitan Museum of Art, New York, and Princeton University Library, Princeton, New Jersey. The fourth state appears in a copy of the 1790 issue in the Library of Congress, Washington, D.C., and in all copies I have seen of the undated Boydell reissue.

[3] Impressions are in the collections of the British Museum (imprint cropped); Robert N. Essick; Philip Hofer, who also owns the copperplate; the Huntington Library, San Marino, California; the Philadelphia Museum of Art; and the Rosenwald Collection of the National Gallery of Art, Washington, D.C.

[4] I have been able to locate only one impression, now in my collection.

⁵ A copy of the catalogue is in the Print Room of the British Museum. I am indebted to Prof. G. E. Bentley, Jr., for this information.

impressions of the large quarto size Boydell Shakespeare prints, including Blake's plate: "Prints, 4s. Proofs, 7s. 6d." A list of the subjects of "Boydell's Small Shakespeare" prints, both "very old impressions, in sheets" and "modern impressions," covers pp. 153-160 of the catalogue. Its heading also indicates that "any of the following Plates may be had separate." Blake's plate is listed on p. 159 following Peter Simon's engraving of the same design.⁵

Part Seven. *Lost, Conjectural, and*
Misattributed Plates

LXIV.

"The Penance of Jane Shore," c. 1779. According to Richard Garnett, *Blake, Painter and Poet*, p. 9, "scarcely was [Blake] out of his articles [of apprenticeship] than he produced (1779) two engravings from the history of England, *The Penance of Jane Shore* and *King Edward and Queen Eleanor*." For the latter, see IV, "Edward & Elenor," Part One of this catalogue. Malkin, *A Father's Memoirs of His Child*, p. xxi, and Gilchrist, *Life of Blake* (1863), I, 30, refer to Blake's engravings of "two designs" from British history executed early in his career, but neither specifically names "The Penance of Jane Shore" as one of these. The subject is known through a pencil sketch (32 × 48.5 cm) in the collection of Sir Geoffrey Keynes, a watercolor sketch (13.3 × 18.4 cm) in a private British collection, and a watercolor (24.5 × 29.5 cm) in the Tate Gallery, London, but I have not been able to find an impression of an engraving of "The Penance of Jane Shore."

Blake includes "The Penance of Jane Shore" in a list of subjects from British history in his *Notebook*, p. 116. This was probably a draft list of plates for "The History of England, a small book of Engravings" Blake advertised in his prospectus "To the Public" of 1793, but no copy of this book is known. It is possible that there never was a separate plate of "The Penance of Jane Shore" and that Garnett was simply mistaken.

LXV.

"Stothard and Friends Prisoners During a Boating Excursion." Image 17 × 21.5 cm, c. 1780. W. M. Rossetti includes this etching, which he attributes to "Stothard and Blake," in his list of Blake's engravings in Gilchrist, *Life of Blake* (1863), II, 260. Blake, Stothard and a "Mr. Ogleby" were detained as suspected French spies while boating on the Medway in about 1780,[1] but the etching associated with this incident is not the least bit like Blake's work in design or execution. According to Mrs. Bray, Stothard's son Alfred "says [the print] was by his father,"[2] which seems likely. There are impressions in the British Museum and the Rosenwald Collection of the National Gallery of Art, Washington. The Rosenwald impression is reproduced in Keynes, *Bibliography of Blake*, facing p. 236; and in Keynes, *The Complete Portraiture of William & Catherine Blake*, London: Trianon Press, 1977, Pl. 2 (where Keynes guesses, p. 118, that the man pictured in the tent is Blake). Stothard's preliminary brown ink and pencil sketch (16.5 × 22.2 cm) of the design is in the British Museum. For another print perhaps associated with the boating trip, see XXXV, "An Estuary with Figures in a Boat," in Part Two of this catalogue.

LXVI.

"Robert May, Esq." Russell, *Engravings of Blake*, p. 148, writes that he "is acquainted with this print, but has no notes of any further particulars in regard to it. It is, as far as he remembers, a small print." I have not been able to find this print, dated by Russell c. 1785, or any other reference to it. If Blake did execute such a plate, it is probably a book illustration.

[1] Bray, *Life of Stothard*, pp. 20-21; Bentley, *Blake Records*, pp. 19-20. The latter, p. 621, transcribes an anonymous note, now in the British Museum Print Room, recounting the adventure and attributing the plate to Blake after Stothard.
[2] *Life of Stothard*, p. 21n.

Part Seven.
*Lost, Conjectural,
Misattributed Plates*

LXVII.

"The Ancient of Days" ("God Creating the Universe"), 1794. Keynes, *Engravings by Blake: The Separate Plates*, p. 26, describes a hand-colored impression of this design and an uncolored impression printed in blue, both in his collection, as having been "printed from different plates." The impression in blue is clearly from the same plate used as the frontispiece to *Europe* (1794), and thus Keynes' statement implies that the colored impression must be from another, separate plate. As Keynes points out, "in the coloured version the beard is not so long, and the lines representing the clouds do not correspond with those in the other." Keynes lent his colored impression (anonymously) to the Tate Gallery in 1978, no. 66 (reproduced) in the exhibition catalogue, where it is described by Martin Butlin as "printed from the first state of the plate" used in *Europe* rather than from a different copperplate. Also exhibited, no. 67 (reproduced), was an impression of the design lent (anonymously) by George Goyder and described as possibly "made from a third, hitherto unrecorded state" of the *Europe* plate.[3]

There are a number of significant differences between the Keynes and Goyder prints and uncolored impressions of the *Europe* plate.[4] The figure's beard is considerably shorter, his left arm is longer and narrower (in proportion to the other elements of the composition), his back slopes down to the left at a shallower angle and continues farther to the left, and his facial features are less taut and seen from a less acute angle in the separate prints. The compass arms are spread about four degrees wider in the Keynes print, and about twelve degrees wider in the Goyder print, than in the *Europe* impressions. Except for the short beard and compass angle, these features can also be found in the frontispiece, printed in two colors and hand tinted, in *Europe*, copy D, acquired by the British Museum in 1859. The hand coloring is also generally similar, although the Keynes print looks somewhat faded in comparison to the other two. Like the *Europe*, copy D, frontispiece, the Goyder print has the distinctive strawberry red in the left side of the circle from which the figure leans. These similarities demonstrate the degree to which hand coloring can affect the appearance of a relief etching and suggest that the beard length and even the compass angle could be changed on an impression without altering the copperplate.

One feature, however, requires a change in the copper. The patterns of small crosshatchings in the clouds, printed in golden-yellow in the Keynes and Goyder prints, correspond to those in the *Europe* plate; but both separate prints contain crosshatching in brick red much larger than the patterns in the *Europe* plate, including those printed in the same color in the copy D frontispiece. Further, these patterns are in different locations in the Keynes and Goyder prints, and neither corresponds in position, crossing angle, or size to any impression of the *Europe* frontispiece.

It is difficult to explain how these crosshatching changes could be made on a single piece of copper to convert the Goyder into the Keynes "state" (or vice versa) and then into the *Europe* state.[5] It is easy enough to add more white-line crosshatching to a relief etching, but entire

[3] In the first printing of the Tate exhibition catalogue, the description of the Goyder impression was inadvertently repeated for the next item, no. 68, the Whitworth Art Gallery, Manchester, impression of "The Ancient of Days." This was corrected in the second printing, which correctly describes the Whitworth impression as from the same state of the plate as that used in *Europe*. The Keynes colored impression is reproduced in color in Keynes, *Engravings by Blake: The Separate Plates*, pl. 16; the Goyder impression is reproduced in color in William Blake, *Europe: A Prophecy*, Introduction by G. E. Bentley, Jr., Memphis: American Blake Foundation, 1978, pl. 21.

[4] Thanks to the generosity of their owners, I have been permitted to compare directly the Keynes colored impression with his uncolored print and with the Goyder impression.

[5] A transformation in the other direction (*Europe* into Keynes-Goyder) is not possible because there is at least one posthumous pull of the plate in the *Europe* state (copy M of *Europe* in the Fitzwilliam Museum, Cambridge).

258

patterns cannot be altered radically and shifted about without great difficulty. To cancel the large patterns on the Keynes and Goyder prints and substitute the small *Europe* patterns would require filling in etched depressions and working over the new surfaces once again in white line. I know of no relief etching by Blake clearly exhibiting this type of reworking, and I am not at all certain that it is technically possible. Thus, we are confronted not just with the possibility of two copperplates of this design, but three: *Europe*, Keynes, and Goyder. There is, however, a simple solution to these difficulties.

In the late nineteenth century, William Muir and his assistants began to execute hand-colored lithographic facsimiles of Blake's illuminated books. They also produced a separate facsimile of "The Ancient of Days." The earliest reference to this work I have been able to find is in a four-page advertising flyer issued by the London bookdealer Bernard Quaritch dated May 1885. This flyer, entitled "William Blake's Original Drawings," lists on the last two pages Muir's facsimiles, including "The Act of Creation, a single plate, very richly coloured and beautifully drawn, folio £1.1s."[6] Muir and Quaritch indicate in their advertisements that the facsimiles of the illuminated books were limited to fifty copies at most, and a similar number of "The Ancient of Days" may have been issued. Muir's print is a lithograph, printed in golden-yellow and issued in at least two hand-colored versions. One type, known to me only through two examples in the Metropolitan Museum of Art, New York, is very awkwardly colored, predominantly in red, yellow, pink, black, and blue. Both Metropolitan Museum copies are inscribed in ink, lower left, "This is the Fifth [Eighth] of nine like this | Wm Muir." A watercolor drawing of "The Ancient of Days" in the British Museum has similar amateurish coloring; it was probably also produced by Muir or one of his assistants and used as a guide for coloring the lithograph.

The other version of the Muir "Ancient of Days" is very beautifully hand colored in a far more skillful and convincing manner than can be found in his other facsimiles. Examples of this type are in the collections of Robert N. Essick, The Huntington Library, San Marino, California, a private Boston collection, and two in the Pierpont Morgan Library, New York. These separate prints are on wove paper very similar to the types Blake used. Untrimmed impressions are on sheets about 39 × 28 cm and signed and/or numbered by Muir in ink in the upper left corner. This issue of the Muirs was very probably based on the frontispiece to *Europe*, copy D. Except for their patterns of large crosshatching in brick red, they generally follow this frontispiece in the delineation of the figure, placement of clouds, and coloring. Muir's lithographic image, however, may have been made photographically from an uncolored impression.

As is to be expected in facsimiles with extensive hand coloring, there are considerable variations among copies of the skillfully executed Muir "Ancient of Days." The angle of the compass varies, ranging all the way from the eighty-seven degrees of the *Europe* plate itself (and of the Essick and Huntington copies of the facsimile) to the ninety-nine degrees of the Goyder print and the example of the facsimile in

[6] A copy of the flyer is in my collection. The facsimile was similarly advertised in Quaritch's catalogue of February 1891, item 108, and is listed as "The Ancient of Days" on the printed paper covers of Muir's facsimiles of *Europe* (dated September 1887) and *The Song of Los* (November 1890).

Part Seven.
Lost, Conjectural,
Misattributed Plates

[7] This print, apparently in a private British collection, was brought to Christie's, London, in August 1980 for appraisal, and sold there on 16 December 1980, lot 171 (£60). It is known to me only through a photograph and information kindly supplied by Robin Griffith Jones of Christie's.

[8] The same small flaws in the rays of light left of the extended arm and just below the rim of the circle appear in some (late?) copies of the separate facsimile and in all copies I have seen of the *Europe* facsimile. The dimensions of the framing lines, the only clearly measurable lines in the separate print not covered with hand coloring, are identical. The awkward hand coloring in the *Europe* facsimile is entirely different from the separate issue.

[9] The provenances given in Bentley, *Blake Books*, p. 109, are inaccurate. Everett Frost, who first brought to my attention the facsimile in a Boston private collection, has kindly informed me that the Goyder print is not the one once owned by A. E. Newton, as Bentley conjectures, but was acquired in the 1880s by the father of L. R. Allen, who sold it (anonymously) at Christie's, 10 February 1958, lot 11 (£231 to Agnew's for Goyder). Allen's father told him that he purchased the picture from the artist himself. This may indeed be true if the "artist" was Muir. Bentley's provenance for Keynes' version places it in the W. B. Scott sale, Sotheby's, 21 April 1885, lot 178 (£10 to Thibaudeau), but that work is the Muir watercolor drawing of "The Ancient of Days," discussed above, acquired by the British Museum in May 1885. Since there is no evidence clearly linking either the Keynes or Goyder prints to Scott, there is no reason to believe that either was one of the two "Ancient of Days" he lent to the Burlington Fine Arts Club in 1876, nos. 268 and 307 in the exhibition catalogue. Even if Scott (1811-1890) did own either or both of the prints in question toward the end of his life, such a provenance would not exclude their execution by Muir since we know, from the history of the watercolor drawing of "The Ancient of Days" in the British Museum, that Scott acquired works by that facsimilist.

a Boston collection. The size, number, and position of the patterns of large crosshatching differ considerably from copy to copy. The example in my collection, numbered "28," has printed framing lines about .5 cm from each side of the image and the figure has a long beard extending well beyond the left side of the circle surrounding him. In others (Huntington; Boston, private collection) the beard is short and confined to the circle. One copy on a large sheet, numbered "2," upper left, is without the framing lines and with the short beard.[7] This suggests that the lithograph was first printed without the framing lines and colored with the short beard; later copies have the frame and long beard. Muir apparently used the same lithograph, printed in dark green-gray with the framing lines, for the frontispiece to his 1887 facsimile of *Europe*.[8]

The Keynes and Goyder prints look more like the Muir facsimiles of the "short-beard" type without framing lines than any impression of the *Europe* frontispiece. They are printed in exactly the same golden-yellow color as the Muirs and have the flat and slightly grainy texture of lithography. Neither has the light plate mark almost always present in Blake's impressions of his relief plates. Although the Keynes print lacks the strawberry red found in the Goyder version and the Muir facsimiles, the handling of washes and delineation of forms is in all other respects similar. Both the Keynes and Goyder prints contain one odd feature that clearly links them to Muir's work and makes it most unlikely that either was produced by Blake and used by Muir as his prototype. In all, the bold, dark brick-red crosshatching patterns in the clouds are *painted* on by hand. All crosshatching in all impressions of the *Europe* plate is *printed*, including the small patterns in brick red in copy D. The hand application accounts for the most puzzling difference between the Keynes and Goyder prints and among all of the skillfully executed Muir facsimiles I have seen. Since it is the interstices that are colored and the lines of crosshatching uncolored, the patterns were probably executed by painting on the color and then scraping in the imitation crosshatching with a rounded point. This is a sensible way for a copyist to reproduce crosshatching by hand; it makes no sense for an original printmaker or watercolorist to paint crosshatching onto a print.

The Keynes print is trimmed, and the Goyder print now matted and probably also trimmed, well below the area where Muir numbered and signed his copies. Neither has a provenance that can be traced back before the 1880s.[9] Both prints came to their present owners in practically identical black lacquer frames which probably date from the late nineteenth century.

I believe that the Keynes and Goyder prints of "The Ancient of Days" are facsimiles produced by William Muir in the 1880s. Once these two prints have been properly attributed, there is no further evidence for a copperplate of the subject executed by Blake other than the plate used in *Europe*.

LXVIII.

An illustration to "Night the Fifth" of Edward Young's *Night Thoughts*, 1797. The edition of Young's poem published by Richard Edwards

260

in 1797 includes Blake's forty-three etched and engraved illustrations to "Nights" one through four. In his *William Blake* catalogue of 1927, the London bookdealer Francis Edwards offered item 44, "One leaf from Night 5" (£26). No such illustration is known and I have not been able to find any other independent references to it.

LXIX.

Harmonic Society ticket or card of introduction, signed *Blake Sc. Change Alley.* An impression was lent by Allan R. Brown to the Philadelphia Museum of Art in 1939, no. 226 in the exhibition catalogue, where it is attributed to Blake and tentatively dated *c.* 1798. Our William Blake never lived on Exchange Alley and this plate was executed by the writing engraver William Staden Blake.[10] Other separate plates by W. S. Blake which have sometimes been taken for William Blake's work are the following:

a. Card of L. Parroissien. Lent by Allen R. Brown to the Philadelphia Museum of Art in 1939, no. 227 (reproduced) in the exhibition catalogue, where it is attributed to Blake and dated *c.* 1798-1799.

b. Admission ticket for a concert "For the Naval Monument," 28 May 1800. Attributed to Blake in Russell, *Engravings of Blake*, pp. 169-170.

c. Admission ticket for the "West Middlesex Water Works," 4 December 1809. Attributed to Blake in Russell, *Engravings of Blake*, p. 179.

LXX.

A portrait of George Romney, 1804. In 1803, William Hayley apparently commissioned Blake to engrave a portrait for his projected *Life of Romney*, not published until 1809. Blake refers to the progress of his work on this plate in his letters to Hayley of 7 October, 26 October, and 13 December 1803 ("Mʳ Romney's Portrait goes on with spirit"); and of 27 January, 23 February, 16 March, 4 May (with a reference to a proof of the plate), 22 June ("My Head of Romney is in very great forwardness"), 28 September, 23 October, 18 December, and 28 December 1804.[11] The only plate by Blake published in the book is "Sketch of a Shipwreck," and presumably the portrait plate was rejected even if completed by Blake.[12] I have found only two other references to the existence of this print. The Philadelphia Museum of Art exhibition catalogue of 1939, no. 104, lists an impression: "Portrait of Romney. Line engraving Executed by Blake for Hayley's *Life of Romney*, but rejected. Lent by Lessing J. Rosenwald." Ruthven Todd, in his 1942 edition of Gilchrist's *Life of Blake*, p. 380, also states that there is an impression in the Rosenwald Collection, although he may have based his statement only on the Philadelphia catalogue entry. There is presently no impression in the Rosenwald Collection, now divided between the National Gallery of Art and the Library of Congress, Washington, D.C. I have not been able to locate any impression of this plate. An India ink drawing of Romney attributed to Blake was sold from the collection of Frederick Tatham at Sotheby's, 29 April 1862, lot 178, with seven others (13s. to Ford). This too is untraced.

[10] See Keynes, "Engravers Called Blake," *Blake Studies*, 2d ed., pp. 46-49; G. E. Bentley, Jr., "A Collection of Prosaic William Blakes," *Notes and Queries*, n.s. 12 (May 1965), 172-178.

[11] See Keynes, ed., *Letters of Blake*, pp. 69, 70, 72, 79-82, 84, 89, 97, 100, 104-105, 107.

[12] As Gilchrist states in his *Life of Blake* (1880), I, 213.

Part Seven.
Lost, Conjectural,
Misattributed Plates

LXXI.
A portrait of "Henry Malken [*sic?*]" was sold from the collection of William Bell Scott at Sotheby's, 21 April 1885, lot 168, with "Wilson Lowry," untraced impression 2, and fifteen other prints (14s. to Edward Daniell). No such plate is known, and the catalogue entry is very probably an erroneous reference to the frontispiece, engraved by Cromek after Blake, for Malkin's *Father's Memoirs of His Child*, 1805—see LVI in Part Five of this catalogue.

LXXII.
"Miscellany. Plate XVIII. Gem Engraving." Engraved by Blake and Wilson Lowry after "Farey" for Abraham Rees, *The Cyclopaedia*. The plate was first issued in a fascicle published September 1819 for inclusion in plates volume III. A proof before letters of the lower two-thirds of this plate, with a smudged impression on the verso in the same state, is in the collection of the Pierpont Morgan Library, New York. As Thomas V. Lange has correctly pointed out, these recto-verso proofs are not from the same copperplate as impressions appearing in most copies of *The Cyclopaedia*.[13] Thus, the Morgan proofs would seem to be candidates for inclusion in Part Five of this catalogue covering book illustrations known only through separate impressions. However, the plate represented by the Morgan proofs does appear in at least one copy of *The Cyclopaedia*, now in the Huntington Library, San Marino, California. The entire image is completed and letters added, including the 1819 imprint and signatures found in other published impressions. A possible explanation for this situation is that, after a few impressions were pulled, the Morgan-Huntington copperplate broke and the somewhat inferior plate found in most copies of the book was hastily prepared. For what may be a similar situation, see LIII, "The Battle of Ai," in Part Five of this catalogue.

LXXIII.
"Windsor Castle," signed *I.B.* (J. Barrow?) as the designer and *G. Maile* as the engraver, 1821. In spite of the signatures, this plate has sometimes been attributed to Blake as the engraver in dealers' catalogues, presumably because of its resemblance to its companion print, "M^rs Q" (which see in Part Two of this catalogue for further discussion).

LXXIV.
Prints of theatrical characters published by W. West, London, *c.* 1812-1824. Several are signed *W.B.* and at least one ("Mr. H. Kemble as Massaniello," 17 March 1825) is signed *Blake fect*. These have sometimes been taken for William Blake's work,[14] but they are totally unlike any of his prints. They were no doubt engraved by someone with the same initials and by the "E. Blake" who signed other prints in the group. Christopher Heppner has also demonstrated that the form of the letters in the *Blake* signature on one theatrical plate is very similar to the *E. Blake* on others and is uncharacteristic of William Blake's copperplate signature in the 1820s.[15]

[13] Charles Ryskamp (actually Lange), "A Blake Discovery," *Times Literary Supplement* (14 January 1977), 40. The information is repeated in G. E. Bentley, Jr., "A Supplement to *Blake Books*," *Blake: An Illustrated Quarterly*, 11 (Winter 1977-1978), 150. Lange is probably correct in his claim that Blake's work on the plate was confined to the three images pictured in the Morgan proofs.

[14] The (mis)attribution is made in Godfrey Turner, "A Penny Plain; Twopence Coloured," *Theatre*, 17 (1886), 177-182; Ralph Thomas, "William Blake," *Notes and Queries*, 96 (1898), 454-455.

[15] Heppner, "Blake and *The Seaman's Recorder*: The Letter and the Spirit in a Problem of Attribution," *Blake: An Illustrated Quarterly*, 12 (1978), 15-17.

LXXV.

"Death of the First-Born." Mrs. Alexander Gilchrist lent an "engraving" by this title to the Burlington Fine Arts Club in 1876, no. 284 in the exhibition catalogue. I have not been able to find such a print or any other independent reference to it. The Burlington Club catalogue may be in error in describing the exhibited work as an "engraving," although it is grouped with other etchings and engravings in the show. A pen and india ink drawing of *c.* 1780, now generally known as "War Unchained by an Angel, Fire, Pestilence, and Famine Following" (17.7 × 22.1 cm; Steigal Fine Art, Edinburgh), may represent the death of the first-born; but neither this work nor several related drawings of "Pestilence" and "War" can be traced to Mrs. Gilchrist.

Bibliography of Frequently Cited Works

Exhibition catalogues are listed by exhibiting institution; collection catalogues, by owner. Sale catalogues are not included. Works not listed here are cited in full in the text.

Adelphi University. *William Blake: The Painter as Poet*. An Exhibition Commemorating the 150th Anniversary of the Artist's Death, 19 March—29 May 1977. Catalogue by Donald A. Wolf, Tom Dargan, and Erica Doctorow. Garden City, New York: Swirlbul Library Gallery, 1977.

Albertina, Vienna. *Austellung von Englischen Graphiken und Aquarellen: W. Blake und J.M.W. Turner*. March-April 1937. Vienna, 1937.

Bentley, G. E., Jr. *Blake Books: Annotated Catalogues of William Blake's Writings*. Oxford: Clarendon Press, 1977.

———. *Blake Records*. Oxford: Clarendon Press, 1969.

Bibliothèque Nationale. *Aquarelles de Turner Oeuvres de Blake*. 15 January—15 February 1937. Catalogue by Campbell Dodgson. [Paris], 1937.

Bindman, David. *Blake as an Artist*. Oxford: Phaidon, 1977.

———, ed. *The Complete Graphic Works of William Blake*. [London]: Thames and Hudson, 1978.

Binyon, Laurence, ed. *The Engraved Designs of William Blake*. London: Ernest Benn, 1926.

Blair, Robert. *The Grave*. London: R. H. Cromek, 1808. London: R. Ackermann, 1813.

Blake, William. *The Letters of William Blake*. Edited by Geoffrey Keynes. Third Edition. Oxford: Clarendon Press, 1980.

———. *The Notebook of William Blake*. Edited by David V. Erdman with the assistance of Donald K. Moore. Revised Edition. New York: Readex Books, 1977.

———. *Poetical Sketches*. London, 1783.

———. *The Poetry and Prose of William Blake*. Edited by David V. Erdman, commentary by Harold Bloom. Garden City, New York: Doubleday, 1970. Revision of 1965 edition.

———. *Vala or The Four Zoas*. Edited by G. E. Bentley, Jr. Oxford: Clarendon Press, 1963.

———. *William Blake's Writings*. Edited by G. E. Bentley, Jr. 2 volumes. Oxford: Clarendon Press, 1978.

Blunt, Anthony. *The Art of William Blake*. New York: Columbia University Press, 1959.

[Boston] Museum of Fine Arts. *Exhibition of Books, Water Colors, Engravings, Etc. by William Blake*. 7 February—15 March 1891. Boston, 1891.

———. *Exhibition of Drawings, Water Colors, and Engravings by William Blake*. Second Edition. Boston, 1880.

Bournemouth Arts Club, 7-21 April 1949 [and Southampton Art Gallery, 25 April—5 May 1949, and Brighton Art Gallery, 11 May—6 June 1949]. *An Exhibition of Original Works by William Blake from the Graham Robertson Collection*. [Bournemouth], 1949.

Bray, Mrs. [A.E.]. *Life of Thomas Stothard, R.A.* London: John Murray, 1851.

British Museum. *Guide to an Exhibition of English Art.* Organised by A. M. Hind, A. B. Tonnochy, G. C. Brooke, Eric Millar, and Edward Croft-Murray. Preface by George Hill, January 1934. [London], 1934.

————. *William Blake and His Circle.* Bicentenary Exhibition. [London, 1957].

[Brussels] Musée royal des Beaux-Arts. *William Blake.* Exposition organisée par The British Council. Brussels [1947].

Burlington Fine Arts Club. *Catalogue: Blake Centenary Exhibition.* Introductory Note [and catalogue?] by "L.B." [Laurence Binyon]. London, 1927.

————. *Exhibition of the Works of William Blake.* Introductory Remarks [and catalogue?] by William B. Scott. London, 1876.

California, University of, Santa Barbara. *William Blake in the Art of His Time.* 24 February—28 March 1976. [Exhibition catalogue, general editor Corlette Rossiter Walker. Santa Barbara], 1976.

Cornell University. *William Blake.* An Annotated Catalogue [of an exhibition], 27 February—29 March 1965. [Ithaca, New York], 1965.

Coxhead, A. C. *Thomas Stothard, R.A.* London: A. H. Bullen, 1906.

Cumberland, George. *Thoughts on Outline.* London: Messrs. Robinson and T. Egerton, 1796.

Cunningham, Allan. "William Blake" in *The Lives of the Most Eminent British Painters, Sculptors, and Architects,* pp. 143-188. Volume 2. Second Edition. London: John Murray, 1830.

Dictionary of National Biography, The. Edited by Sir Leslie Stephen and Sir Sidney Lee. 22 volumes. London: Oxford University Press, 1967-1968. Reprinting of the 1917 edition.

Drouin, Galerie René. *William Blake.* Catalogue de l'Exposition organisée par le Galerie René Drouin et The British Council. Paris, 1947.

Easson, Roger R., and Robert N. Essick. *William Blake: Book Illustrator.* Volume I, Normal, Illinois: American Blake Foundation, 1972. Volume II, Memphis, Tennessee: American Blake Foundation, 1979.

Erdman, David V. *Blake: Prophet Against Empire.* Third Edition. Princeton: Princeton University Press, 1977.

————, ed. *The Illuminated Blake.* Garden City, New York: Anchor Books, 1974.

Essick, Robert N., ed. *The Visionary Hand.* Los Angeles: Hennessey & Ingalls, 1973.

————. *William Blake, Printmaker.* Princeton: Princeton University Press, 1980.

————, and Morton D. Paley. *Robert Blair's The Grave Illustrated by William Blake.* London: Scolar Press, 1982.

————, and Donald Pearce, eds. *Blake in His Time.* Bloomington and London: Indiana University Press, 1978.

Fitzwilliam Museum. *William Blake: Catalogue of the Collection in the Fitzwilliam Museum Cambridge.* Edited by David Bindman. Cambridge: Heffer and Sons, 1970.

Fogg Art Museum. *Loan Exhibition of Works of William Blake.* 22 October—15 December 1930. [Cambridge, Massachusetts], 1930.

————. *Works by William Blake Lent to the Fogg Art Museum.* [Cambridge, Massachusetts, 1924]. Typescript in the British Museum, Department of Prints and Drawings.

Garnett, Richard. *William Blake, Painter and Poet.* London: Seeley and Co., 1895.

Gilchrist, Alexander. *Life of William Blake.* 2 volumes. London and Cambridge: Macmillan, 1863. Second Edition. 2 volumes. London: Macmillan, 1880. Edited by W. Graham Robertson. New York: Dodd, Mead, 1906. Edited by Ruthven Todd. London: J. M. Dent, 1942. Revised edition, 1945.

Grolier Club. *Catalogue of Books, Engravings Water Colors & Sketches by William Blake.* 26 January—25 February 1905. [New York], 1905.

————. "William Blake and His Followers [exhibition catalogue]." From the Collection of Charles A. Ryskamp, 13 March—1 June 1974. *Gazette of the Grolier Club.* N.s. nos. 20-21 (June/December 1974), 81-89.

————. *William Blake an Exhibition.* 5 December 1919—10 January 1920. New York, 1919.

Hamburg Kunsthalle [and Frankfurt am Main Kunstinstitut]. *William Blake.* [Exhibition catalogue by David Bindman. Hamburg], 1975.

Hayley, William. *Designs to a Series of Ballads.* Chichester: P. Humphry and R. H. Evans, 1802.

Illinois State University, Normal, Illinois. *Imagination and Vision: Prints and Drawings of William Blake.* [Exhibition catalogue by Pamela D. Kingsbury]. 17 October—7 November 1971. The University of Kansas, Lawrence, 28 November—18 December 1971. [Lawrence, Kansas], 1971.

Iowa, University of. *Blake.* An Exhibition Arranged by the Iowa Print Group, 17 November—8 December 1961. [Iowa City], 1961.

Keynes, Geoffrey. *A Bibliography of William Blake.* New York: Grolier Club, 1921.

————. *Bibliotheca Bibliographici.* A Catalogue of the Library Formed by Geoffrey Keynes. London: Trianon Press, 1964.

————. *Blake Studies.* London: Rupert Hart-Davis, 1949. Second Edition. Oxford: Clarendon Press, 1971.

————. *Drawings of William Blake.* New York: Dover, 1970.

————. *Engravings by William Blake: The Separate Plates.* Dublin: Emery Walker, 1956.

————. *Pencil Drawings by William Blake.* London: Nonesuch Press, 1927.

————. *William Blake's Laocoön.* London: Trianon Press for the Blake Trust, 1976.

————, and Edwin Wolf 2nd. *William Blake's Illuminated Books: A Census.* New York: Grolier Club, 1953.

Klonsky, Milton. *William Blake, the Seer and His Visions.* New York: Harmony Books, 1977.

Lavater, John Caspar. *Essays on Physiognomy.* Translated by Henry

Hunter. 3 volumes. London: John Murray, H. Hunter, and T. Holloway, 1789.

Lindberg, Bo. *William Blake's Illustrations to the Book of Job*. Acta Academiae Aboensis, Series A, Vol. 46. Abo, Finland: Abo Akademi, 1973.

Lister, Raymond. *Infernal Methods: A Study of William Blake's Art Techniques*. London: G. Bell & Sons, 1975.

Little Museum of La Miniatura. *A Descriptive Hand-List* [by Mrs. George M. Millard?] *of a Loan Exhibition of Books and Works of Art by William Blake, . . . Chiefly from the Collection of Mr. Lessing J. Rosenwald*. 16-28 March 1936. Pasadena, California, 1936.

Malkin, Benjamin Heath. *A Father's Memoirs of His Child*. London: Longman, Hurst, Rees, and Orme, 1806.

Manchester Whitworth Institute [now Whitworth Art Gallery, University of Manchester]. *Catalogue of a Loan Collection of Works by William Blake*. March-February 1914. London, 1914. *Note*: This exhibition, with some important changes in items presented, was also shown at the National Gallery, London, City of Nottingham Art Gallery, and the National Gallery of Scotland (which see below).

Morgan, Pierpont, Library. See Thorne, Mrs. Landon K., *Blake Collection of*.

National Gallery, British Art. *Catalogue* [by A.G.B. Russell] *of Loan Exhibition of Works by William Blake*. October-December 1913. Second Edition. London, 1913.

National Gallery of Art, Washington, D.C. *The Art of William Blake*. Bi-Centennial Exhibition, 18 October—1 December 1957 [by Elizabeth Mongan]. Washington, 1957.

Newton, A. Edward. *A Magnificent Farce and Other Diversions of a Book-Collector*. Boston: Atlantic Monthly Press, 1921.

Newton, Miss Caroline, collection of. See Princeton University.

Palmer, Samuel. *The Letters of Samuel Palmer*. Edited by Raymond Lister. 2 volumes. Oxford: Clarendon Press, 1974.

[Pennsylvania] Academy of the Fine Arts. *Examples of the English Pre-Raphaelite School of Painters, Including Rossetti, Burne-Jones, Madox-Brown and Others, Together with a Collection of the Works of William Blake*. 8 December 1892. [Philadelphia], 1892.

Philadelphia Museum of Art. *William Blake 1757-1827. A Descriptive Catalogue* [by Edwin Wolf 2nd and Elizabeth Mongan] *of an Exhibition of the Works of William Blake Selected from Collections in the United States*. Philadelphia, 1939.

Philadelphia, Print Club of. *Illustrated Books and Original Drawings of William Blake* [and] *Drawings, Etchings, Lithographs by Muirhead Bone*. Loaned by Lessing J. Rosenwald. 17 February—1 March 1930. [Philadelphia], 1930.

Princeton University. "*Songs of Innocence and of Experience* and Miss Caroline Newton's Blake Collection [exhibition review]." By Charles Ryskamp. *Princeton University Library Chronicle*, 29 (Winter 1968), 150-155.

Princeton University. *William Blake Engraver*. A Descriptive Catalogue of an Exhibition by Charles Ryskamp. December 1969—February 1970. Princeton, New Jersey, 1969.

Rees, Abraham, ed. *The Cyclopaedia*. 45 volumes. London: Longman, Hurst, Rees, Orme, & Brown, et al., 1802-1820.

Robertson, W. Graham. *The Blake Collection of W. Graham Robertson*. Edited by Kerrison Preston. London: Faber and Faber, 1952.

Rosenwald, Lessing J. *The Lessing J. Rosenwald Collection*. Preface by Frederick R. Goff. Washington: Library of Congress, 1977.

————. *The Rosenwald Collection*. [Compiled by Marion Schild, ed. Frederick R. Goff]. Washington: Library of Congress, 1954.

Royal Academy and the Victoria & Albert Museum. *The Age of Neo-Classicism*. 9 September—19 November 1972. [Exhibition catalogue. London], 1972.

Russell, Archibald G. B. *The Engravings of William Blake*. Boston and New York: Houghton Mifflin, 1912.

Schiff, Gert, *Johann Heinrich Füssli, 1741-1825. Text und Oeuvrekatalog*. 2 volumes. Zurich: Verlag Berichthaus, 1973.

Scotland, National Gallery of. *Catalogue of Loan Exhibition of Works by William Blake and David Scott*. 22 May—4 July 1914. Edinburgh, 1914.

Scotland, National Library of. *William Blake*. A Loan Exhibition, 21 August—30 September 1969. Edinburgh, 1969.

Skidmore College, Saratoga Springs, New York, 21 April—11 May 1980 [and] Union College, Schenectady, New York, 12 May—15 June 1980. *With Corroding Fires: William Blake as Poet, Printmaker, and Painter*. A Descriptive Catalogue by James McCord. Schenectady, New York: Schaffer Library, Union College, 1980.

[Smith, George C., Jr.] *William Blake: The Description of a Small Collection of His Works in the Library of a New York Collector*. New York: privately printed, 1927.

Smith, John Thomas. *Nollekens and His Times*. 2 volumes. London: Henry Colburn, 1828.

Tate Gallery. *William Blake*. 9 March—21 May 1978. [Exhibition catalogue by] Martin Butlin. Second impression with corrections. London, 1978.

————. *William Blake*. [Exhibition] Organized by The British Council. [London], 1947.

Thorne, Mrs. Landon K. *The Blake Collection of Mrs. Landon K. Thorne*. Catalogue by G. E. Bentley, Jr. Exhibited at the Pierpont Morgan Library, 19 November 1971—22 January 1972. New York: Pierpont Morgan Library, 1971.

Todd, Ruthven. *William Blake The Artist*. London: Studio Vista, 1971.

[Tomory, Peter]. *The Poetical Circle: Fuseli and the British*. Exhibition catalogue, April-November 1979. Australia and New Zealand [no cities given], 1979.

Victoria and Albert Museum. *Catalogue of an Exhibition of Drawings, Etchings and Woodcuts by Samuel Palmer and Other Disciples*

of William Blake. 20 October—31 December 1926. Introduction and notes by A. H. Palmer. London, 1926.

Virgil. *The Pastorals of Virgil*. Edited by Robert John Thornton. 2 volumes. Third Edition. London: F. C. & J. Rivingtons, Longman and Co., et al., 1821.

[Walsall] Art Gallery and Museum. *Catalogue of the Second Loan Exhibition of Pictures, Sculpture, etc. in the Art Gallery and Museum*. Works by Blake lent by Mr. Edward J. Shaw. Opened 24 April 1893. [Walsall], 1893.

Young, Edward. *The Complaint, and the Consolation; or, Night Thoughts*. [Illustrations designed and engraved by William Blake]. London: R. Edwards, 1797.

Zurich, Kunsthaus. *Ausstellung der Werke von William Blake*. [Organized by] The British Council. Zurich, 1947.

Index

NOTE: *Page numbers for main catalogue entries appear in bold face type.*

Color Plates

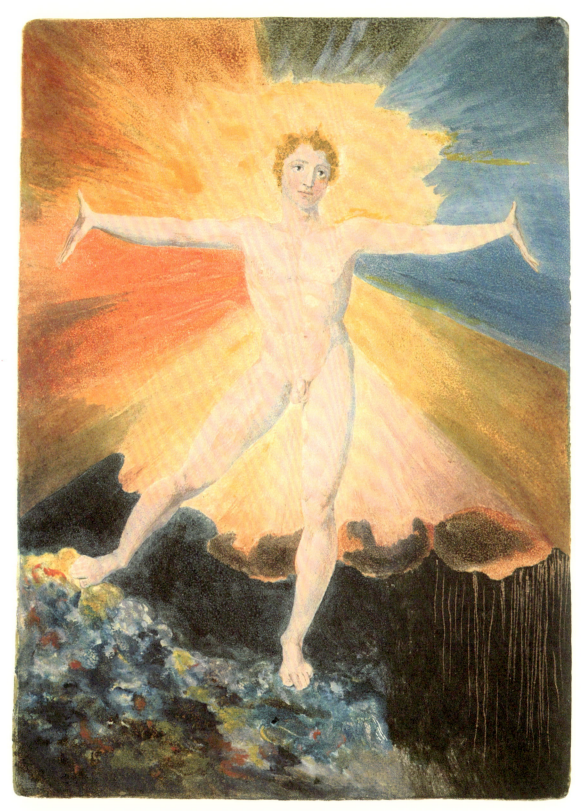

1. "Albion rose." First state, color-printed impression 1A. 27.2 × 20 cm

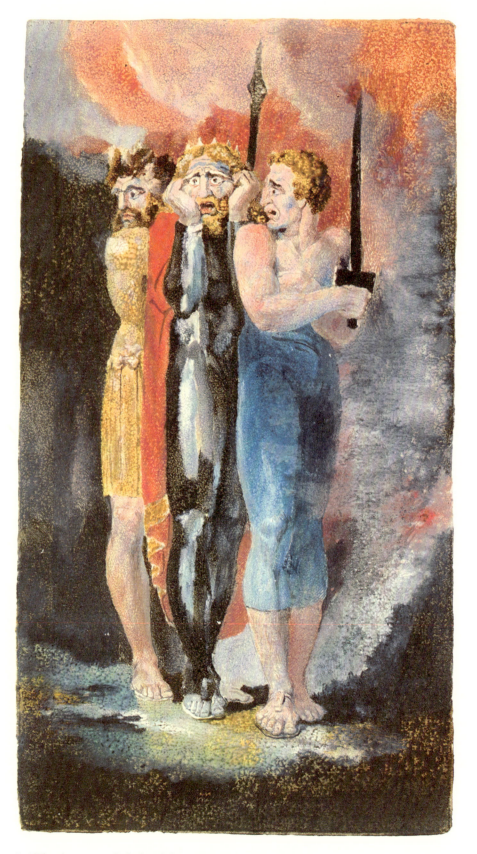

2. "The Accusers of Theft Adultery Murder." Second state,
color-printed impression 2B. 21.5 × 11.8 cm

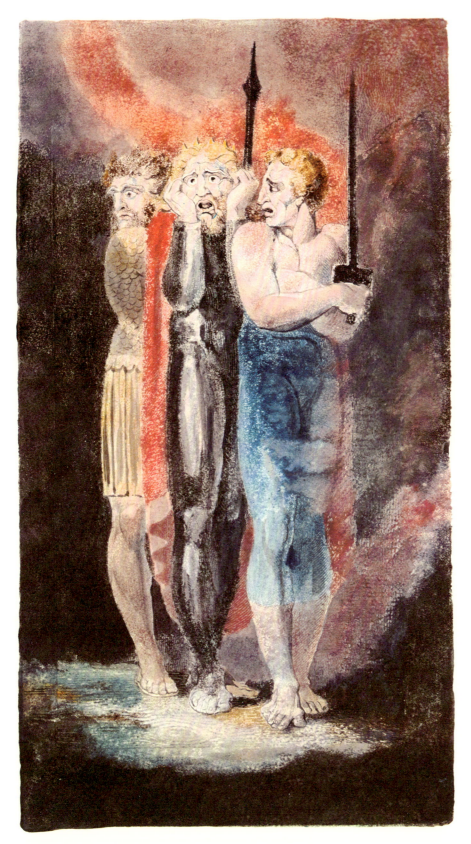

3. "The Accusers of Theft Adultery Murder." Second state,
color-printed impression 2C. 21.4 × 11.9 cm

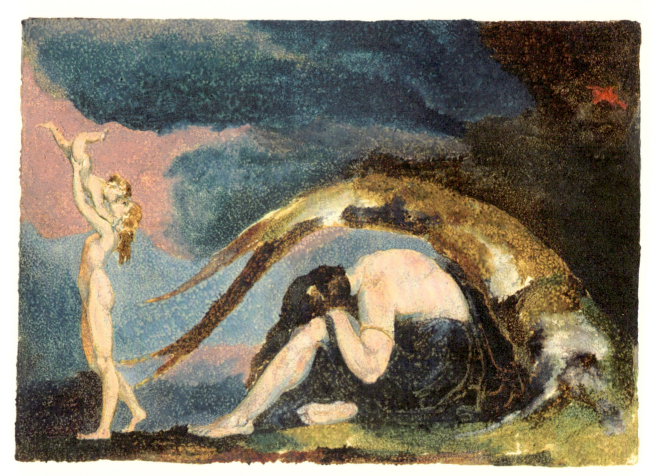

4. "A Dream of Thiralatha." Relief etching. Color-printed impression 1A. 11.7 × 17 cm

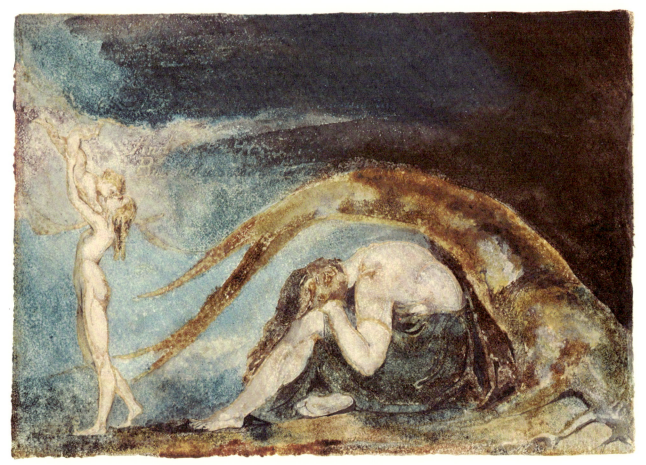

5. "A Dream of Thiralatha." Relief etching. Color-printed impression 1B. 11.7 × 17 cm

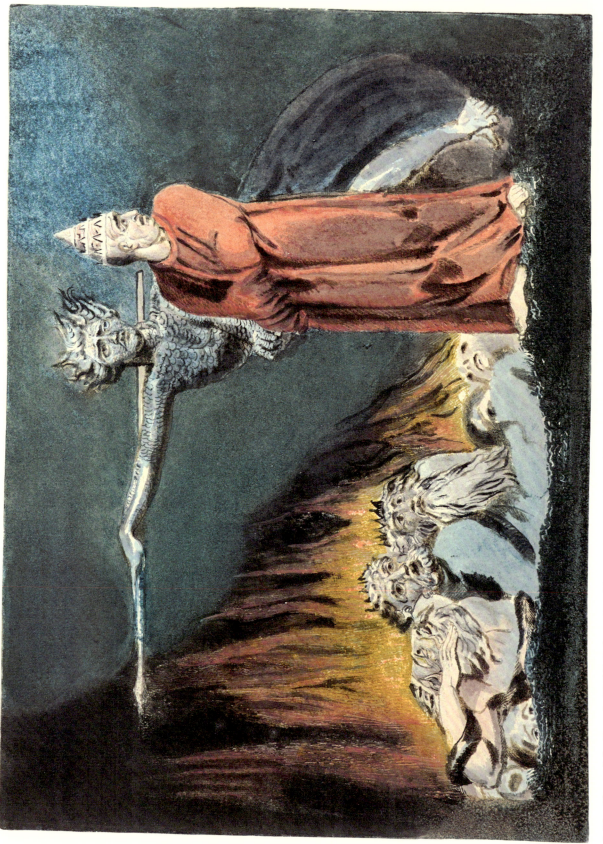

6. "Lucifer and the Pope in Hell." Color-printed impression 1B. 19.9 × 27.4 cm

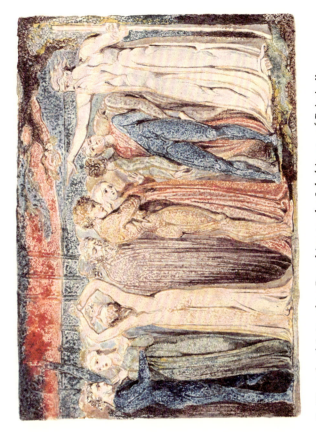

8. "Joseph of Arimathea Preaching to the Inhabitants of Britain."
Relief etching. Color-printed impression 1B. 7.8 × 10.7 cm

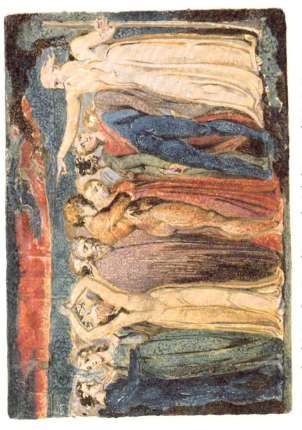

7. "Joseph of Arimathea Preaching to the Inhabitants of Britain."
Relief etching. Color-printed impression 1A. 7.8 × 10.7 cm

9. "An Estuary with Figures in a Boat," after Stothard(?).
Relief etching with color printing(?). 9 × 8.8 cm

Black and White
Illustrations

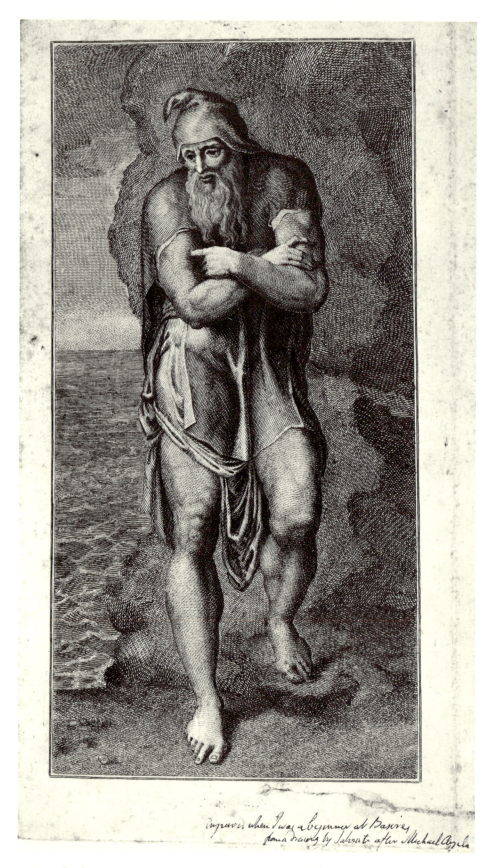

1. "Joseph of Arimathea Among the Rocks of Albion." First state, impression 1A. 22.9 × 11.9 cm

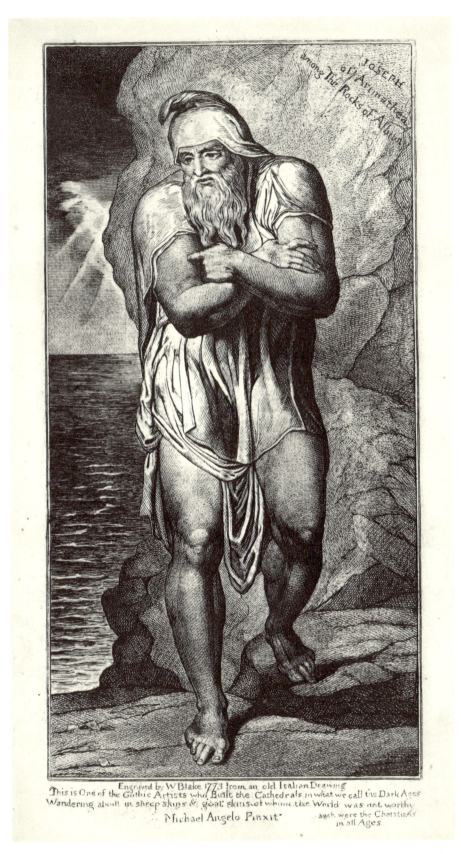

Engraved by W Blake 1773 from an old Italian Drawing
This is One of the Gothic Artists who Built the Cathedrals in what we call the Dark Ages
Wandering about in sheep skins & goat skins of whom the World was not worthy
 such were the Christians
Michael Angelo Pinxit· in all Ages

2. "Joseph of Arimathea Among the Rocks of Albion." Second state, impression 2G.
22.9 × 11.9 cm

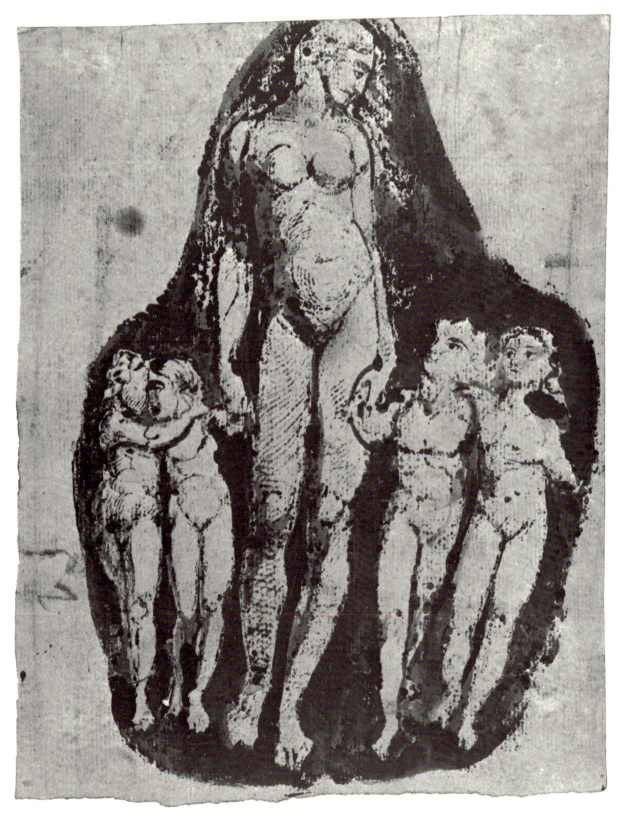

3. "Charity." Planographic transfer print. 18.7 × 13.3 cm

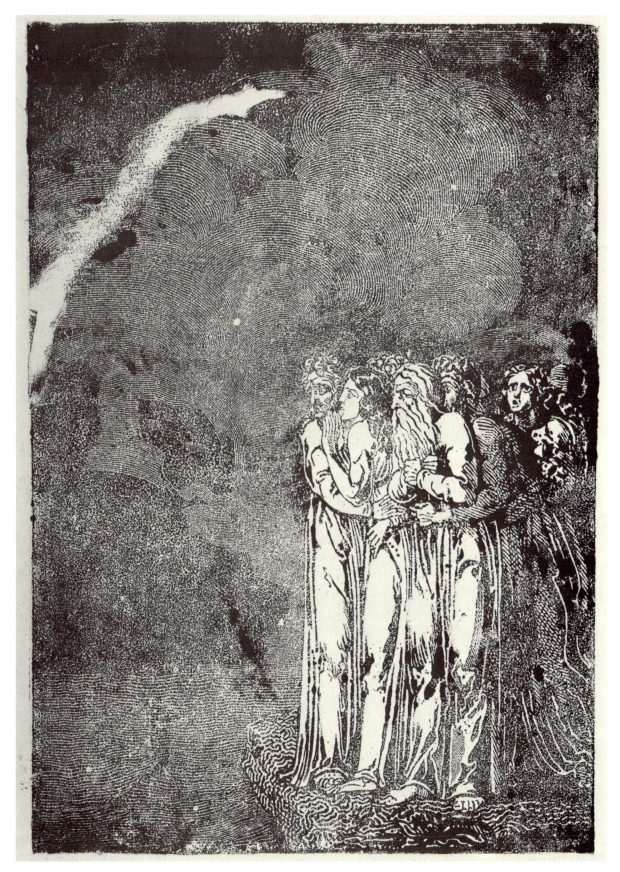

4. "The Approach of Doom." Relief and white-line etching. 29.7 × 20.9 cm

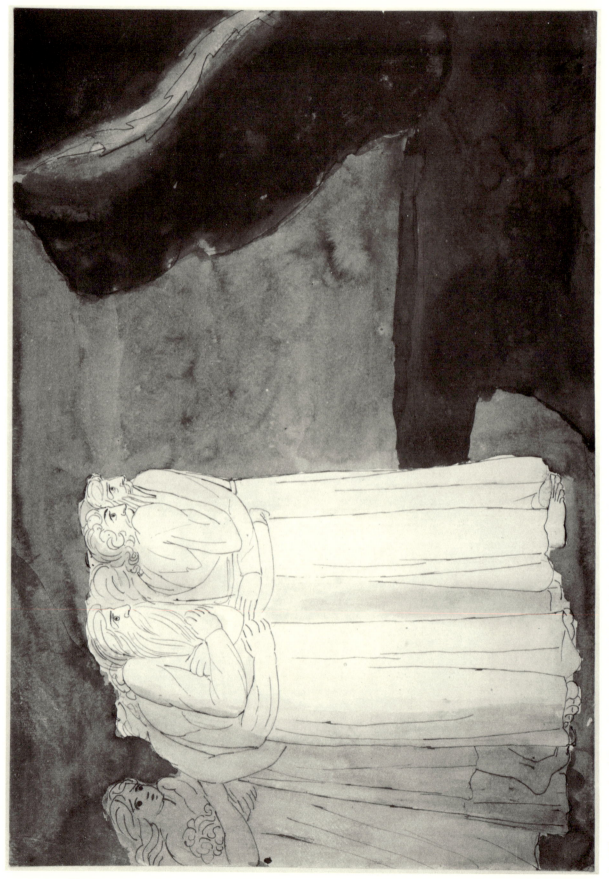

5. "The Approach of Doom." Drawing by Robert Blake. 33.5 × 47.5 cm

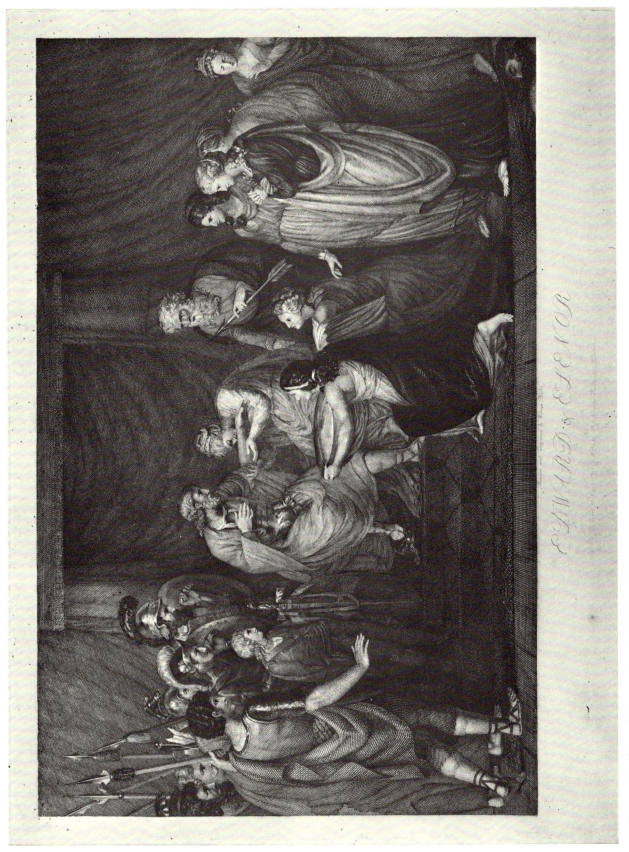

6. "Edward & Elenor." Impression 1B. 30.7 × 45.7 cm

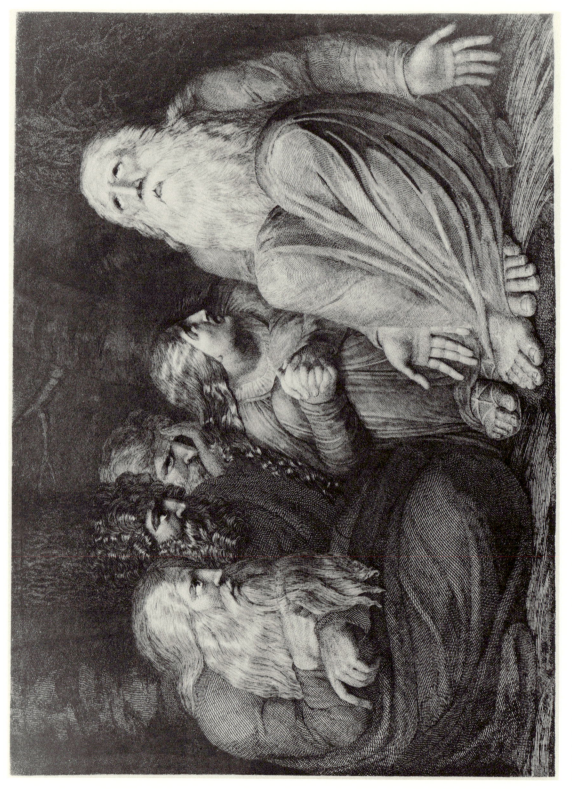

7. "Job." First state, impression 1A. 34.4 × 48.2 cm

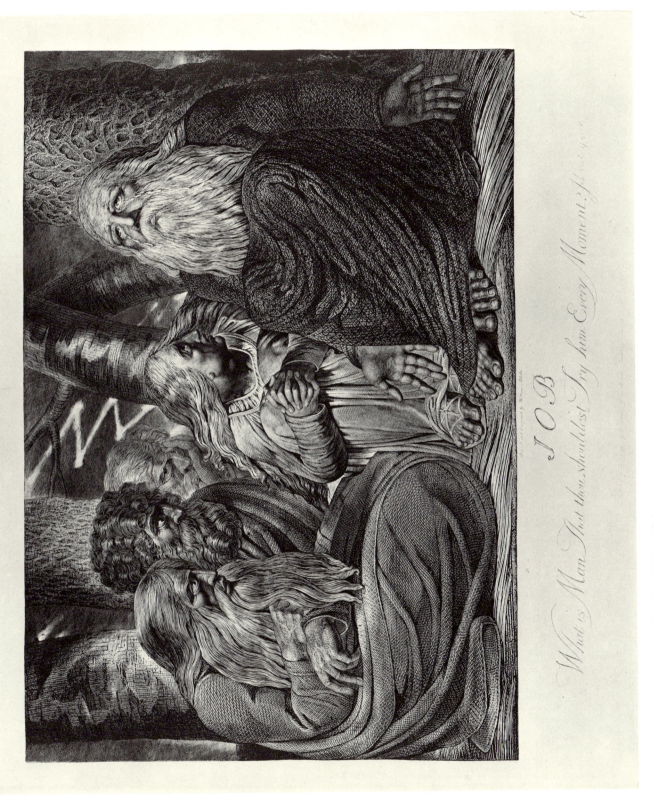

8. "Job." Second state, impression 2D. 34.8 × 49.1 cm

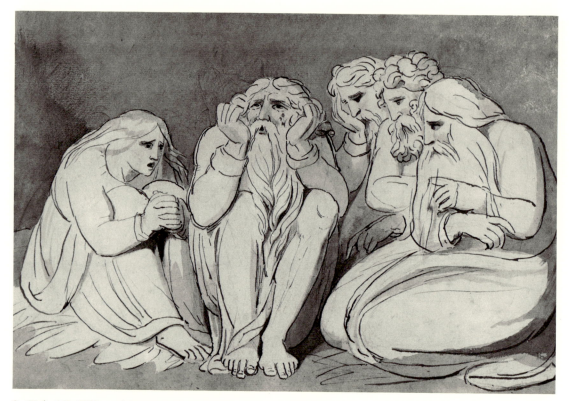

9. "Job, His Wife and His Friends." Drawing. 31.1 × 45.1 cm

10. "Job's Wife." Drawing, verso of Fig. 9. Sheet 31.1 × 45.1 cm

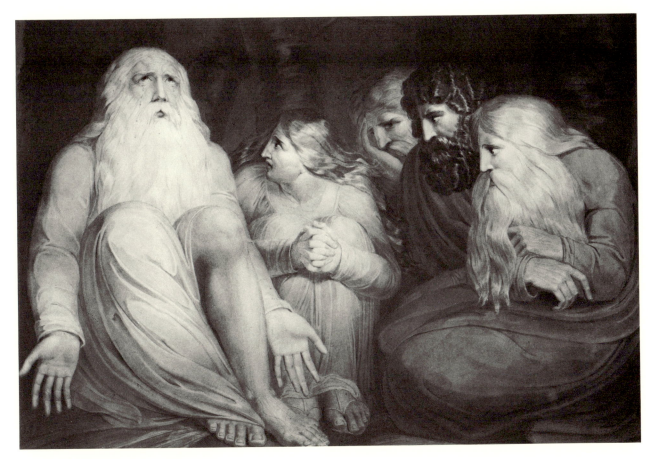

11. "Job." Drawing. 32.2 × 48.2 cm

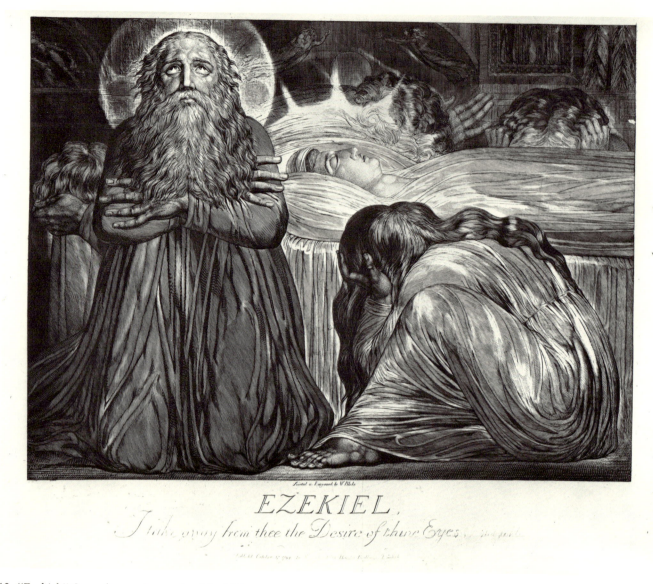

Painted & Engraved by W Blake

EZEKIEL,

I take away from thee the Desire of thine Eyes.

12. "Ezekiel." Second state, impression 2A. 35.5 × 48 cm

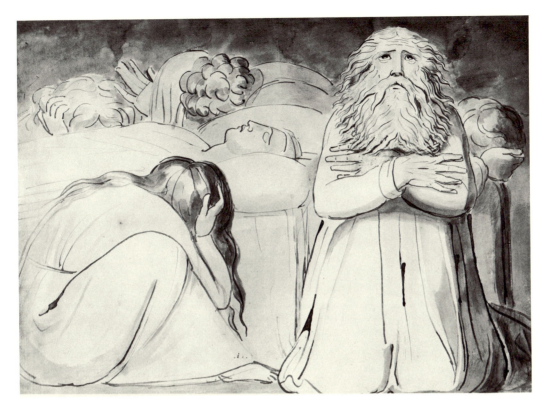

13. "Ezekiel." Drawing. 33 × 47 cm

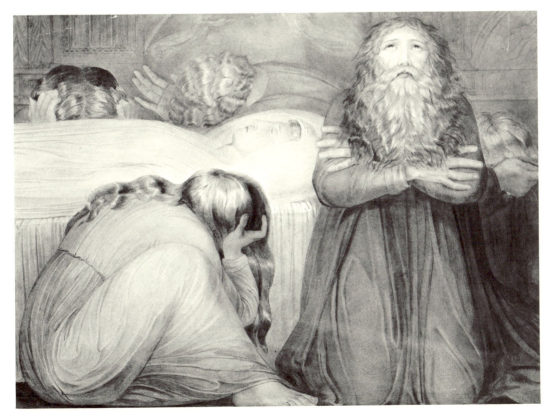

14. "Ezekiel." Drawing. 34.5 × 48 cm

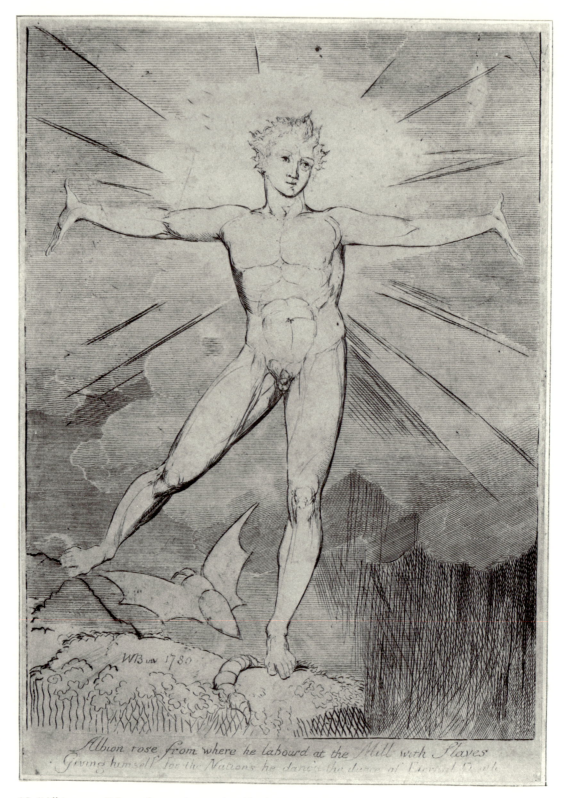

15. "Albion rose." Second state, impression 2D. 25.1 × 18.8 cm

16. "Albion rose." Drawing. Sheet 20.6 × 28.8 cm

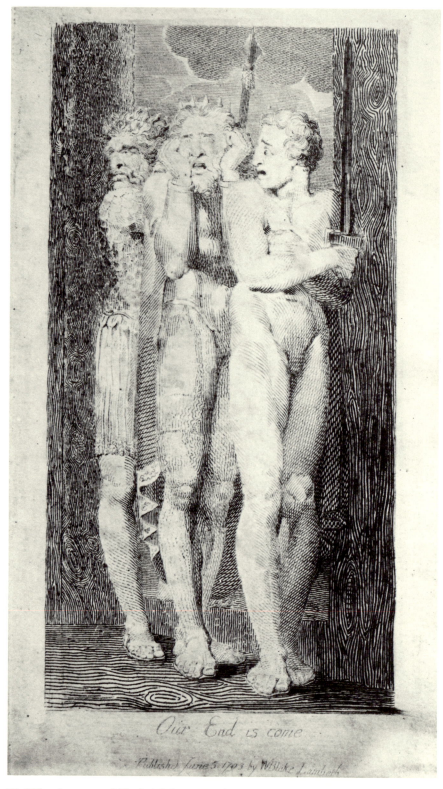

Our End is come

Publish'd June 5 1793 by W Blake Lambeth

17. "The Accusers of Theft Adultery Murder." First state, impression 1A. 18.3 × 9.5 cm

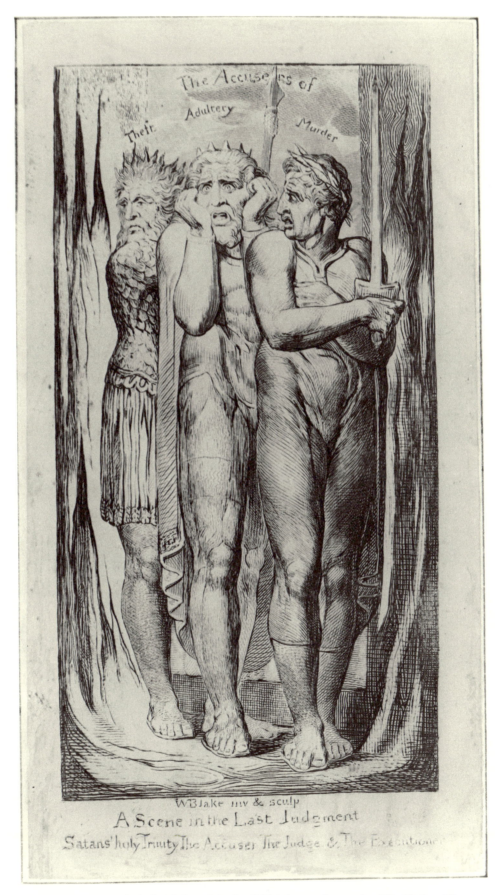

18. "The Accusers of Theft Adultery Murder." Third state, impression 3G. 18.4 × 10 cm

19. "War and the Fear of Invasion." Drawing. 17.9 × 23.9 cm

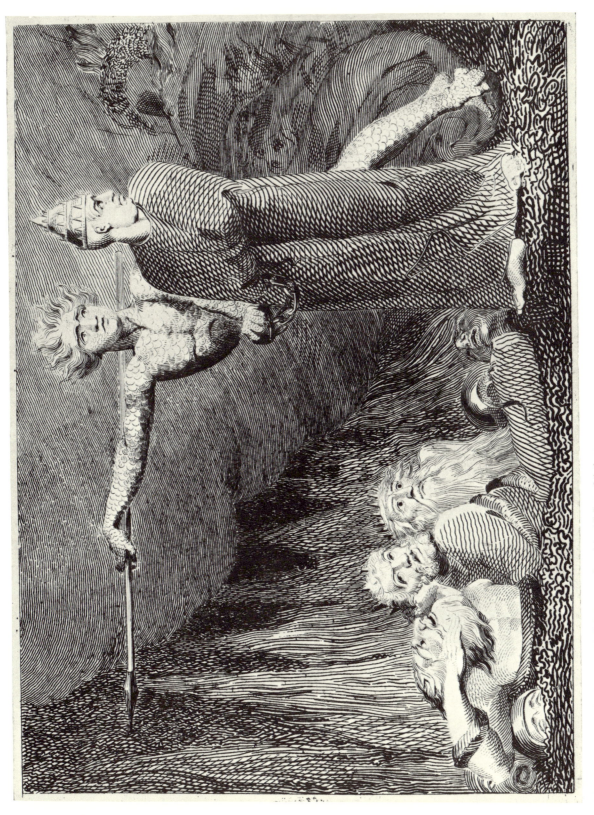

20. "Lucifer and the Pope in Hell." Impression 1A. 18.3 × 24.6 cm

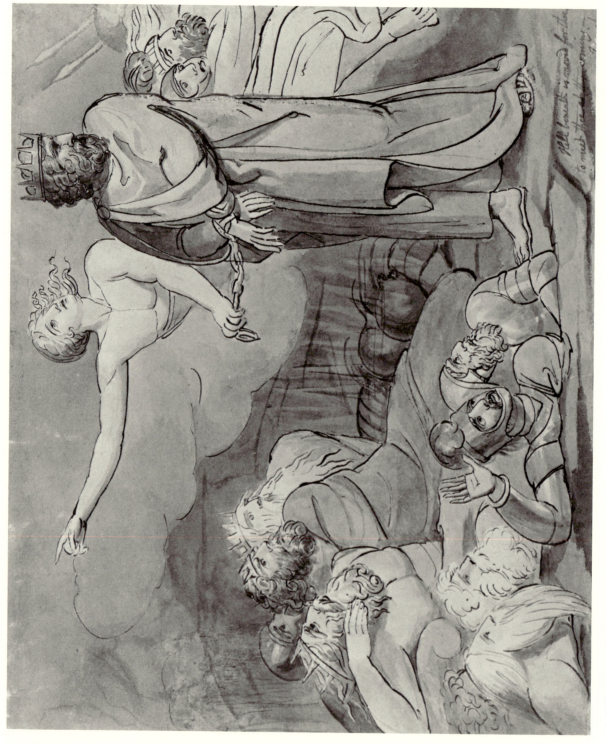

21. "The King of Babylon in Hell." Drawing. 36 × 43.2 cm

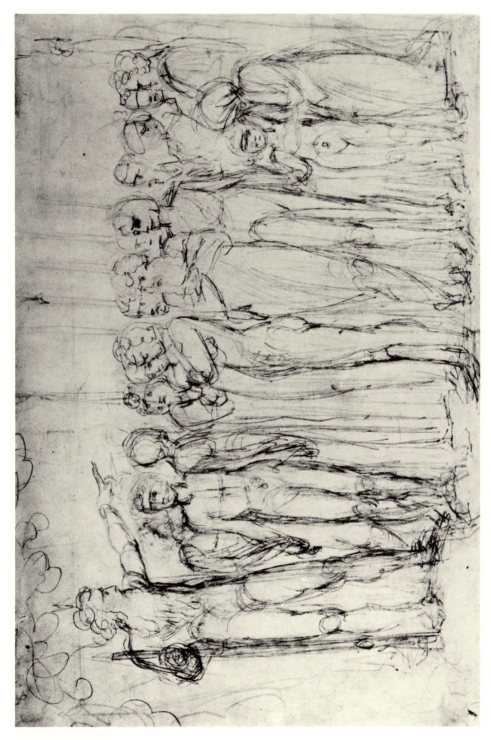

22. "Joseph of Arimathea Preaching." Drawing. 28.5 × 42.1 cm

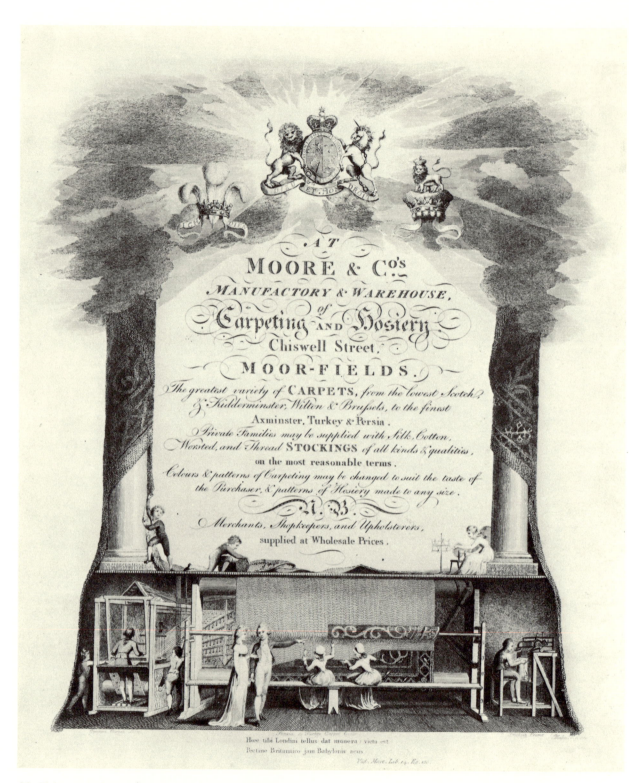

23. "Moore & Co's Advertisement." 26.7 × 22 cm

24. "Moore & Co's Advertisement." Drawing. 21 × 23 cm

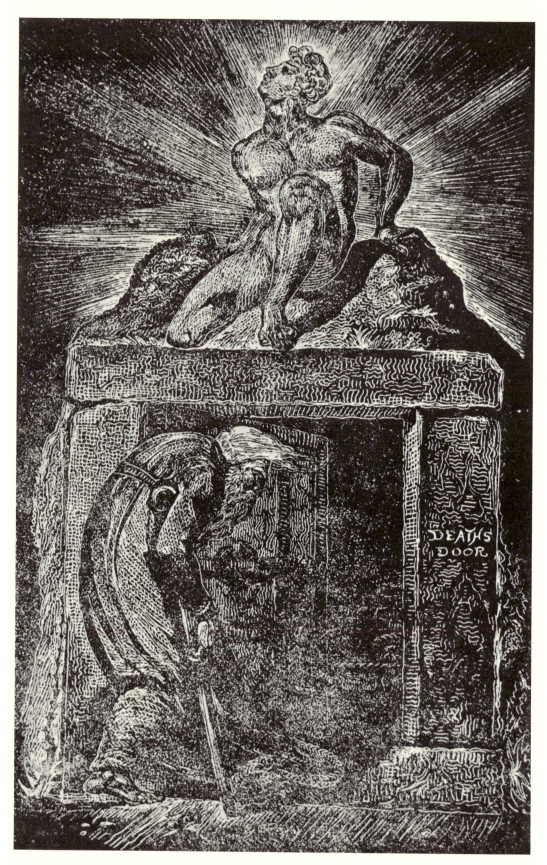

25. "Deaths Door." White-line etching. 18.6 × 11.7 cm

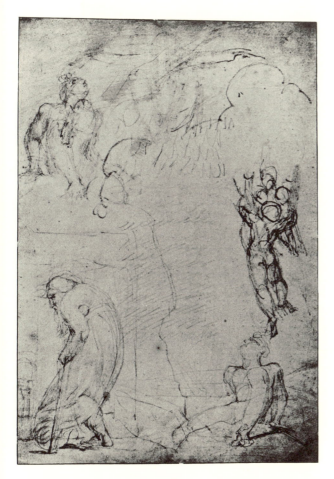

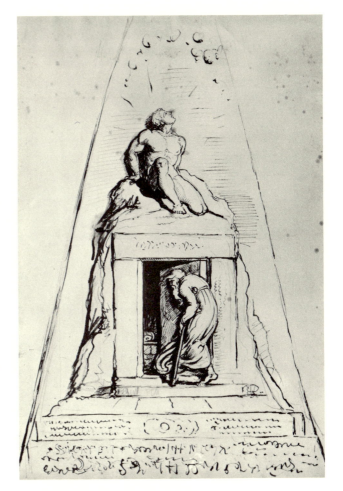

26. "Death's Door." Drawing. 44.4 × 31.8 cm

27. "Death's Door." Drawing. 47 × 32.1 cm

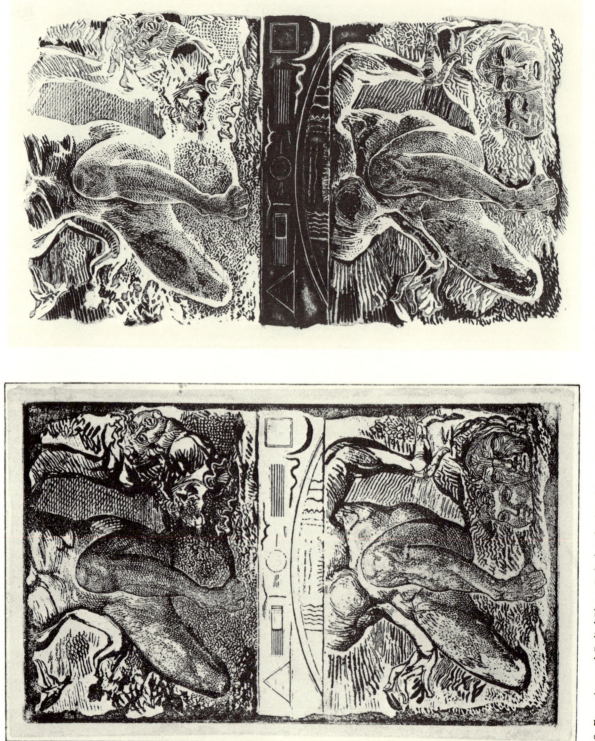

29. Experimental Relief Plate. Relief and white-line etching, per-
haps with engraving. Impression 1B, printed in intaglio. 16.5 ×
9.5 cm

28. Experimental Relief Plate. Relief and white-line etching, perhaps
with engraving. Impression 1A, printed in relief. 16.5 × 9.5 cm

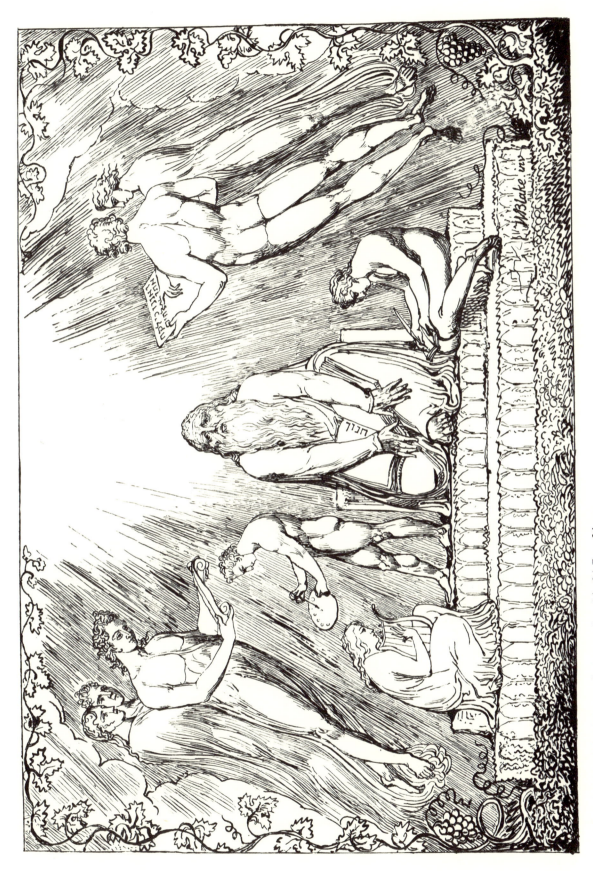

30. "Enoch." Modified lithograph. Impression 1A. 21.7 × 31 cm

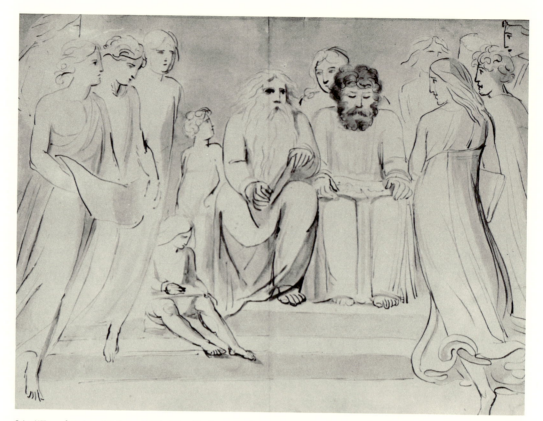

31. "Enoch" (or "Job and His Family Restored to Prosperity" or "Moses and Aaron"). Drawing. 45.7 × 59.7 cm

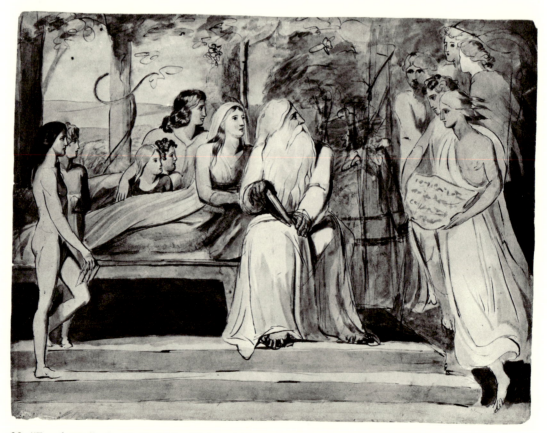

32. "Enoch Walked with God" (or "Job and His Family"). Drawing. 45.4 × 61 cm

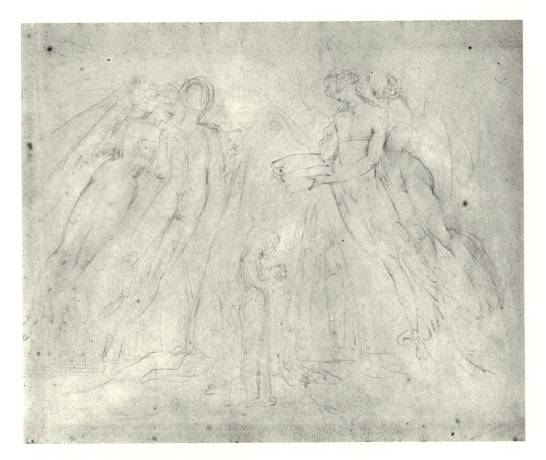

33. "Enoch." Drawing. Sheet 21.2 × 27 cm

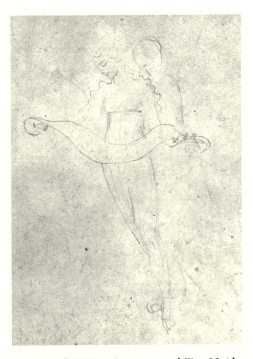

34. "Enoch." Drawing, verso of Fig. 33 (detail). Sheet 21.2 × 27 cm

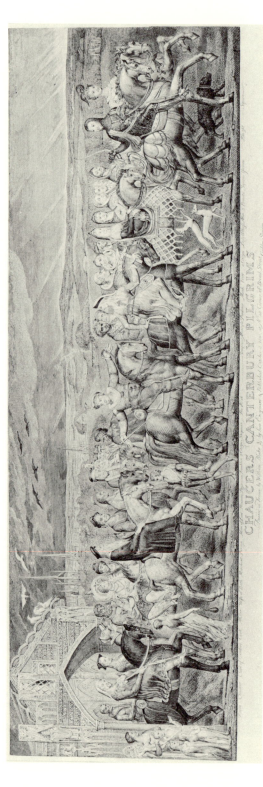

35. "Chaucers Canterbury Pilgrims." First state, impression 1A. 29.9 × 93 cm

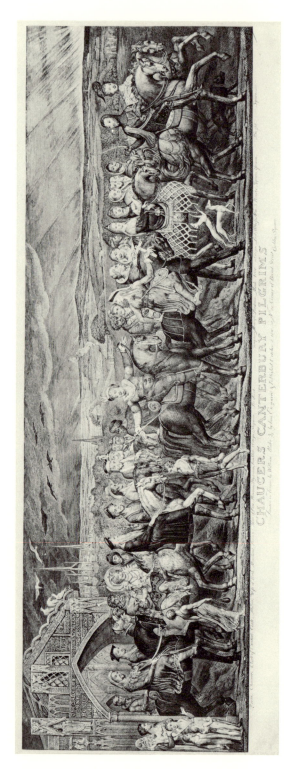

36. "Chaucers Canterbury Pilgrims." Third state, impression 3G. 30 × 93.2 cm

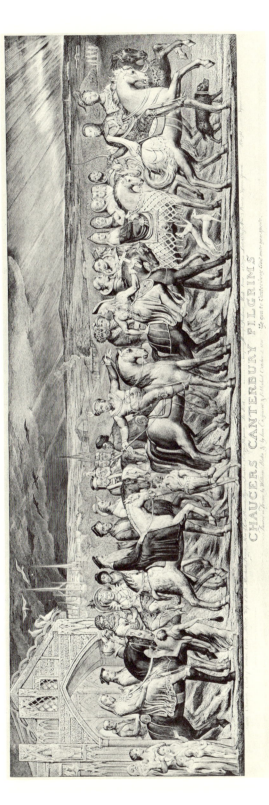

CHAUCERS CANTERBURY PILGRIMS

37. "Chaucers Canterbury Pilgrims." Fourth state, impression 4BB. 30.5 × 94.9 cm

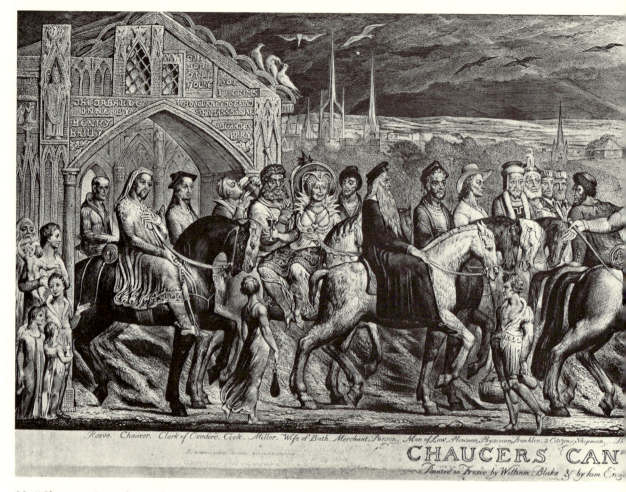

Reeve. Chaucer. Clerk of Oxenford. Cook. Miller. Wife of Bath. Merchant. Parson. Man of Law. Plowman. Physician. Franklin. 2 Citizens. Shipman. Sh

CHAUCERS CAN
Painted in Fresco by William Blake & by him Eng

38. "Chaucers Canterbury Pilgrims." Fourth state, impression 4BB. Detail of left half of the print. 30.5 × 45.7 cm

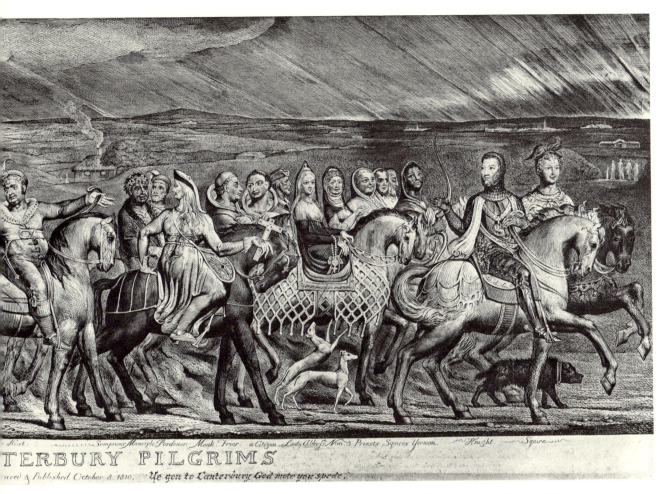

. "Chaucers Canterbury Pilgrims." Fourth state, impression 4BB. Detail of right half of the print. 30.5 × 50.2 cm

40. "Chaucers Canterbury Pilgrims." Fourth state, impression 4BB. Detail of scratched inscriptions, left of the title. 2.9 × 24.2 cm

41. "Chaucers Canterbury Pilgrims." Fourth state, impression 4BB. Detail of scratched inscriptions, right of the title. 2.4 × 24.2 cm

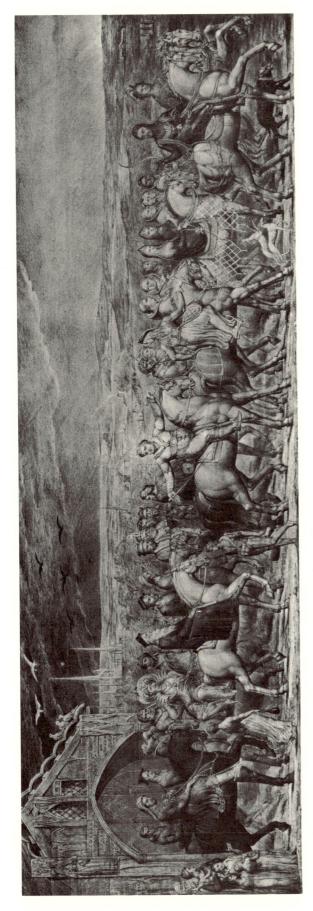

42. "Chaucer's Canterbury Pilgrims." Tempera painting. 46.7 × 137 cm

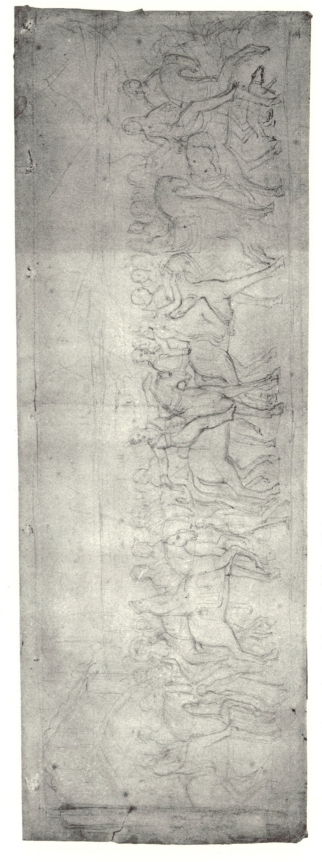

43. "Chaucer's Canterbury Pilgrims." Drawing. 34.3 × 95.4 cm

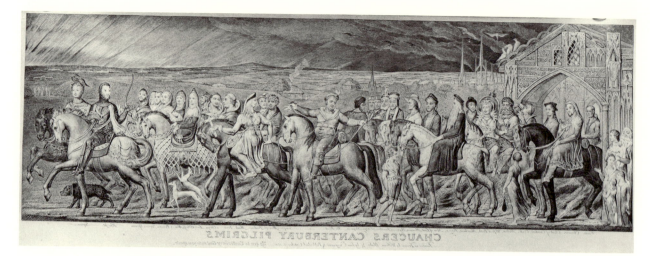

44. "Chaucers Canterbury Pilgrims." Original copperplate. Plate 35.7 × 97.1 cm

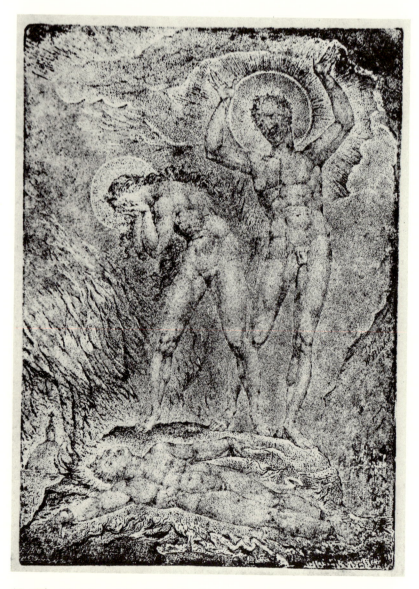

45. "The Chaining of Orc." Relief etching(?). Impression 1A. 11.1 × 8 cm

6.

For conscious of her every care
He strain'd each feeling nerve
To please that friend, his lady fair
Commanded him to serve.

7.

Of many friends to Lucy dear,
One rose above the rest;
Proclaim'd, in glory's bright career,
The monarch of her breast.

And

H 2

Tender

46. "The Chaining of Orc." Drawing. Sheet 18.7 × 28.5 cm

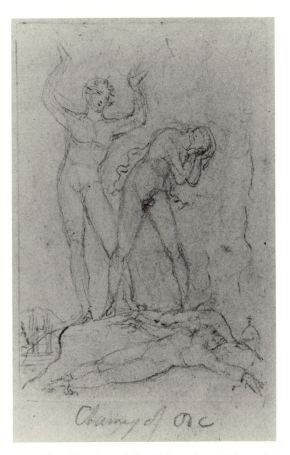

Chaining of Orc

47. "The Chaining of Orc." Drawing. 11.1 × 7.4 cm

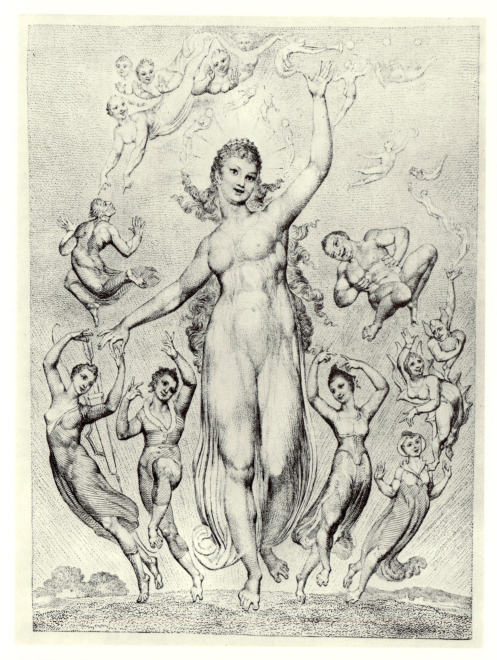

48. "Mirth." First state, impression 1A. 16.1 × 12.2 cm

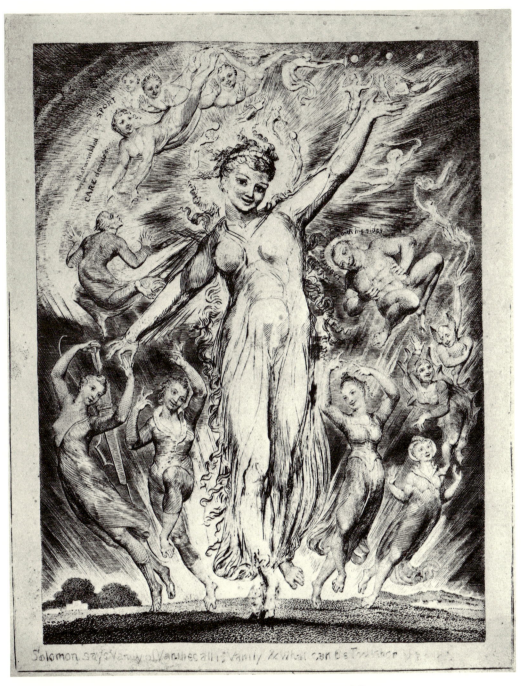

49. "Mirth." Second state, impression 2B. Framing lines 17.6 × 13.8 cm

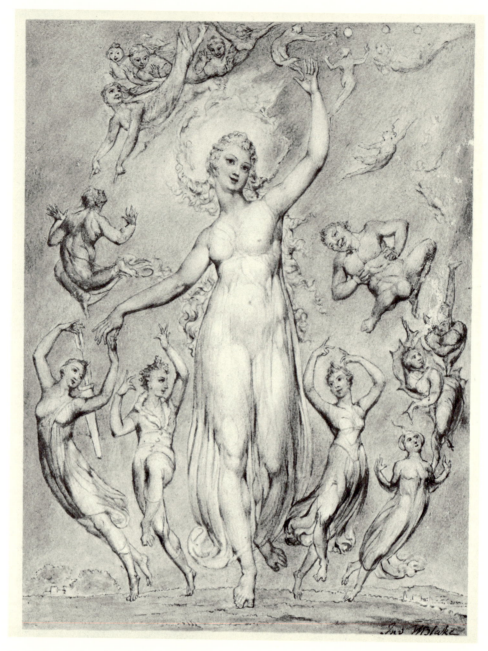

50. "Mirth." Drawing. 16.1 × 12.1 cm

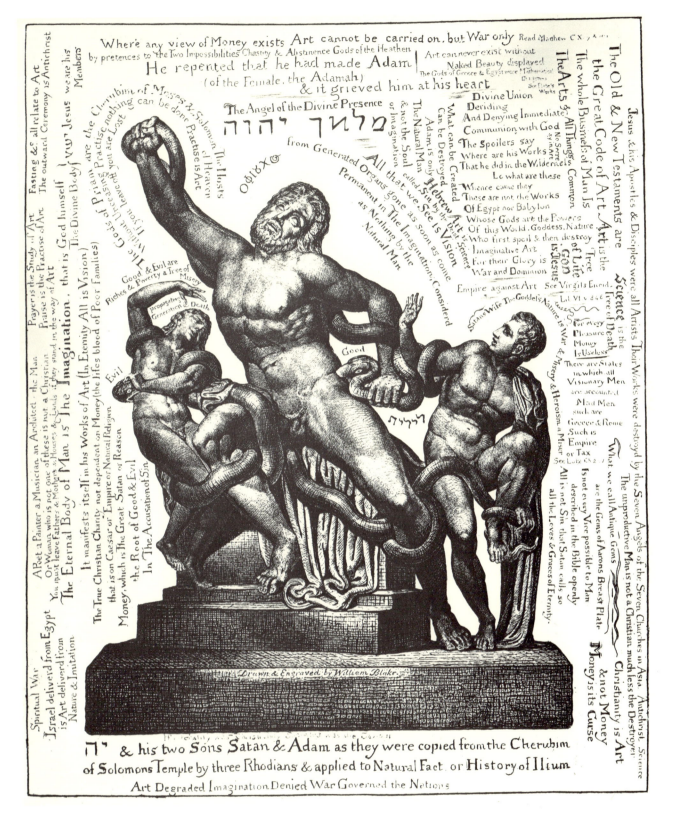

Where any view of Money exists Art cannot be carried on, but War only Read Matthew C X [X]

by pretences to the Two Impossibilities Chastity & Abstinence Gods of the Heathen

He repented that he had made Adam
(of the Female, the Adamah)
& it grieved him at his heart

Art can never exist without Naked Beauty displayed
The Gods of Greece & Egypt were Mathematical Diagrams See Plato's Works

The Angel of the Divine Presence מלך יהוה

Jesus & his Apostles & Disciples were all Artists Their Works were all destroyd by the Seven Angels of the Seven Churches in Asia Antichrist Science

The Old & New Testaments are the Great Code of Art Art is the Tree of Life Art is the Tree of Death GOD is JESUS

The whole Business of Man Is The Arts & All Things Common No Secret in Art

Spiritual War Israel deliverd from Egypt is Art deliverd from Nature & Imitation

A Poet a Painter a Musician an Architect: the Man Or Woman who is not one of these is not a Christian You must leave Fathers & Mothers & Houses & Lands if they stand in the way of Art The Eternal Body of Man is The Imagination. that is God himself The Divine Body ישוע Jesus we are his Members

Fasting &c. all relate to Art The outward Ceremony is Antichrist
Prayer is the Study of Art Praise is the Practise of Art

The Gods of Priam are the Cherubim of Moses & Solomon The Hosts of Heaven
Without Unceasing Practise nothing can be done Practise is Art If you leave off you are Lost

Good & Evil are Riches & Poverty a Tree of Misery
Propagating Generation & Death

All that we See is Vision from Generated Organs gone as soon as come Permanent in The Imagination, Considerd as Nothing by the Natural Man

The Natural Man is by the Deist Science called Sin Hebrew Art & not the Soul or Imagination

Good
Evil

Divine Union
Deriding
And Denying Immediate
Communion with God
The Spoilers say
Where are his Works
That he did in the Wilderness
Lo what are these
Whence came they
These are not the Works
Of Egypt nor Babylon
Whose Gods are the Powers
Of this World. Goddess, Nature
Who first spoil & then destroy
Imaginative Art
For their Glory is
War and Dominion

Empire against Art See Virgils Eneid. Lib VI v 848

What can be Created Can be Destroyed Adam is only The Natural Man & not the Soul or Imagination

Science is the Tree of Death

Satans Wife The Goddess Nature is War & Misery & Heroism a Miser

For every Pleasure Money Is Useless

There are States in which all Visionary Men are accounted Mad Men such are Greece & Rome Such is Empire or Tax See Luke Ch 2 v 1

What we call Antique Gems are the Gems of Aarons Breast Plate

Is not every Vice possible to Man described in the Bible openly All is not Sin that Satan calls so all the Loves & Graces of Eternity.

The unproductive Man is not a Christian much less the Destroyer
Christianity is Art & not Money Money is its Curse

The True Christian Charity not dependent on Money (the lifes blood of Poor Families) that is on Caesar or Empire or Natural Religion Money, which is The Great Satan or Reason the Root of Good & Evil In The Accusation of Sin

It manifests itself in his Works of Art (In Eternity All is Vision)

Drawn & Engraved by William Blake

ה' & his two Sons Satan & Adam as they were copied from the Cherubim of Solomons Temple by three Rhodians & applied to Natural Fact. or History of Ilium

Art Degraded Imagination Denied War Governed the Nations

51. "Laocoön." Impression 1A. 26.2 × 21.6 cm

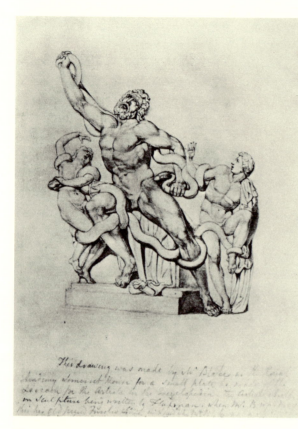

52. "Laocoön." Drawing. 19 × 15 cm

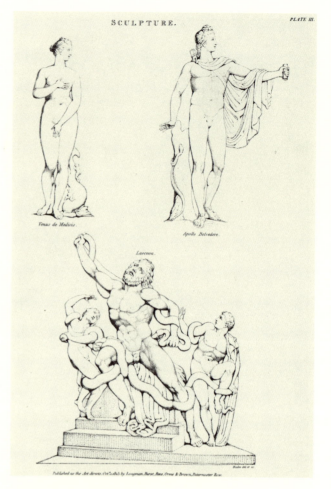

53. "Sculpture, Plate III," from Abraham Rees, *The Cyclo-paedia.* 25 × 14.8 cm

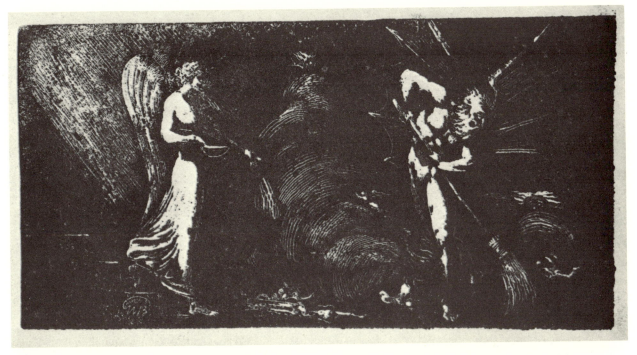

54. "The Man Sweeping the Interpreter's Parlour." White-line metal cut. First state, impression 1A. 8 × 16.1 cm

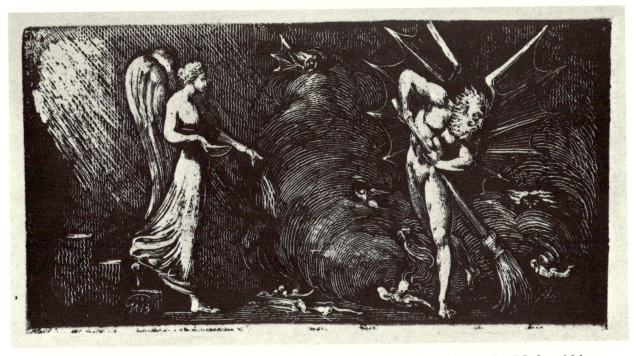

55. "The Man Sweeping the Interpreter's Parlour." White-line metal cut. Second state, impression 2C. 8 × 16.1 cm

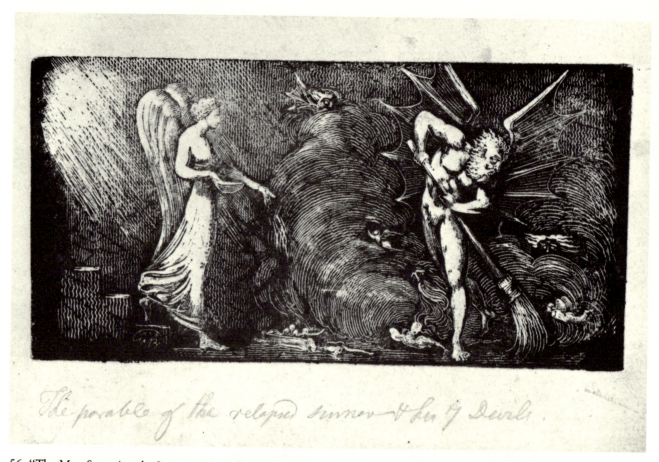

The parable of the relapsed sinner & his 7 Devils.

56. "The Man Sweeping the Interpreter's Parlour." White-line metal cut. Second state, impression 2D. 8 × 16.1 cm

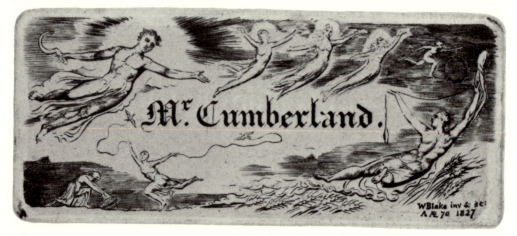

57. "George Cumberland's Card." Impression 1G. 3.1 × 7.8 cm

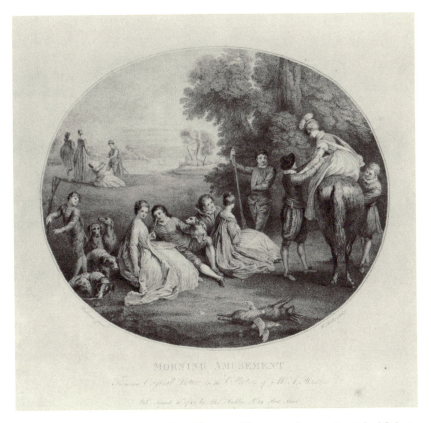

58. "Morning Amusement," after Watteau. First state, impression 1A. 25.4 × 30.3 cm

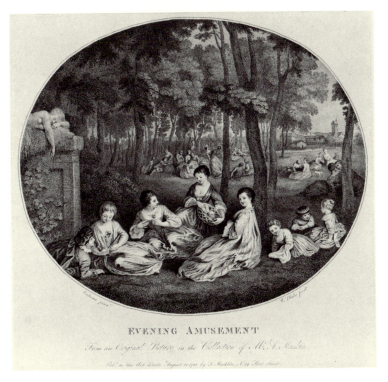

59. "Evening Amusement," after Watteau. Second state, impression 2B. 25.2 × 30.3 cm

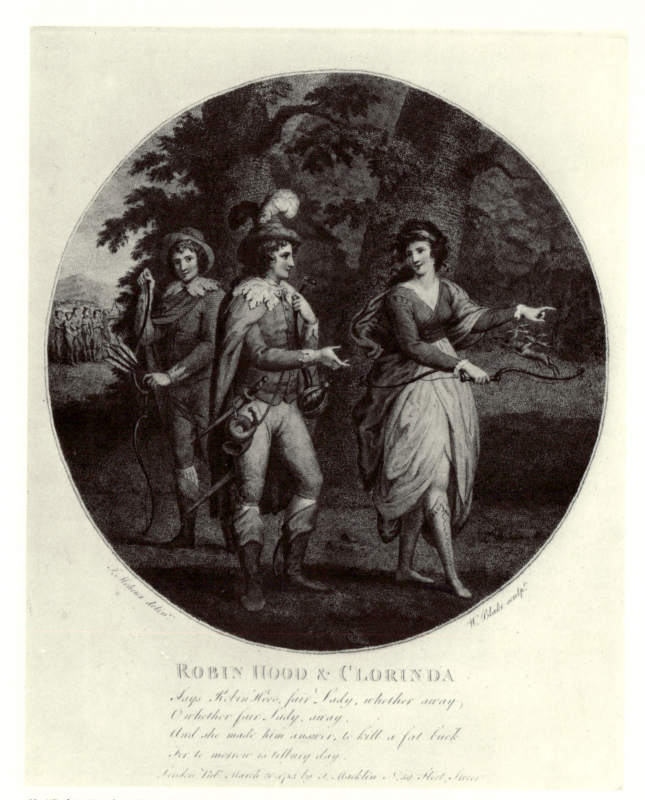

ROBIN HOOD & CLORINDA

Says Robin Hood, fair Lady, whether away,
O whether fair Lady, away.
And she made him answer, to kill a fat buck
For to morrow is tilbury day.

London Pub. March 30 1783 by S. Macklin N.39 Fleet Street

60. "Robin Hood & Clorinda," after Meheux. Impression 1A. 21.4 × 21.5 cm

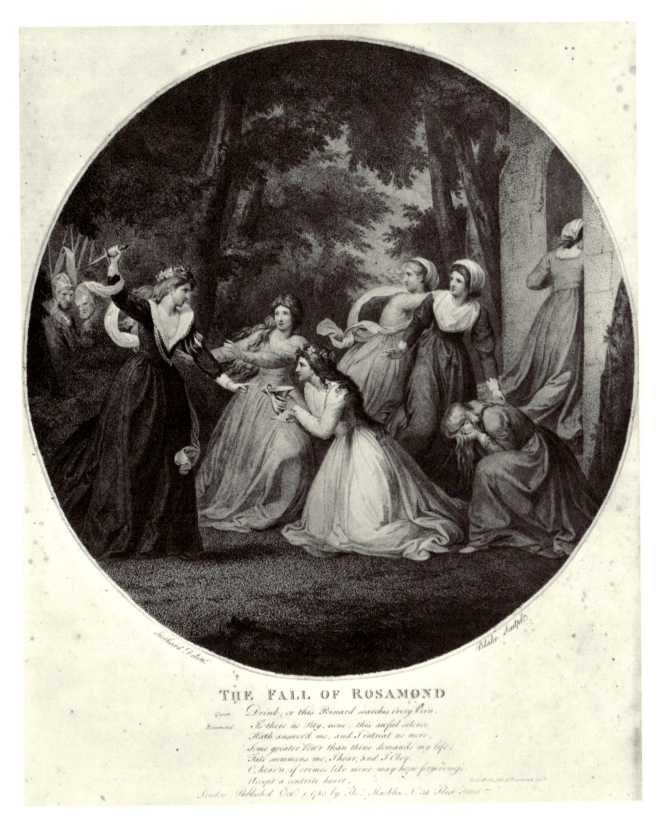

THE FALL OF ROSAMOND

Queen: *Drink, or this Poinard searches every Vein.*

Rosamond: *Is there no Pity, none, this awful silence*
Hath answer'd me, and I intreat no more,
Some greater Pow'r than thine demands my life,
Fate summons me, I hear, and I Obey,
O heav'n, if crimes like mine may hope forgiveness,
Accept a contrite heart.

London Publish'd Oct.r 1. 1783 by Tho.s Macklin N.o 39 Fleet Street

61. "The Fall of Rosamond," after Stothard. Second state, impression 2F. 30.7 × 30.7 cm

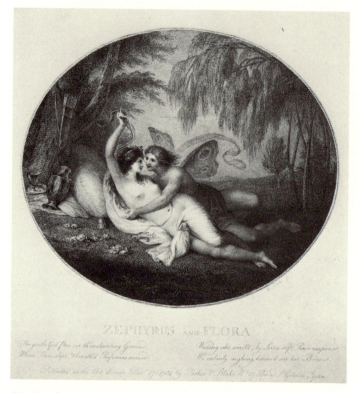

62. "Zephyrus and Flora," after Stothard. First state, impression
1A. 17.4 × 20.5 cm

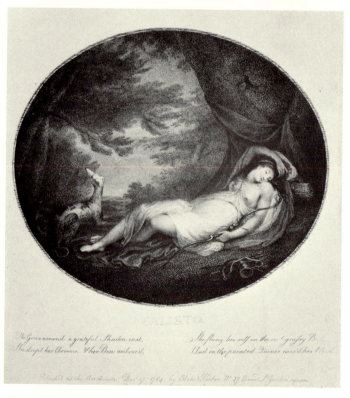

63. "Calisto," after Stothard. First state, impression 1A. 17.2 ×
20.3 cm

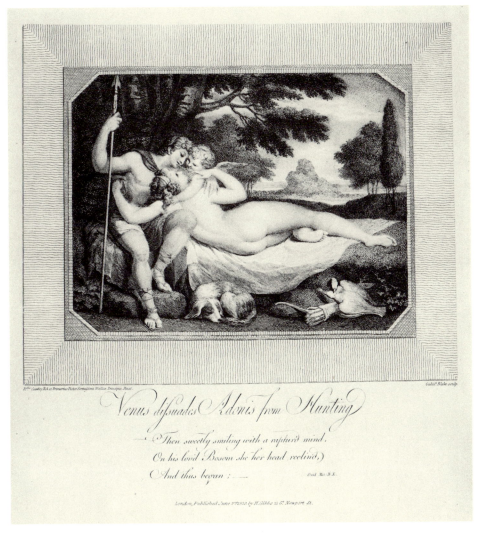

64. "Venus dissuades Adonis from Hunting," after Cosway. Second state, impression 2A.
13.9 × 17.3 cm

65. "Rev. John Caspar Lavater," after an unknown artist. First state, impression 1A. Detail of the inscriptions below the image. 8.3 × 23.2 cm

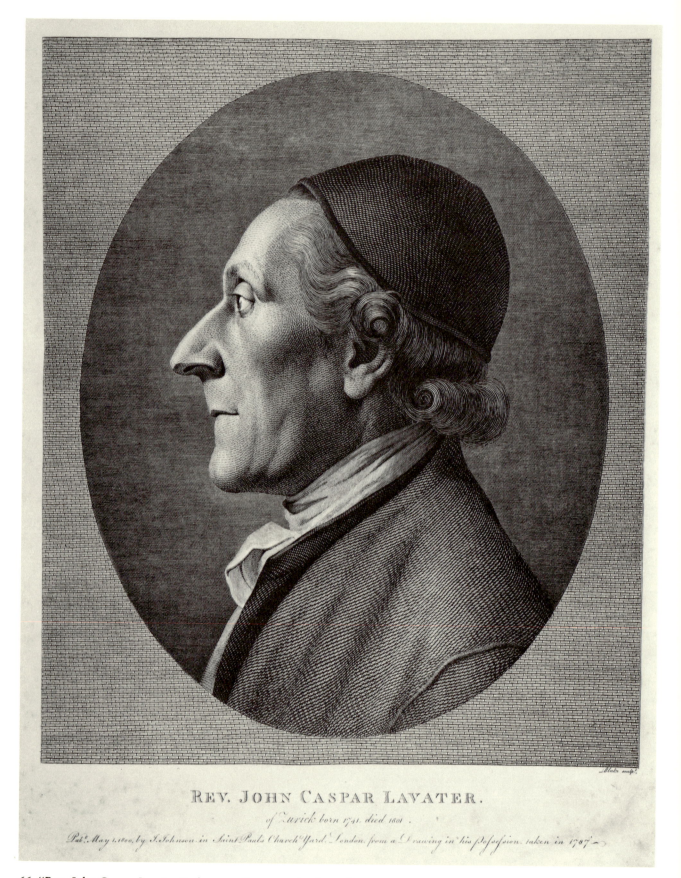

REV. JOHN CASPAR LAVATER.

of Zurick born 1741. died 1801 .

Pub^d May 1.1800, by J. Johnson in Saint Pauls Church Yard. London. from a Drawing in his possession. taken in 1787.

66. "Rev. John Caspar Lavater," after an unknown artist. Second state, impression 2B. 27.7 × 23.9 cm

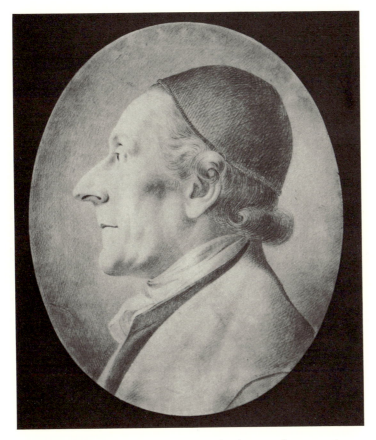

67. "Rev. John Caspar Lavater." Drawing by an unknown artist.
40.9 × 33.2 cm

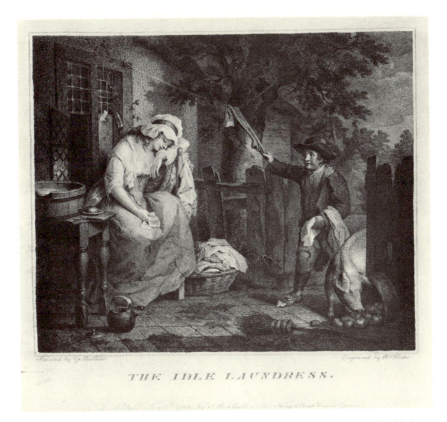

68. "The Idle Laundress," after Morland. Second state, impression 2B. 21.1 ×
26.1 cm

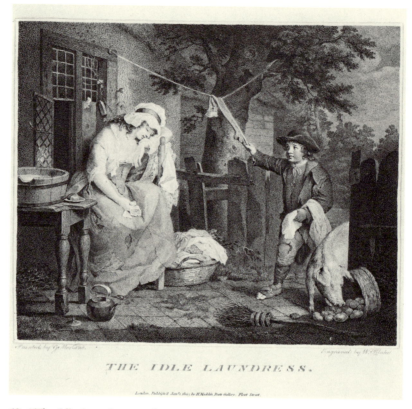

69. "The Idle Laundress," after Morland. Third state, impression 3D. 21.1 × 26.1 cm

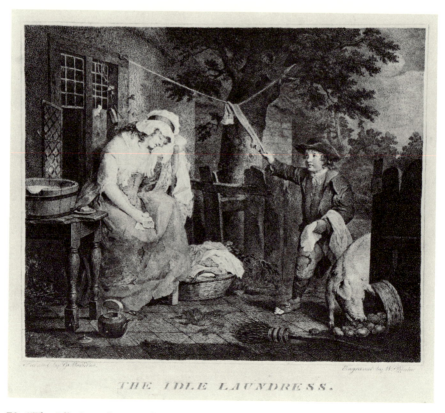

70. "The Idle Laundress," after Morland. Impression G, probably third state. 21.1 × 26.1 cm

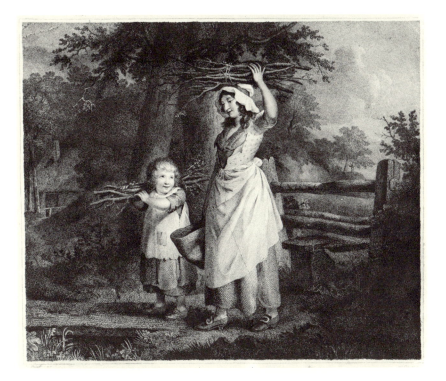

71. "Industrious Cottager," after Morland. First state, impression 1A. 21.3 × 26 cm

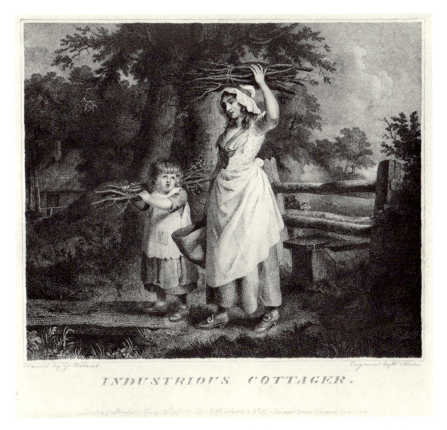

72. "Industrious Cottager," after Morland. Third state, impression 3B. 21.3 × 26 cm

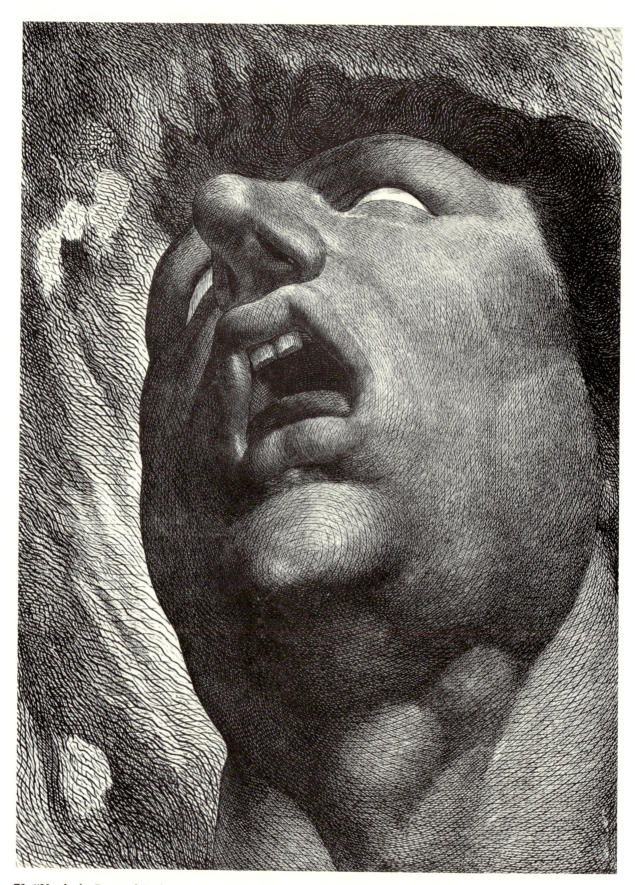

73. "Head of a Damned Soul in Dante's *Inferno*," after Fuseli. First state, impression 1A. 35.1 × 26.5 cm

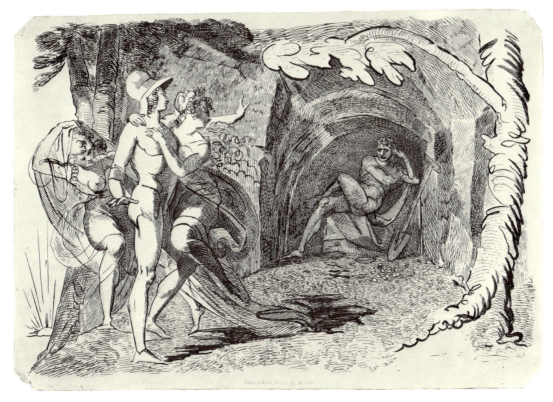

74. "Timon and Alcibiades," after Fuseli. 20.2 × 29.6 cm

75. "Timon and Alcibiades." Drawing by Fuseli. 20.5 × 29.9 cm

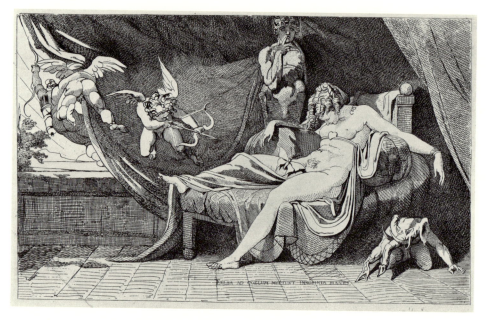

76. "Falsa ad Coelum," after Fuseli. 22.2 × 35.8 cm

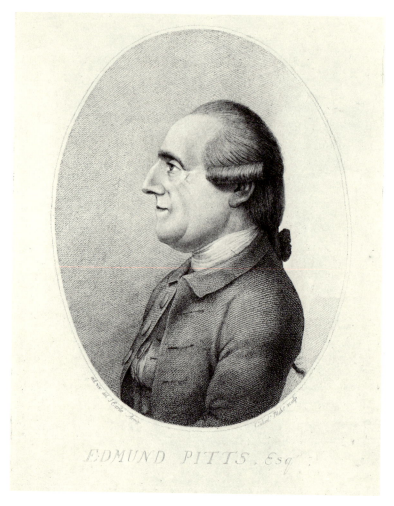

77. "Edmund Pitts, Esqʳ," after Earle. Second state, impression 2B. 18.5 × 14.2 cm

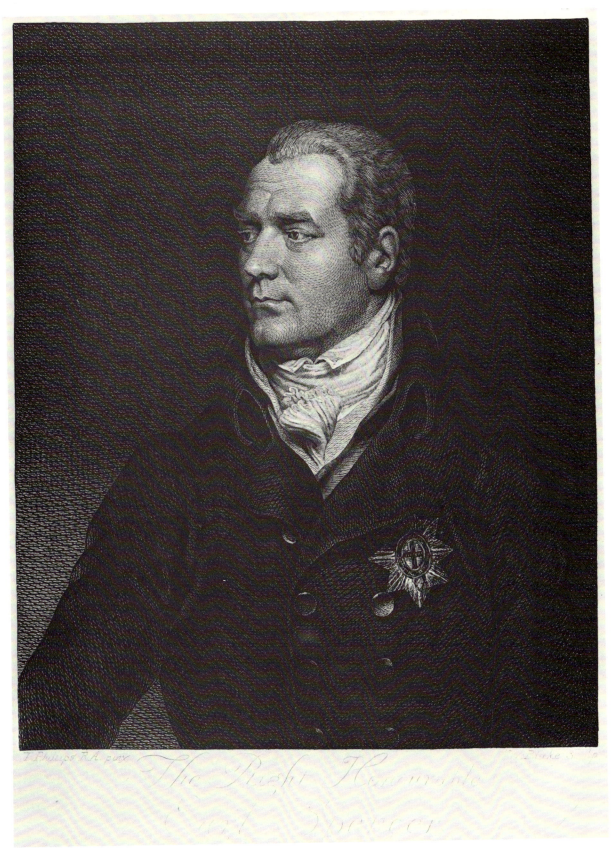

78. "The Right Honourable Earl Spencer," after Phillips. Second state, impression 2C. 30 × 24.7 cm

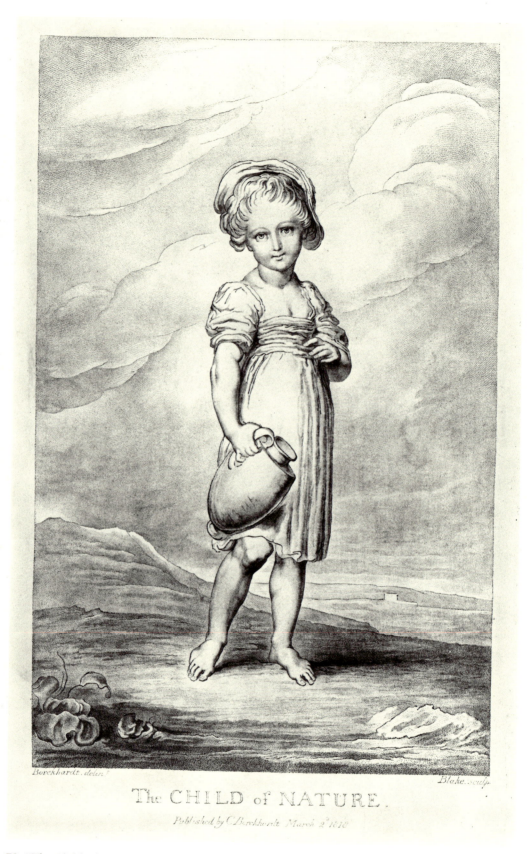

Borckhardt. delin. Blake sculp.

The CHILD of NATURE.

Published by C.Borckhardt March 2ᵈ 1818

79. "The Child of Nature," after Borckhardt. Impression 1A. 38.1 × 24.8 cm

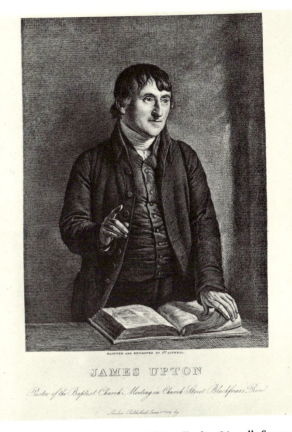

JAMES UPTON

Pastor of the Baptist Church Meeting in Church Street Blackfriars Road

80. "James Upton," Blake and Linnell after Linnell. First state, impression 1A. 26.1 × 19.4 cm

81. "James Upton," Blake and Linnell after Linnell. Second state, impression 2B. 26.1 × 19.4 cm

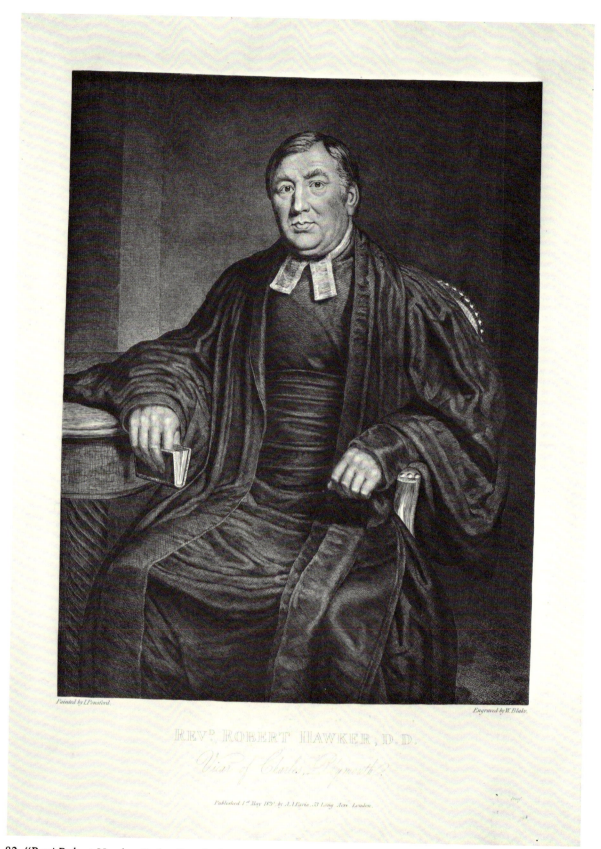

Painted by I.Ponsford.

Engraved by W.Blaky.

REV.^D ROBERT HAWKER, D.D.

Vicar of Charles, Plymouth.

Published 1st May 1821 by A.J.Faris, 53 Long Acre, London.

Proof.

82. "Rev.ᵈ Robert Hawker," after Ponsford. Impression 1C. 35.1 × 27.7 cm

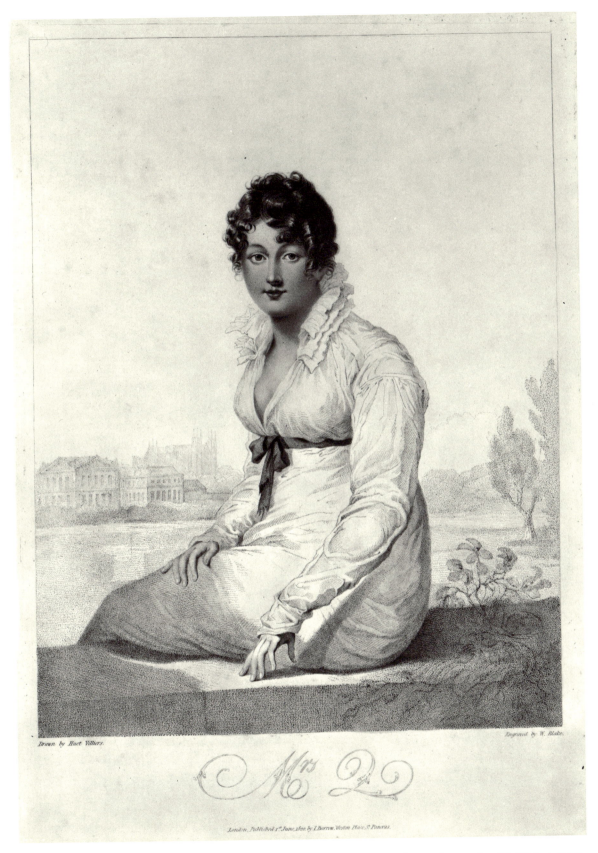

Drawn by Huet Villiers.

Engraved by W. Blake.

Mrs Q

London, Published 1st June, 1820 by I. Barrow, Weston Place, St Pancras.

83. "M^{rs} Q," after Villiers. Stipple etching/engraving with mezzotint. Second state, impression 2J. 29.4 × 22.9 cm

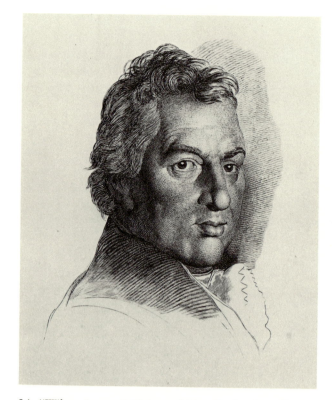

84. "Wilson Lowry," Blake and Linnell after Linnell. First state, impression 1A. 13 × 9.5 cm

85. "Wilson Lowry," Blake and Linnell after Linnell. Second state, impression 2B. 13 × 9.5 cm

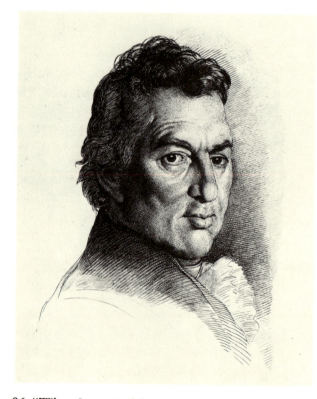

86. "Wilson Lowry," Blake and Linnell after Linnell. Third state, impression 3D. 14.5 × 10.5 cm

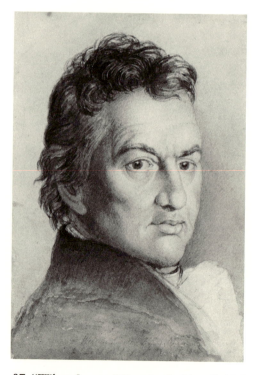

87. "Wilson Lowry." Drawing by Linnell. 15.5 × 10.7 cm

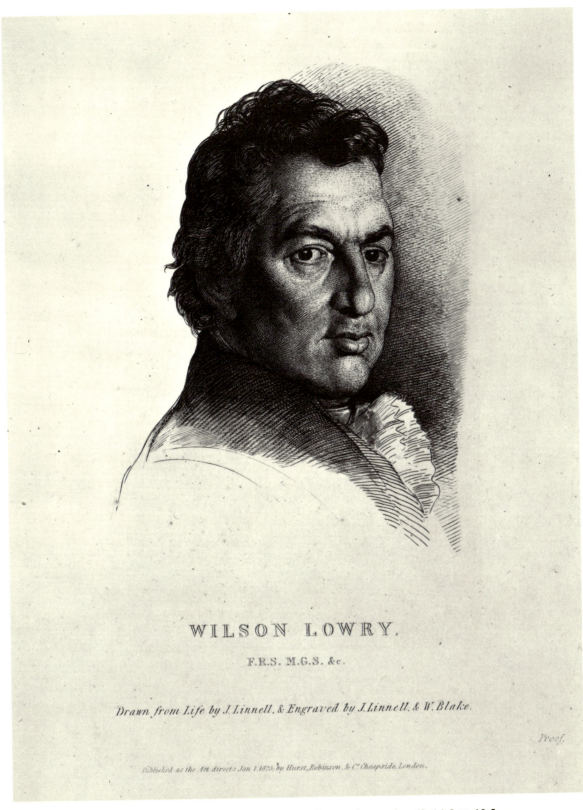

WILSON LOWRY.

F.R.S. M.G.S. &c.

Drawn from Life by J. Linnell, & Engraved by J. Linnell, & W. Blake.

Proof.

Published as the Act directs Jan. 1.1825, by Hurst, Robinson, & C.º Cheapside, London.

88. "Wilson Lowry," Blake and Linnell after Linnell. Fourth state, impression 4I. 14.5 × 10.5 cm

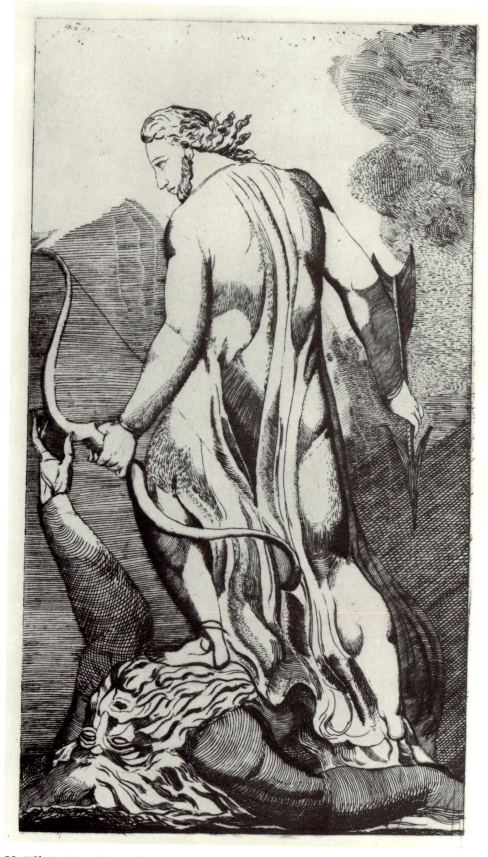

89. "Christ Trampling on Satan," Butts after Blake. Impression 1H. 24 × 13.6 cm

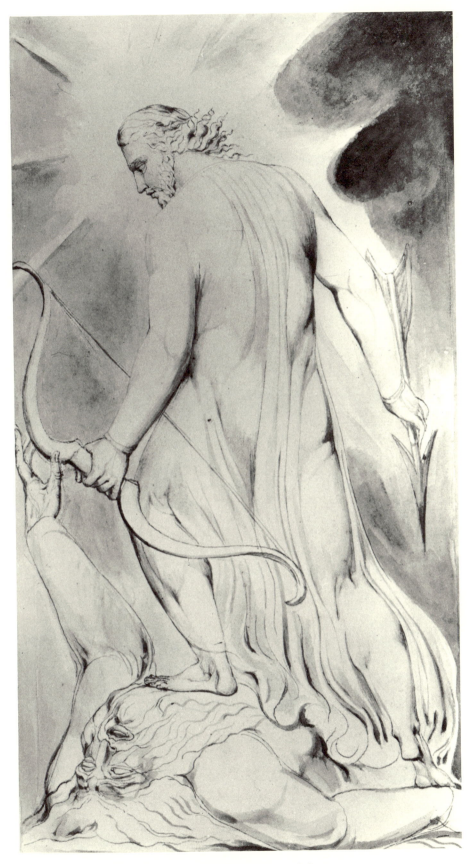

90. "Christ Trampling on Satan." Drawing. 23.9 × 13.2 cm

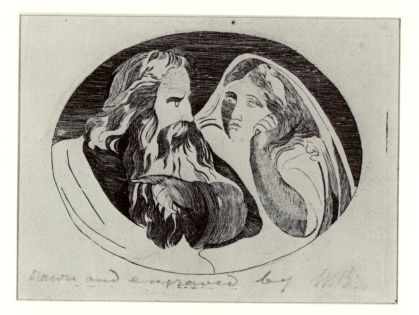

91. "Lear and Cordelia," Butts after Blake. First state, impression 1A. 7.4 × 9.7 cm

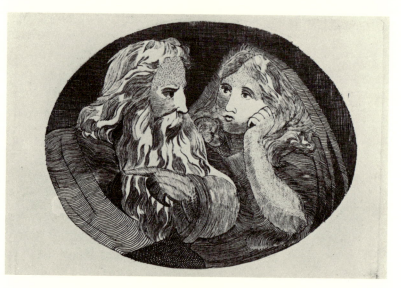

92. "Lear and Cordelia," Butts after Blake. Second state, impression 2B. 7.4 × 9.7 cm

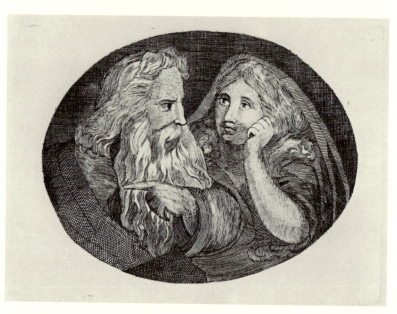

93. "Lear and Cordelia," Butts after Blake. Third state, impression 3D. 7.4 × 9.7 cm

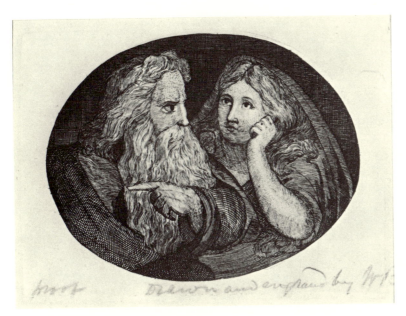

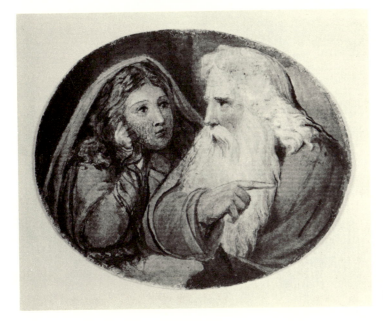

94. "Lear and Cordelia," Butts after Blake. Fourth state, impression 4G. 7.4 × 9.7 cm

95. "Lear and Cordelia." Drawing. 7.4 × 9.5 cm

96. "Two Afflicted Children," Butts after Blake(?). 6.5 × 10.3 cm

97. "Two Views of an Afflicted Child," Butts after Blake(?). 6 × 10.5 cm

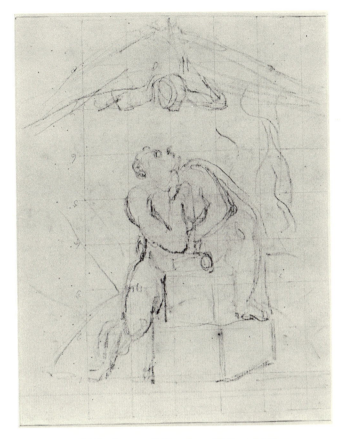

98. "Los and His Spectre." Drawing. 17.2 × 11.1 cm

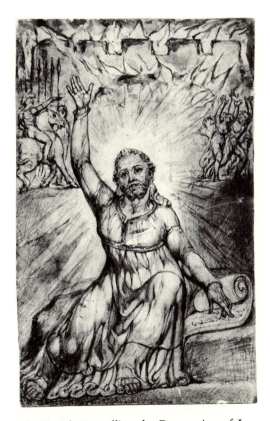

99. "Isaiah Foretelling the Destruction of Je-
rusalem." India ink over pencil on a wood block.
12.5 × 8 cm

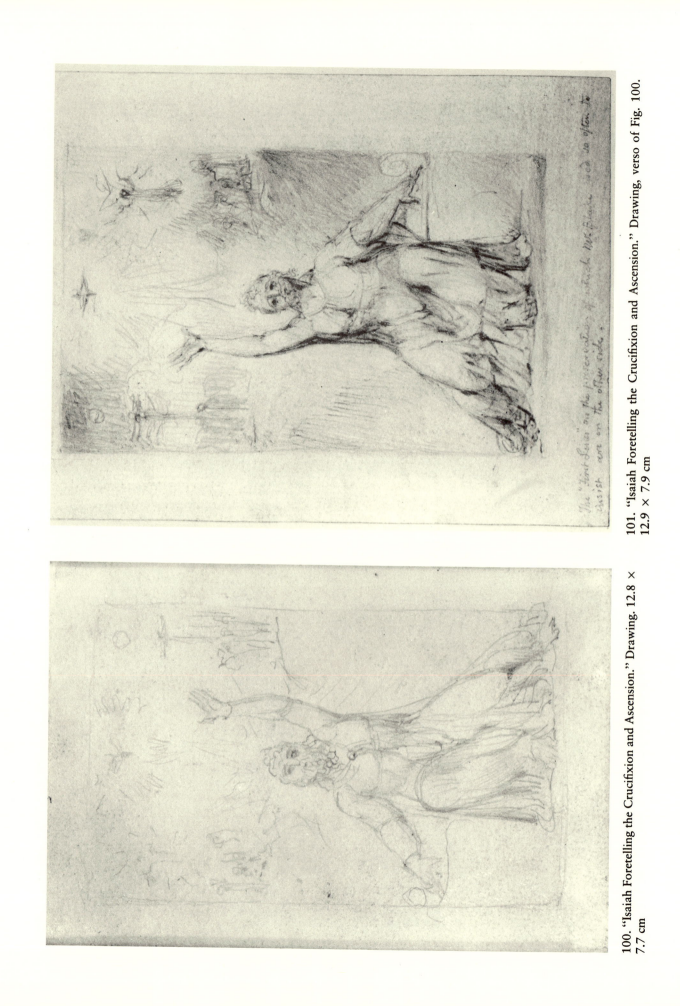

101. "Isaiah Foretelling the Crucifixion and Ascension." Drawing, verso of Fig. 100. 12.9 × 7.9 cm

100. "Isaiah Foretelling the Crucifixion and Ascension." Drawing. 12.8 × 7.7 cm

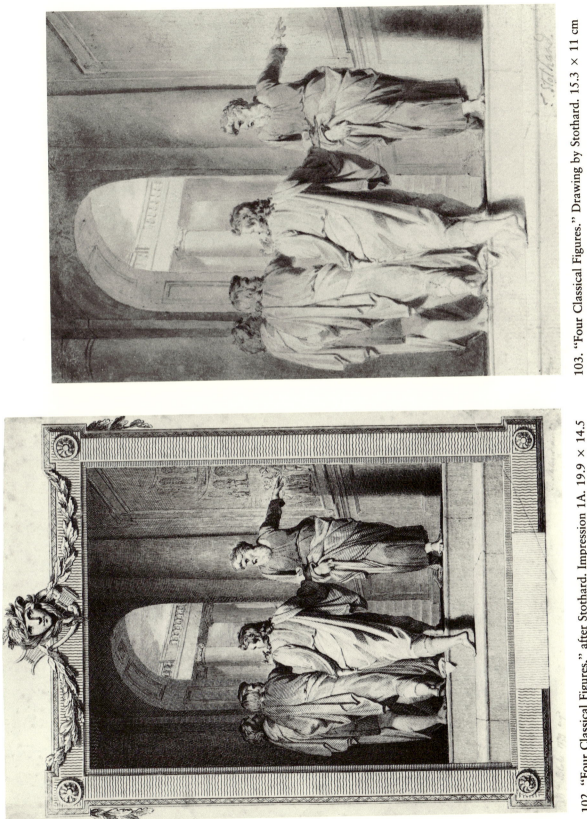

103. "Four Classical Figures." Drawing by Stothard. 15.3 × 11 cm

102. "Four Classical Figures," after Stothard. Impression 1A. 19.9 × 14.5

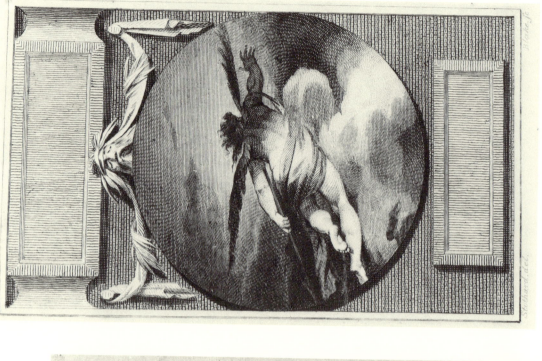

105. "Winged Figure Flying through Clouds," after Stothard. Impression 1A. 10.6 × 6.3 cm

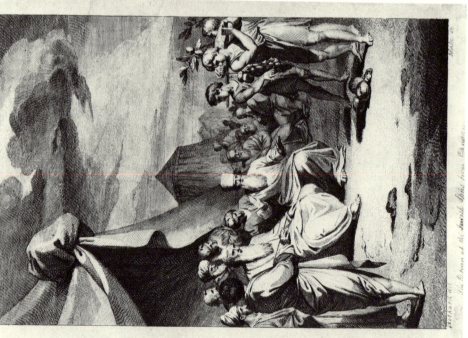

104. "The Return of the Jewish Spies from Canaan," after Stothard. 16.7 × 10.9 cm

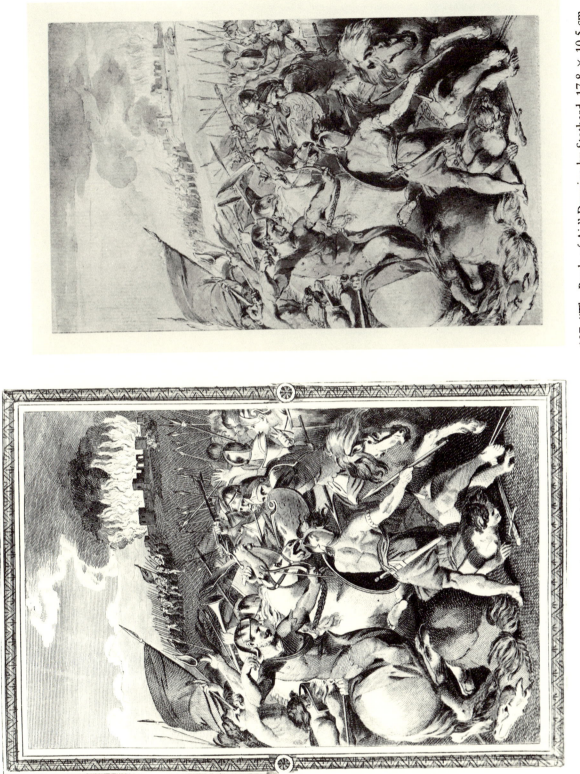

107. "The Battle of Ai." Drawing by Stothard. 17.8 × 10.5 cm

106. "The Battle of Ai," after Stothard. 19 × 12.3 cm

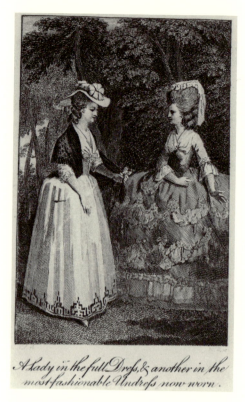

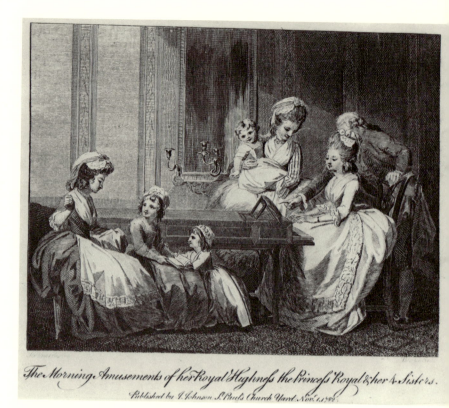

108. "A Lady in the full Dress," after Stothard. Second state, impression 2B. 9.6 × 6.5 cm

109. "The Morning Amusements of her Royal Highness," after Stothard. Second state, impression 2B. 9.6 × 12.6 cm

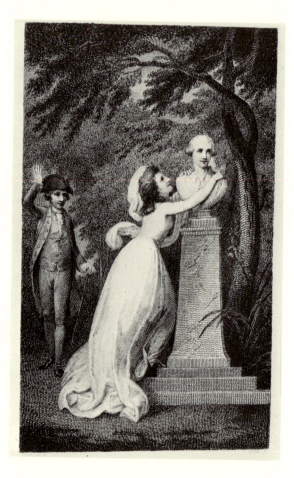

110. "A Lady Embracing a Bust," after Stothard. Second state, impression 2D. 12.8 × 8.1 cm

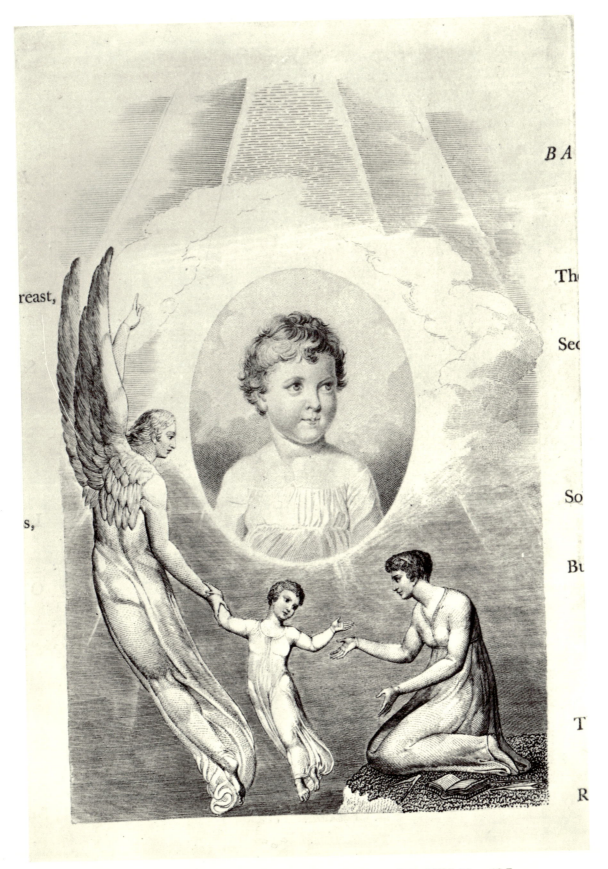

111. A Frontispiece for Benjamin Heath Malkin's *A Father's Memoirs of His Child*. 19 × 12.7 cm

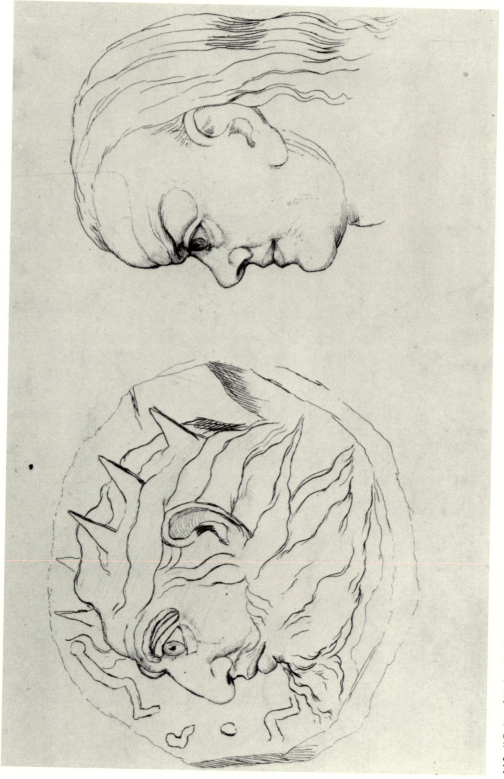

114. "Cancer." Drawing. Sheet 18.8 × 13.9 cm

113. "Coin of Nebuchadnezzar." Tracing (by Linnell?) after Blake. Sheet 20.5 × 18.8 cm

THE SEPARATE PLATES OF
William Blake

HAS BEEN COMPOSED IN LINOTRON SABON AND
PRINTED ON WARRENS OLDE STYLE BY PRINCETON
UNIVERSITY PRESS, PRINCETON, NEW JERSEY

COLOR PLATES AND BLACK AND WHITE ILLUSTRATIONS
PRINTED BY THE MERIDEN GRAVURE COMPANY,
MERIDEN, CONNECTICUT

DESIGNED BY LAURY A. EGAN